PALGRAVE STUDIES IN THEATRE AND PERFORMANCE HISTORY is a series devoted to the best of theatre/performance scholarship currently available, accessible, and free of jargon. It strives to include a wide range of topics, from the more traditional to those performance forms that in recent years have helped broaden the understanding of what theatre as a category might include (from variety forms as diverse as the circus and burlesque to street buskers, stage magic, and musical theatre, among many others). Although historical, critical, or analytical studies are of special interest, more theoretical projects, if not the dominant thrust of a study, but utilized as important underpinning or as a historiographical or analytical method of exploration, are also of interest. Textual studies of drama or other types of less traditional performance texts are also germane to the series if placed in their cultural, historical, social, or political and economic context. There is no geographical focus for this series and works of excellence of a diverse and international nature, including comparative studies, are sought.

The editor of the series is Don B. Wilmeth (EMERITUS, Brown University), Ph.D., University of Illinois, who brings to the series over a dozen years as editor of a book series on American theatre and drama, in addition to his own extensive experience as an editor of books and journals. He is the author of several award-winning books and has received numerous career achievement awards, including one for sustained excellence in editing from the Association for Theatre in Higher Education.

Also in the series:

Undressed for Success by Brenda Foley
Theatre, Performance, and the Historical Avant-garde by Günter Berghaus
Theatre, Politics, and Markets in Fin-de-Siècle Paris by Sally Charnow
Ghosts of Theatre and Cinema in the Brain by Mark Pizzato
Moscow Theatres for Young People by Manon van de Water
Absence and Memory in Colonial American Theatre by Odai Johnson
Vaudeville Wars: How the Keith-Albee and Orpheum Circuits Controlled the Big-Time and Its Performers by Arthur Frank Wertheim
Performance and Femininity in Eighteenth-Century German Women's Writing by Wendy Arons
Operatic China: Staging Chinese Identity across the Pacific by Daphne P. Lei
Transatlantic Stage Stars in Vaudeville and Variety: Celebrity Turns by Leigh Woods
Interrogating America through Theatre and Performance edited by William W. Demastes and Iris Smith Fischer
Plays in American Periodicals, 1890–1918 by Susan Harris Smith
Representation and Identity from Versailles to the Present: The Performing Subject by Alan Sikes
Directors and the New Musical Drama: British and American Musical Theatre in the 1980s and 90s by Miranda Lundskaer-Nielsen
Beyond the Golden Door: Jewish-American Drama and Jewish-American Experience by Julius Novick
American Puppet Modernism: Essays on the Material World in Performance by John Bell
On the Uses of the Fantastic in Modern Theatre: Cocteau, Oedipus, and the Monster by Irene Eynat-Confino
Staging Stigma: A Critical Examination of the American Freak Show by Michael M. Chemers, foreword by Jim Ferris

Performing Magic on the Western Stage: From the Eighteenth-Century to the Present edited by Francesca Coppa, Larry Hass, and James Peck, foreword by Eugene Burger
Memory in Play: From Aeschylus to Sam Shepard by Attilio Favorini
Danjūrō's Girls: Women on the Kabuki Stage by Loren Edelson
Mendel's Theatre: Heredity, Eugenics, and Early Twentieth-Century American Drama by Tamsen Wolff
Theatre and Religion on Krishna's Stage: Performing in Vrindavan by David V. Mason
Rogue Performances: Staging the Underclasses in Early American Theatre Culture by Peter P. Reed
Broadway and Corporate Capitalism: The Rise of the Professional-Managerial Class, 1900–1920 by Michael Schwartz
Lady Macbeth in America: From the Stage to the White House by Gay Smith
Performing Bodies in Pain: Medieval and Post-Modern Martyrs, Mystics, and Artists by Marla Carlson
Early-Twentieth-Century Frontier Dramas on Broadway: Situating the Western Experience in Performing Arts by Richard Wattenberg
Staging the People: Community and Identity in the Federal Theatre Project by Elizabeth A. Osborne
Russian Culture and Theatrical Performance in America, 1891–1933 by Valleri J. Hohman
Baggy Pants Comedy: Burlesque and the Oral Tradition by Andrew Davis
Transposing Broadway: Jews, Assimilation, and the American Musical by Stuart J. Hecht
The Drama of Marriage: Gay Playwrights/Straight Unions from Oscar Wilde to the Present by John M. Clum
Mei Lanfang and the Twentieth-Century International Stage: Chinese Theatre Placed and Displaced by Min Tian
Hijikata Tatsumi and Butoh: Dancing in a Pool of Gray Grits by Bruce Baird

Hijikata Tatsumi and Butoh

Dancing in a Pool of Gray Grits

Bruce Baird

HIJIKATA TATSUMI AND BUTOH
Copyright © Bruce Baird, 2012.

All rights reserved.

First published in 2012 by
PALGRAVE MACMILLAN®
in the United States—a division of St. Martin's Press LLC,
175 Fifth Avenue, New York, NY 10010.

Where this book is distributed in the UK, Europe and the rest of the world, this is by Palgrave Macmillan, a division of Macmillan Publishers Limited, registered in England, company number 785998, of Houndmills, Basingstoke, Hampshire RG21 6XS.

Palgrave Macmillan is the global academic imprint of the above companies and has companies and representatives throughout the world.

Palgrave® and Macmillan® are registered trademarks in the United States, the United Kingdom, Europe and other countries.

ISBN: 978–0–230–12040–2

Library of Congress Cataloging-in-Publication Data

Baird, Bruce, 1968–
 Hijikata Tatsumi and Butoh : dancing in a pool of gray grits / Bruce Baird.
 p. cm.—(Palgrave studies in theatre and performance history series)
 ISBN 978–0–230–12040–2 (alk. paper)
 1. Tatsumi, Hijikata, 1928–1986. 2. Choreographers—Japan—Biography. 3. Butoh—Japan—History. 4. Japan—Social life and customs. I. Title.

GV1785.T38B35 2011
792.82092—dc23 2011026027
[B]

A catalogue record of the book is available from the British Library.

Design by Newgen Imaging Systems (P) Ltd., Chennai, India.

First edition: January 2012

10 9 8 7 6 5 4 3 2 1

Printed in the United States of America.

For Jeanne, Beckett, and Axel
And in memory of
William R. Lafleur and Michael F. Marra

Contents

List of Illustrations	ix
Acknowledgments	xiii
Notes on Style	xv
1. Introduction: And, And, And	1
2. Forbidden Eros and Evading Force: Hijikata's Early Years	15
3. A Story of Dances that Sustain Enigma: Simultaneous Display and Sale of the Dancers	59
4. Pivoting Panels and Slashing Space: Rebellion and Identity	105
5. My Mother Tied Me on Her Back: *Story of Smallpox*	137
6. The Possibility Body: Embodying the Other, Negotiating the World	159
7. Metaphorical Miscegenation in Memoirs: Hijikata Tatsumi in the Information Age	185
8. Epilogue: The Emaciated Body in the World	207
Appendix: Original Japanese Names, Terms, and Dance Titles	219
Notes	229
Bibliography	269
Index	283

Illustrations ❦

Cover Photo: Hijikata Tatsumi, *Story of Smallpox*, (Shinjuku Culture Art Theater, Tokyo, Nov. 1972) by Onozuka Makoto.

2.1 Man (Hijikata Tatsumi) with Chicken and Young Man (Ôno Yoshito) walking around, "Forbidden Colors Studio Performance," (Tsuda Nobutoshi Dance Studio (Later Asbestos Hall), Tokyo, Summer 1959) by Ôtsuji Seiji. 18
2.2 Young Man looking at hands with despair, "Forbidden Colors Studio Performance," (Tsuda Nobutoshi Dance Studio, Tokyo, Summer 1959) by Ôtsuji Seiji. 19
2.3 Young Man with chicken, *Forbidden Colors*, (Daiichi Seimei Hall, Tokyo, May 1959) by Kurokawa Shashinkan. 20
2.4 Man handing chicken to Young Man (long shot), "Forbidden Colors Studio Performance," (Tsuda Nobutoshi Dance Studio, Tokyo, Summer 1959) by Ôtsuji Seiji. 21
2.5 Man handing chicken to Young Man (close up), "Forbidden Colors Studio Performance," (Tsuda Nobutoshi Dance Studio, Tokyo, Summer 1959) by Ôtsuji Seiji. 22
2.6 Man pulling hair of Young Man, "Forbidden Colors Studio Performance," (Tsuda Nobutoshi Dance Studio, Tokyo, Summer 1959) by Ôtsuji Seiji. 23
2.7 Young Man with chicken, "Forbidden Colors Studio Performance," (Tsuda Nobutoshi Dance Studio, Tokyo, Summer 1959) by Ôtsuji Seiji. 24
2.8 Young Man on floor crushing chicken between legs, "Forbidden Colors Studio Performance," (Tsuda Nobutoshi Dance Studio, Tokyo, Summer 1959) by Ôtsuji Seiji. 25
2.9 Man celebrating over Young Man, "Forbidden Colors Studio Performance," (Tsuda Nobutoshi Dance Studio, Tokyo, Summer 1959) by Ôtsuji Seiji. 26
2.10 Young Man (Ôno Yoshito) and Man (Hijikata Tatsumi) rolling around, *Forbidden Colors*, (Daiichi Seimei Hall, Tokyo, May 1959) by Kurokawa Shashinkan. 27
2.11 Divine (Ôno Kazuo), *Forbidden Colors 2*, Scene 1 "Death of Divine," (Daiichi Seimei Hall, Tokyo, Sept. 1959) by Kurokawa Shashinkan. 33
2.12 Divine and Young men with arrows, *Forbidden Colors 2*, Scene 1 "Death of Divine," by Kurokawa Shashinkan. 34

x *Illustrations*

2.13 Man watching Young Man crush chicken between his legs, *Forbidden Colors 2*, Scene 2 "Death of the Young Man," photographer unknown. 35
2.14 Young Man wrapped in ropes, *Forbidden Colors 2*, Scene 2 "Death of the Young Man," by Kurokawa Shashinkan. 36
2.15 Scene from 1959 or from the early 1960's (possibly *Forbidden Colors 2*, Scene 2 "Death of the Young Man" or *Dark Body*) by photographer unknown. 55
3.1 *Three Phases of Leda*, (Asbestos Hall, Tokyo, June 1962) by Tanno Akira. 65
3.2 Kazakura Shô watching the action and the dancers walking blindfolded, *Masseur: A Story of a Theater that Sustains Passion*, (Sôgetsu Hall, Tokyo, Nov. 1963) by Yamano Kazuko. 68
3.3 Dancer doing cartwheel in front of shamisen players, *Masseur*, by Tanno Akira. 69
3.4 Dancers spinning around, *Masseur*, by Yoshioka Yasuhiro. 69
3.5 Invitation, *Rose-colored Dance: To M. Shibusawa's House*, (Sennichidani Public Hall, Tokyo, Nov. 1965) by Nakanishi Natsuyuki. 75
3.6 Poster, *Rose-colored Dance*, (Sennichidani Public Hall, Tokyo, Nov. 1965) by Yokoo Tadanori. 76
3.7 Motofuji Akiko and Hijikata Tatsumi's Dancing Duo (possibly Blue Echoes), photographer unknown. 82
3.8 Dancing Gorgui, photographer unknown. 83
3.9 Ishii Mitsutaka in a "Gold Dust Show" (March 1968) by Nakatani Tadao. 84
3.10 Sugar Candy *Objet*: Edible Program, *Rose-colored Dance*, (Sennichidani Public Hall, Tokyo, Nov. 1965) by Kanô Mitsuo. 86
3.11 Stage with men and dogs facing into the backdrop, *Rose-colored Dance*, (Sennichidani Public Hall, Tokyo, Nov. 1965) by Nakatani Tadao. 87
3.12 Ishii Mitsutaka and Kasai Akira in a rubber hose duet, *Rose-colored Dance*, (Sennichidani Public Hall, Tokyo, Nov. 1965) by Nakatani Tadao. 91
3.13 Hijikata Tatsumi and Ôno Kazuo in a duet, *Rose-colored Dance*, (Sennichidani Public Hall, Tokyo, Nov. 1965) by Nakatani Tadao. 92
3.14 Cameraman taking pictures of the dancers during the dance, *Rose-colored Dance*, (Sennichidani Public Hall, Tokyo, Nov. 1965) by Nakatani Tadao. 93
3.15 *I Ching* acupuncture chart, *Rose-colored Dance*, (Sennichidani Public Hall, Tokyo, Nov. 1965) by Akasegawa Genpei. 95
3.16 Rickshaw puller, *Rose-colored Dance*, (Sennichidani Public Hall, Tokyo, Nov. 1965) by Nakatani Tadao. 98

3.17	Ôno Kazuo and unidentified dancers, *Instructional Illustrations for the Study of Divine Favor in Sexual Love: Tomato*, (Kinokuniya Hall, Tokyo, July 1966) by Nakatani Tadao.	100
3.18	Tezuka Osamu's Mickey Mouse bat from the graphic serialized novel (*manga*) *Beribboned Knight*, *Tomato*, (Kinokuniya Hall, Tokyo, July 1966) by Nakatani Tadao.	100
3.19	Trumpeter riding another dancer, *Metemotionalphysics* (Kinokuniya Hall, Tokyo, July 1967) by Nakatani Tadao.	103
3.20	Takai Tomiko with mirrors on breasts, *Metemotionalphysics* (Kinokuniya Hall, Tokyo, July 1967) by Fujisaki Masaki.	104
4.1	Procession with cart and pig, *Hijikata Tatsumi and Japanese People: Rebellion of the Body*, (Nihon Seinenkan, Tokyo, Oct. 1968) by Nakatani Tadao.	116
4.2	Hijikata Tatsumi in white backwards bridal kimono, *Hijikata Tatsumi and Japanese People: Rebellion of the Body*, by Torii Ryôzen.	117
4.3	Hijikata with golden phallus, *Hijikata Tatsumi and Japanese People: Rebellion of the Body*, by Torii Ryôzen.	118
4.4	Hijikata in ball gown, *Hijikata Tatsumi and Japanese People: Rebellion of the Body*, by Nakatani Tadao.	118
4.5	Hijikata in T-shirt dress and can can skirt, *Hijikata Tatsumi and Japanese People: Rebellion of the Body*, by Nakatani Tadao.	119
4.6	Hijikata as young girl, *Hijikata Tatsumi and Japanese People: Rebellion of the Body*, by Nakatani Tadao.	120
4.7	Ascension, *Hijikata Tatsumi and Japanese People: Rebellion of the Body*, by Hasegawa Roku.	121
4.8	Hijikata in white suit, *Hijikata Tatsumi and Japanese People: Rebellion of the Body*, by Nakatani Tadao.	122
5.1	Kobayashi Saga and Tamano Kôichi, *Space Capsule Show*, (Space Capsule, Akasaka, Tokyo, Feb. 1969) by Nakatani Tadao.	139
5.2	Kobayashi Saga, Ashikawa Yôko and one other unidentified dancer, *Dissolute Jewel*, (Shinjuku Art Village, Tokyo, June 1971) by Onozuka Makoto.	140
5.3	Hijikata Tatsumi in a *dotera*, *Story of Smallpox*, (Shinjuku Culture Art Theater, Tokyo, Nov. 1972) by Onozuka Makoto.	141
5.4	Hijikata Tatsumi, Tamano Kôichi, Waguri Yukio, et al, *Story of Smallpox*, by Onozuka Makoto.	142
5.5	Courageous Women (Ashikawa Yôko, Kobayashi Saga, Nimura Momoko), *Story of Smallpox*, by Onozuka Makoto.	142
5.6	Hijikata Tatsumi, *Story of Smallpox*, by Onozuka Makoto.	143
5.7	Stage left from Hijikata's solo. Tamano Kôichi, Waguri Yukio, and others, *Story of Smallpox*, by Onozuka Makoto.	144
5.8	Reclining dancers, (Ashikawa Yôko, Kobayashi Saga, Nimura Momoko, Yoshino Hiromi), *Story of Smallpox*, by Onozuka Makoto.	145

xii *Illustrations*

5.9	Multiaxial torso (Tamano Kôichi, Waguri Yukio, and others), *Story of Smallpox*, by Onozuka Makoto.	146
5.10	Bending over on half point, (Ashikawa Yôko, Kobayashi Saga, Nimura Momoko, Yoshino Hiromi), *Story of Smallpox*, by Onozuka Makoto.	147
5.11	Courageous Women, seated, (Ashikawa Yôko, Kobayashi Saga, Nimura Momoko, Yoshino Hiromi), *Story of Smallpox*, by Onozuka Makoto.	150
8.1	Ashikawa Yôko, *Lady on a Whale String*, (Asbestos Hall, Tokyo, Dec. 1976) by Nakatani Tadao.	208
8.2	Ashikawa Yôko, *Lady on a Whale String*, (Asbestos Hall, Tokyo, Dec. 1976) by Nakatani Tadao.	209
8.3	Hijikata Tatsumi, *Quiet House*, (Seibu Theater, Tokyo, 1973) by Onozuka Makoto.	212
8.4	Hijikata Tatsumi, *Quiet House*, (Seibu Theater, Tokyo, 1973) by Onozuka Makoto.	213
8.5	Hijikata Tatsumi, *Quiet House*, (Seibu Theater, Tokyo, 1973) by Onozuka Makoto.	214

Acknowledgments

One strand of philosophical thought holds that the distinction between the inside and the outside is ultimately untenable, and that inside and outside actually require and constitute each other. This being the case, the argument of this book must already be present in these acknowledgments, which cannot be extraneous to the book. That argument, in a schematic form, is that people, things, and ideas can interact with each other and change each other, but that in order to do so, they must be in, or put themselves in, a position to be able to interact with others and they must open themselves to the change that comes from those interactions. And so it is with me. Over the years that this book has taken shape, I have interacted with many people, and to the extent that I have been able to open myself to what they had to offer, I have benefited greatly. In Amherst, Amanda Seaman, Stephen Miller, Patrick Donnelly, and Tim van Compernolle have been the kind of colleagues that anyone could wish for: we have both sparred and shared dinner. Also, at UMass Amherst, Doris Bargen, Sharon Domier, Steve Forrest, Reiko Sono, Yuki Yoshimura, and Yuko Takahashi have been invaluable departmental mates in checking translations, answering questions, and giving advice. At the University of Pennsylvania, three people were crucial to my academic growth: Ayako Kano, the late William LaFleur, and Linda Chance. Anyone who knows their academic work will realize that their ideas permeate every part of this project. I express to them my deepest gratitude. Also at Penn, Cappy Hurst, Sari Kawana, Maki Morinaga, and Noriko Horiguchi aided me immeasurably. Leslie Pincus and the late Michael Marra made my time at UCLA rewarding, and I was sorry to part with them for the Ph.D. portion of my journey. At Keio University, Takamiya Toshiyuki provided a home for a nonclassicist, and Sumi Yôichi, Maeda Fujio, Morishita Takeshi, Takemi Murai, Yuka Asaki, Honma Yu, and Ishimoto Kae answered questions, provided me with materials, and provided the "Bruce-desk" at the Hijikata Tatsumi Archive, housed in the Keio University Research Center for the Arts and Arts Administration. The archive and the center provide many of the photographs in this book. At Palgrave Macmillan, Sammantha Hasey, Kristy Lilas, and Don Wilmeth have given valuable advice and put up with my endless queries and negotiations. I hope that they are as happy to have their names associated with this book as I am. Bespeaking the international nature of a project like this, Deepa John and Rohini Krishnan of Newgen Publishing, Chennai, India oversaw the production of the book which was copy edited by Prasanna Chandrashekharan and typeset by Pownraj Rajamanickam and Revathi Dakshinamoorthi. Susan Blakely Klein was the anonymous reviewer who chose to forsake her anonymity in order to carry on an extensive conversation about butoh. The book is much stronger for her attention to it. Tim, Sean Gilsdorf, Jason Mumford, Rebecca Dhondt, and

Monica Couch read portions of the manuscript and made generous comments. My research was funded by the Fulbright Foundation, the Northeast Area Counsel of the Association of Asian Studies, a UMass Amherst Faculty Research Grant, and UMass Research Funds, and I thank each of these agencies for their support. A subvention to defray the cost of numerous images was provided by the UMass Office of Research and Engagement. Sam, Matt and Jason—thanks for everything over the years. Perhaps it is no accident that the author of a book about interactions comes from a large family. To my parents—Jim and Betsy—and my eight brothers and sisters—Richard, Lynn, Ken, Karen, (this is where I fit), Ellie, Paul, Dianne, and Linda—go a triple portion of thanks for their support in various ways. And most of all, thanks go to Jeanne and Beckett for interacting with me and changing me, and for so much more than I can possibly write.

Notes on Style

Aside from one noted exception, Japanese names are rendered surname first and given name second. I have followed the modified Hepburn system in transcribing Japanese words and names (including the use of macrons in all but well-Anglicized Japanese words). The word "butoh" will be used in Anglicized spelling with an "h" at the end, but Japanese bibliographic references will use the macron: *butô*.

Many of the dance titles are quite long and cumbersome. In order to avoid cluttering the text, a list of original Japanese titles and romanized transliterations is available in the appendix. I have also included in Japanese words and phrases in the appendix, as well as names. When I could insert a Japanese gloss for a word or phrase without disturbing the flow, I have done so.

1. Introduction: And, And, And ∽

> *Dreams, works of art (some), glimpses of the always-more-successful surrealism of everyday life, unexpected moments of empathy (is it?) catch a peripheral vision of whatever it is one can never really see full-face but that seems enormously important.*
>
> <div align="right">Elizabeth Bishop</div>

Butoh defies description. Observers seem compelled to verbal contortions to articulate what they see: "the grotesque and the beautiful, the nightmarish and the poetic, the erotic and the austere, the streetwise and the spiritual."[1] Either in spite of or due to these contortions, this performance art—which was founded by Hijikata Tatsumi during a two-decade span from the late 1950s to the 1970s—has spread around the world, and one can now find butoh companies or dancers based in nearly every major city in the world. Several cities outside Japan have annual butoh festivals, and other theater and dance festivals almost uniformly feature butoh performers. One can go to see butoh several times a month in many cities and nearly every night in Tokyo. In addition, many of the particulars of the art form have crept into the consciousness of the performance world, and numerous artists—while not claiming to specifically practice butoh—cite a period of studying butoh as a formative part of a larger artistic trajectory. Butoh has even infiltrated the wider world; one can walk the streets of Omote Sando or the Ginza in Tokyo and see sixty-foot-tall billboards advertising fancy watches or other hipster products with bald white-skinned butoh denizens peering out at the passersby. However, even as butoh has spread and gained popularity, it has not been well understood within the context of the sixties, seventies, and eighties in Japan. Observers have been drawn to the striking images of butoh, but usually know little else about it.

The gap between the striking images and sparse knowledge has been nowhere more apparent than in a performance midway through Hijikata's career. In 1968, Hijikata choreographed the stunning and audacious solo *Hijikata Tatsumi and Japanese People: Rebellion of the Body*, which could easily serve as the referent for "grotesque and beautiful, nightmarish and poetic, erotic and austere, streetwise and spiritual." Hijikata was carted onto the stage in a procession that included a pig, a rabbit, and a revolving barbershop pole. Initially clad in a blindingly white long-sleeved kimono, a hunchbacked Hijikata contorted himself as if beset with palsy. Disrobing, he exposed a naked, gaunt, muscled body, an erect ten-inch golden phallus, and shaggy black pubic hair. He leaped and gyrated to chainsaw noises and classical music coming from an onstage piano, and threw himself repeatedly against large spinning brass panels suspended at the back of the stage.

Throughout the course of the dance, he changed costumes several times while continuing a barrage of wild and varied movements. Wearing a sumptuous full-length shiny ball gown and thick black rubber gloves, he danced with movements that were vaguely flamenco-like or appeared as if they were inspired by the limitations of scoliosis, and then removed and flogged the ground with the bottom half of the dress. After a change to a rather plain thigh-length T-shirt dress worn beneath a girdle with a ruffled can-can skirt tied over the top, he walked leaning backward while dropping his pelvis and lifting his knees high. Then, in a short thigh-length kimono and knee-high athletic socks, he squatted on the ground, bounced around like an excited little girl, and danced like a cheerleader.

Despite the doubled title *Hijikata Tatsumi and Japanese People: Rebellion of the Body*, the majority of attention has focused on the smashing body, pulsating phallus, and the titular idea of a bodily rebellion. In fact, the second half of the title has so overshadowed the first half that many assume that the dance was simply entitled *Rebellion of the Body* (also often rendered Revolt of the Flesh).[2] A contrasting minority of observers, drawn to the first part of the title, *Hijikata Tatsumi and Japanese People*, assumed that Hijikata was making a statement about his connection to Japanese identity, and thus saw butoh as an expression of traditional Japanese aesthetics, Japanese folk art, or the Japanese body.[3] Few have bothered to try to understand the dance in light of both the titles.

However, a closer look reveals that contrasts and oppositions permeate the dance: human and animal; elegant dress and rubber gloves; male and female; young and old; disabled or diseased and healthy; athletic and infirm; strong and weak; violent and serene; classical and contemporary; costumes coded as culturally Japanese (kimono) and culturally foreign (gown, can-can skirt). The title seems to prefigure this structural bifurcation. The first part, *Hijikata Tatsumi and Japanese People*, points to a terpsichorean consideration of the relationship between Hijikata and other Japanese people, while the second, *Rebellion of the Body*, calls attention to a corporeal resistance to authority and established convention. Lest this be thought an aberration, over the course of his career, Hijikata's dances were routinely concerned with diametrical and orthogonal oppositions, and he often gave his dances and essays doubled or even tripled titles.

This concern with opposition and juxtaposition points to an entry into apprehending Hijikata's work. In the introduction, I shall only sketch an outline of how studying the creation and use of oppositions and juxtapositions can expand our understanding of Hijikata and butoh. The concrete details and evidence to support my argument follow in subsequent chapters. For the moment, the beginning of a more complete understanding of butoh lies in the recognition that almost from the beginning of his dance career, Hijikata befriended key players in the postwar Japanese surrealism movement. From those friends, Hijikata appropriated an artistic technique of bringing various elements into contact with each other to see what would arise. These artists assumed that any contiguity of elements will produce an interaction or conflict between those elements, and that the more disparate the elements, the greater and more promising the interaction will be.[4] These artists also thought that the body and mind were hemmed in by various customs, concepts, and goal-oriented practices, and pursued the interactions produced by the creation of novel

combinations as a way to stimulate the emergence of something new, or as a means of rousing their imagination to draw previously unseen connections, and thus to uncover or happen upon something beyond preexisting conventions. Thus it is no accident that observers are forced to stretch so far to describe butoh; they are only attempting to match the distance within the dances.

The idea of interaction or conflict between elements was not just an artistic principle; it had parallels in many parts of Hijikata's world. Artists not only thought of things or ideas as in competition, but also thought of themselves as in competition with each other during the co-creation of a work of art. Similarly, they saw a kind of competition between themselves and audiences; between people or groups within athletic competition or within society; between individuals and larger ethnically or spatially oriented (imaginary) communities; between peripheries and geographic, artistic, economic, and political centers; and between geopolitical powers writ large.[5] In short, the society around them was chock-full of competition and conflict between people, institutions, and geopolitical entities.

A situation in which there are many elements interacting with or in conflict with each other (whether they be artistic concepts, artists, or institutions) presents special problems for the observer. One is the possibility of the observer focusing on only one element within an interaction and not noticing the other(s). Ironically (given the aim of the surrealists to happen upon something unconventional through their use of juxtaposition), in these interactions, the observer's focus is often determined by preexisting conventions, which the observer may not be aware of at the moment. Thus, while we can conceive of the elements of an interaction as within a (conflictual) relationship of their own, in which an observer plays no part, the observer also often plays a role in the interaction due to the observer's preexisting mental horizons. We can even conceive of a competition between the elements and the observer in which the observer will either maintain control of her observations of the elements, or the elements (or one side of an interaction or conflict) will sweep away the observer with their strength.

However, often it is not the strength of one element that overpowers the observer, but rather, the very blizzard of elements and the dizzying interconnections between them that poses a problem. Recognizing the complexity of interactions allows us to observe that while surrealists strove to create novel combinations, they did so in an environment that was increasingly filled with novel combinations and overflowing with information of all kinds. Since one of the aims of Hijikata was to create and observe interactions and confrontations between disparate elements, it is possible to see him and other butoh artists as responding to that world of increasing but incomplete information and information of varying strengths by developing ways to be attentive to all sides of an interaction and also as developing ways to cope with either an overload or lack of information.[6] This means that not only do we have to take seriously all the elements interacting with each other within a single butoh performance, but we need to think about the ways that butoh artists were responding to a world of increasing information.

The recognition that the observer can lose track of one side of a juxtaposition or be overwhelmed by the complexity of the interactions within a juxtaposition poses a peculiar problem. Paradoxically, the very nature of competition (which implies a

winner and a loser based upon fitness within the competitive realm) is now opposed to the goal of not letting one element within a competition overpower the others, but rather, holding them in tension within the mind. The problem can only be partially overcome by noting that while the various elements were indeed thought of as existing within an interaction or competition, the observer was expected not to let one of the elements overpower the other(s) or herself, but rather to hold the elements in suspended animation. In turn, if we are to judge by the mental requirements Hijikata imposed on his dancers, Hijikata seems to have thought it was necessary to hold in tension both the idea of conflict, and the very idea itself of holding something in tension. Through a quirk of paradoxical logic, it then appears that the idea of holding two opposing things in tension must win out over victory itself. This tension might seem to be a purely logical conundrum, but it was real to the people of the time (and is real for us today).

To allow this mode of thinking to inform us as observers of butoh, it is not enough merely to point out that there are oppositions within Hijikata's dances or in the titles. We also have to remember that the doubling of titles and the juxtaposition of opposites show the necessity of expanding any interpretive or explanatory framework to account for all elements within the interaction. That is, it is imperative to hold in tension the various competing elements within Hijikata's dances and titles. To the extent to which we are unaware of, or do not take into account, one element within the juxtaposition, we risk missing crucial parts of the interaction, and thus crucial parts of the dance. Moreover, we need to explore those elements within a society (Hijikata's) in which competition and managing information were increasingly required.

For example, to return to the title, *Hijikata Tatsumi and Japanese People: Rebellion of the Body*, there is a tension between the first half of the title and the second half, as well as between the two elements within the first half: Thus, "Hijikata Tatsumi" should be seen in some sort of interaction or conflict with "Japanese people," just as the first part of the title should be grasped in some sort of relationship with the second part. In due course, I shall return to the specifics of Hijikata's relationship with the other inhabitants of the Japanese archipelago, to this corporeal rebellion, and to the rebellion's target and means. For the moment, I want to again stress that any understanding of this particular dance and butoh in general that omits one of these four elements (Hijikata Tatsumi, Japanese people, rebellion, and the human body) is incomplete.

The recognition that a combinatory and combative principle is at work on so many levels in Hijikata's work and within Japanese society of the postwar era presents a challenge for the scholar and reader, but it also dictates one defining element of this book: the devil is always in the details, and in this book, that devil often resides in "and, and, and"—in two, three, or four different sets of competing details. Hence, this will be an information-rich book. This strategy does not stem from some mistaken notion that things speak their own truth easily and clearly for themselves. They never do. Things are always caught up within prior discursive frameworks that shape them in various ways. It would, however, be a mistake to say that things can never speak for themselves at all. The repressed will return; the sediments of history will remanifest themselves; and the physical world will force us

to keep changing the theories by which we describe it. Even if languages constitute our only tool for communicating about the things of the world, and inevitably affect any understanding of the world, the things of the world (including we ourselves) are not completely bound by languages. The world always exceeds language. To put this in the words of Hijikata himself: "Bleeding nature always overflows the allotments of historiography and sociology."[7] But things that are not present can rarely speak at all, so inclusion of detail is a first and proactive step in letting things have a voice. Moreover, this attention to detail matches a preference of Hijikata's, which went beyond the juxtaposition of opposites and prized minute detail, as something to be valued for its own sake.

As a structuring device for this welter of detail, Hijikata's doubled title *Hijikata Tatsumi and Japanese People: Rebellion of the Body* provides two main themes: the relationship between Hijikata and other Japanese people; and the status of the body and rebellion in Hijikata's dance and thought. These two themes will serve to historicize Hijikata and to counter both readings that see only the body in butoh, and readings that interpret butoh narrowly as an expression of Japanese identity or aesthetics.

Reversing the sequence of the title and turning first to the "rebellion of body," inherent in the idea of a rebellion of the body against existing conventions and established authority is the sense that the body is being held in check by those conventions or authority structures, and is in a struggle with them to free itself. To successfully rebel, the body should cultivate techniques and tools to become more fit and thus ensure its eventual freedom. This implies a means-ends orientation to butoh, but to speak of butoh in terms of means and ends or techniques and tools is a stretch by the standards of much current discourse surrounding butoh. Butoh's practitioners by and large see themselves as doing something that has no discernible utility or significance, and indeed—as will become clear later—Hijikata early on appeared to reject any sort of productive or practical value for his dances.

In addition, the theater scholar Ozasa Yoshio observed that the 1960s theater movement (of which butoh was a part), was the first kind of theater in Japan not based upon advancement from an amateur to a professional based upon acquiring a skill.[8] He is echoed by dance scholar Judith Hamera, who has argued that Hijikata and his fellow artists "created a revisionist view of technical competence, one based not on faithful reproduction of traditional forms, but instead on fidelity to the essence of their psycho-social experience of their culture."[9] Putting aside for a moment the issue of fidelity to a psychosocial experience, two things bear pointing out about this view: of course, butoh artists did not try to faithfully replicate traditional forms (although they were not reflexively against them either—traditional forms show up in butoh from time to time). However, the characteristics of butoh ensured that the artists did indeed embrace a contradictory vision of butoh as both something without any purpose and as something with a specific aim for which they cultivated specific techniques, including replicable forms. Since the artists placed themselves in (and saw themselves in) interactive and often competitive relationships (including rebellion against society as a whole), the artists had to develop techniques for those interactions. Moreover, just as competition and victory required the development of techniques, so also, holding two opposing things

in tension without losing track of either, required effort and the development of its own set of skills.

* * *

Butoh, then, carries with it its own techniques and its own standards of technical competence, and these were by no means limited to "fidelity to the essence of psycho-social experience." Despite the emphasis on the body in butoh in such ideas as the "Rebellion of the Body," the techniques in question are not solely bodily techniques, but also include many things that might be termed mental techniques (such as concentration). In fact, the butoh artists cultivated a panoply of body-mind techniques, which were useful in staging dances, and can also help us understand the wider society around them. Elucidating these will place butoh within a wider scholarly discussion that seeks to understand how from the 1960s to the 1980s Japanese people were gradually undergoing a narrowing of options that left many of them trapped within roles sanctioned by corporate capital in the era of high-growth economics. In outlining this era, Anne Allison writes of the Japanese state seeking "a hard working citizenry willing to sacrifice to their jobs and welcome technology into their workplace, consumer lifestyle, and subjectivity"; of the state "retooling normal citizens into high performing" worker/warriors; and finally of a "lean" or "flexible" production ethos featuring "flexible workers, who though replaceable, are keenly valued for the exceptional service they give to their unit."[10] Another scholar describes the "work of producing fit subjects for both accelerated production and individualized consumption."[11] We could in shorthand characterize this shift as demanding maximum physical and mental usefulness and pliability from the workers and subjects of postwar "Japan Inc."

Foucault provides a useful rubric for organizing and analyzing these techniques with his idea of technologies or techniques of the self, developed late in his career. His inquiry was not centered on or an attack of specific institutions or classes but sought rather to understand techniques or forms of power. He wrote of four kinds of "technologies":

> (1) technologies of production, which permit us to produce, transform, or manipulate things; (2) technologies of sign systems, which permit us to use signs, meanings, symbols, or signification; (3) technologies of power, which determine the conduct of individuals and submit them to certain ends or domination, an objectivizing of the subject; (4) technologies of the self, which permit individuals to effect by their own means or with the help of others a certain number of operations on their own bodies and souls, thoughts, conduct, and way of being, so as to transform themselves in order to attain a certain state of happiness, purity, wisdom, perfection or immortality.[12]

As Foucault immediately observed, these "technologies hardly ever function separately." I argue that in the postwar era, as Japan rebuilt its economy and was integrated into global commerce, technologies of production (no. 1 above) were beginning to demand a new configuration to the body, and thus technologies of power (no. 3 above) were being brought to bear, in order to acclimate that body for the technologies of production.

Hijikata and his cohorts saw themselves as trying to evade the impress of those technologies of production and power. In part, they simply claimed that their dance was outside the purposiveness of these wider forces—that it had no productiveness whatsoever. But they can be seen as going beyond that disavowal of utility in a two-pronged campaign of attacking, changing, expanding, and supplementing the current sign systems (no. 2 above—which were taken to be shot through with conventions, and therefore, largely dictated what one could think or say), and developing various new physical and mental technologies of the self (no. 4 above) to enable the body and mind to be more and do more than it had been able to do before. In short, it is fruitful to think of Hijikata and his fellow artists as seeking to alter the existing sign systems and create new technologies of the self, in order to combat an age in which forms of power were trying to adjust the body to new forms of production.

The first prong of this attack concerned technologies of the body. Hijikata strove to increase the athleticism of the body: its strength, pliability, ability to contort, and its ability to remain off balance. Hijikata also inherited an assumption (probably in part from German expressionist dance) that the body had or could have a language.[13] In his case then, it is not possible to separate Foucault's idea of a technology of the self from the technology of a sign system, because the body was Hijikata's sign system. Hijikata sought to expand the language of the body by finding new sources for movements and by subjecting the new movements to further operations to further increase the language of the body.

These secondary operations could also be described as mental techniques. They had to do with spreading out one's focus, concentrating on many things at once, and transforming movement in infinitesimal ways. In what might be characterized as a surrealist twist on the Stanislavski System and American Method acting, in the late sixties and early seventies, Hijikata began dictating to his dancers, not just how to move, but what to imagine while they moved in order to alter their performances. The required imagery might have included assigning a character-type who is imagined to be the one dancing, assigning an imaginary background medium in which one danced (such as rock, wood, wind, mist, or light), and assigning a sound or smell to imagine while dancing (separate from whatever background music accompanied the dance). The dancer might also have been assigned to imagine various things—such as being eaten by differing numbers of insects, or shocked by differing charges of electricity—with the assumption that the use of such imagery will qualitatively transform the movement (sometimes in extremely minute ways).

Drawing on Arjun Appadurai's work on globalization, I argue that the use of imagery to subtly alter performance was not just a response to the conditions of postwar Japan, but also indicative of the role of the body-mind in a new age. Appadurai chose as the emblematic story of a new era of globalization the magical realist short story "Swimming in a Pool of Gray Grits" by Julio Cortázar.[14] This is a story written by an Argentine author, Cortázar, (born in Belgium and living in France), in which the alter ego narrator (born in a suburb of Buenos Aires) tells the story of a Latin American (possibly Mexican) professor who invents a way to swim in finely ground gray grits. We might characterize this as changing the background medium of a popular sport. Swimming in grits soon becomes an international sensation. At a competition in Baghdad, a Japanese swimmer variously named Tashuma/Teshuma

sets a world record owing to two infinitesimal advantages he gets from a supporting Japanese-funded sports think tank.[15] The first is a more efficient way to start the race: "The initial dive consists mainly of sliding over the grits, and those who know how have a head start of several centimeters over their opponents" in a five-meter race. The second is a way to get an in-race boost in productivity by ingesting a few hundred grams of grits while swimming:

> Calculations of the Tokyo Research Center estimate that in a ten meter race, only a few hundred grams of grits are swallowed, which increases the discharge of adrenaline, producing metabolic vivacity and muscular tone, more essential than ever in races like these. (Cortázar, 81–82)

Owing to the new swimming craze, prices rise in the international grits market, and the sport has the unintended consequence of impacting the lives of Australian families when seven amateur swimmers die.

Appadurai focused on contrast between the planetary-wide span of the story—the "transnational journey of ideas"—and the minuteness of the story—"the technical obsession with small differences in performance"—and saw the imagination as connecting the two poles. He reproduced this quotation from Tashuma/Teshuma's press conference:

> He let it be understood that the imagination is slowly coming into power and that it's time now to apply revolutionary forms to old sports whose only incentive is to lower records by fractions of a second, when that can be done, which is quite rare.[16]

Appadurai was drawn to the way that the people in this story use their imagination to make minute changes in their bodies to increase their competitiveness, and argued that people are using their imaginations in a similar way to reconfigure such things as identity, nation, and place in a more completely globalized world.

There is an uncanny resemblance between Cortázar/Appadurai's world of swimming in gray grits and what we could term Hijikata's "obsession with small differences" that alter a performance. On one occasion, Hijikata told his charges "the density of the rock is 90%, one must pass through the density of the rock," so it is not hard to conceive of him telling his dancers to imagine dancing in a pool of finely ground flour in order to subtly alter their performance.[17] I propose that we read Hijikata through the lens of Appadurai's citation of Cortázar as a way to more fully understand the worldwide changing status of the body in the 1970s.[18] The imagery techniques Hijikata developed were similar to the fantasy techniques that a magical realist imagined appropriate to a new world and the ones that others were feverishly developing for world outside the theater.

* * *

Hijikata's mental technologies were also directed toward negotiating and manipulating information in an age of information overload in order to draw nearer to actuality.[19] Hijikata suspected that his own body-mind and its languages were covered in conventions and concepts, which stood in the way of his seeing the world

accurately. He attempted to neutralize the conventions that were already present in his body-mind and his languages by trying to account for everything that had formed him throughout his life, and used this inventory as a way of understanding these conventions and thus rendering them less able to distort his observations of the outside world or his languages.

The fact that not only the body but its languages are covered in concepts requires further explanation and a return to the first part of the title for Hijikata's dance, *Hijikata Tatsumi and Japanese People*. As noted, the name "Hijikata Tatsumi" is not cleanly aligned with "Japanese people," but is rather in some unspecified but probably partially combative interaction with "Japanese people." By bringing the first half of the title into dialogue with the second, we can conjecture that the rebellion of the body is in part a rebellion against the constraints of an imaginary ethnic or national identity, and also that, rebellion notwithstanding, Hijikata saw himself in some relationship with the other people in that imaginary community. One way to understand the succession of characters in the dance is to see the dance as hinting that the rebellion needs to be widened to include all people: the old, young, infirm, healthy, strong, weak, those of all sexualities and sexual orientations, outsiders, and the Japanese people themselves.

However, in order to expand the rebellion to include people from all walks of life, some sort of communication must take place between them. This communication would involve using languages, but Hijikata already suspected that the languages surrounding him were beset by conventions and limitations.[20] Thus, the second prong of Hijikata's attack was the spoken and written languages of Japan.[21] My argument is that Hijikata tried to change these languages (or even create entirely new languages) by contorting written language with strong surrealist modifications. These acts highlighted the limitations and arbitrariness of all current languages, and thus cast into doubt their validity, so Hijikata could replace them with new, different, or augmented languages.

Foucault saw that these technologies of the self were always a double-edged sword. In an age of increasing pressures on the body, to make the body more pliable and able to move in different ways or more able to bear up under enormous strain might only amount to a basic survival skill (which is no small thing) and not constitute a meaningful revolt against the system. As the theater critic Auslander said, "Too often performance practices that have sought to reclaim the body without denying technology have succeeded only in 'making the body docile for its tasks in the technological age.'"[22] The mental techniques might occasion a similar ambivalence. For example, the mental abilities that Hijikata encouraged, such as being able to concentrate on many things simultaneously, may be useful in the task of opposing the systemization of the technologies of power and production, but are certainly also useful within the productive realm itself.

This is also the case with the attempt to enumerate an entire life's worth of customs and conventions that have formed one's physical and mental totality. Foucault argues that over a broad span of time, institutions and practices evolved in which humans came to pay more attention to each part of their bodies and to monitor closely all of their thoughts, urges, and emotions.[23] We can see this development of mental technologies (and in particular the effort to account for all of the conventions that have formed oneself) as related to this wider process.

Understanding one's own totality may make it easier to understand how one is distorting the world (and thus may make it easier to understand the outside world if one acts to neutralize one's distortions), but it also may risk a reification of the self. Foucault theorized a process of making individuals into subjects in two senses: as units under the control of something else, and as self-aware self-capable entities. Foucault saw this subject-making as both enabling and constraining, as the subject would have no identity without it, but is always overly tied to that identity and somewhat controlled by it. In a broader sense, we can see similar enabling and controlling mechanisms in the various technologies of the self that concerned butoh artists, such as selfhood, (ethnic or regional) identity, and mental ability.

Butoh dancers and choreographers saw themselves as opposed to the wider societal trajectory of turning people into individualized (ethnically identified) producers and consumers and even as existing outside it, but they could only alter the way they fit into that world, not escape from it completely. To say this is not to malign their efforts, only to note the limits of their success. I contend that the techniques that Hijikata and his cohorts developed were (and continue to be) meaningful for individuals within the postwar society but those techniques involved their own accommodations to the pressures of that society.

* * *

Considering the full title, *Hijikata Tatsumi and Japanese People: Rebellion of the Body*, and bringing the first half of the title into competition and dialogue with the second half, allows us to revisit the issue of the techniques of the self that Hijikata created. They can be categorized as follows: self-understanding (including an understanding of all of the conventions and practices that formed the self in an attempt to neutralize them), bodily ability, mental ability, communicative ability. Hijikata and his fellow artists came to these techniques, in part, while rebelling against that which constrains the body, including national, ethnic, or regional identity. And they came to the realization that the rebellion would not be easy, nor would it be accomplished singly. Thus, they recognized the need to communicate with others about their viewpoints, and the need to not be overwhelmed by competing ideas or elements but rather to hold them in their minds and allow them to remain in tension. Each of these goals required its own set of overlapping mental and physical skills.

In a surrealistic and roundabout way, Hijikata developed bodily techniques that enabled joints to bend in the wrong way, that allowed the body to bear more strain and pain than normal, and that accustomed the body to being continually off balance. He coupled these bodily skills with mental techniques such as the following: seeing the world from other viewpoints; understanding and minimizing mental distortions that might stand in the way of seeing the world from other viewpoints or seeing the world more accurately; preparing others to understand one's own viewpoint; transforming oneself to be anything at any moment; and dealing with either excessive or insufficient information.

In sum, then, the performance *Hijikata Tatsumi and Japanese People: Rebellion of the Body* serves as an ideal departure point for articulating the theme of this book, which examines how a group of dancers tried to fashion and refashion themselves

during a hypercompetitive information-laden age of high-growth economics. The first part of the title is related to the second part because the rebellion of the body is in part a rebellion against an ethnic identity such as Japaneseness, but also because Hijikata recognized that because the rebellion would be long and not easily completed, it would have to be widened to include many of the people from within that imaginary ethnic group. To accomplish this rebellion, Hijikata would need to create techniques to expand the capacities of the body and mind, techniques to understand the world better, techniques to navigate the world during moments of uncertainty, and techniques to understand others better and communicate with them more effectively.

OUTLINE OF THE BOOK

Hijikata did not start his career with *Hijikata Tatsumi and Japanese People: Rebellion of the Body*. He had already been dancing for twenty-two years and choreographing for ten years. Hints of later preoccupations were visible right from the beginning of his career, but *Hijikata Tatsumi and Japanese People: Rebellion of the Body* was different from the kinds of dance he initially studied, and the first dances he choreographed. What is more, despite the electric vividness of this dance and its usefulness as an organizing principle for thinking about his work, it was only one of several high points in his career. Hijikata would go on to dance and choreograph for another seventeen years before his untimely death in 1986, and in that time developed the choreographic method that serves as the basis for much of the butoh we know today. This book traces a zigzagging evolution in Hijikata's ideas about the body, his relationship to Japanese people, and his development of techniques appropriate to a competitive information-laden age by starting with his first dances and working chronologically through to consider at length his mature choreography.

Before outlining the book, a simple pre-chronology will have to suffice to situate Hijikata within the general chronology of this book. Born in the Akita prefecture in northern Japan in 1928 as Yoneyama Kunio, Hijikata was the tenth of eleven children.[24] His extended family were pillars of the community, and his immediate family seems to have been reasonably well off, though Hijikata had a promoter's penchant for embellishment and routinely claimed that his family was dirt poor.[25] By the fifth grade, Hijikata says that he had attended performances by the famous dancer Ishii Baku (1886–1962), one of the pioneers of modern dance in Japan. If his account his reliable, he must have grown up with dance. At roughly the age of eighteen, he joined the modern dance studio of Masumura Katsuko, a student of Eguchi Takaya and Miya Sôko who had studied German expressionist dance with Mary Wigman. Between 1947 and 1952, Hijikata shuttled back and forth between Akita and Tokyo, where he first saw Ôno Kazuo dance in 1949.

After settling permanently in Tokyo in 1952, Hijikata worked odd jobs, continued his dance education, and cultivated contacts in the artistic community (Okamoto Tarô, Shinohara Ushio, Kanemori Kaoru, Kawara On, Ikeda Tatsuo, and Ôno Kazuo and Yoshito). From 1953–1958, he joined the studio of Andô Mitsuko, and studied ballet, jazz, and modern dance. During the mid-fifties, Hijikata's efforts paid off, and he was increasingly in demand as a dancer, including appearing in the

"Andô Mitsuko Special Performance of The Dancing Heels" (1954), successive performances of the "Andô Mitsuko, Horiuchi Kan Unique Ballet Group Performance" (1955, 1956, 1957), Takechi Tetsuji's *Music Concrete's Maiden of Dôjô Temple* (a remake of the classic kabuki piece), and as a background dancer in television shows and a movie (Nikkatsu's Sunohara Masahisa film *Birth of a Jazz Maiden*). Roughly in 1954, Yoneyama began to use the stage name Hijikata Kunio.[26] Subsequently, he would dance under the names Hijikata Genet, Hijikata Nue (Chimera), and Hijikata Nero.[27]

Sometime in 1958, he left the Andô Mitsuko Dance Studio and joined Yoneyama Mamako and Imai Shigeyuki's Contemporary Theatre Arts Association. During this period, he also studied mime with Yoneyama and Oikawa Hironobu and dance with Tsuda Nobutoshi (who had studied with another German expressionist dancer, Max Terpis). He also met Motofuji Akiko (a student of Tsuda), who eventually became his wife.[28] It was in 1958 that he first appeared under the stage name Hijikata Tatsumi for the "Theatre Human/Contemporary Theatre Arts Association Joint Concert." The newly minted Hijikata Tatsumi danced the part of the Snipe in *Hanchikik*, a dance based on an indigenous Ainu legend. On the same program he choreographed a solo as part of a section called "Stillness and Motion" in a piece called *Dance of the Burial Mound Figurine*. This is the first Hijikata dance for which we have any information; just the tantalizing one-line synopsis that Hijikata played with a chicken and then ultimately smothered it.

Hijikata formally debuted in his own choreography in *Forbidden Colors* (1959). For reasons that will become clear later, *Forbidden Colors* is the point at which the main account of this book starts.

* * *

Hijikata's earliest dances were mimetic narrative performances marked by a contradictory quadrangle of characteristics: Hijikata ferociously disavowed any utility to the dances, but paradoxically, the dances critiqued socialization and attempted to remodel self and society, while searching for actuality behind socialization. The dances began to evolve away from mimetic narrative structure (but not away from social commentary), as Hijikata became acquainted with the novelist Mishima Yukio and other artists of postwar Japan. This change was motivated, in part, by Mishima's assertion of the limitations of the body as compared with language. Hijikata responded with various bodily (formalist) experiments centered on expanding the abilities of the body and understanding how to utilize the reactions of the audiences in order to hold their attention in the absence of narrative. (The early dances and Hijkata's initial change are the subject of Chapter 2, "Forbidden Eros and Evading Force: Hijikata's Early Years.")

Hijikata's subsequent collaborations with neo-Dada and Happenings artists provide the backdrop for the next era in butoh's history (1963–1965). In the context of explorations into the nature of collaboration, the dances of Hijikata's second period (*Masseur* and *Rose-colored Dance*) were structured as competitions for artists to write themselves into each other's psyches. In the best-case scenario, there was also a concomitant willingness to see one's self or one's own art transgressed by others. The competition was echoed in the athleticism of the dances and is related to the

era-wide concern in Japan for bodybuilding and one-on-one athletic competition. This creative competition further resonated in the imagined competitive relationship between the audience and the artists, in which the artwork required the audience to make provisional interpretations and then modify those prior interpretations as new information became available. The invitation to provisionally interpret and reinterpret dances was also necessitated by an artistic attempt to code one action or dance element with more than one nuance. (Chapter 3, "A Story of Dances that Sustain Enigma: Simultaneous Display and Sale of the Dancers.")

In the mid- to late sixties, Hijikata rebelled against the atopicality of these rather more formalist bodily experiments in both his concern for his own body, and in his strategy of beginning to engage more forcefully and directly with Japanese matters in his art works. Expanding the abilities of the body remained central, as is manifest in the way he explored using the body as a musical instrument in the 1968 dance *Hijikata Tatsumi and Japanese People: Rebellion of the Body*. At the same time, he began to think about the relations and connections between people (including those between himself and members of his own family, and between himself and other "Japanese people"), and began to think of using dance as a way to see the world from other viewpoints and to communicate with other people. (Chapter 4, "Pivoting Panels and Slashing Space: Rebellion and Identity.")

In the late sixties and early seventies, Hijikata began to create a deeply structured choreographic method that was an attempt to enact a bodily surrealism and serves as the basis for much of the butoh we know today. While he continued to expand the abilities of the body (manifest in such things as the twisted torso), the choreography constituted a return to character- and narrative-based dance. However, only he (and to a certain extent his dancers) knew the referents to these dances. Through the use of these characters and narratives, Hijikata not only encoded several stories within one dance and increased the depth of performance in his dancers, but also began to think about his socialization in rural Japan. (Chapter 5, "My Mother Tied Me on Her Back: *Story of Smallpox*.")

After these four broadly sequential chapters that present a history of Hijikata's dances from 1959–1972, the argument shifts to an in-depth examination of his mature choreography from two vantage points; that of the dancer and that of the audience. From the perspective of the dancer, I look at three aspects of the dance and training techniques of Hijikata's mature butoh—transformation, emergence, and the choreographic structure. The first two were geared to achieving maximal ability for the body-mind. Initially, Hijikata had advocated the technique of imitation as a survival tactic (which is in keeping with the mimetic narrative works of his early period), but over time, he came to prefer the technique of transformation as a way to surpass the limits of imitation. Transformation was taken as way to play a role more fully, and also as a tool for seeing the world from other viewpoints. Hijikata also strove to allow movements to emerge from the body rather than applying them to the body, which allows the choreographer to use the tools of randomness and the unconscious as bodily techniques. I argue that the emphasis on the abilities and possibilities of the body-mind reflects a society in which people must fluidly transform themselves so as to be different things to different people at different times. It also demonstrates that, despite the avowed disutility of the dances, butoh stems from a world in which one cannot allow unconscious processes and random events to go to waste, but must

utilize them. The techniques for creating the possibility body/mind were used, ironically, as a means of representing on stage those people who were most physically and mentally incapacitated by current circumstances, but they also represent, again ironically, an accommodation to those circumstances.

The choreography that these physically and mentally enabled dancers were performing consisted of movements or poses along with accompanying instructions for how to modify them using various kinds of seemingly arbitrary mental images. The movements or poses were then chained into sequences of movements arbitrarily meant to tell multiple surreal narratives. My argument is that for the audience, the complex structure reflects a society filled with too much information and yet lacking enough information. The insufficiency of information invites viewers to practice constructing narratives, while the excess information requires viewers to spread out their concentration to more and more things, and to weed things out and make revisions. (Chapter 6, "The Possibility Body: Embodying the Other, Understanding the Self.")

After developing this choreographic method, for a time Hijikata interrupted his dance activities to concentrate on writing his quasi-memoirs—"quasi" because the text continually casts doubt on the status of the subject who writes it, and the veracity of the memories of that subject. Analysis of these quasi-memoirs clarifies Hijikata's aims because he can be seen in his writing to address many of the same things he had been doing with the body for 20 years. As a corollary to his attempt to account for all the things that had formed him, Hijikata provided minutely detailed descriptions of numerous (clearly partially fictionalized) events of his life. Parallel to his efforts to increase the vocabulary of the body, he developed language techniques to modify language in order to say more than had been said up to that point while also demonstrating that not everything had been or could be said about any one topic, and that not all causes of any one thing could be enumerated. The repeated use of two prominent techniques, "likeness" (*rashisa*), and collocations served as experiments to see what new things could be created by language. Hijikata used a third technique, the representational or alternative form called *tari*, to indicate that despite the minute detail of his descriptions, he was only able to say a small fraction of what could possibly be said about any one thing. His continual use of *sei* ("on account of") amounted to an attempt to understand all of the reasons why things turned out the way they did, and was analogous to the requirement that the dancers widen their focus. In keeping with my broader theme of seeing butoh as a response to the information age, the use of *sei* was thus an attempt to articulate diffuse causality in an age in which causality is hard to pin down, while acknowledging the difficulty of enumerating all causes of any one event. (Chapter 7, "Metaphorical Miscegenation in Memoirs: Hijikata Tatsumi in the Information Age.")

The dances from Hijikata's final years are often thought to lack the power of his earlier works. As a means to complicate the common appraisal of his later work, the epilogue takes up the concept of the "emaciated body" that Hijikata developed late in his career. The epilogue speculates on the conditions that lead to those evaluations, and then, in closing, assesses Hijikata's place in the postwar artistic climate of Japan, by examining the way that butoh is used by several dancers today.

2. Forbidden Eros and Evading Force: Hijikata's Early Years

> *The emperor of the Southern Sea was Lickety, the emperor of the Northern Sea was Split, and the emperor of the Center was Chaos. Lickety and Split often met each other in the land of Chaos, and Chaos treated them very well. Wanting to repay the kindness of Chaos, Lickety and Split said, "All people have seven holes for seeing, hearing, eating, and breathing. Chaos alone lacks them. Let's try boring some holes for him." So every day they bored one hole, and on the seventh day Chaos died.*
>
> Zhuangzi

What we now know as butoh looks nothing like Hijikata's first dances. In the early works there was no characteristic white body paint, nor achingly intense and precise chorography. Yet, twenty years later, these were staples of the butoh aesthetic. This chapter describes the initial dances, and then begins to show how they began to change due to various currents in the artistic climate of the time, and due to Hijikata's interactions with newfound friends. More broadly, I seek here to tease out Hijikata's initial goals (even though he claimed that his dance should be unproductive and impractical), and then to highlight the problems he encountered in achieving those goals, and the solutions he then began to explore. As will be seen, Hijikata started by making mimetic narrative dances and then moved toward more abstract experimental works that challenged the limitations of the body and expanded its abilities and vocabulary. Meanwhile, instead of narratives, Hijikata explored using the physical responses of the audience in order to provide continuity for the dances. This was an important period in Hijikata's development and he began it with a bang.

FORBIDDEN COLORS

Hijikata presented his first work, *Forbidden Colors* (*Kinjiki*), on May 24, 1959. It is probably difficult for us to understand how shocking Hijikata's *Forbidden Colors* was, and how different it was from any dance that came before, but at the same time, we can be and have been too shocked by this dance. That may seem strange. How can we be too shocked by a dance that was intended to shock to the core? Quite simply, because current descriptions of the dance distort it badly. In 1987, one of the earliest Euro-American commentators on butoh, Mark Holborn, wrote:

> The whole dance was performed without music. Ôno's son, Yoshito, who was still a young boy, enacted sex with a chicken squeezed between his thighs and then succumbed to the advances of Hijikata.[1]

Viala and Masson-Sekine echoed,

> In this piece a young man (Yoshito Ono) has sexual relations with a hen, after which another man (Tatsumi Hijikata) makes advances to him. There is no music. The images are striking: the young man smothers the animal between his thighs to symbolize the act.[2]

Buggering and bestiality—that is what the dance has become known for; but the story gets better as it goes on down the line. By the time a feature piece on butoh appeared in the *SF Weekly* in 2002, *Forbidden Colors* had been turned into a phantasmagorical hodgepodge of bestiality, obscenity, and cross-dressing:

> In one of the first performances in 1959, Hijikata dressed like a woman and held a chicken between his legs, dancing as if he were masturbating with it. He was expelled from the Japanese Modern Dance Association.[3]

I will endeavor to provide a more nuanced account of this dance, but first I want to stress something: One of the side effects of over-sensationalizing this performance is that we can be fooled into thinking that Hijikata was unique—that he was the only one trying to do something new—and this notion might lead one to disconnect Hijikata from his historical context. He was, in fact, a product of his times.

The world of Japanese dance at the time was split into two broad categories. One was classical dance derived largely from Kabuki. Hijikata must have been aware of this dance to some degree, but largely his world was divorced from that world. The second was various kinds of Western dance such as ballet, flamenco, jazz, and modern dance. By the 1950s, these genres would hardly have been thought of as imports, so thoroughly had they been incorporated into the Japanese dance world. While Hijikata was earnestly studying all these forms of Western dance, he most thoroughly belonged to the world of modern dance.

Before he entered it, the world of modern dance was already filled with ferment. Hijikata was preceded by Mavo, a group of prewar avant-garde artists who engaged in erotically and violently charged performances.[4] He was also studying with Tsuda Nobutoshi, who was striving for independence from the world of modern dance, and who strove to create a "new genre of figurative art that would use as its material the healthy body" and that would be neither dance, theater, painting, nor literature.[5] The dance critic Kamizawa Kazuo notes that Hijikata's contemporary, Atsugi Bonjin, anticipated some of Hijikata's experiments with dances such as *Stand*, which prefigured Hijikata's experiments, in which he might take an hour to stand up.[6]

Even on the same program with Hijikata, the tendencies of the time are visible. One anonymous reviewer singled out both *Forbidden Colors* and another dance on the same program, Wakamatsu Miki's *Situation* (*Jôkyô*), as pushing the furthest in "challenging the existing system," and later in the review identified three male dancers as having presented "Evil" in their dances.[7] The same reviewer also wrote that Nagata Kiko's *Poinciana* emphasized the "emptiness of male-female dialogue." Another reviewer passed over Hijikata's dance in silence, but complained that it was not clear what connected Nagata's dance (with its bongo rhythms and Afro-Cuban primitivism) to the subtitle "Beginning of the Summer that will Freeze and Wane

in the Non-melodic Metropolis."[8] That Hijikata's dance chronologically followed in the line of Mavo, Tsuda, and Atsugi, and shared the stage with Nagata's dance with this subtitle and with other "evil" dances that sought to contest the "existing system," shows that Hijikata was not the only one who was trying new things.

Without even considering Hijikata's dance, one can already see in the titles of the dances and in the reviews some of the preoccupations of the time: a new look at the body itself, a concern with transcending boundaries between arts, the impossibility of communication and related obfuscatory use of language, and the combative nature of society, and between society and individual artists. Hijikata was merely one among many who were trying to find new kinds of dance. There are even those who thought that they had discovered butoh, only to have it stolen from them by Hijikata.[9] It is not yet possible to judge this claim, but given Hijikata's general behavior, it is likely that he would have stolen ideas and movements from wherever and whomever he could. That such thievery might have taken place, surely speaks of the shared nature of the initial project, and to the extent to which similar issues preoccupied people across the artistic and societal spectrum. In any case, the distortions in the descriptions of this dance render it even more shocking than it was, and cause us to see Hijikata as even more out of the mainstream than he was. One goal of this work will be to place Hijikata squarely within the contentious era of sixties and seventies Japan, and to see butoh as part of a collective response to the information age and Japan's era of high-growth economics.

The occasion for Hijikata's debut was the "All Japan Art Dance Association: Sixth Newcomers Dance Recital."[10] There are essentially three sources for information about *Forbidden Colors*.[11] They are: Ôno Yoshito, one of the dancers himself; the dance critic Gôda Nario; and several photographs (two of the dance, eleven of a studio performance, and five more of a subsequent dance that incorporated the content of the dance).[12] Each of the sources is problematic, and there are discrepancies among them, but it is possible to make a tentative reconstruction of the dance, with the caveat that the order may not be accurate.

The title of the dance, *Forbidden Colors*, came from the highly successful novelist Mishima Yukio's book of the same name—which might also be translated as *Forbidden Eros* owing to its focus on same-sex eroticism—but the content of the dance is said to have derived from Hijikata's readings of Jean Genet.[13] Each dance on the program was limited to seven minutes, so Hijikata had to pay for two time slots for his 15 minute dance. There were two performers—Hijikata (then 31 years old) dancing the role of the Man, and Yoshito (21 years old) dancing the role of the Young Man (*shônen*).[14] Hijikata wore only a pair of gray and navy arabesque- or plaid-patterned jersey-cloth bell-bottom pants. He had applied some greasepaint diluted with olive oil to his torso to make himself look darker.[15] His head was shaved perfectly bald. Yoshito wore lemon-colored shorts and a light-colored scarf around his neck. Both were barefoot. Some of the dance was performed in silence, and some of it was accompanied by a prerecorded soundtrack of moaning, heavy breathing, and harmonica music by Yasuda Shûgo. The light was concentrated downstage left so that with the exception of the time when a blue-white suspension light was lowered in the middle of the stage, the rest of the stage was only lit with residual light spilling over from the corner. The light fluctuated so that at times the rest of the stage was

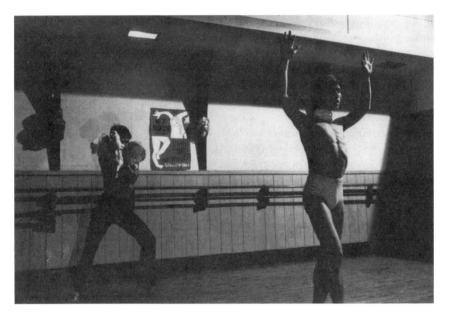

Figure 2.1 Man (Hijikata Tatsumi) with Chicken and Young Man (Ôno Yoshito) walking around, "Forbidden Colors Studio Performance," (Tsuda Nobutoshi Dance Studio (Later Asbestos Hall), Tokyo, Summer 1959) by Ôtsuji Seiji. Courtesy of Ôtsuji Seiko, Morishita Takashi Butoh Materials, NPO, and the Research Center for the Arts and Arts Administration, Keio University.

quite visible and at times it was plunged into near darkness (see figure 2.3 and figure 2.10).

For a short time before and after the curtain rose, the sound of bluesy harmonica music wafted through the hall. Yoshito says that he somehow came to the center of the stage but that he cannot remember how he got there. He remembers Hijikata running around behind him (he does not say Hijikata was chasing him). Gôda says that the Young Man entered from the upstage right wings and made his way downstage left in a clockwise arc. As he passed the upstage left wings, the Man entered the stage and began following him. The Young Man realized that he was being chased and began to flee from the pursuing Man, and they ran around the stage clockwise a few times. Motofuji's account has Hijikata waiting stage-right for the Young Man, and then starting to run around him. Nanako Kurihara quotes Atsugi Bonjin as saying that Hijikata ran around Yoshito. The studio photographs closest to what Gôda, Motofuji and Atsugi describe have Hijikata standing still and Yoshito walking around him (see figure 2.1). Because it was dark, the way that the Man ran was unclear, but Gôda says that it appeared that he was doing a straight-legged run with his heels pounding the floor. Gôda asserts that the Young Man appears to have been struck with a feeling of inevitability and despair, and stared at his palms and struck himself (see figure 2.2).

A small blue-white light was lowered in the center of the stage. Yoshito only remembers finding himself in the center of the stage and having the Man hand him the chicken. Gôda remembers the Man waiting in the center of the stage and

the Young Man—drawn as a mosquito to the light—shuffling on straight legs toward the light. When he reached the light, the Man was waiting there. Given the agreement between Atsugi and Motofuji that Hijikata ran around Yoshito, perhaps Gôda misremembered who was who. Regardless, somehow the Man and the Young Man both got to the middle of the stage and the Man thrust a white chicken into the light, and the nervous Young Man accepted it (see figures 2.3, 2.4, and 2.5). The chicken fluttered and tried to escape, and the Young Man clenched the chicken tightly to his chest. Gôda says the Young Man returned to stage right (see the studio photo, figure 2.7). The studio photos show the Man seemingly grabbing the Young Man's hair and bending the Young Man backwards, (as if to force him to do something or force him down to the ground; see figure 2.6). Then the Young Man scissored the chicken between his legs and sank to the ground suffocating it (see figure 2.8, and compare with figure 2.13).[16] The studio photos show the Man exulting over the prone body of the Young Man, dancing a little jig with movements that strongly suggested Hijikata's jazz dance training (see figure 2.9).[17] Yoshito says that while he was kneeling on the ground, Hijikata had instructed him to write something with his thumb on the floor, not something smooth or rounded, but rather something jagged and jerky. At this point, there was considerable outrage from the audience as evidenced by the many people who walked out.

The Young Man laid the chicken down on the stage, and the Man approached him and the two rolled around entwined on the floor, with, Yoshito says, the intent to mime sodomy (see figure 2.10). The lights were lowered and the stage plunged

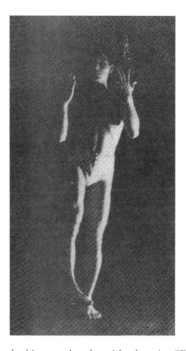

Figure 2.2 Young Man looking at hands with despair, "Forbidden Colors Studio Performance," by Ôtsuji Seiji. Courtesy of Ôtsuji Seiko.

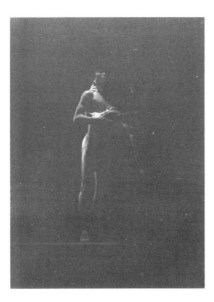

Figure 2.3 Young Man with chicken, *Forbidden Colors*, (Daiichi Seimei Hall, Tokyo, May 1959) by Kurokawa Shashinkan. Courtesy of the Ōno Kazuo Dance Studio.

into near darkness, leaving the audience to try to follow the action by peering into the darkness and listening to the sounds of the two rolling around and struggling. A prerecorded tape of heavy breathing and moaning sounds played. The Man yelled out to the Young Man several times, "Je t'aime, Je t'aime." Yoshito then says that Hijikata instructed him to stamp his feet and says that Hijikata told him to imagine that he was a chicken caught in a fire at night in order to enact the frenzy of being completely terrified. Finally, there was silence. After a while, the harmonica could be heard, and the lights came up a little. Gôda says that the Young Man appeared from the darkness and picked up the chicken. Yoshito maintains that it was not he who came out to retrieve the chicken but someone else. Yoshida Yoshie says that Hijikata sat in the dark holding the chicken for long after the performance was over, and had to be forced off the stage.[18] Given Yoshida's comment and the unlikelihood of Gôda, as a dance critic, manufacturing the scene, I think it is safe to assume that someone (likely Hijikata) came on to the stage to fetch the chicken accompanied by the sound of blues on the harmonica.

READING *FORBIDDEN COLORS*

We do not know precisely what Hijikata thought of this dance, because, at the time, he wrote nothing about it. Later he published a few quasi-manifestos written in surrealist-influenced and twisted language from which we can possibly see how he conceived of his own project in retrospect. But the practice of rewriting the past begins the very moment the present recedes. So, although I will use Hijikata's later writings, initially there is nothing to do but try to infer his intentions from the work

itself, with the knowledge that we will certainly only ever have a tentative understanding of the dance.

Shock

Because of the distortions in the way that the dance has been recalled, we can be too shocked by this piece, but it was plenty shocking, so any account of *Forbidden Colors* must acknowledge the pain and violence of the piece (the suffocation of the chicken, the sodomizing of the terrified Young Man). I begin here, because Hijikata must have wanted to shock people, and he certainly succeeded. Almost all accounts of the evening include references to horrified people who walked out of the show, and to the collective sigh or groan when the Young Man smothered the chicken. This observation highlights an important point: one of the main purposes of this dance was its shock value. This shock was largely achieved by breaking the social norm that prevented overt sexuality (and particularly same-sex eroticism) and violence from being presented on stage.[19]

Making the Audience Work

The dimness of the stage lighting is striking. Gôda takes this as one of the truly groundbreaking elements of the dance. He notes that Hijikata eschewed most of the

Figure 2.4 Man handing chicken to Young Man (long shot), "Forbidden Colors Studio Performance," by Ôtsuji Seiji. Courtesy of Ôtsuji Seiko, Morishita Takashi Butoh Materials, NPO, and the Research Center for the Arts and Arts Administration, Keio University.

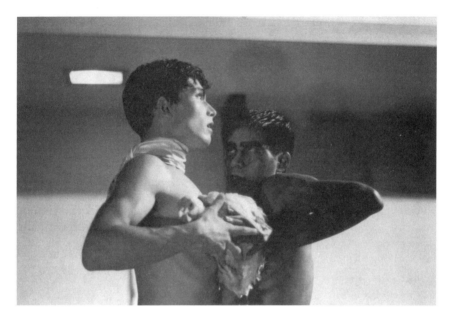

Figure 2.5 Man handing chicken to Young Man (close up), "Forbidden Colors Studio Performance," by Ôtsuji Seiji. Courtesy of Ôtsuji Seiko, Morishita Takashi Butoh Materials, NPO, and the Research Center for the Arts and Arts Administration, Keio University.

usual methods for conveying content in dance such as program notes, and writes that Hijikata only allowed the audience to see the Man clearly twice in the entire performance: once when the Man came out of the darkness to hand the chicken to the Young Man, and once just moments later when the Man supervised the suffocation of the chicken.[20] For the rest of the time, the audience would have had to listen intently to the sound of footfalls in the near dark, and peer into the darkness to try to infer what was happening.

The combination of shock and making the audience work hard is strange and perhaps contradictory. Shock should overpower the spectators, sweep them away, but spectators will not be shocked by something they cannot see. Additionally, peering into the dark and listening intently characterize an active orientation of the senses that may have made the spectators less liable to shock. In his work, Walter Benjamin referred to various mechanisms that continually try to parry shock.[21] The alert orientation necessitated by peering into the darkness may have been analogous to the mechanisms that Benjamin explored. Conversely, it is also possible that the members of the audience were surprised and shocked all the more when they finally figured out what was happening.

Narrative

And yet for all the work that Hijikata required—the straining of the eyes and ears, the recovery from shock—the strong narrative content is striking. In 1959, the wider world of dance was in the process of swinging from mimetic narrative-driven works to abstract works that appear to have no story or plot.[22] However, Hijikata was not

yet a part of that movement, and this, the first of Hijikata's dances, was entirely on the narrative side of the continuum. One might say that, in essence, Hijikata created a ballet d'action or a German Expressionist dance similar to Kurt Jooss's *Green Table*.[23] Even with the problem of relying on faulty memory and even if there is plenty of room for debating the significance of certain elements in this narrative (for example, just exactly what does the chicken signify?), the basic plotline is not in doubt: man meets boy, gives boy chicken, supervises boy killing chicken, sodomizes boy, someone comes back for chicken.

This narrative and mimetic quality should not be surprising. Hijikata had appeared in the *Dance of the Burial Mound Figurine* and the "Ballet-Pantomime" *Hanchikik* in 1958, and Oikawa Hironobu tells of Hijikata, Ôno Kazuo, and Yoshito's study of mime during the late 1950s.[24] Although Hijikata certainly studied ballet, jazz, mambo, and flamenco, and despite Hijikata's friendships with people on the fringe of the modern dance world, the training that loomed largest for him and the other people who took part in the initial formation of the new avant-garde dance was a combination of mime and German Expressionism, which had its own mimetic impulse. However, with a few exceptions, they would not have been in a position to know developments in Germany well, so in a sense they were reinventing the wheel.[25]

Certainly, if Hijkata could have seen Wigman's *Hexentanz* or Jooss's *Green Table*, or even Graham's *Lamentation*, he may have either felt scooped, or felt a deep resonance with what they were trying to do. Suffice it to say, the connections with German

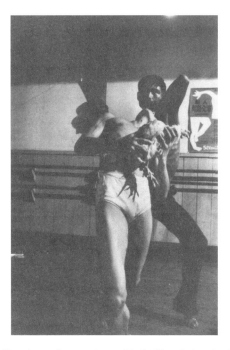

Figure 2. 6 Man pulling hair of Young Man, "Forbidden Colors Studio Performance," by Ôtsuji Seiji. Courtesy of Ôtsuji Seiko, Morishita Takashi Butoh Materials, NPO, and the Research Center for the Arts and Arts Administration, Keio University.

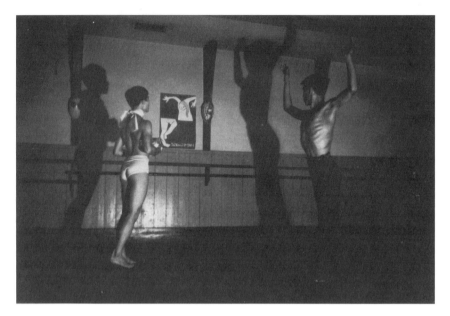

Figure 2.7 Young Man with chicken, "Forbidden Colors Studio Performance," (Tsuda Nobutoshi Dance Studio, Tokyo, Summer 1959) by Ôtsuji Seiji. Courtesy of Ôtsuji Seiko, Morishita Takashi Butoh Materials, NPO, and the Research Center for the Arts and Arts Administration, Keio University.

Expressionist dance almost ensured both the narrative and mimetic quality of the dances as well as the emphasis on intense feeling and emotion. Gradually, Hijikata was to move away from this plot clarity, although we shall see that mime stays with Hijikata throughout his career.

Coercion and Social Forces

Going beyond the usual three-line descriptions of *Forbidden Colors* makes evident that although the standard short descriptions of this dance usually emphasize same-sex eroticism, bestiality, and antisocial behavior, *Forbidden Colors* was considerably more complex than being just a mere celebration of these actions. The coupling of violence and same-sex eroticism is troubling, and in fact, one may come away from this dance with a decided ambivalence as to exactly where it stands on the issue of same-sex eroticism. One may welcome a level of representational saturation in which same-sex relations have become so unremarkable that gay people can be depicted in a wide range of both favorable and unfavorable lights, but one may feel somewhat ill at ease if that level of saturation has not been achieved and, instead, the first depiction of same-sex eroticism in Japanese modern dance seems to draw a direct link between that eroticism, seemingly nonconsensual sex, and the killing of small animals. Yet, understanding exactly how Hijikata was using same-sex eroticism is crucial to understanding this dance, because a closer look at the dance shows that while Hijikata was certainly trying shock his audience, he was also interested in coercion or in the social forces that determine our actions.

The interpretive information we have about *Forbidden Colors* comes from an essay of Hijikata's written over a year later, and largely from a description by dance critic Gôda Nario. Moreover, given the internal textual problems of Hijikata's essay, it is not entirely clear if Hijikata was referring to *Forbidden Colors* or some other dance. He wrote:

> For days I slept holding a chicken. Taking care not to eat it. Boyhood hunger is vivid. The chicken my father killed for me was red. To the hungry boy, the father even looked like a chicken as we were pounding the carcass. I have stood for hours in front of a Tokyo shop windows where chicks are strung up. Love always comes late. I slept like that the night before the newcomers' performance. This chicken, which laid an egg in the green room, played a vital part in the initiation into love. I sometimes visit this partner of mine at a poultry shop in Asagaya. The first time I danced my self-portrait, at a dance studio in Nakano, I opened my throat and started crying.[26] I shrieked and gradually foamed at the mouth. That was the first accompaniment to my dance. It turned out to be an overwhelming dance. The guardians of children complained. Over and over I apologized to the chicken I held while dancing. Hunger must have been the theme of the universe.[27]

Originally, Hijikata gave no indication that *Forbidden Colors* was a self-portrait, but here he refers to holding a chicken while dancing for the first time. He had also danced with a chicken in the *Dance of the Burial Mound Figurine*, the previous year and it is impossible to tell which, if either, of the performances is indicated in this

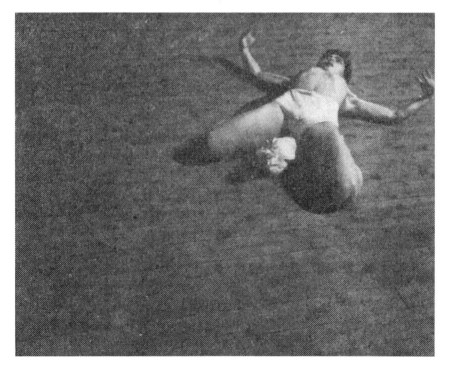

Figure 2.8 Young Man on floor crushing chicken between legs, "Forbidden Colors Studio Performance," (Tsuda Nobutoshi Dance Studio, Tokyo, Summer 1959) by Ôtsuji Seiji. Courtesy of Ôtsuji Seiko.

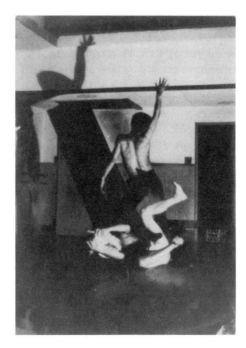

Figure 2.9 Man celebrating over Young Man, "Forbidden Colors Studio Performance," (Tsuda Nobutoshi Dance Studio, Tokyo, Summer 1959) by Ôtsuji Seiji. Courtesy of Ôtsuji Seiko, Morishita Takashi Butoh Materials, NPO, and the Research Center for the Arts and Arts Administration, Keio University.

recollection, or if the two performances were related in some way. (Hijikata seems to locate the dance in the Nakano area of Tokyo whereas *Forbidden Colors* was actually presented in Yûrakuchô, the *Dance of the Burial Mound Figurine* took place in Roppongi, and the Tsuda Nobutoshi Dance Studio was located in Meguro; moreover there are no reports of shrieks in *Forbidden Colors*.) Assuming that this passage is in indeed about *Forbidden Colors*, there are the usual problems with this account in that it traffics in the self-mythologizing that Hijikata was prone to. Also the account does not map well onto the dance, and it is impossible to know if Hijikata's understanding of his own dance had already changed in the year since he had first staged it. What is certain is that this account treats the dance as a self-portrait in the context of gnawing hunger, an initiation into love (*ai*—platonic love, not *koi*—erotic love), and apology to the chicken. There may be a hint of bestiality in that the word Hijikata uses to describe sleeping with the chicken, "sharing a blanket" (*dôkin*), has erotic overtones. The reference to an initiation into love may give us evidence to read the exchange of a chicken and the subsequent sodomy in *Forbidden Colors* as depicting a sexual transaction between the man and an extremely hungry boy.[28]

Gôda's writings about the dance provide an alternate way of understanding the dance. Gôda claims that he initially proposed a reading of *Forbidden Colors* in which the same relationship obtained between the Man and the Young Man as between the Young Man and the chicken, and he subsumed both relationships under the rubric of

"love." As the Man seems to sodomize the Young Man, and tells the Young Man over and over in French that he loves him, Gôda supposed that the Young Man must have buggered the chicken and that he also must have loved the chicken.

This may have been exactly what Gôda thought at the time and told everyone, but in his published writings, the connection was left quite tenuous. In his original review of the dance, he wrote that the dance "caused [him] to feel pure desire for a human" (or, "the purity of desire for humanity") and in an essay examining the significance of the chicken, he said that given Hijikata's upbringing in the country (in which killing a chicken would portend a feast), the treatment of the chicken was a natural form of love.[29] Nonetheless, the hint of bestiality either in Hjikata's essay or Gôda's writings proved too tempting for most secondhand observers to pass up. The two set a ball rolling that would not be easily stopped. This interpretation was picked up by Westerners who played up every aspect of the iconoclastic dance. The problem with these original hints is that they have now taken on an afterlife of their own, but the dance was sufficiently iconoclastic without the necessity of exaggerating it.

Moreover, the interpretations of bestiality do not take into account the details of the dances. Gôda's original idea that the chicken was a symbol of love is undercut by the fact that the Young Man stamps his feet in terror after he has just been given what is supposedly a symbol of love and then consummated that love. One would not expect the young man to be terrified of love. If, however, the chicken is payment for a sexual transaction and the Young Man is so hungry that he will do anything to

Figure 2.10 Young Man (Ôno Yoshito) and Man (Hijikata Tatsumi) rolling around, *Forbidden Colors*, (Daiichi Seimei Hall, Tokyo, May 1959) by Kurokawa Shashinkan. Courtesy of the Ôno Kazuo Dance Studio.

eat, then we can dispense with the notion that the chicken is a symbol of love, and account for the terror that the Young Man felt.

Viala and Masson-Sekine argue that the suffocation of the chicken between the legs is a symbolic representation of the actual sexual act. That is, they seem to see the very act of squeezing a chicken between the legs (as opposed to wringing its neck with one's hands) as inherently sexual. However, the photographs of Yoshito taken when he is about to suffocate the chicken, and after having done so, show him in a posture that does not appear to be sexual. The chicken hangs between his legs at roughly the level of his knees (see figure 2.13 and compare with figure 2.8). The constriction between his calves and the backs of his thighs is going to crush the chicken. Later Yoshito lies on his back with his ankles up under his buttocks, and the chicken's body is between his legs and it appears that its head is caught underneath Yoshito's buttocks. The chicken is in the wrong place for a symbolic buggering. It is mostly behind him with only the legs or neck protruding out front.[30] If one considers that Hijikata had already smothered a chicken in the "Stillness and Motion" section of *Dance of the Burial Mound Figurine*, it becomes hard to defend even the less brutal notion that the death of the chicken is symbolic of the sexual act. Of course, it is characteristic of a symbol that there be a gap between it and what it represents, but in this case, I would contend that it is a stretch to argue that suffocating the chicken symbolizes a sexual act.[31] If we read the dance as not just being about shock (and certainly not about love), but also about unequal relationships, we can begin to make sense of the role the chicken plays in the dance.

So where did the notion of love or bestiality come from? Aside from Hijikata's assertion that he slept with the chicken for days on end and had to ensure that he did not kill it, Gôda wrote that his initial response "was partly a way to vigorously defend Hijikata from the reaction of the dance world of the time" by reading the dance as "dealing with the nobler things of existence." Later, after the initial furor died away, Gôda acknowledged that he had tried to fit Hijikata's dance into an acceptable framework—the framework of love. He wrote:

> Since the first performance of *Forbidden Colors*, I have thought of the chicken as a symbol of love. This is due to the fact that the white image was very powerful. Also, as I will relate later, due to the fact that the emotion that I felt at the lowering of the curtain was the epitome of peacefulness, I saw the Young Man's actions as bestiality and read the male-male sexuality of the second half as a nightmarish scene for the Young Man. Yet, whether this love is male-male sexuality or not, and regardless of what happens before and after, I took the love as necessitating a sacrifice so that they could become the same as each other, and I lined up the Man, Young Man and chicken and read the relationship between the Young Man and the chicken as bestiality.[32]

At the time he revisited *Forbidden Colors* in his 1987 essay, he replaced this attitude with the following:

> I came to think that there was some power close to force in the Man's attitude towards the Young Man that cannot be subsumed under the categorization of love. This is perhaps because although the Man appears suddenly from time to time, he remains strictly from start to finish in the background and in a way becomes something that bears the

darkness. I had to switch my reading from seeing bestiality between the Young Man and the chicken to seeing the Young Man suffocating the chicken. I also had to replace my phantom love ceremony with a plain and simple crime. The chicken is killed by the Young Man. Thus the Young Man achieves the credentials of a criminal. If we said this in Hijikata's terms, he is recorded in the roster of criminals. He becomes the Man's equal and of the same class. Yet, it cannot be that [the world of] male-male sexuality requires such a strict verification of one's credentials. Thus it must be that the principle structuring device of *Forbidden Colors* is the crime of forcing the Young Man to kill the chicken, or the structure of the society of criminals—societies that turn their backs on the world. The male-male sexuality of the title is merely a false structure for the stage.[33]

Gôda rereads *Forbidden Colors,* not as a facile antisocial dance, but as a savvy examination of physical and social forces. This points to a larger issue which is that the breaking of norms, and the shocking of audiences, are both ethically neutral actions. They gain whatever ethical tinge they may have only when one feels that the background society is somehow unacceptable. Otherwise one might find oneself feeling as outraged by the breaking of norms as many of the people in the audience were that night. Once Gôda had time to reflect on the dance and his own response, he was able to see that the dance was concerned with more than just shocking the audience and breaking norms.

His new reading opens up a whole avenue of questions: Why does the Young Man submit to the Man? Why not refuse? How does the Young Man know what to do with the chicken (obviously we are in the realm of mime, but the Man does not appear to communicate in any way), and why is it only necessary for the Man to observe that it is done? Why does the Man stay hidden in the dark for so much of the dance? As long as we read this dance in terms of love between men, the answers to these questions must remain forever just as far in the dark as the Man. Yet, as soon as we see this dance in terms of force or power relations (either a sexual transaction between a Man and an extremely hungry Young Man, or, as Gôda has it, a marker of the Young Man entering into the society of criminals), then these questions become considerably clearer. For it is characteristic of force (or power) that while its workings are often transparent, just as often they are obscure. Indeed, force sometimes depends for a great deal of its strength on its invisibility. Brute force can overtly compel us to act in some way or another, but social forces can teach us how to act even when no one has to tell us outright what to do.[34]

Of course, the two studio photographs in which the Man bends the Young Man over backwards by pulling his hair indicate that Hijikata was not only interested in discursive power, but also the more directly coercive power that often accompanies it. However, the Man's stiff-legged run and the Young Man's straight-legged shuffle belong squarely in the category of discursive power. Surely, Hijikata intended to distance himself from the world of modern dance, and the two similar ways of ambulating without bending the knees were likely partially dictated by his rejection of the smoothness and suppleness that mark most modern dance.[35] *Forbidden Colors* stemmed from Hijikata's readings of Genet and Mishima, but nothing in either of their works would suggest that a stiff-legged gait and running on heels were suitable for depicting gay men. Rather, they are suitable as a marker of how the social forces

that the Man brings to bear are enacted on the body of the Young Man. The studio photos show us that even before the Man had the chance to grab the Young Man by the hair in a more overtly forceful act, the Young Man somehow was already coming under the influence of something larger that controlled how the Man walked and began to be manifested in the Young Man. Whether this force stemmed purely from economic disparity and hunger to motivate the Young Man to somehow act like the Man, or from the deeper power of the society of criminals manifesting itself in the body of the Young Man, the force appeared to be operative all the same.

Before concluding that same-sex eroticism is a purely ancillary phenomenon in this dance, we need to think about one more thing. The keen reception of *Forbidden Colors* in the initial Western works on butoh has to be seen within the context of the gay rights movement and betrays an attitude in which certain antisocial actions were taken by their very nature to be blows against a monolithic and repressive heterosexist social structure that trapped humans. It is likely that same-sex eroticism and the supposed bestiality fell into the same category for many of the later commentators. Once upon a time, the very depiction of homosexuality or the very engagement in same-sex relations was taken as striking a blow for freedom and the right of people to express themselves unreservedly. It does not undervalue the impact that the depiction of queer acts has had in transforming society to say that today we are more hesitant to make such extravagant claims for the revolutionary potential of putting antisocial or same-sex relations on stage. This was the crucial message of Foucault's *The History of Sexuality*, which was both an examination of the functions of power, and, in the process, a demonstration that the battle against the repression of sexuality was entwined within larger epistemic structures in which that battle entailed bringing all of human life "under the sway of a logic of concupiscence and desire" that could in turn be manipulated in repressive ways.[36] Indeed, we might restate Foucault in layperson's terms as follows: every step forward is at the same time a half step, full step, or step and a half back. The Euro-American commentators on butoh seem to have been bent on overlooking Foucault's point as they (not without some justification given Gôda's initial reading) trumpeted the same-sex eroticism and bestiality of this dance.

However, *Forbidden Colors* does not unconditionally celebrate same-sex eroticism and antisocial behavior as natural or unmediated actions with revolutionary potential based solely on their status as such behaviors. Rather, the dance assumes that the worlds of criminals and men who have sex with men are characterized by strong and permeating social structures, and it examines the way that social structures are both physically and unconsciously transferred from one entity to another.[37] Hijikata, it seems, recognized the imbricated nature of same-sex eroticism and social factors, and mirrored them in his dance.

Thus, the use of same-sex eroticism cannot have been completely an accident. It was Hijikata's genius to have recognized the value of putting same-sex eroticism on stage, thus widening the sphere of topics suitable for artistic representation. However, he did not treat that same-sex eroticism as an unquestioned alternative practice. Rather, with artistic representation came artistic examination. The chicken, then, is not a symbol of love or sodomy but rather a marker or token of an unequal relationship.

So, in *Forbidden Colors* killing a chicken may either fulfill the economic contract between the Man and the hungry Young Man, or satisfy the requirements for entrance into a community (in Gôda's words, the "Young Man achieves the credentials of a criminal"), which in fact, the Young Man might not even want to enter. In that sense, it is proper to theorize the chicken in the same way that scholars have looked at structural inequalities or structural violence in society. In these cases, a society is built upon and depends on structurally unequal relationships.[38]

For example, consider the groundbreaking work done by David Roediger in *The Wages of Whiteness*. Roediger argues that there are both benefits and a cost to being "white," but looked at from the perspective of the black population, one could say that the physical violence and racism directed toward blacks are not so much intended to keep them down directly (although they surely do that as well), but to ensure that lower-class white people will accept the costs that they are being asked to bear because at least they can "fashion…identities as 'not slaves' and 'not blacks.'"[39] In a similar manner, what happens to the chicken has nothing to do with passing a symbol of love from one person to another, but rather, everything to do with the Young Man's standing within a community. It may be the bargaining chip with which the Man compels sex with an unwilling, but hungry partner. Or, in Gôda's reading, the chicken is a ticket so that the Young Man can enter a community, which he may not even want to enter, given that he acts terrified.[40]

For that reason, we should not dismiss Gôda's acknowledgment that he felt peace at the end of the dance, even if the peace stems from a different source than love. Once we have the vocabulary for seeing the death of the chicken as a kind of by-product of unequal social forces, then we can reread the final scene of the dance with the tenderness with which it was probably received by those who stayed to the end. Undoubtedly, the people in the audience felt tremendous tension and were relieved when the dance was finally finished, but at the same time, the return of the Young Man or someone else (maybe even Hijikata, considering his emphasis on apologizing to the chicken over and over) to the stage to pick up the chicken, accompanied by blues played on the harmonica, becomes a kind of acknowledgement of the real costs of an unequal interaction, because it may be an apology or a manifestation of an unwillingness to let the seemingly dead chicken lie there unmourned.

In sum, Hijikata's first dance, *Forbidden Colors*, was a strongly mimetic and socially concerned narrative that placed extremely high demands on its audience. It demanded both that the viewers cope with the shock of the scenario it depicted, and that they peer intently into the dark and listen carefully in order to follow its narrative and decode its political valances. After this first explosive piece, Hijikata's dances would gradually change as he left the Japanese modern dance world behind.

NEW FRIENDS AND A NEW AUDIENCE

Regardless of Gôda's initial attempt to save Hijikata (by deflecting criticism through reading Hijikata's dance as "associated with higher things" such as love), this dance (and another one not treated here) touched off a maelstrom of criticism. No less a giant of the dance world than Eguchi Baku criticized unnamed dancers for their "sex

dances," which in his eyes were merely shocking and did not have any other artistic merit.[41] There was no doubt that Hijikata was one of those at whom the criticism was directed, and in the name of artistic freedom, Hijikata, Motofuji, Ôno, Tsuda, Atsugi, and a few others chose to leave the All Japan Art Dance Association.[42] This, along with the following event, was to prove decisive for the subsequent history of butoh.

Some weeks after the dance, the novelist and essayist Mishima Yukio received word that Hijikata had used the title of his book *Forbidden Colors* without permission.[43] He went to the Tsuda Nobutoshi Dance Studio to confront Hijikata. Mishima was won over instead by an impromptu studio performance of the dance. Hijikata and Mishima began a relationship that was to prove somewhat contentious but highly beneficial for Hijikata.[44] Mishima was so excited by the dance that he dragged a succession of friends to the studio and made Hijikata and Yoshito perform the dance several times. In the process, he introduced Hijikata to a wide circle of artists, and also lent his prestige to the struggling dancer. The two ended up becoming friends, and Mishima would often come to the studio to drink and socialize with Hijikata and other artists, writers, and critics. This is the reason that *Forbidden Colors* is so important in the history of butoh, even though the dance form we know today is very different from that dance. Before meeting Mishima, Hijikata was virtually unknown in the wider world. It is entirely possible that without Mishima's help, Hijikata would have remained unknown. Many commentators have remarked upon Hijikata's ability both as a choreographer and producer, and the standard line in Japanese butoh criticism is that Hijikata combined the abilities of the Russian Ballet impresario Diaghilev and the dancer and choreographer Nijinsky into one person.[45] True to this description, Hijikata's persuasive ability was on display as he was able to turn what could have been a sticky situation involving authorial rights with Mishima into a way to advance his own career.

At a time when Hijikata had severed contact with most of the modern dance and ballet world of Tokyo, Mishima's publicity (in the form of articles and introductions) and support enabled Hijikata to find and cultivate a new audience for dance in postwar Japan.[46] This audience was primarily composed of various artists and writers and interested college-aged people who knew next to nothing about dance. Their accounts of colliding with Hijikata's dance usually followed a similar pattern. They confess that they think dance is boring—all Tchaikovsky, tutus and toe shoes—but when they see Hijikata's dance they are amazed by how powerful, fresh, and new it is.

Hijikata, in turn, cultivated this stratum of viewers for artistic contacts and collaborators, setting up a pattern that would hold for the rest of his career. With the same charm he used to defuse the difficulty with Mishima, he persuaded artist after artist to provide set designs, lighting, music, costumes, posters, fliers, and other performance elements. These artists did not just provide backdrops and support for Hijikata's shows, they became part of a vibrant and contentious melee of artistic life that Hijikata centered around himself, which included drinking parties, fist fights, and long intense conversations about art and life. Hijikata pulled and pushed just as much as he was pulled and pushed. These were seminal times for Hijikata, and the dynamics of these early years went far beyond the typical issues of influence and appropriation by which we try to account for an artist's development. These artists

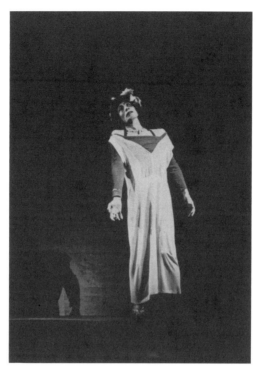

Figure 2.11 Divine (Ôno Kazuo), *Forbidden Colors 2*, Scene 1 "Death of Divine," (Daiichi Seimei Hall, Tokyo, Sept. 1959) by Kurokawa Shashinkan. Courtesy of the Morishita Takashi Butoh Materials, NPO, and the Research Center for the Arts and Arts Administration, Keio University.

evolved together, exchanging ideas on a daily basis: sometimes a fresh idea that an artist was sure was his or her own had already been passed back and forth through several iterations and was now merely an unrecognizable version of an idea that that same artist had several days before.

Most crucial for understanding the subsequent history of Hijikata's performance art is the realization that Hijikata was unmoored from the history of the dance world after 1959, and now centered in a different world with a new audience who came to his dances with few preconceptions or expectations.[47] This left him free to approach problems differently from other dancers, and gave him contacts that would take him in directions other choreographers would have been hard pressed to go. He was not to reconnect with the dance world for a decade, when the dance world would grudgingly come to him to understand what he had been doing for ten years, and in some respects try to reclaim him.

FORBIDDEN COLORS 2

As an early indication of Hijikata's membership in that new world of artists, later in 1959, Hijikata presented an expanded *Forbidden Colors* at the "6 Avant-gardists: September 5th 6:00 Gathering" sponsored (or performed) by the 650

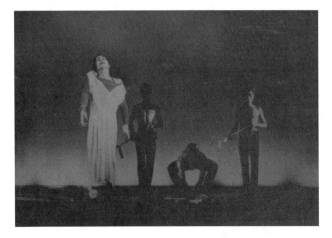

Figure 2.12 Young men with arrows and Divine, *Forbidden Colors 2*, Scene 1 "Death of Divine," by Kurokawa Shashinkan. Courtesy of the Ôno Kazuo Dance Studio.

EXPERIENCE Society.[48] The 650 EXPERIENCE Society consisted of the filmmaker Donald Richie, the dancers Hijikata and Wakamatsu Miki, art director/production designer Kanamori Kaoru, and musicians Mayazumi Toshirô and Moroi Makoto. Each presented his own work as part of the bill of entertainment.

In order to understand how Hijikata was changing, let us turn to the expanded version of *Forbidden Colors*, (which I shall refer to following Hijikata as *Forbidden Colors 2*).[49] *Forbidden Colors 2* was divided into two acts, each with two scenes, and the acts were parallel in that the first scene in each was either a solo or duet, followed by a group dance that ended with the group killing the main character. The first act is generally known as 'Death of Divine' and the second act, as 'Death of the Young Man.' In the first scene of the first act, Ôno Kazuo danced the solo role of Divine based very loosely upon the aging male prostitute Divine in Genet's *Our Lady of the Flowers* (which was to serve as the prototype for the following year's *Divinariana* and much later for Ôno's famous 1977 piece *Admiring La Argentina*). Ôno started the performance seated in the audience on the right-hand aisle about seven or eight rows back. He was dressed as a down-and-out male prostitute—he had on a thin green negligee, a brick-red sweater, a white lace gown, cheap vinyl shoes bedecked with fake red flowers, and a straw hat festooned with wilted flowers from a mortician, perhaps suggesting flowers stolen from a graveside (see figure 2.11).[50] After a few moments, Ôno arose from his seat, and climbed onto the stage.

The first scene may have been somewhat improvisational but was generally choreographed by Hijikata, and was probably influenced by Hijikata's and Ôno's studies in German Expressionist dance.[51] The scene appears to have been an attempt to express feeling or atmosphere in bodily form—in this case, the poverty, sadness, and societal alienation of a male prostitute. In the second section, some men joined Ôno on stage and, using feathers wrapped in paper (and thus transformed into arrows), harassed and taunted Divine. She writhed and twitched and finally, succumbing to this abuse, fell over and died (see figure 2.12). The men then carted Divine's dead body offstage.

The first scene of the second act was a reproduction of much of the action of *Forbidden Colors*—the chase, the passing and killing of the chicken, and the subsequent sodomy (see figure 2.13). However, this was carried out on a well-lit stage, so the action was visible to everyone. In the final scene, four boys appeared on stage, and charged at the Young Man who had just been sodomized (compare with figure 2.15). After the four boys hit the Young Man, suddenly ropes that had been lying on the stage were snapped taut. The ropes slapped the Young Man on his bare chest, back, and underarms (see figure 2.14). The boys slackened and re-snapped the ropes over and over. Finally, they wrapped one of the ropes around the Young Man's neck. Two boys then sawed from either side on the rope while the other two taunted and mocked him. Finally the Young Man fell to the floor, and was dragged out.

Intimations of Change

In the new and expanded version, *Forbidden Colors 2*, the violent abuse and killing of Divine and the Young Man are striking. In one respect, this was natural progression. In *Forbidden Colors*, Hijikata had examined the forces at work between two men; now, he added more men and thus provided a wider societal background, in which two successive homosexual men were killed. Hijikata even indicated that he had adjusted the focus from the first version to the second in this excerpt from a contemporary essay:[52]

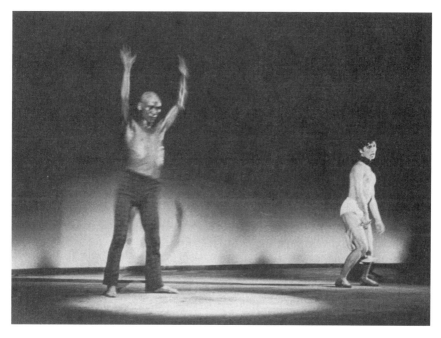

Figure 2.13 Man watching Young Man crush chicken between his legs, *Forbidden Colors 2*, Scene 2 "Death of the Young Man," photographer unknown. Courtesy of the Ôno Kazuo Dance Studio.

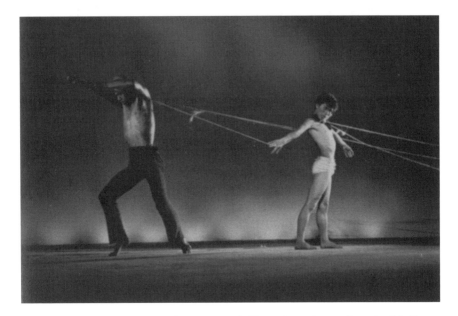

Figure 2.14 Young Man wrapped in ropes, *Forbidden Colors 2*, Scene 2 "Death of the Young Man," by Kurokawa Shashinkan. Courtesy of the Morishita Takashi Butoh Materials, NPO, and the Research Center for the Arts and Arts Administration, Keio University.

With respect to the material buttocks that I employ, during this series, I will adjust the focus shared by *Forbidden Colors 1* and *Forbidden Colors 2*. The anus of the boy dazed by the huge root of a flesh opens resolutely of its own accord like a flower. In the opening of *Forbidden Colors*, I sent the boy out to do a solo in which, manifesting the fluid of cylinders in the limbs of his flesh, he eagerly advanced to meet each moment of rending. This is a boy who throws his body onto the bodily pillars of males (who have only partial possession of the ideal essence of crime) without a moment of illusion, and without trembling.[53]

Gôda Nario quoted this passage in his analysis of *Forbidden Colors 2*, and observed that there is a considerable gap between what Hijikata professes in the essay and what actually took place on stage.[54] It seems difficult to square the text's assertion that the boy eagerly advances without trembling, with both Yoshito and Gôda's descriptions of the boy fleeing from the Man, then beating himself and manifesting terror and agony when he realized that there was no escape, and Hijikata's instructions to Yoshito that he should stamp like a chicken caught in a fire in order to indicate his terror. In both versions of *Forbidden Colors*, it was not at all obvious to everyone (including the main participant) that the boy "eagerly advanced" to his fate, or that he participated without trembling.

However, in the essay at least, Hijikata seems to be drawing a distinction between the same-sex eroticism and the violence shown in *Forbidden Colors 2*. Later in the essay, Hijikata continues:

Letters of welts from touching an elevated train run across the skin of the youth who receives the attack of hard muscles. They signify death. At the same time, the youth

distantly feels a world moving in his viscera. The youth dimly considers that death breaks down in tears at rape. But I cannot allow that. The boy must live. Over and over just like a miracle.[55]

The second passage might seem to be at odds with the first passage in that it focuses on the way the boy is harmed. The "script of welts" (*mimizubare no moji*) might be Hijikata's code word for the rope burns that the Young Man received from the snapping and pulling of the ropes, while "the attack of hard muscles" likely refers to the way that the boys charged Yoshito with outstretched fists. The discrepancy between these two passages can perhaps be explained as Hijikata trying to distinguish (in his own strange way) between hetero-normative violence and same-sex eroticism, which would be pleasurable for the participants.[56]

Whatever the case of Hijikata's intentions, the tension between eroticism and violence remains. Gôda wonders how the boy is supposed to come back to life over and over again, and therefore he concludes that, at least in this part of the essay, Hijikata presents violence and then minimizes its effects.[57] Gôda connects this minimization to a subsequent debate over the relationship between the first and second acts of the dance. Apparently, there were those who thought that Divine was resurrected in the Young Man, only to be attacked and killed again.[58] If that was the case, then the resurrection (momentarily) cancels the previous death so that the boy can live "over and over just like a miracle."

At this remove and without only a minimum of visual materials to guide us, it is impossible to say whether it would have been more sad or jarring for the audience if Divine were to get one more chance at life (to be resurrected) and then get killed by the same forces that killed her earlier, or to get killed only once and that violence be final. However, if Gôda is correct and Hijikata presented violence and then erased it, it cannot be that the violence disappears, but just that the effects of violence turn out to be fleeting in *Forbidden Colors 2*. The passages that present the boy as an eager participant in same-sex eroticism jar against the passages that present the pain of the boy, and leave us without a firm basis for a finalized reading of the dance based upon Hijikata's essay.

Gôda felt that the tension between the dance and Hijikata's essay was mirrored in the way that the dance itself had changed, and he honed in on this transformation of *Forbidden Colors*, using the alteration of the lighting of the scene from near darkness to bright lighting to explore another way that Hijikata was beginning to change. Gôda argues that the original darkness in the first *Forbidden Colors* had the effect of focusing the attention (peering and listening intently) of the audience on figuring out what was happening on stage, that is, focusing their attention on the narrative.[59] However, Gôda notes that the way Hijikata altered the dance ensured that the actions were rendered more obviously and openly erotic. It is as if by making the lights bright, the same-sex acts and the naked bodies drowned out the narrative.

At the same time, according to Gôda, the violence was cut off from any outside source and became "everyday" violence.[60] I take Gôda to have been making a distinction between the violence in the scene of the boy's death, and the force that he identified as functioning in *Forbidden Colors*, whereby either the boy was forced to exchange sex for a meal, or the boy was admitted into the society of criminals at the cost of the collateral damage of the life of the chicken.

If Gôda's interpretation is correct, and *Forbidden Colors* was focused on social forces, the ropes in *Forbidden Colors 2* might have represented a concretization of these forces, but Gôda says that the ropes in the 'Death of the Boy' scene conveyed no significance relating to external power, but were purely instruments of violence deployed by the boys. Thus, Gôda concludes that just as Hijikata said, the focus was adjusted: the examination of force in *Forbidden Colors* was altered into an emphasis on eroticism and naked violence in *Forbidden Colors 2*. He pins this change partially on the influence of Mishima. But the contradiction in Hijikata's essay (between the passage that focuses on the pain of the boy and the passage that proclaims his willingness) alerts us that the transformation was by no means as complete as Gôda would have it. The tension, between a kind of socially engaged dance (albeit one in which two gay men are taunted and murdered) and erotic spectacle, remained in the essay, and certainly came across to Gôda during the dance.

The transformation in Hijikata's dance is echoed in the passage from his essay that most clearly sets out his artistic aims, rather than the aims of this particular dance:

> My choreography pursues the forms of round dance, and features dancers as temporal torture paintings that are valued as evasions of centripetal force. Even if the technique for continuing to bring one core to erection is incomprehensible to everyone, it will not harm the drama. It is sufficient if we wipe the eye clouded with practicality. In *Forbidden Colors 2*, I am forced to choose the bodies of amateurs who are not spoiled by the aesthetic consciousness of previous dancers. With the background of these young awkward bodies it should be possible to establish a new forbidden material. By not bending joints in the way they are used to, we will be able to execute simultaneous actions. The expression of writhing under the constraints of strict cylinders will be transplanted from the face to the back. In this drama in which all evil comes from behind, the back will be employed with equal value as the revolving breast, the breast that slowly moves, the breast that both alights and leaps, as the preferred way to play the main roles.[61]

The most clearly comprehensible goal here is the establishment of a "new forbidden material," but there are some curiosities here. Hijikata also claims to prize evading "centripetal force."[62] Evading force may be related to Hijikata's exploration of coercion or the workings of power that govern unequal interactions between people. However, for Hijikata, it does not matter if the dance is incomprehensible, and one cannot view it as in any way practical.

This is the first manifestation of a strange puzzle in Hijikata's art. Our understanding of the dance is pulled in four directions at once. There is a split between presenting new forbidden material as something with value in its own right, and championing the evasion of force. This split is accompanied by a corresponding ambivalence as to whether the dance should be seen as having any practicality or whether it even matters if the viewer understands it at all.

However we understand that puzzle, Hijikata seems to have assumed that there are two obstacles to the accomplishment of the goal of presenting new forbidden material while evading centripetal force: the preexisting notions of practicality that cloud the eye, and the extant aesthetic consciousness that spoils trained dancers (perhaps by rendering them unable to do new forbidden things). To overcome these limitations, Hijikata proposed using dancers who he assumed were not hindered by preexisting expectations of what dance should be (in this case, young working-class boys from a

vocational evening school). He also refused to bend joints in the way that people at the time were accustomed to bending them as a way to execute simultaneous movements.

Finally, Hijikata wanted to elevate the back of the dancer to a status as an equal or preferred agent of performance. Later in the essay, he continues: "...the back is my new alter ego that masters pronunciation."[63] I take 'mastering pronunciation' to mean enabling the back to express various things. Hijikata likely observed that a cardinal rule of performance is never to turn one's back to the audience, and decided to overturn that rule and see what he could achieve with the back.

However, the use of the back, the young "uncontaminated" working-class boys, and the refusal to bend joints in the usual way are tied together by something larger than just a reaction against previous forms of dance and drama. Hijikata was already beginning to formulate techniques that would overcome bodily and mental limitations and enable the body to express more than hitherto possible. If he was going to put new material on stage, it was going to take more than just the same old techniques or the same old body to present that material.

At this remove, it is difficult to assess Gôda's supposition of Mishima's influence on Hijikata in this partial transformation, but it may clarify the relationship if we juxtapose Gôda's impressions about how Hijikata's dance was changing with Mishima's essay about *Forbidden Colors*, which was the product of Mishima's initial interactions with Hijikata.[64] The essay appeared in time to call attention to Hijikata and perhaps act as advertising for "6 Avant-gardists: September 5th 6:00 Gathering," so Hijikata almost certainly read it. In his first essay on Hijikata's dance, Mishima opened with a description of improvisational exercises for which Mishima provided themes, and then threw down something that must have seemed like a challenge to Hijikata:

> From watching the circus, gymnastic competitions, and various sports, we have figured out, in so far as is possible, the movement possibilities of the human body—how much it can bend and contort. We have come to understand that compared with the language of written characters, the language of the human body is significantly restricted.[65]

To a dancer, the assertion that the language of written characters (*moji*—also alphabet) was significantly larger than the language of the body must have been galling indeed. Considered in the light of Hijikata's attempts to surmount the shortcomings of the body and expand the expressive ability of the body by employing the back and bending joints in the wrong way, it certainly seems that Hijikata was keenly aware of and trying to refute this assertion by increasing the vocabulary of the body. That is, it seems that Hijikata was not convinced that Mishima had seen all the ways that the body could "bend and contort" and he meant to explore other means of bodily vocabulary.

Mishima continued:

> While watching modern dance, or the improvisational exercises, the movements and forms did not surprise us that much. What was surprising was the way the sudden movements of the body, or the sudden shouts did not correspond to any of our everyday expectations, but rather delicately betrayed our purposive consciousness....I think you will be able to imagine this from the photographs, but the alienated feeling that comes from psychological laws being crushed by the strange and shocking movements of the body is not available in the dance that has retained classical techniques. That feeling of alienation is agreeably piquant.[66]

Continuing, he wrote:

> For a fixed period of time the dance continues and then finally it ends. The audience will be hard pressed to understand why it continued and why it had to end.... The thing that preserves the temporal continuity of the dance from beginning to end is not music but several sweaty half-awake half-dreaming bodies.[67]

Mishima noted that the audience did not understand why the dance began or ended or why it lasted as long as it did (a reaction that may have contributed to Hijikata's assertion that it does not matter whether anyone understands the dance).

Mishima then proposed something else that provided "temporal continuity" for the dance. I would posit that "temporal continuity" must be that which ties the dance together over time or what unifies the dance from the beginning to the end. He answers his own question by identifying the sweaty bodies as the element that ties the dance together. It is perhaps not surprising that Mishima, given his sexual preferences, enjoyed watching young male bodies. However, Mishima had actually already given two other answers to that question earlier in the essay.

One was the aforementioned agreeably piquant feeling of having his expectations thwarted. The other was directly related to the improvisational exercises, but spoke to a larger issue in Hijikata's dance:

> An idea gives birth to an action, and an action gives birth to a purposeless energy, and that energy flows back to the idea and enriches it and causes it to divide and develop. At that moment, I was able to understand a deeper and truly musical interest in the comparatively long dance productions of *Forbidden Colors* and *Black Point*.[68]

Mishima here finds interest in following the interplay between an idea and movements, and in seeing how movements will alter the original idea. So it is not just the body or the thwarting of expectations that holds his interest over time, it is also the evolution in the relationship between ideas and movements. In sum, three things tie the dance together from beginning to end for Mishima: the "truly musical" interplay between movements and ideas; the "agreeably piquant" feeling of having one's expectations thwarted; and watching the sweaty (half-naked) bodies.

It is almost possible to predict the entire subsequent history of butoh from this essay, because Mishima realized right from the beginning that dancers necessarily struggle with unifying dances or holding the interest of the audience. The way various artists solved this problem would be what made the several kinds of butoh different, and what made butoh, in general, different from other kinds of dance. Faced with the task of trying to overcome the perceived inadequacies of the body, it is likely that along with his own solutions, such as bending joints in the wrong way in order to execute simultaneous movements, Hijikata could not help but see Mishima's responses as solutions to the problem that he himself faced (increasing the language of the body).

If Mishima could not figure out what the dance was about (or possibly, given the tenor of the times, thought that he should not even be searching for the answer to what the dance was about), but found the bodies enjoyable, and reveled in the piquancy of the musical interplay between movement and ideas that yielded something that

did not correspond to his expectations, then it would not be a surprise if Hijikata (as a young dancer) decided to actively pursue those methods as addenda to his new expressive attempts, such as employing the back or bending joints in the wrong way. Nor would it be surprising if violence functioned in much the same manner, which perhaps accounts for the way that Gôda felt that violence was being presented and immediately erased.

The various currents around *Forbidden Colors 2* all nudged Hijikata towards bodily (or more formal) experimentation rather than narrative communication. As a result, Hijikata seems to have alternated his efforts between increasing the abilities of the body (such as using the back or bending joints in the wrong way), and understanding the physical and mental responses of the audience and utilizing these (the piquant feeling of pleasure at having one's expectations thwarted). Of course, this bodily experimentation was in the service of establishing a "new forbidden material," but whatever the final goal, for the moment the narrative was beginning to be eclipsed by bodily experiments.

HIJIKATA TATSUMI DANCE EXPERIENCE GATHERING

Nine months later, in July 1960, Hijikata held the "Hijikata Tatsumi DANCE EXPERIENCE Gathering." By all accounts, the dances on the bill were quite different from either version of *Forbidden Colors*. Before describing the dances themselves, it is worth trying to piece together what Hijikata was thinking about in the intervening months by looking at the essays he and his friends wrote for the performance, which were presented in the program entitled *Hosoe Eikô's Photographic Collection Dedicated to Hijikata Tatsumi*.[69] Hijikata included two essays in the program, "Inner Material" and "Material," and persuaded Mishima to include one as well, "Crisis Dance."

"Inner Material" and "Material"

"Inner Material," is a coded, twisted, and possibly embellished account of Hijikata's prior artistic and life experiences during the fifties, accompanied by observations about his ideas about art and dance. It is the stuff of his mind and memory—his inner material—that provides the background for his dance. "Material" presents Hijikata's current crop of friends and collaborators and his current choreographic process. Taken together, the essays can enlarge our understanding of Hijikata's aims and the difficulties he faced.

Hijikata begins "Inner Material" by recounting an exchange he had with a collaborator, and asserts, "There is no way to remove ignorance and misery from my dances, but I do not want people to draw a lesson from hereditary diseases, as Ms. Margaret did."[70] The first half of the sentence is obvious enough: Hijikata insisted on presenting pain and misery on stage and was dissatisfied with previous dances that he felt had actively ignored them. The second half of the sentence is more puzzling, but I take the implication to be that the ignorance and misery in Hijikata's dances stem from sources other than hereditary diseases. In keeping with the focus

in both versions of *Forbidden Colors*, I suspect that Hijikata was not concerned with just any kind of ignorance and misery, but specific kinds of ignorance and misery. If ignorance and misery come from one's hereditary allotment, then they are no one's fault. They are just brute facts of nature.[71] If, on the other hand, they come from something other than genetic inheritance, then one can begin to ask for causes and explore ways to avoid them. In the dances we have considered thus far, the misery derives from specific situations such as the taunting of an aged male prostitute or a young queer man.

Hijikata continues by presenting his own position in a debate about the nature of art: "Tragedy must be given precedence over production, if not, it is just too frivolous."[72] This dichotomy between tragedy and production is strange, to be sure.[73] Certainly, production here must be related to the postwar managerial focus on productivity (*seisansei*)—an ideology of productivity supported by US business interests and championing a non-class-based and noncontentious way of bringing together labor and management.[74] One wants to know if tragedy produces anything in terms of achieving any ends (as it would have in Aristotelian catharsis), and it is going to seem as we go along that indeed tragedy does produce something for Hijikata. For the moment, however, at this stage of his career, he seems to be striving for a kind of nonproductive tragedy without which theater for him becomes frivolous (*fumajime*, which could also be dishonest, disloyal, unserious, and insincere).

Yet why would a theater of production entail frivolousness? The accusation that someone does not take the world seriously enough usually amounts to accusing someone of overlooking reality—maybe the person is not taking into account how hard it is to succeed in the world and therefore not approaching school or work with sufficient vigor, or maybe the person is refusing or failing to see the bad things that are happening to other people. Later Hijikata was to proclaim, "We have the right to ask for a guarantee of actuality among the random noise and bad taste that are almost the equivalent of raw materials."[75] For Hijikata, this was the problem with ballet-inflected modern dance of Japan in the 1950s. It did not represent actuality well enough.

But presenting actuality on stage turned out to demand a certain kind of technique. In a passage that straddles the line between a (pseudo-)description of his life, and presentation of his artistic aims, he explains:

> My friendship with the male prostitutes at Ueno Kurumazaka strongly inclined me toward the art of imitation. A ragged head of hair, size 11 feet, rouge, freezing to death in a public lavatory—with these tools at hand any choreographer, no matter how lazy, should be able to create a dance.[76]

Here Hijikata implies that he is not just concerned with pain and misery because of the requirements of seriousness, or because he seeks to portray on stage something more true to his life than other kinds of dance were willing or able to portray. There is something here about misery that is taken to shortcut the choreography process: "with these tools at hand any choreographer...should be able to create a dance."

After initially promoting tragedy over production, Hijikata ironically seems inclined to a choreographic method that makes it easier to produce dances. He seems

to have assumed that faithfully imitating the painful reality of life was sufficient to draw the attention of the audience, and thus the artist need not resort to any fancy techniques or measures to satisfy the audience. The accompanying assumption would be that misery has it uses—among other things it enables choreography.

This contradictory attitude toward production and tragedy continues in another passage that explores the satisfaction that an audience derives from seeing painful reality.

> What is it I go to see at theatre after theatre? Audiences pay money to enjoy evil. We must make atonement for that. Both the "rose-colored dance" and the "dance of darkness" in general must spout blood in the name of the experience of evil. A body that has kept the tradition of mysterious crisis is set aside for such an eventuality. Sacrifice is the source of all work and every dancer is a bastard child set free to experience that very quality. Because they bear that obligation, all dancers must first of all be pilloried. Dance for display must be totally abolished. Being looked at, patted, licked, knocked down. A striptease is nothing to laugh at.[77]

Audiences, Hijikata says, go to the theater to experience evil, but he does not say why. Perhaps he believes that the audience also senses some irrelevance, or some frivolousness, in the other arts available and so is searching for a relevant theater, but it is also possible that Hijikata thinks that the audience simply has a bloodlust that watching sacrifice satisfies. Elsewhere Hijikata had told a reporter:

> Why do people go to the theater? They come to furtively enjoy evil in the night. So we must disclose more evil in order to live up to the expectations of the audience. In order to obliterate the roots of evil, we must increasingly resurrect evil from the inner impulses of humans. Therefore, I intend to stare intently at the evil and sex that are the essence of humans.[78]

This makes it seem that (to some extent) Hijikata had a Roman Coliseum conception of art—throw the slaves or prisoners to the lions for the enjoyment of the people. His dancers act as a sacrifice for the audience's desires. In that respect dancing would provide a service, and his performances could be thought of as an updated Coliseum. At the same time, Hijikata claims that the overall purpose is to extirpate the roots of evil by bringing a scopic gaze to bear on it, and identifies sacrifice as the source of all work. It is strange to prioritize tragedy over production and then turn around and advocate thinking of that tragedy and the dancer who enacts it as the source of work and thinking of the act of watching that tragic sacrifice as a means of performing scopic surgery to eliminate evil.

In Hijikata's formulation, his dance serves yet another purpose as is evident in the next section, "Material." He writes of going out to working-class or industrial neighborhoods to "pick up material from among the boys wiping up at metal-plating workshops or squatting in garages," and then in opposition to those boys, says:

> There is a lethargic generation arrogant with fat and I vomit on its lotioned and powdered pale limp skin. A penis in such a case never becomes a radiant dagger. Wearing an apron, I go into service in the classification of fat that must be shaved away. To slaughterhouses, to schools, to public squares.... The radiant vitality of athletes at a sports ground

intimately exists side by side with death. Legs extended for the sake of being chosen as well as for all-out vitality may be registered as new springs in order to run rampant in the dance of death.[79]

The problem identified here is that people (and by extension the arts and society) have gone soft and flabby, and Hijikata means to rectify this situation, and in the process to remake education and the public sphere. At roughly the same time, Hijikata reported in a newspaper, "My dance lies in persistent human revolution. The utopia of the future is reflected in my retina. There is only one method for causing this ideal society to emerge—the remodeling of the human."[80] It seems that the way to fix the fat, soft generation is through the remodeling of the human by inflicting pain—shaving off the excess fat. The means for doing so and the goal at the end of the process turns out to be the toned athletic body, which probably should be interpreted both literally and figuratively as physical and mental toughness.

Finally, Hijikata refers to his students at the vocational night school where he taught:

The material given precedence for my next performance is from five boys who encountered me in a classroom at a Tokyo high school.... As soon as I met those boys, 80 percent of my work fell into place. That was because I discovered beyond their midday labor a colorful dance literally unlike any I had seen elsewhere. This kind of material excites me and furiously challenges my usual method of choreography. In this separation between this material and myself, bodies that have passed along the crisis of primal experience celebrate their mutually dizzying encounter.[81]

In much the same way that watching male prostitutes freeze to death was supposedly useful for chorography, we sense the usefulness of seeing the working–class, young, male bodies of these vocational students, and we recall Hijikata's idea that he had to find bodies uncontaminated by current aesthetics in order to create his new forbidden material.

Experience

Let us linger for a moment on Hijikata's focus on "primal experience." It is curious that the six artists who came together for the "6 Avant-gardists: September 5th 6:00 Gathering" used the word "experience" in the title of their group the 650 EXPERIENCE Society, which Hijikata subsequently borrowed and changed for the title of his show, "Hijikata Tatsumi DANCE EXPERIENCE Gathering." Few words carry more weight in the intellectual history of modern Japan than "experience." Not only has "experience" been important in various artistic developments and to Western thinkers of various stripes, but it bore the philosophical weight of the most famous book of Japanese philosophy, Nishida Kitarô's *Zen no kenkyû* (*A Study of the Good*), and thus has stood at the center of Japanese intellectual and artistic discourse.[82]

Amagasaki Akira has argued that one aspect of this concern for experience lay in a development through which the art world (including, but not limited to Japan) became less and less concerned with an artist conveying a meaning to an audience through some medium (such as paints or dance moves), and more interested in

creating the conditions for an experience for the audience.[83] Using material to express meaning was particularly troubling for the world of dance, because people balked at a choreographer treating dancers—who are humans after all—in the same way that someone might treat a tube of paint or a piece of bronze, that is, as mere material. According to Amagasaki, during the fifties and sixties an emphasis on individual experience replaced expression, and this individual experience occurred in three areas: First, creating a work of art was thought to be an experience for the artist. Second, the dancer was thought to have an experience during the creation and staging of the performance. Finally, the audience would have an experience while at the performance and thus participate in the creative process.[84]

To be sure, what constitutes an experience was often not well theorized, but usually when artists thought about themselves, or their dancers, or audience having an experience, they were generally thinking about inducing some new mental state (feeling or thought). One of the European artists Hijikata was most interested in, Genet, usually used the term "experience" in a standard sense of passing through or undergoing something, but sometimes used it in much this way in order to indicate having passed through something special or exclusive that not everyone has access to as when he refers to someone who has had the "rare experience" of committing murder.[85]

However, there were other ways of thinking about experience during the fifties and sixties aside from the way that Amagasaki outlined. Structuralist philosophy held that people from all cultures had identical foundational mental states. Each culture organized these mental states in its own way using its own categories and explanatory mechanisms.[86] In the common parlance, one "experienced" these mental states, and thus these mental states were termed "experiences." The other thinker that Hijikata was deeply immersed in, Bataille, used the term "experience" more nearly in this sense. He explicitly took up experience in his *Eroticism: Death and Sensuality* (which Hijikata cites in an essay a year later).[87] There, Bataille explored the dissolution of self that happens in erotic acts and mystical experience. That view of experience envisions a primal or basal mental state available to anyone—even if the explanatory mechanism for articulating the significance or cause of that mental state differs from society to society. There may also have been, at the time, an overlap between the idea of new experience and primal experience, in that the artist may have supposed that the primal experience has been hidden, and thus that uncovering a primal experience will paradoxically yield that which feels like a new experience.

In Japan, Kyoto School philosophers, looking to meld Western and local philosophical insights, took up the category of experience. A quick detour through that initial Nishidan salvo, *A Study of the Good*—which truly put experience on the map in Japan—nets the knowledge that Nishida's early philosophy is based upon the premise that the mind begins in and desires to be in (or return to) a state of mental unity, which is called "pure experience" (*junsui keiken*).

Certain things appear to be able to bump the mind out of pure experience: among these are deliberative discrimination and the awareness of subject/object distinction. To use Nishida's example, as we scrabble up a cliff, we do not have the luxury of deliberating about ourselves as distinct from and acting on the rock, the rock as different from ourselves, and ourselves as engaged in an activity called "climbing."[88] We are just

a bundle of preoccupied climbing. At that moment, a notion of a distinct subject and object and all discrimination between things do not enter into our minds.

Because it will be important for the subsequent discussion, it is necessary to examine in more detail some of the complexities of this notion of experience. Nishida was vague about whether or not pure experience was affected by cultural constraints. He charged that "experience means to know facts just as they are...by completely relinquishing one's own fabrications," and continued by referring to a state "without the least addition of deliberative discrimination."[89] This seems to indicate that he was assuming that pure experience is not affected by fabrications such cultural or social conventions. However, he gave playing music as another example of pure experience.[90] Music, though, is already a fabrication, an inextricably cultural thing. If, in the middle of playing music, you are not aware of the difference between the subject and the object, or if no rational thought disturbs your playing, this does not mean that you have successfully escaped from culture, for music is part of culture.

At the same time, Nishida recognized that certain mental states could cloud our interactions with what surrounds us more than others. Think of how we take anger to impair the judgment of people. At the moment of anger, one is no more able to cognize the difference between subject and object, than in the case of climbing the cliff, or playing music. However, Nishida seemed to hold out hope that it was possible to arrive at mental states that cloud what is out there less than other mental states. That is to say, despite some waffling on the subject, it seems that initially for Nishida, the issue of experience and the issue of socialization were separate issues. The fact that experiences were socialized did not lessen their status as experiences; it did not even, for that matter, damage their purity, because it is possible to have a unity of consciousness centered on a product of socialization such as music. Yet, if it is possible to do something to adjust the level of mental interference downward in order to contact whatever is out there with less distortion, it also must be possible that socialization (just like anger) can distort one's contact with what is out there. In turn, one can imagine the desirability of having a particular kind of experience—an encounter with what is out there free from distortions such as anger and socialization.

Note that because of the premise that the mind begins in and ever wants to return to unity, what started out as a somewhat contradictory claim about the relationship between pure experience and socialization became a goal to strive for, but it is a bifurcated goal that retains the traces of its origins. One part of the goal is freedom from distortion. The other is the prized mental unity of Nishida in which one is not thinking about any other considerations and is not aware of a distinction between oneself and the outside world. This is partly the kind of experience that artists were striving for, according Amagasaki's schema, in which the artist would present something new and shocking that would so engross viewers that they would momentarily not be aware of any gap between themselves and the outside world.

However, there seems to have been a widespread assumption on the part of artists and even philosophers that if you achieved the second goal (mental unity/being totally engrossed), then you had also achieved the first (minimizing distortion). In fact, it is likely that the idea of an undistorted interaction with the world, coupled with the idea of mental unity, has been anachronistically appended over the top of the

notion of "pure experience" in such a way as to cause a general loss of understanding of the original contradictions inherent in the idea of pure experience.

Thus, in Japanese thought and arts in the postwar period, there was two-pronged (and perhaps not well distinguished) idea of experience, which held out the possibility that some mental states added less distortion to what one encountered than others, and encouraged artists and audience to try to achieve a unity of consciousness. That philosophy of experience had been caused by and was existing side by side with a structuralist philosophy, which held that there are foundational experiences that originally all human beings must have shared—and that some societies or portions thereof may still retain the ability to access these, although in the case of Western society, socialization, metaphysics, and enlightenment have gummed things up—and these experiences can only be accessed by some mechanism by which one cuts through the strata of civilization until one comes to a point when these experiences are allowed to come out unalloyed.

Now, we can return to Hijikata via Amagasaki. There are certainly elements in this early avant-garde dance that look like they fit the model of experientially centered performance. One is the aforementioned 650 EXPERIENCE Society. Motofuji says that they entitled the group, "650 EXPERIENCE Society," because there were 650 seats in the hall where they were going to perform, so that each person would have an experience for a total of 650 experiences.[91] The grand doyenne of Japanese surrealism, Takiguchi Shûzô, went a step further and said that as there are six performers and 650 spectators, one should properly speak of 3900 experiences, because each spectator would have six experiences during each performance.[92]

Hijikata subsequently appeared in his own show for three years (1960, 1961, and 1963) entitled "Hijikata Tatsumi DANCE EXPERIENCE Gathering." This title loses the connotation of everyone in the theater having an experience, replacing it with a hint that he, as the choreographer, and his dancers were having an experience that the audience was privy to. In the first "Hijikata Tatsumi DANCE EXPERIENCE Gathering," Hijikata designated Ôno Kazuo as the "Senior Experiencer" (*senkensha*); and the rest of the dancers as "Experiencers" (*taikensha*).[93] In the pamphlet for the second "Hijikata Tatsumi DANCE EXPERIENCE Gathering," Hijikata, Ôno and the rest of the Dance of Darkness Faction are designated as "Experiencers" and the other participants are "galloping experiencers" (*chitaikensha*).[94]

Understanding the place of experience in Hijikata's work, lets us look at both versions of *Forbidden Colors* in a new light. To pass over the portrayal of pain and terror (and the attending outrage and sighs) as something merely intended to shock people or break norms, is to miss the fact that this audience was engaged by the performance in a way that few dance audiences are. It is to miss the fact that something was happening inside the members of this audience that was much stronger than what usually happens inside spectators. In *Forbidden Colors*, most people in the audience would have been so mesmerized by the spectacle on stage that it would have been impossible for them to think about anything other than what was happening. They were having an experience—in the sense that they were engrossed by a strong centering sensation. Here, again, Gôda's reaction is apropos this definition of experience as overpowering sensation. He wrote that Hijikata "presented a scene that caused one to shudder with a deep sense of being."[95] Others who have watched butoh over the

years have claimed that they felt alive, or that they felt great power. These reactions are probably partially a function of the mind-unifying quality of the shock, pain, or the breaking of norms that occurs on stage, and in that sense they enabled the viewers to have a strong centering sensation, an "experience."

This was neither the presocialized, nor the nondistorted kind of experience. It was entirely dependent upon a set of socializations that lead the audience to expect certain content in modern dance concerts. If the audience had been socialized in a completely different manner (for example, to expect sodomy on stage), they would not have had this mind-unifying experience. It was more like the Nishidan example of climbing a cliff: the preoccupation with danger keeps one from thinking about differences between the self and the other.

If in this light we reconsider the opposition between shock and perception raised earlier, we can see that, in terms of mental unity, both shock and the effort to peer into the darkness or listen intently for footfalls qualify as activities that unify the consciousness, and which in that sense would have been felt as "experiences." Hijikata's claim that he and the high school boys had access to some kind of primal experience shows that he was not just concerned with experience as mental unity, but also that he thought, somewhat in the structuralist terms above, that there were foundational mental states that could be accessed by finding someone who had not been contaminated by conventional modes of thinking.

In a kind of experiential merry-go-round, it would not be surprising if the primal mental experiences were believed to be mind-unifying as well. Bataille argues that erotic and mystical experiences are the most intense, thus perhaps the most mind-unifying. Furthermore, there is the hint that Hijikata assumed that to reach this primal experience was to access actuality, and there may have been the accompanying assumption that any mind unifying experience was at the same time a primal experience.

If we take a step back from the details of this triply complicated world of experience, which included the possibly related facets of mind-unity, actuality, and primality, it's hard to escape the suspicion that this emphasis on experience was not just a development in the world of arts to which Hijikata was privy, but echoed the world outside Hijikata's avant-garde dance. Several scholars have noted a new focus on what we might term reality or actuality in the postwar era (which spanned such diverse movements as Sakaguchi Ango and Tamura Taijirô's renewed focus on the body itself, and Abe Kôbô's avant-garde reportage and the documentary arts movement), and the focus on actuality shares in this wider concern.[96] However, owing to influx of new ideas and products from the United States and Europe, the postwar period must have been a time of many new experiences (in the sense of mind-unifying moments), and to that extent, a focus on experience echoes both the concern with actuality in the larger society and the many mind-unifying experiences that people must have been having, as their culture was transformed from a military-dominated society to one that took many of its cues from the outside world.

* * *

The companion essays, "Inner Material" and "Material," are difficult, to be sure. They are often contradictory, and resist any final attempt to unify them into a

coherent artistic whole. But, in them, Hijikata struggles with a tension between productive and nonproductive conceptions of dance. On the one hand, an attitude of evil for evil's sake or tragedy for tragedy's sake permeates the essays and brooks no compromise. On the other hand, tragedy and evil are taken to have a special effect on the choreographer that makes him stronger and more athletic or eases the task of choreography as one need only imitate tragedy or evil directly in order to create dances. Tragedy and evil in this context seem to have an equally direct effect on the audience, which leads, in turn, to Hijikata thinking of dance as useful and goal-oriented, whether that consists of making over society to trim its metaphorical fat, or sacrificing himself and his fellow dancers for the audience, because looking at evil will help to negate it or because sacrifice is the source of work.

"Crisis Dance"

Mishima also provided an essay, "Crisis Dance," for the program. In it, Mishima appears to have shared Hijikata's preoccupation with actuality and refers specifically to the "requirement for actuality in dance."[97] Given the amount of time that Mishima spent socializing with Hijikata, this essay can deepen our understanding of the role of actuality in postwar society. In "Crisis Dance," Mishima tries to account for the differences between classical and avant-garde arts. He begins with the assumption that humans exist in a natural state of crisis, and then sets out an evolution in which people first feel crisis directly and manifest it in their arts in the fear of nature, then try to placate that crisis with ceremonies, then come to need crisis, and finally begin to express crisis directly again in avant-garde dance. For example, Mishima argues that ballet makes use of toe shoes in order to create an artificial sense of crisis upon which to build its beauty, but that avant-garde dance attempts to scrape off customs and present crisis straightforwardly.

However, Mishima noticed a problem that was going to confound those who sought to satisfy the requirements of actuality by presenting crisis directly: "There is nothing (even words) that bears customary and practical purposes as much as the human body, which is the means of expression, . . . for without first scraping off those concepts actuality will not appear." This is quite a forward-thinking statement, and perhaps troubling to Hijikata, who had claimed that he was going to use bodies that were uncontaminated by preexisting aesthetic consciousness and eyes that were unclouded by practicality to realize his new forbidden material. Usually we think of language itself as the bearer of customs and concepts, but Mishima argues that, in fact, the body (perhaps including the eye) is more imbued than anything else (including language) with purposiveness, customs, and concepts. And remember, this was from the person who had previously so forcefully expounded upon the limitations of the language of the body, as compared with the language of characters.[98] In short, the problem is that Mishima thought that the goal of avant-garde dance was to present actuality (crisis) on stage, but also thought that the means of expression, the body, is limited in the extent of its language and more covered with concepts, customs, and goal orientation than anything else. However, it is precisely concepts, customs, or purposes that were thought to block access to actuality.

Postwar Japanese scholar, Miryam Sas argues that Mishima's sophisticated negative phrasing ("without first scraping off those concepts actuality will not appear") nowhere guarantees that actuality will appear even if the artist scrapes at customs. She further states that for Mishima the body, as well as actuality, "becomes a horizon...of what cannot ultimately be accessed."[99] This is certainly the case, but Mishima's hesitancy in the face of accessing actuality neither diminishes the importance of actuality as a goal for the artists, nor as an important horizon guiding all inquiry. It only acknowledges the difficulty of arriving at actuality because if Mishima is right, actuality cannot be easily accessed through traditional modes of inquiry, or traditional ways of using the body. It will, rather, take special measures to draw near to actuality, and these measures preoccupied Hijikata for another two and a half decades. Importantly, Hijikata's search for actuality was not just limited to the content of his dances, in which he staged things that had not previously been thought worthy of representation in dance. He gradually turned to the task of scraping away the concepts and customs encasing the body. To that end, he developed new dance training techniques, as well as, examined himself and the conventions and customs that had formed him.

* * *

There are a few important points to linger over before proceeding to an account of the dances in the recital. One is the implicit decontextualization inherent in Mishima's essay. In this same essay, Mishima wrote that, when speaking of crisis, Hijikata had referred to the specific image of "the back of a man standing urinating." The scholar of European decadence, Shibusawa Tatsuhiko, was subsequently to connect Hijikata's idea to the Roman Emperor Caracalla, who was assassinated while urinating standing up.[100] Mishima, though, proceeded to turn crisis into a generalized structural concept divorced from any concrete situation—something that one would strive for because it had ostensibly been the source of art in times long past. The two versions of *Forbidden Colors* certainly presented crises and could be said to scrape at customs, but they did not scrape off customs to present some primal crisis. In these dances, the crises came about within the context of contemporary customs and social attitudes, and if anything, the removal of the negative social attitudes toward homosexuality would be likely to remove the crisis.

In *Forbidden Colors*, either the chicken was payment for sex, or, if Gôda is correct, it represents an exchange object in an initiation ritual for entry into the society of criminals. The terror of the Young Man allows us to see this state of affairs as troubling, and in the retrieval of the chicken there is a hint at an attempt to make amends to the chicken for having used it as the price of a sexual transaction or for admission into the society of criminals. *Forbidden Colors 2* featured two different moments when people taunted and killed a homosexual man (even if confusingly this is supposed to be the same man who dies twice). Mishima seems to have valued crisis in its own right, such that one should work to find a way past customs to access crisis directly, whereas, at least initially, for Hijikata, customs produced crisis, and finding one's way around or beyond customs was seen as a way to ameliorate that crisis.

Mishima's take on the method for arriving at actuality may also tend toward the decontextualization of narrative. According to Mishima, avant-garde dance must try to use the body that is covered in conventions as the means for expressing crisis,

and so it must scrape those customs off. Mishima is essentially saying that if, at an avant-garde dance, the viewers encounter incomprehensible scraping, they should not be thrown off by that, but recognize that the scraping is the sound of customs and conventions being peeled away. In that sense the scraping should be easy to understand once viewers realize that the scraping is not supposed to mean anything in and of itself, but just indicates that customs are being disposed of. Scraping off the customs of the body is then a necessary but insufficient condition for any avant-garde dance that aims to present actuality. Logically, then, any dance that does not have the dissonance of scraping will not be able to present actuality, and it is illogical, but perhaps it was tempting, for the artists to assume that any dance that was dissonant was presenting actuality. That is, scraping could have become a goal in its own right on the assumption that the scraping itself guaranteed either a mind-unifying experience, or the appearance of actuality.

Finally, Shu Kuge has argued that for Mishima the emphasis on form also amounts to an emphasis on Japaneseness.[101] That is to say, for Mishima, holding onto form was tantamount to holding onto Japaneseness. Content is not what is Japanese, but rather the delivery method is what encodes Japaneseness. Given that Mishima also hinted at the possibility of accessing actuality through dance, it may be the case that these points overlap, as a concern for actuality might be taken to coincide with a focus on "Japanese" form, on the assumption that one can truly arrive at actual Japaneseness.

Hijikata may have sought to explore the depths of the Japanese body, but Hijikata never assumed that he had gotten to the reality of the body, and as time went on maintained a wary distance from Mishima.[102] Nevertheless, the problem of the body bearing concepts and conventions was to haunt Hijikata for years, and eventually he had to deal with the fact that much of the socialization of his body had occurred in a place called Japan.

Looking back over these dances and his commentary on them, on one hand, it seems that Hijikata certainly wanted to present something shocking (forbidden material, tragedy, or evil), and claimed that presenting this should take little to no choreographic effort, and require no training by the dancer. As a bonus, he wanted to provide himself and his audience with an experience, and it seems that the shocking content would provide that as well, because of its centering and mind-monopolizing quality. This presentation of tragedy and/or evil seems to have had productive value despite Hijikata's claims to the contrary.

However, a second set of goals that Hijikata had for the dances exacerbated the contradictions inherent within their structure. These goals were: accessing actuality; remodeling self and society; engaging in persistent revolution; critiquing physical and social forces and evading them. It is difficult to say whether or not Hijikata thought he could achieve all these goals just by presenting "new forbidden material," and whether or not he recognized that if he achieved these goals, he would thus be ensuring that the dance would entail a kind of production. Almost from the beginning, however, he acknowledged that he needed bodies that were not tainted by preexisting "aesthetic consciousness" and needed new techniques in order to present this forbidden material—such as bending joints in the wrong way, or emphasizing the back rather than the front of the body. However, Mishima cut off that solution when he observed that the body's language is extremely limited, and that there were no pre-tainted bodies out there for Hijikata to find, because the body is covered with

purposiveness and conventions. So what should have taken no choreographic effort and no training was instead going to take an extreme amount of effort and training and require its own set of new techniques.

"Catalogue of Experiences"

At the recital proper Hijikata presented a full evening of works. The "Catalogue of Experiences" included the dances *Crowds of Flowers, Seed, Dark Body* (Antai), and *Disposal Place—Extract from the Song of Maldoror* (Shorijô—Marudorôru no uta yori bassui). That we do not have good descriptions of these dances is probably an indication that the nature of the dances had changed. In the case of *Forbidden Colors*, its basic narrative provided a framework into which people could insert their memories of specific details. Beginning with this recital, the descriptions of the dances become more vague and fragmented. At times there is only one source of information about a dance, a one- or two-line comment within the context of other observations about Hijikata by critics or commentators. The vagueness came about, in part, because as the dances themselves became more fragmentary, people did not have a narrative framework around which to organize their impressions, and their memories of the dances also grew more fragmentary. For example, writer and poet Yagawa Sumiko described three different moments in the evening of performance without identifying which part belonged to which individual piece:

> Several boys wearing negligees form a line with cramped shoulders and trembling hands. They look like a procession of polio children. Elsewhere, young men in black underwear and their heads wrapped in black cloth enter holding black cubes up in front of them. Their bodies stretch and shrink, as they wind about, locked together. Following them, a man in long pants ripples his sweaty, bare chest with wavelike motions, each rib discernible as he gasps in anguish.[103]

It is as if Yagawa is describing a circus (over on one side an elephant stood on its hind legs, while on the other side a person put her head inside the mouth of a lion, while elsewhere a person bent a bar of steel and ripped a phone book in half, while elsewhere a clown rode an oversized bicycle, and above it all a tightrope walker twirled on a rope). It is not that Yagawa's memory is faulty as compared with Gôda's (although as a dance critic Gôda was more careful to take notes while watching performances), but that the action was more fragmentary and not tied together by any overarching theme. This obviously presents a problem in trying to sort out which description goes with which dance, and once again we have somewhat contradictory information. Nevertheless, we can get a general feel for the dances from the descriptions we find in the historical record.

Disposal Place

The stage designer Mizutani Isao, for example, provides a glimpse into the dance *Disposal Place—Extract from the Song of Maldoror*.[104] While strolling the Ginza one day, Hijikata fortuitously stepped into a gallery at which Mizutani was

showing his surrealist paintings. Ever resourceful, Hijikata engaged Mizutani to design the sets for his next show, and it was through Mizutani that Hijikata met such members of the Japanese surrealism movement as Takiguchi Shûzô. For the set, Mizutani wrapped up hundreds of newspapers into sausage shapes (in a manner somewhat similar to later works by Kusama Yayoi), white-washed them, and then sprinkled black ink over them.[105] He then devised a movable back wall for the stage and covered it with these speckled sausages. He created a floppy doll-shaped figure out of these same sausages and suspended it in the middle of the stage.

Mizutani had two ideas for this set: that the set should be able to dance and the dancers should become part of the set, and that the set should be in a mirror relationship with the audience. Mizutani's ideas came to fruition in *Disposal Place—Extract from the Song of Maldoror*. Ôno, dressed in drag, once again started the dance seated in the audience. When he walked up on to the stage, the moveable sausage wall was positioned at the front of the stage so he could only move about in the small strip where the stage protruded past the curtain. The wall receded to open up the full space for Ôno, and the newspaper doll was lowed into the middle of the stage. Unfortunately, there are no records of how Ôno danced with the doll, so we are forced to jump directly to the end of the dance, at which time the wall began to move back to the front gradually squeezing Ôno off the stage. Finally Ôno disappeared into the audience and the dance was over.

Mizutani explains that the end result was that the backdrop and the audience were like a virtual and a real image. They began as a unit, and then as the backdrop moved back, the audience and the backdrop became split apart. Ôno came from the audience and, after donning a suit, returned to it, whereas the doll, speckled with whitewash and ink, came from the backdrop and merged with it again in the end. Finally, the audience and its doppelganger wall merged with each other again. It is clear that Hijikata and Mizutani were inviting the audience to ponder the status of reality, representation, and reflection. One has to ask: "Who is watching whom?" "Which side is more real?" And most importantly, "What is backdrop and what is part of the action on stage?" Or "Who is the star of the show and what is merely peripheral?" In this sense, Mizutani's stage design functioned much like Mishima's interaction between ideas and movements as a way to provide conceptual temporal continuity to the dance.

Crowds of Flowers

Using other sources we can begin to sort out Yagawa's description and identify which element belongs to which dance. Ôno Yoshito told of Hijikata's dance lessons at a night school, to which Yoshito came as a guest lecturer to demonstrate stiff, jerky movements.[106] The students were working-class boys who held jobs during the day and were continuing their education at night. On the day of the performance, Hijikata suddenly switched their costumes and made them wear negligees. Of course they were terribly embarrassed. However, it appears that Hijikata wanted to cultivate this embarrassment, and when one of the students turned out to have had some previous dance training, Hijikata kicked him out of the class. Apparently,

these chemise-clad teenage boys with their blooming "flower" of embarrassment became the dance, *Crowds of Flowers*. One could think of embarrassment as a primal experience, or imagine that the audience was having an experience of unease while they watched the embarrassed boys. Or, this might have been another solution to the temporal continuity problem—rather than Mishima's sweaty body, Hijikata placed nervous bodies, tense bodies, embarrassed bodies, or bodies with inferiority complexes on stage for the audience to contemplate.

Dark Body

Ôno Yoshito explained some of Hijikata's thinking behind *Dark Body*. Apparently, it featured three or four boys including a boxer, a bodybuilder, and Yoshito. They faced the back of the stage, and were lit from above—with their bodies covered with olive oil—so as to emphasize their musculature. They moved their shoulders in a jerky manner somewhat like popping from funk dance or hip hop.[107] Yoshito says that Hijikata explained to him that the dance was supposed to be about Japanese people who had inferiority complexes about their bodies (and here Hijikata apparently singled out Mishima as his example) which lead them to bodybuilding.[108] It is not clear what the jerky movements had to do with the idea of bodybuilding, but certainly from pictorial evidence, it is possible to see the way that the lighting emphasized the muscles in the backs of the boys. The following October, Hijikata was featured in a photographic spread in which there is a photograph identified as "Dark Body."[109] It depicts three teenage boys in black Speedos with black hoods over their heads. The boys stand stiffly facing forward with their heads bowed; their shoulders hunched inward; and their arms extended down in front of their crotches with their fists clenched. Yoshito says that this pose was featured in the dance *Dark Body*, and the photo probably corresponds to Yagawa's account of men in black underwear with their heads wrapped in black cloth (see figure 2.15).[110]

One of the sketches Mizutani drew from memory shows Hijikata with bare protruding ribs dancing in the foreground (which probably corresponds to Yagawa's description "each rib discernible"), and at the back right side of the stage there are other dancers moving in unison facing the left side of the stage so we see them in profile. In one, two dancers stand on tiptoe and extend their heads and arms out in front of them. In the other, three dancers appear to be walking from left to right and they all hold their arms out in front at about elbow height, and are stepping in unison. Their right legs are straight and their left legs are raised up with the knee in front and the foot behind and ankle cocked.

Also in October, Hosoe Eikô's sixteen-millimeter movie *Navel and A-bomb* (in which Hijikata and Motofuji played roles) premiered at the Jazz Cinema Experimental Laboratory. In the pamphlet for the screening, a short biography says that Hijikata "established experience dance, studied naked movement, and then went on to rose-colored dance, dance of darkness, stratification methods, mold walk, back, erased face, and others."[111] The "erased face" (*kesu kao*) may indicate the face covered with black cloth from Hosoe's photographs and from *Dark Body*. But it is "mold walk" (*igata no hokô*) that concerns me here.

In the photograph entitled "Dark Body" and in the Mizutani sketches, groups of dancers held their bodies in identical stiff poses. Of course, a sketch or photograph

Forbidden Eros and Evading Force 55

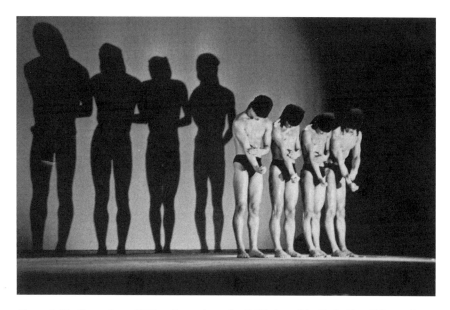

Figure 2.15 Scene from 1959 or from the early 1960's (possibly *Forbidden Colors 2*, Scene 2 "Death of the Young Man" or *Dark Body*), photographer unknown. Courtesy of the Ôno Kazuo Dance Studio.

freezes a moment in time, but sketches and photographs can easily suggest motion. These do not. The people walking appear as though they are doing something very slow and deliberate. Many choreographers require that their dancers move in unison, but Hijikata's word "mold walk" conveys something much stronger than unison. This could be the cookie-cutter walk, the stamp walk, the cast walk, the pattern walk.

It seems unlikely that the way to scrape off the customs of the body is to have everyone move in unison, and it seems equally improbable that a stiff slow walk would emerge if all previous customs were scraped off. So, it is important to see Hijikata's "mold walk" in relation to the experimental stage I have been tracing in which Hijikata was trying out many things in order to explore techniques for creating new possibilities for the body. The movements might be an indication of membership in a group, but given Yoshito's explanation about the dance as a satire of Japanese weight lifters who had complexes about their bodies, the dance may also be making a comment about the trade-offs one makes when acquiring muscles: one may get stronger, but also become less pliable. Hijikata's attitude towards bodybuilding, athleticism, and muscles was to take several turns in the course of his career, so I shall revisit it again.

Seed

The dance *Seed* supposedly depicted the process of a dormant seed gradually sprouting, and stood out for its minimalist tendencies. The cultural critic Tanemura Suehiro saw Hijikata for the first time at this performance, and was most impressed by *Seed* and returned to it several times in the course of writing and thinking about butoh. Each time he described it slightly differently, but from the aggregate of his

descriptions, we can safely assert that Hijikata began the dance curled in a ball in a fetal position atop a small box, and the entire dance took place in the space above the box.[112] If spectators expected the frozen, dormant seed to stretch up into the warm spring sunlight, they were disappointed. Tanemura focused on the way that Hijikata continually frustrated his expectations. Over and over, Tanemura would expect that Hijikata was going to move his arms or legs in a certain way, but he would not move in that way. Tanemura's reaction recalls the "agreeable piquancy" that Mishima felt in having his expectations overturned.

Tanemura also had the impression that Hijikata's body "was cruelly dislocated in every place, chopped, and in the space of a moment was floating in innumerable fragments."[113] This impression of disconnectedness has been echoed by other butoh observers over the years. For example, Takeda Ken-ichi wrote that he watched the hand movements in one of Hijikata's dances and received the impression that "it was not that the hand position forms one element in a symbolic structure of body positions and movements, but that the hands, and even the fingers, and even the separate joints of each finger groped in space as separate entities."[114] It is crucial to connect Tanemura and Takeda's impression of a dislocated fragmented body with the jerky movements resembling popping in *Dark Body* and Hijikata's idea of not bending joints in the way that one is used to bending them as a means to execute simultaneous actions, because each speaks to the same attempt to rethink the limitations of the body.

In looking back over this short period from 1959 to 1960 in Hijikata's dance, I want to highlight once again the tension in Hijikata's dance between two partially opposed vectors. One was nonpurposive impractical dance for dance's sake, and the other was seeing this dance as having a practical purpose. Within the broader category of dance for dance's sake we could subsume experience for experience's sake, tragedy for tragedy's sake, shock for shock's sake, sacrifice for sacrifice's sake, and the list could go on. On the other side was the problem of finding actuality, evading force, and remaking self and society. These two vectors could overlap in certain moments. The act of cutting away lotioned fat in an attempt to remake society was bound to be a shocking and mind-centering experience for both those who cut and those whose fat was cut away. Hijikata's use of dancers to put the tragedies of gay male prostitutes on stage may have helped the audience to a more nearly complete understanding of the actuality of roles gay males play within society, and led the audience to empathize with gay males. Moreover, the shock and pain of these performances was bound to transform the selves of both the performers and the audience.

* * *

While it appeared initially that Hijikata's use of simple mimetic imitation had been enough to achieve his aims, he soon came up against two problems. The medium (dance) he was using turned out to have two inherent difficulties: the language of the body was limited, and the body was more clouded with practicality and conventions than anything else. This forced him to experiment with new techniques; but the very idea of techniques seems at odds with today's image of butoh, which is that it is a dance with no techniques and no rules.

Be that as it may, owing to the ideas he was exposed to in this early era of his dance, Hijikata began a long process of expanding the expressive vocabulary of the body, while stripping it of practicality and conventions. He started by exploring the movements of joints, and then moved on to trying to disconnect each bodily part and give each its own autonomy. He also began to try to utilize the responses of the audience by presenting them with decontextualized violence, embarrassment, and sexuality. The journey was to go through many twists and turns on its way to the butoh of today.

3. A Story of Dances that Sustain Enigma: Simultaneous Display and Sale of the Dancers ⌒

> *Everywhere* it *is machines—real ones, not figurative ones: machines driving other machines, machines being driven by other machines, with all the necessary couplings and connections.*
>
> Deleuze and Guattari

A number of commentators have remarked on the heady atmosphere of the 1960s in Japan. Some speak approvingly of fistfights breaking out between artists who disagreed violently and just as approvingly about their cheerful willingness to bury the hatchet the next day. Hijikata was right smack in the middle of this cultural and political melee, and certainly had the reputation of being an indefatigable partier, drinker, and conversationalist. This image provides a useful counteractive to overly facile notions of Japanese (or Asian) harmony, but it also highlights a deeper characteristic of the times—conflict and competition. I argue that butoh was one attempt to create mind-body techniques to cope with this era. The previous chapter charted a starting point for Hijikata's dances as socially engaged narratives, and then showed how he began experimenting with widening the expressive abilities of the body as well as exploring how to use the reactions of the audience to hold their interest. The aim of the current chapter is to demonstrate the competitive characteristics of the era (as manifested in part by a preoccupation with athletics), and to show how Hijikata and his peers dealt with these competitive conditions by examining Hijikata's encounters with neo-Dada, Happenings, and surrealist artists who were not willing to content themselves with commentary on his dances (as Mishima had), but wanted to participate actively in the creation of performances. Hijikata and his peers did not leave behind the quest for actuality, but the search for ways to access actuality in the Japan of the 1960s was shaped by a new orientation to the properties of objects, and a concern with how to manage proliferating and contradictory information. In keeping with the tenor of the times, the impact of those artists' contributions shapes this era of butoh's development as the most wild and tumultuous era. There was, in the sixties, an anything-goes attitude, an explosive force that continually threatened to break everything apart. That attitude could not help but spill over into the interaction between audience and artist, so the chapter includes an examination of the ways that the artists engaged the audience and brought them into the agonic ambit.

SYNTHESIS AND COMPETITION

In the program for the next recital, "Second 6 Avant-gardists" (Oct. 1960), Hijikata persuaded three of his new friends to contribute essays: Mishima, the surrealist Takiguchi Shûzô, and the French literature specialist and translator of Sade, Shibusawa Tatsuhiko. Each, in his own way, addressed the format of the evening, in which six different artists presented works. Mishima examined a trajectory in which various arts had initially moved toward purity and were in the process of subsequently moving away from purity to what he called "synthesis" (sôgô).[1] He pointed out that the new "synthesis" would not look like the previous interdisciplinary arts that "just rubbed their skin together and became intoxicated" (he identified Wagner as a representative of the prior synthetic arts); rather, he said, it would be the "exchange of ice, the fusion of glaciers" as the art forms, by now thoroughly differentiated and hardened, slowly ground into each other.

As if in reply to Mishima, in his essay Takiguchi focused on the contact between the artists, and rejected the idea that it results in a synthesis.[2] He said, rather, that the various works on the program "remain solitary," but "brush each other, negotiate with each other, and even cooperate with each other," in the context of exploring their own individual developments. In part, Takiguchi's argument stems from the nature of the performance, in which there were six consecutive items on the bill. Thus, the artists were not working together to achieve one unified art form (with one providing the sound, one the lights, one story, one the choreography, and so on); rather, each was presenting his own independent work—each trying to attain what Takiguchi called his own "spontaneous inevitability." However, Takiguchi also suggested an understanding of the interpretive nature of the evening, in which each work would cause both the artist and the viewer to reinterpret all the other works on the bill.[3]

There was a tension inherent in Takiguchi's formula, between the artists who were spontaneously attempting to attain their own inevitability in order to express primal motivations and spontaneous desires, and the somewhat contradictory idea that their arts could rub, negotiate, and cooperate with other arts. The first idea would seem to indicate that the artist himself remains untouched by the other artists, while the second would seem to imply that the artist's work can be shaped and altered by other works.

Takiguchi's argument that the artists necessarily remain solitary while their arts negotiate with each other can perhaps be related to two aspects of his own experiments with surrealism. As a friend of André Breton (one of the founders of surrealism), Takiguchi was likely drawing on Breton's elaboration on Lautréamont's formulation of the "meeting on an operating table of an umbrella and a sewing machine," in which Breton says that a reality "whose naïve purpose seems fixed for once and for all (an umbrella)" will be altered on "finding itself suddenly in the presence of another very distant and no less absurd reality (a sewing machine), in a place where both must feel out of their element (on a operating table)."[4] One could think of the "Second 6 Avant-gardists" as (again in Breton's words) "the coupling of two realities which apparently cannot be coupled on a plane which apparently is not appropriate to them" as a way to find out what kind of negotiations would transpire

between them.⁵ As an informal student of Takiguchi, over the course of his career Hijikata was to continually draw on and experiment with the surrealist technique of juxtaposing realities in order to alter both.

At the same time, Takiguchi's injunction that the artists remain solitary and explore their own inevitability is perhaps related to the long struggles he had with translating the texts and techniques of surrealism into Japanese. Sas notes that Takiguchi was committed to the ideal of pure communication between surrealists and to transcending the "boundaries of national language" and the "traditional genres of literature," but came to recognize the inherent difficulty in achieving that ideal, which was that the surrealist texts and techniques were developed in one place and time, and written in one language (largely in France and in French) and did not transparently translate to another place, time, and language.⁶

Here, Takiguchi reiterates those concerns in referring to arts that "attain a spontaneous inevitability," but it is important to see that from Takiguchi's surrealist perspective, the attainment of a spontaneous inevitability was not an insurmountable stumbling block to collaboration, but rather an expression of the distance separating realities between which an interaction would spark.⁷ Thus, despite the acknowledged difficulty, Takiguchi held out hope that in the process of rubbing, negotiating, and cooperating, the artists could do "better work in the places of communication and presentation that society has already accepted and freely used."⁸

Ironically, the one essay on the program not specifically dealing with synthesis, Shibusawa's "Avant-garde and Scandal," seems the most prescient, given the form that Hijikata's synthetic arts were to take. Shibusawa argues that the world is happy to have its "nose bloodied" or to be "knocked over" by the artist through terrorism or scandal (he says the choice of which word to use is purely a matter of prevailing preference), and that the problem facing the artists is "whether art itself will become history through terrorism."⁹ He goes on to note that scandal imprints itself on the artist's brain more strongly than any other mental phenomenon, and that it is thus through scandal that artists come to know themselves ("writers recognize themselves through scandal"). For Shibusawa, history and the human psyche are similarly structured. Both can be marked by shocking or scandalous events.¹⁰ Therefore, artists also imprint themselves into history through scandal, because, according to Shibusawa, something only becomes part of history if it stuns the system.

In a manner similar to Amagasaki's theorization of experience (in which the artist should have an experience while creating a work of art while the audience should have an experience while consuming the work), for Shibusawa a scandalous performance can take on two valences: the artist can have an identity-forming moment in the process of the performance, and at the same time provide the audience with its own identity-forming opportunity. There is a tension in Shibusawa's formula between shock as something that overwhelms identity, and shock as something to process and transform into a part of identity. Similarly, for Shibusawa, scandal can write itself into history, the psyche of a (fellow) artist, or a member of the audience, but this depends on the (fellow) artist or the audience not being completely overcome by the shock, but rather being able to process the shock into a new identity.

Notwithstanding differences in the respective attitudes of these essayists toward synthesis and collaboration, in the context of the difference between the earliest

works (such as *Forbidden Colors*—in which the set design was intended to complement the narrative) and what was to come (in which the spontaneous interaction of the costumes and set design with the dancer and the audience was one of the foci of the work), these essays on collaboration nicely describe the agonistic nature of artistic creation as Hijikata's avant-garde dance style developed. The effort to increase the expressive ability of the body was turned into an intense competition between artists to imprint themselves through scandal onto each other and onto the world at large.

THE SECOND HIJIKATA TATSUMI DANCE EXPERIENCE GATHERING

Hijikata did not need any help from Shibusawa to be interested in scandal, but, as if to answer Shibusawa's emphasis on the way that certain experiences write themselves into the psyche, Hijikata's next dance marked new ground in his experiments with personally undergoing psyche-marking (or identity-forming) pain on stage. This was the second "Hijikata Tatsumi DANCE EXPERIENCE Gathering" in September 1961. The "Catalogue of Experiences" included a dance called *Mid-afternoon Secret Ceremony of a Hermaphrodite: Three Chapters*.

The artist Yoshimura Masunobu had seen one of Hijikata's dances and promptly decided to invite Hijikata and his dancers to a neo-Dada party. Hijikata subsequently asked Yoshimura to provide the costumes for the show, and through his costume design, Yoshimura wrote himself into the history of butoh. In *Mid-afternoon Secret Ceremony of a Hermaphrodite*, Yoshimura wrapped Hijikata's entire body in gauze and plaster of Paris (making him look like a mummy) to create a thin whole-body cast that he envisioned would be a "reverse intervention" on the choreography.[11] During the dance, the plaster around Hijikata's joints broke off and scattered around the stage, and the gauze came undone and flapped wildly. When Hijikata came back to the dressing room after the dance, he complained that he was cold (because the plaster of Paris had sucked the heat out of his body) and that the thin cast caused his muscles to twitch, but he clearly came to value the discomfort of that "reverse intervention" because the plaster was to show up in his dances again, and he began to experiment in many different ways with making the dancer uncomfortable.[12]

The personal discomfort that the plaster body-cast provided was extremely important to Hijikata. He was equally delighted by the "reverse intervention" that Yoshimura's costume had provided, because, in practice, he began to create performances through what we might term a combination of Takiguchi's surrealism of artists rubbing against each other and Shibusawa's psyche- and history-marking scandals.

Of course, a precursor had been Mizutani's movable set in *Disposal Place*, which had dictated the choreography to a certain extent, but here a performance was to be a kind of collaboration and contest, a chance for various artists to write themselves onto the arts and psyches of each other. In the process, they could create a scandal that would write itself onto the audience and into world history. In practice this meant that not only would they try to outdo each other in a performance, but that they felt free to exact from the audience a toll that went far beyond the price of admission to the performance.

THREE PHASES OF LEDA

In June of 1962, Hijikata and Motofuji presented *Three Phases of Leda*, which marked the first step in the development of performance as a contest between artists and between artists and audiences. Two different essayists focused on the process of gaining admission to the show. It is almost as if they felt that the performance started long before the dance began. Consider the following from Haniya Yutaka:

> As we left the de Sade trial courtroom and were walking thru Hibiya Park, we received a strange flier. It is not surprising that something like this should happen in some secret basement—as this is the country where people want to read Sade even if they are put on trial for it—but I will reproduce the mutinous and evasive contents of the flier, since if no one else does, there is a chance it will be lost forever.
>
> The Inauguration of the Leda Association Secret Performance No. 1
>
> Three Phases of Leda/Bloody Leda/Holy Womb/Empty Egg/ Seed—Yagawa Sumiko
> Form—Motofuji Akiko
> Decorations—Nonaka Yuri
> Moment—Western Calendar Common Era 1962 June 10th evening seventh hour zero minute
> Hall—ASBESTOS HALL
> Lighting—Mr. Tungsten Hughes
> Roar—the Late Wolf
> Sound sculpture—things
> Shadows—Mitsukuchi Tateo[13]
> Scent—Association of Bromine on the Surface of Oil
> Doers—Hijikata Tatsumi Dance of Darkness Faction
> Support—Kirin Beer Seat Price Extremely Cheap[14]

Note that although no copy of this 'flier remains (therefore we do not have any idea what images might have been in the 'flier), we can still tell a lot about what was going on. There will be a performance, which will be the first one in a series. The location is Asbestos Hall. The time is June 10, 1962 at seven in the evening. The lighting is to be supplied by tungsten light bulbs, but the attentive reader will note the play on the name of African-American author Langston Hughes. Then follows a list of rather opaque designations: seed, form, roar, sound sculpture, shadows, and scent. Perhaps "seed" indicates that the original idea comes from Yagawa Sumiko, and "form" means that either direction or some part of the choreography is by Motofuji. Surely "sound sculpture" must correspond to "sound," and "shadows" might refer to "lighting" in the more traditional sense—the person who decides which tungsten bulbs to shine where and at what strength. "Doers" indicates which dance group is putting on the performance. Normally "support" seems like it should refer to underwriters, but perhaps, since this was an obscure performance (and thus not likely to be underwritten by a corporation), it indicates which intoxicant allowed them to stage such a performance. Finally, the poster offers the information that the price of admission is very small. With that in mind, let us return to Haniya's account of the day.

On the appointed day, when—after searching in the rain—I and my editor Mr. T finally arrived at the site, protruding from the door was a single bluish-white arm, which looked like the arm in the dark corridor holding the candle in *Beauty and the Beast*. Above the arm it said, 500 Franks. After a few minutes of incomprehension, we finally realized that if we did not put 500 yen in the out-stretched arm, the door would not be opened. After handing over the price of admission, we entered into a dance studio and received a small bottle of beer and a paper cup. Unexpectedly, every corner of the hot and stuffy room was filled with spectators.

Similarly, Akasegawa Genpei recalled, "It was already evening, so Asbestos Hall was dark.... We were thinking about getting in for free, so we circled the place, but it was completely sealed, so we finally plunked down real money and went inside."[15] One can discern a certain relation between the experience of receiving a mysterious flyer in the park, and passing the test to gain entrance into the hermetically sealed performance. Both activities demand provisional decoding. This is in keeping with the attitude that the artists felt toward the spectators. If artists saw a performance as a chance to write themselves into the psyches of fellow artists, they also saw that same performance as an opportunity to write themselves into the psyches of spectators. Shibusawa supplied one way of doing that—putting something scandalous on stage. However, there were other ways as well, and one of them was to make demands of the audience. The first "scandal" of this performance was that the audience had to work just to attend the show.

There was, however, some leeway for the audience (although Akasegawa's experience shows that the leeway did not extend to the price of admission). Presumably, if one throws up one's hands in front of the "500 Franks" sign, then one is not admitted. If one sees that "Franks" equals "francs," and that "francs," in turn, must be a code for "yen," then one can proffer the required fee to the bluish-white arm to gain admission. Otherwise, one will have to head back out into the rain. However, spectators are not required to be right about everything. If one misconstrues "roar" or "sound sculptures," one can still go to the show. One is only required to attempt interpretations, act on them, and see what happens, and one can revise one's interpretations based upon subsequent evidence. Later performances will demand similar strategies.

Having made it this far, the spectator would have entered a dimly lit hall decorated with old rusty bicycles and wire objects hanging from the ceiling.[16] There, men dressed only in jock straps with newspapers wrapped around their heads and rancid boar's tusks strapped to their ears performed what Haniya termed "acute movements" to the discordant sounds of a trumpet and saxophone (and possibly other contrived wind and percussion instruments) (see figure 3.1). These were satyrs.[17] A man (Hijikata) wearing a thick, padded kimono kept time for them by beating on a tangerine box and yelled out instructions like a ringmaster. Sometimes the music emanated from the bathroom off of the hall, and sometimes the musicians came out into the hall and joined the dancers. A woman (Motofuji, playing the role of Leda) entered the area stark naked with one of her legs painted pink and the other painted white. Interspersed among attitudes, arabesques, and plies, she twisted, contorted, and hunched her body in various ways. At some point, the bicolored woman fled to a tall locker, climbed in, and curled up in a ball there. The ringmaster fetched her out and after putting a marble in her buttocks sent her back out to dance without

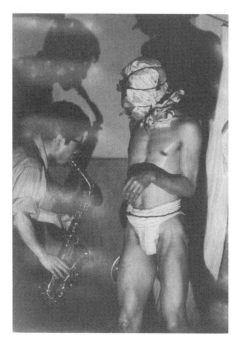

Figure 3.1 Three Phases of Leda, (Asbestos Hall, Tokyo, June 1962) by Tanno Akira. Courtesy of Tanno Akira.

allowing the marble to fall out. At another point in the show, the satyrs left the hall en masse and after making a complete circuit of the building came back inside.

Haniya wrote that the dance was characterized by a continual thwarting of expectations as the movement "stopped without going to the place where we expected it to go in the next instant." The music was at odds with the movements as well. In contrast, the sounds of *Forbidden Colors* had all advanced the narrative—the taped heavy breathing had helped the audience understand what was happening in the near dark; and the harmonica music that accompanied the return to the stage to retrieve the chicken had contributed to the sense of relief that the ordeal for the boy was over, and to the atmosphere of regret over the death of the chicken. Haniya described the music here as discordant and the men's movements as "acute," so one might have expected that the music and movements would match, but instead he had the impression that the music was designed to "generate a disconnect between our sense of sight and hearing."

Mishima had written of the agreeably piquant feeling of having his expectations thwarted by the movements of Hijikata's avant-garde dance, but Haniya's "disconnect" between two senses is stronger. It is almost as if Haniya felt assaulted by the music. It is also possible, however, to see this dissonance in terms of psyche-marking events or the surrealism of juxtaposing distant realities (rancid boar's tusks, and bicycles, and arabesques). This dance went beyond countering the expectations of the spectators. After having caused the spectators to expend so much energy in order to arrive at the performance, Hijikata and Motofuji volleyed a barrage of visually, aurally, and rhinally dissonant stimuli at them that would render the show unforgettable.

BANQUET TO COMMEMORATE LOSING THE WAR

Merely marking the psyche turned out not to be sufficient for one of the artists of this era. Later that summer in August, Hijikata participated in the "Banquet to Commemorate Losing the War" in which the Dada performance artist Kazakura Shô asked Hijikata to assist him in a piece in which Kazakura was planning to brand his own chest. Kazakura says that he was still preventing himself from wholeheartedly letting go of previous concepts of art when he saw *Three Phases of Leda*. At that time, he came up with the idea of objet-ifying (*obuje-ka*) his own body and decided to put it into practice at the banquet.[18] The "banquet" consisted of the artists eating while the spectators watched.

After dining, Kazakura began falling off a chair repeatedly while Hijikata slept on the table. Yoshimura Masunobu brushed his teeth over and over again until his gums bled, while Masuda Kinpei wrapped his body in a vinyl tube and then inserted one end in his anus and the other end in his mouth and breathed in and out.[19] Then Yoshino Tatsu'umi began clearing the table. Hijikata got up and went to the kitchen where Akasegawa Genpei had heated the brand (it appears to have been an old hook used to draw a bucket from an abandoned well). When he returned with the brand, Kazakura grabbed it and plunged it into his chest. White smoke and the smell of burning flesh filled the hall. Kazakura appears to have fainted, or else at least been only partially conscious (he says he could hear cicadas chirping), as he remembers only applying the brand one time, but Ichikawa Miyabi reports that Hijikata then wrangled the brand from Kazakura and reapplied it to Kazakura's chest.

Certainly, one could say that in this performance the choreographer, the performers, and the audience all had scandalous psyche-marking experiences. It is as if Kazakura and Hijikata were channeling the observation by Levinas: "Physical suffering in all its details entails the impossibility of detaching oneself from the instant of existence," and thus recognized that one route to these experiences was pain.[20] In Kazakura's case, his own flesh must have split, rippled, and seared—leaving a lifelong testament to the fact that he had finally let go of previous concepts of art. The audience then would have had actual charred molecules of Kazakura's chest and hair stinging their eyes, and assailing their nostrils—certainly a memorable and centering experience, a scandal that would have written Kazakura into the psyches of the audience.

On the face of it, there is a problem with Kazakura's objet-ification. It would seem to be at cross-purposes with experience. At least in the world of dance as articulated by Amagasaki, the focus on experience should have elevated the performer and the audience. It should have rendered them both co-creators and co-experiencers with the artist. The dance critic Ichikawa Miyabi explored this contradiction in what he called the "superimposition of the subject and the medium."[21] However, roughly contemporaneous with the trend that Amagasaki identifies, that of moving away from expression-centered art and dance because of its tendency to objectify the medium, there arose in Japan the *objet* movement—a phenomenological movement to explore the properties of things, and in this particular case the properties of bodies, which can be seen as an extension of the drive to access actuality.[22] Japanese neo-Dadaism in the early 1960s, in which found objects and trash jumped into the art gallery and onto the museum wall, partook of this movement's ethos. Artists were exploring the

properties of objects during the neo-Dada period, and this can be seen as a continuation of the focus on actuality already seen in the writings of Hijikata and Mishima.

The performance of Kazakura and Hijikata in "Banquet to Commemorate Losing the War" shows that pain can indeed pull together the centering quality of experience, the psyche-marking quality of the performances, and the *objet* orientation as well. It does this by demonstrating to people their own physical properties. Flesh splits and sears. Muscles give, weight sags. Noses wrinkle in disgust. Throats gag. These reactions by the audience to the stimuli of the performance satisfy the demands of phenomenology. In the process, the audience engages with the pain of the demonstration—which absorbs them, or preoccupies them. This in turn satisfies one of the demands of experience (while of course leaving other demands unmet), and in this way experience and the phenomenological search for actuality come together. In a different essay, Ichikawa observed that "an illness is a favor because it allows you to know your own body."[23] He captured the same idea that motivated Kazakura, Hijikata, and their fellow artists: that becoming an *objet* could lead one to know more about actuality, including the actuality of one's self, all the while enabling the artist to have or provide a psyche-marking experience.

MASSEUR

The next show was the November 1963 groundbreaking *Masseur: A Story of a Theater that Sustains Passion*, presented at the third "Hijikata Tatsumi DANCE EXPERIENCE Gathering." The film artist Iimura Takahiko preserved a roughly 20-minute film of *Masseur*,[24] and there are also several descriptions of parts of the dance.[25] This show represented a continuation of the focus on *objet* and psyche-marking experiences, but broke new ground in dealing explicitly with the competition inherent in athletic pursuits.

Perhaps, as a reworking of Mizutani's set for *Disposal Place* in which Ôno and the audience came face-to-face with their newspaper alter egos, the stage for *Masseur* was in the middle of the audience. The set designers transferred approximately ten rows of seats from the front of the auditorium onto the stage, and laid tatami mats in their place so the dancers would be in the middle of the viewers. When the spectators entered the hall, they had to navigate a maze of objects and pass under a "sound arch" in order to get to their seats, where they were joined by a special spectator.[26] In exchange for Hijikata's assistance at the "Banquet to Commemorate Losing the War," the performance artist Kazakura Shô had agreed to participate in *Masseur*.[27] He selected a spot about 15 feet off the ground on an acoustic panel at the side of the stage. Wrapped in newspapers from head to foot, he watched the entire show and the audience from that vantage point (see figure 3.2).

The dance began when the set designers (Akasegawa Genpei and Nakanishi Natsuyuki of the Hi Red Center group) and other stagehands physically carried the dancers to the stage.[28] The dancers were wearing white undergarments stippled with pink and green dots. The pink and green dots were in response to Hijikata's request to Motofuji to create "gonorrheal costumes." She imagined a person infected with gonorrhea taking a therapeutic bath in the light green waters of the Karatsu hot springs and came up with the idea of the white undergarment for a kimono stained

68 *Hijikata Tatsumi and Butoh*

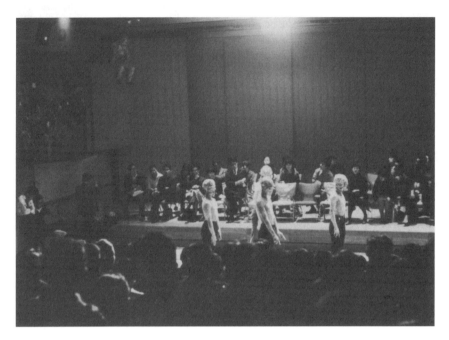

Figure 3.2 Kazakura Shô watching the action and the dancers walking blindfolded, *Masseur: A Story of a Theater that Sustains Passion*, (Sôgetsu Hall, Tokyo, Nov. 1963) by Yamano Kazuko. Courtesy of the Morishita Takashi Butoh Materials, NPO, and the Research Center for the Arts and Arts Administration, Keio University.

with green spots representing the water of the hot springs and red spots representing suppurating sores.[29]

The dancers sat in a row of chairs by the stage area and read newspapers. One by one, and for no apparent reason, they would get up to do various things.[30] The assorted movements can be divided in two categories: bizarre and random vignettes, and athletic movements. The first category included wrapping up saluting soldiers and carrying them off the stage; dancers eating cake, riding bicycles on tatami mats, banging on plates; affixing clothespins to the hair, nostrils or skin of the dancers; a character with a Dali mustache; a person who looks like he is dowsing; suspending testicle-like bags of purple (or blue) fluid between the legs of the dancers that Hijikata would occasionally grab or rest on the back of his hand; and elderly *shamisen* players singing bawdy folk songs.[31]

The overtly athletic actions included wind-sprints from one side of the stage to the other; miming throwing an imaginary baseball back and forth or over a long distance as if to throw from one side of the universe to the other; deep breathing and stretching exercises (especially for the neck but also for other parts of the body); wrestling moves; a dancer standing on his head; another doing a cartwheel; and three people spinning like a helicopter (see figures 3.3 and 3.4).[32] This last action, a pinnacle of athleticism and the tour de force of *Masseur*, was a partnered spinning move called the "Propeller" performed by three dancers. Dancer A sat on the shoulders of dancer B (probably Hijikata). Then dancer C (facing outward) grabbed A's ankles underneath

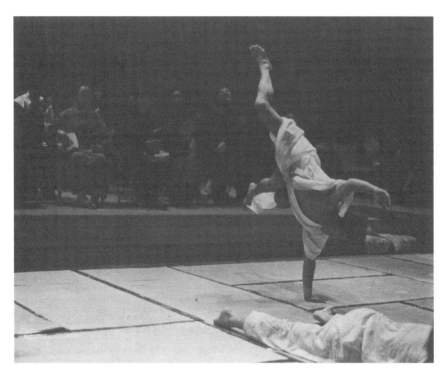

Figure 3.3 Dancer doing cartwheel in front of shamisen players, *Masseur*, by Tanno Akira. Courtesy of Tanno Akira.

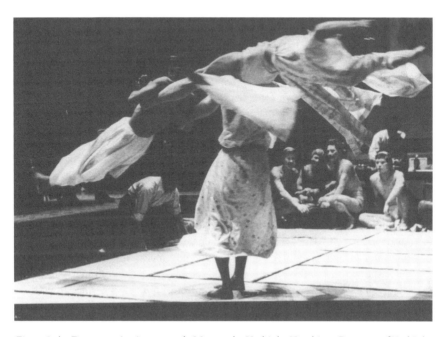

Figure 3.4 Dancers spinning around, *Masseur*, by Yoshioka Yasuhiro. Courtesy of Yoshioka Kumiko and the Morishita Takashi Butoh Materials, NPO, and the Research Center for the Arts and Arts Administration, Keio University.

his armpits, at which point A leaned back and B began to spin. Centrifugal force lifted C into the air, and the counterbalance of C's weight allowed A to lean all the way back with his arms outstretched. After approximately seven spins, the three let go of each other without slowing down and tumbled over the stage.

Neo-Dadaism

One can comment on these activities from two perspectives: the relationship to other art forms such as neo-Dadaism, and athleticism. At least three of the people involved in this performance were associated with neo-Dadaism: Kazakura Shô, Akasegawa Gempei, and Nakanishi Natsuyuki. One of the first neo-Dada activities in Japan, sponsored by the Neo-Dada Organizers, had featured Kazakura plunging his head into a bucket of water and making bubbling sounds, and other people smashing beer bottles and karate chopping chairs while Akasegawa read the group's manifesto. Later, the group Hi Red Center (which included Akasegawa and Nakanishi), cleaned the Ginza streets with cotton swabs and toothbrushes and threw clothing and other junk from the top of a building.[33] These groups were interested in the immediacy of the athletic body, the potential of random processes, introducing art into various nonmuseum localities, and also in examining the properties of various found objects.

The connection to neo-Dadaism can also shed light on some of the similarities of early Japanese avant-garde dance and the Judson Dance Theater. The artists who were involved in the Judson Church performances were drawing from a similar wellspring of exploration including Happenings (events considered as art), Dadaism, Fluxus, but also drawing from the work of John Cage, Merce Cunningham, and Robert Dunn.[34] The artists who contributed to Judson Dance Theater and the works they presented were quite diverse and span what Sally Banes terms the "analytic, reductive wing" (which initially left the biggest mark on American modern dance), the "theatrical, often humorous baroque" wing, and "multimedia work." Within this diversity, Banes located two specific themes. One was "methods that seemed to stand for freedom" from or leveling of hierarchies, including deriving movements from heretofore unused sources, the use of improvisation, chance procedures, and everyday movements. The other was "a refined consciousness of the process of choreographic choice," according to which "questions of technique and its perfection, were considered less important than formal compositional problems."[35]

Clearly, at a similar point in history, Japanese avant-garde dancers struggled with similar issues as the members of the Judson circle. But there are crucial differences between the two groups of artists. Both were doing stuff that one might term weird or zany Happenings (Banes's "theatrical, often humorous baroque" wing) and also incorporating collage, assemblage, and everyday movements into their choreography. Japanese avant-garde dancers wore jock straps and boar's tusks, read newspapers, ate cake, rode bicycles, banged on plates, stood on heads, mimed throwing, and affixed clothespins to their noses. The Judson Dance Theater counterparts drank water, ate pears, stood on heads and pulled hair out, hoisted themselves into an elbow stand and fell over, and mimed swimming, planting a flower and shaking hands.[36] In both, dancers experimented with extremely slow dances confined to small spaces.[37] Both also repudiated technique, and a quest for perfection. Finally, implicit in the leveling

of hierarchies in both neo-Dada and Cunningham/Cage, both used the stage space in decentered ways, and flattened the flow of time to avoid building tension, reaching a climax, and then resolving the tension.

Not present in Hijikata's works was the attention to the formal properties of choreographic choice and the obsession with chance processes in the act of choreography itself. One huge component of the Judson Dance Theater was the use of various procedures to randomize output and replace narrative. These included choosing a set of movements, but letting the dancers dictate the order and speed at which to progress through the movements; basing all movements on a Dadaist cut-up of photographs from a newspaper; choosing a base set of movements, but then choreographing all aspects of a dance by lottery or coin toss including order, speed, quality, direction, and vertical and horizontal location (the choice could be made beforehand or during performance), giving each dancer separate sets of specific instructions and then letting them interact with each other on the basis of those instructions. To be sure, there were some unchoreographed elements in *Leda* and *Masseur*. The location of each step of the wind-sprints in *Masseur* or the run around the building in *Leda* cannot have been planned, and the dancers tumbled out of the helicopter haphazardly. The use of combinations (jock straps and boar's tusks) introduced unexpected novel sensations into the dance, but Hijikata and his cohorts did not have a background of taking classes from Cage, Cunningham, or Robert Dunn and thus were not questioning the hierarchical role of the choreographer beyond the implicit down-grading of the role of the choreographer in putting a competition between artists on stage.

The neo-Dada and Happenings artists also participated in the general antisocietal bent of the age, which perhaps explains what motivated Hijikata and his cohort to deface the mats. Tatami mats are approximately two inches thick and covered with reeds. It is customary in Japan to avoid walking on them while wearing shoes, because both the relatively hard soles of the shoes and the minute grinding action of any dirt tracked in with the shoes quickly wears away the covering on the mats. After a few centuries of this exceptional treatment, tatami mats have taken on an inviolable character. Many Japanese people would sooner step on a nail than step on a tatami mat wearing shoes. In this performance, all the dancers appear to have been barefoot (but not the stagehands carrying them on and off stage). However, running, playing ball, and bicycling on the tatami mats were sure to have caused almost as queasy a feeling in the members of the audience as if the dancers had trod the Eucharist underfoot in countries where Christianity has a strong presence.

The dancers approached the Japanese custom of bowing with equal irreverence. In one scene, a man bows and then another who is standing much too close for comfort bows and rests his stomach on the back of the first bower. There is something both comical and troubling about this send-up of the standard greeting. The act of bowing becomes both more officious (and hence downright amusing) and more ominous, since the initial person who bowed now carries the weight of the other person. In another scene, a man bows and then keeps going down until his head rests on the floor. Then he pops his legs off the floor and rises up into a headstand. This bow is also humorous, but at the same time it plays with the expectations of the audience by encoding one action with two valances. What the audience thought was a bow (an

action showing respect) turns out to have been the initial part of a gymnastic exercise, or maybe it genuinely was a bow, but then changed halfway through.

Athleticism and Conflict

The doubled nature of the bow-transformed-into-a-headstand returns us nicely to the nexus between neo-Dadaism and athleticism, and demonstrates that the interest in athletics goes beyond neo-Dadaism. Michael Raine paints a picture of the broader background for this interest in his examination of the sun tribe (*taiyôzoku*) films that started in 1956. These films featured prominently such athletic activities as waterskiing and boxing.[38] He notes that sumo and other sports gained popularity during this era. Additionally, the 1964 Tokyo Olympics were still a year away, but constantly in the minds of everyone owing to the widespread construction projects undertaken to prepare the city for the games.[39]

Raine observes that the emphasis on sports was not just related to international cooperation, but that "violence" and "struggle" were "key terms in the discourse of economic development in Japan" as the economy picked up steam after the economic infusion from serving as the United States supplier for the Korean War and entered into the high growth period. Ann Sharif corroborates this understanding with her observation that the appeal of athleticism at the time lay in its relationship to violence and speed.[40] The speed of athletic pursuits (such as waterskiing) was connected to the speed of technology, while the violence of athletics (such as boxing) was connected to the "opportunity for individual triumph" in an increasingly competitive world. Similarly, Andrew Gordon writes of the "intense domestic competition in the boom of the late 1950's" and the anxiety produced by "the specter of international competition" in the early sixties.[41] These commentators share a view of Japan in the 1960s as a violent and competitive place.

Conflict and violence were not merely metaphorical. Labor historians Moriguchi and Ôno say that "the most violent labor disputes in Japanese history took place between 1949 and 1954," including the famous 113-day strike at the Mitsui Miike Mine in 1953, and these disputes were followed by labor strikes for the remainder of the decade that dovetailed with violent demonstrations and protests over the renewal of the mutual security treaty from 1958 to 1960.[42] Of course, during World War II, deprivation, fire bombing, and reports from the front would have been a daily experience, and millions of Japanese soldiers had experienced combat. However, the main islands of Japan (not counting Okinawa) remained untouched by face-to-face fighting. Dissent during the war was all but nonexistent, as it had been stamped out by the authoritarian regime. But during the postwar period, violent conflict raged among the Japanese people. Violence and conflict were not merely economic metaphors in postwar Japan, but a new reality.

More specifically and closer to Hijikata, Mishima was also interested in athletics, and he participated in bodybuilding, boxing, and kendo (sword fighting with wooden swords).[43] He turned to these activities midway through his career to improve his physical health but also in a narcissistic attempt to refashion himself as not merely a man of letters, but also as a man of the body.

The perspective of Mishima and the societal background of athletics can help bring together our understanding of reciprocal psyche-marking scandals and Kazakura's

objet-ification as that which teaches you who you are. In his essay, "Sun and Steel," Mishima refers to that which "lurk[s] beyond the flash of the fist and the blow of the fencing sword"—the opponent.[44] For Mishima, the encounter with an opponent in sports is an encounter with an extraverbal actuality, which has its own properties. Because the opponent is an actuality that is beyond us, and can even visit the flash of a fist on us, an encounter with the opponent becomes an encounter with the actuality of oneself and one's own abilities. One learns whether or not one can parry the fist, and if one cannot parry the fist, one learns the body's response to that fist—pain.[45]

The grand spinning move mentioned above combines the athleticism of the wind sprints with the attitude found in both Mishima's flash of the fist and Kazakura's branding—crisis or pain, which imprints itself on the psyche. In the same way that Kazakura's branding demonstrated his properties, implicit in Mishima's remarks about the flash of the fist is the pain when that fist finds its target. As the dancers tumbled out of the spin they risked getting hurt, but that risk, or the hurt, would be another way for them to have a psyche-marking, self-awareness-inducing experience. A different part of the dance included some of the men wearing clothespins attached to their nostrils or skin. This was Nakanishi's idea. He had already worn clothespins to a neo-Dada mixer in May of that year, and created a large multipanel exhibition covered with clothespins entitled *Clothespins Assert Churning Action* for the "15th Yomiuri Independent Exhibition" in 1963.[46] Clothespins pinching the skin and nostrils likely gave the performers a similar "experience" of pain. For Mishima, Kazakura, Hijikata, and many others of that generation, it was not just that struggle and competition marked the postwar era as Japan's economy boomed, but that competition provided a means of accessing actuality and by extension taught people about themselves.

Athletics provided one more benefit for Mishima that is implicit in butoh: self-fashioning. It was not enough for Mishima to find out about himself and the extraverbal reality outside himself. He was committed to the idea of refashioning himself, in part to be able to respond to that reality outside himself (he eventually started his own private army after all), and in part for purely narcissistic reasons. Vera Mackie comments on the way that Mishima physically crafted his body as a way to assume different personas ranging across European high culture, American pop culture, and Japanese high- and working-class culture: He was, at various times, a novelist, playwright, public intellectual, ascetic, shrine carrier, boxer, bodybuilder, gangster, samurai warrior, soldier, aesthete, devoted husband and father, and campy gay man.[47] In sum, Mishima was a self-fashioner and shape shifter who was at home in many worlds and could communicate with many different people. Hijikata was already looking for ways to increase the physical vocabulary of the body, and as he progressed, he was to take more and more seriously the idea of self-fashioning, communicating with different types of people, and being instantly at home in many worlds.

* * *

One might think that the body would become less useful and less important as the Japanese economy reindustrialized after the war and tasks originally done by humans were increasingly done by machines, but during the development of Hijikata's dance, the wider society passed through an era in which the strengthening

and shaping of the body were thought to be absolutely necessary for success in the wider (economic) struggle.[48] David Harvey writes of the return of sweatshops and "domestic, familial and paternalistic labour systems," and these were by no means limited to Europe and America, but were also a feature of the Japanese economy.[49] For example, large Japanese manufacturing corporations often employed (and still employ) a concentric circle of subcontractors, and secondary and tertiary subcontractors. The outermost two rings of the system are rural part-time farmers also working part-time in manufacturing, and housewives working at home doing manual labor such as working machine presses, piecework in textiles, and assembling electronic appliances.[50] These woman are poorly paid and the first to be fired in economic downturns.[51] For these workers, and the economic system based on them, the body still mattered tremendously during the 1960s and 1970s.

It is signal that a few years later (1968), in the essay "Asian Sky and Butoh Experience," Hijikata wrote, "In the year when I was born, Zhang Zuolin was killed by a bomb, and Hitomi Kinue ran."[52] Zhang Zuolin (Chang Tso Lin, 1875–1928) was a warlord, caught up in machinations between the various warlords in China, Mongolia, and Manchuria, who was assassinated by a member the Japanese Guandong Army, which was protecting Japanese economic interests in Manchuria.[53] Hitomi Kinue was a track and field athlete and world record holder in the 100 meter and 200 meter sprints, and the long jump. She was the first Japanese female to win an Olympic medal (a silver medal in the 800 meters at the 1928 Amsterdam Olympics).[54] Tellingly, when he chose which elements of his birth year to retroactively emphasize, Hijikata focused on an athlete who had performed well in international competition, and a moment in geopolitical history when "the sky over Asia was clouding ominously" as Japan joined the ranks of imperialist countries jockeying for influence in China and Japanese militarists blew up the train car of a warlord who threatened their interests in northern China. The competition and sense of crisis that marked the late fifties and sixties and was manifest in a concern with the athletic body that could compete effectively within this milieu eventually found its way into Hijikata's dance and his quasi-biographical essays as well.

The competition inherent in artists attempting to write themselves onto each other's psyches, and the freewheeling environment of neo-Dada and Happenings contributed to an attitude of one-upmanship. This soon lead to an even more circus-like atmosphere than of the "Hijikata Tatsumi DANCE EXPERIENCE Gathering," (which had consisted of several short dances all on the same program), as artists increasingly explored ways to assault the audience or make an impression on their fellow artists. *Masseur* was, by turns, humorous, athletic, dangerous, irreverent, sarcastic, and subtle. Hijikata's next dance would continue those themes and add to them.

ROSE-COLORED DANCE

Hijikata returned to the stage with *Rose-colored Dance: To M. Shibusawa's House* in November, 1965. *Rose-colored Dance* pointed ahead to Hijikata's later structurally layered dances, but was also looked back to *Masseur* in its varied, almost circus-like emphases. The competition between the audience and the choreographer, in which the audience was forced to decode the elements of the dance, was given an even

greater priority while the philosophical commentary and societal critique continued unabated. This agon between the artists themselves and between the artists and the audience was sharpened as the artists begin to deal even more specifically with watching and being watched.

The Invitation

Given the reproducibility of visual sources—and thus their easy accessibility over time and space—the invitations and posters for this dance have been more widely seen than the dance for which they were created and are perhaps more famous. Hijikata consciously chose to use these visual elements to set the stage of the dance. As they were the first visual representations that many people saw relating to the dance, they would also have been the first clues as to what to think about the dance.

The artist who was eventually to design many of the sets and costumes for the show, Nakanishi Natsuyuki, recalled meeting with Hijikata half a year prior to the show to begin discussing such things as the design of the tickets.[55] He thought it was strange that they should already be planning what the tickets would look like when the choreography was not even completed, but Hijikata told him that the audience would see the tickets and posters before it saw the dance, so the dance began long before the spectator took their seats and the action began.[56]

The invitations were pink with green writing and folded in half (see figure 3.5). The left side was a reproduction of the poster (see figure 3.6) and the information from the poster. A piece of gold leaf was attached with wax between both sides of the folded invitation so that when the recipient opened the invitation, the gold leaf would shatter. Because the foil would break in a different way every time, every invitation was unique. In line with the 650 EXPERIENCE Society's assumption that if there were 650 seats in the auditorium, then there would be 650 different experiences in

Figure 3.5 Invitation, *Rose-colored Dance: To M. Shibusawa's House*, (Sennichidani Public Hall, Tokyo, Nov. 1965) by Nakanishi Natsuyuki. Photo courtesy of the Hijikata Tatsumi Memorial Archive, and the Research Center for the Arts and Arts Administration, Keio University.

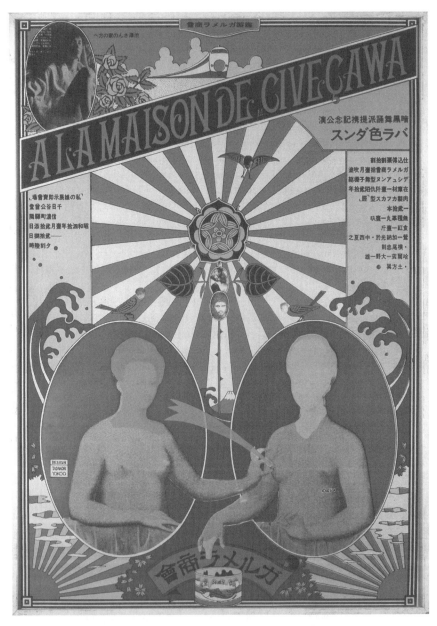

Figure 3.6 Poster, *Rose-colored Dance*, by Yokoo Tadanori. Photo courtesy of the Hijikata Tatsumi Memorial Archive, and the Research Center for the Arts and Arts Administration, Keio University.

the performance, the mechanics of the invitations ensured that the number of unique invitations for *Rose-colored Dance* would equal the number of invitations printed, and thus guarantee that as each person opened their invitation they would be privy to a similar but exclusive occurrence.

If someone found out about the dance from Yokoo Tadanori's poster instead, this is what they would have seen: a rose crest on a cross-shaped stem replaces the rising sun on a Japanese naval flag (see figure 3.6). The stem of the rose is adorned with round photographs of Hijikata and Ôno, and below the rose are two ovals in which Yokoo placed reproductions of the figures from the painting *Presumed Portrait of Gabrielle d'Estrée and her Sister the Duchess of Villars* of the Fontainebleau school. In the original painting, the Duchess of Villars has her hand on the nipple of Gabrielle d'Estrée as a sign of fertility.[57] Yokoo has sent a jet of green milk spurting from Gabrielle's nipple and this transforms Villars' touch into a sensual squeeze that appears to have covered Villars' own face and neck with green milk. Gabrielle's face and neck are also covered, but with pink paint she seems to have smeared over herself out of a tin of Akebono brand salmon (in an homage to Warhol's *Campbell's Soup Cans*). The subtitle *A LA MAISON DE M. CIVEÇAWA*, written on a bend sinister, dwarfs the main title *Rose-colored Dance*, which is printed backward in black on a pink background in the upper right-hand corner. In the upper left-hand corner, a bullet train seems to emanate from behind a rose bush bearing a photograph of Shibusawa. The information about the dance sandwiches the naval flag between two yellow columns. Other smaller elements include waves lapping up over the ovals, birds with human faces, an image of Mt. Fuji, and a scroll at the bottom and box at the top advertising "Garmela Mercantile."

Beyond deciding the title and subtitle and composing the information about the performance, Hijikata apparently specified only that the poster should contain a reference to either the Taisho emperor or Taisho era (1912–1926), and that it include the school of Fontainebleau painting of Gabrielle d'Estree, which was originally a suggestion of Nakanishi, who had used this painting in some color-complementarity experiments. However, recall that Motofuji had dyed pink and green spots on undergarments for the costumes in *Masseur* as a sign of gonorrhea, so it is likely that Hijikata encouraged this combination of colors as an indication that Villars and Gabrielle d'Estree (and as we shall see, the emperor and empress) had contracted a venereal disease.

It is not clear why Hijikata wanted to allude to the Taisho emperor or era. The standard explanation applied to other areas of the Hijikata oeuvre—that he wanted to explore his childhood memories—will not work here, as Hijikata was born and raised in the Showa era. Richie reads *Rose-colored Dance* as a paean to the freewheeling nature of the Taisho era, which was characterized by both a flowering of democracy and by *ero-guro nansensu* (erotic-grotesque nonsense).[58] The Taisho emperor was known to have been mentally weak, so it is likely that Hijikata was drawn to the idea of depicting a mentally incapable emperor and a time of relatively relaxed restraints in Japan.[59] Whatever the case, to satisfy Hijikata's requirement, Yokoo reproduced the ovals that normally would have been on display in ordinary households containing photographs of the emperor and the empress. He then replaced the emperor and empress with the two d'Estree sisters gaily and incestuously flirting with each other.

Finally, we come to the information about the dance, which is conveyed in two columns on the left- and right-hand sides of the poster. Both columns are justified to the sides of the poster, and both columns have the words in reverse order. That is, the words are not turned around backward, but merely the order from first to last is reversed—as though someone had written "Hat the in Cat The" rather than "taH eht ni taC ehT." Goodman points out that this technique was much more common in posters and signs of the late nineteenth century, perhaps reinforcing the look back at the transitional Taisho era.[60]

In composing the information, Hijikata used the Chinese characters in a playful manner—somewhat like a rebus. Some of the Chinese characters are complicated, archaic forms that have since been replaced by simplified forms (會 as opposed to the current 会). A second variety are complicated forms of numbers (*daiji*) used for decoration or in legal documents.[61] In the same way that the Arabic numeral 1 could be transformed into 11 by adding an extra line, so also certain Chinese characters are easily altered, so the character for one (一) could easily be transformed into the character for ten (十) by adding an extra vertical line. The numbers Hijikata used are the more complicated forms used as a rhetorical flourish or in check-writing (and other financial documents) as a precaution against altering monetary value. (For example, "twenty" is usually written 二十, but the form for financial documents is 貳拾, which sounds phonetically identical.) A third variety incorporates the original character into a more complicated character with a different meaning, but retains the base meaning. Finally, one of the characters seems to have no rhyme or reason to it at all.

In addition to using strange Chinese characters, in some of the sentences the information itself is also presented as a riddle. In *Leda*, Haniya felt as if he had to solve a riddle in order to arrive at the right place at the right time, and then another riddle in order to gain admittance into the show. Here, the riddles have been multiplied exponentially. Below are the contents of the actual poster followed by my rendering of the poster. Those who read Japanese can test themselves on the original while those who only read English can test themselves on the translation. (Although I have reproduced the original side by side and in its original order, I have taken the liberty to rearrange the English front to back and in one longer column.)

會商ラメルガ製謹

ヘ方の家のんさ澤澁

A LA MAISON DE M. CIVEÇAWA

演公念記携提派踊舞黒暗

スンダ色ラバ

割拾割票伝込仕

塗吹月壹拾會商ルメルガ

総棚子舞型ヌンアユシデ

年拾貳陌仇阡壹—材庫在

「脛」型スカフカ製肉

「場會賣即示展娘の私」

堂會公谷日千

本拾貳一

隣驛町濃信

叺壹—丸睾種無

A Story of Dances that Sustain Enigma 79

昭和肆拾壹年拾貳月添日
—貳拾捌日
夕刻陸時

ガメルラ商會

食紅—壹斤
鶯—加納光於・中西夏之
橫尾忠則
哈爾濱—大野一雄
土方巽

(Top)
Manufactured with Care by Garmela Mercantile

(Left column)
To M. Shibusawa's House

A LA MAISON DE M. CIVEÇAWA

Meeting Place for Display and Sale of My Daughter
Sennichidani Pvblic Hall
Next to Shinano ßtation
Year: Showa Sno4 Tea, Month: Won, Day: To Add
—Too Ate
Evening Sex Hour

(Right Column)
Dance of Darkness Faction Partnership Commemoration Performance
Rose-colored Dance

Discount for stocking-up on tickets—Won Tent off
Spewed out and Spread by Garmela Mercantile in Ye Leaven Month
A Full Shelf of Duchenne-style Dancing Girls
Material from the Storehouse—the year Won Th1000sand Fo9 H100dred
 Too Oh
Meat products: Caucasus-style "shins"
—Twin Tee
Seedless testicles—won bag
FD and C Red—won catty
Bush Warblers—Kanô Mitsuo, Nakanishi Natsuyuki
Yokoo Tadanori
Haerbin—Ôno Kazuo
Hijikata Tatsumi

(Bottom)
Garmela Mercantile

It is no shame to get to the end of this enigmatic poster still not quite positive what is going on. However, keeping in mind the transformations that Hijikata made and trying to match them up to the transformations that I have made, one might conclude that Hijikata was to present a dance called either *Rose-colored Dance* or *A la Maison de M. Civeçawa/To M. Shibusawa's House* at the Sennichidani Public Hall

next to the Shinano Train Station—"pvblic" being the presumably Roman archaic form of "public" and "ßtation" being a pseudo-German-archaic form for "station." Leaving aside for a minute all the other difficulties, one might guess that the date of the performance is sometime in the Showa era on the 28th (Too Ate) day of some month at six (roughly homophonous with "sex") in the evening.

Weeding through the obfuscation in the other column should yield at least the basic information that buying ahead of time gives you a 10 percent discount ("won tent off" equals "one-tenth off"), and that as there are twenty (the homophonous—"twin tee") Caucasus-style shins participating there must be ten dancers making up the shelf-full of Duchenne-style dancing girls.[62] They will use one catty (Roman numeral I—roughly 600 grams) of red makeup for the performance.

Some parts of this poster would be immediately more obvious to the Japanese reader than I have been able to render in English. For example, take the year "Showa Sno4 Tea." The Japanese "泗拾" is homophonous with the word for "forty" (*shijû*), so perhaps it could also have been rendered as "fore tea," and yet "泗" is a character meaning "snot" or "mucus" that will immediately be obvious to those who know Japanese as incorporating within it "四." Thus, "泗" is both homophonous with and looks like "four" and yet means "snot." Rather than choosing the standard legal form for the Japanese character 四 which is 肆, Hijikata chooses the rather more visceral character for snot. In order to capture this, I have rendered it as "Sno4 Tea" with the "four" substituting for the "t" in order to attempt to capture its triple valence, as a way to indicate that the year of the performance was to be Showa 40 (1965).

A similar method obtained for the "Material from the Storehouse," (presumably the subject of dance in some way or another) which was the year "Won Th1000sand Fo9 H100dred Too Oh," in which the 1000 (阡) and 100 (陌) predictably contain within the archaic character the more usual characters 千 and 百. The "Fo9" where the "nine" should come is not the standard legal or decorative form 玖 (jet black rock) but rather 仇, which incorporates the standard number nine, 九, but means enemy, foe, or harm, so I have used a backward nine in place of the "e" in "foe." Thus we can understand that the dance is going to have something to do with the year 1920.

My "Day: To Add//—Too Ate" is not obvious even to the Japanese reader. While the "Too Ate" is homophonous for "two eight" meaning "twenty-eight," the "To Add" can only be inferred backward from the "two eight" to signify rather arbitrarily "two seven" or "twenty-seven." Yet, this matches the mental jump that the Japanese reader would also have had to make, as the "添" that stands in where the "seven" should come is not homophonous with, nor looks like, nor is one of the legal, or decorative versions of the Japanese seven (柒, 漆).

Even after having come this far, there remains the problem that the program says that the date will be in the First Month (my "Month: won," but could also be rendered perhaps as the "F1rst Month"), but it also says that the dance will be "Spewed out" in the eleventh month (my "Ye Leaven"). One is left to surmise that as most people would have been encountering the poster after the first month of Showa 40 was passed, perhaps they would have assumed that the crucial month was November—the eleventh month. The invitations for the dance replicate most of the puzzles, but date both the performance and the "spewing out" in the homophonous and archaic "Ye Leaven" month. It is possible that Yokoo merely ran out of room and that he and Hijikata decided to opt for another puzzle, or that Hijikata intentionally

had Yokoo give conflicting dates (one of which had already passed) as another rebus for the viewer.

Leading the reader through the laborious work of decoding the poster serves to indicate the kinds of demands that he made on his audience in the contest between himself and the audience. Here he mixed visual and aural similarity, connotation, and denotation to create puns, but he also wrote in such a way that the attentive viewer could glean quite a lot of information that is useful for an interpretation of the dance and as an aid to enable one to show up at the right place at the right time. As with the flyer for *Masseur*, one does not have to be completely right, but one does need to make a provisional interpretation and then act upon it, and then one may revise the interpretation with the addition of subsequent information.

Finally, there are elements to the poster that I have not yet been able to decode. There are five specifically named people involved in some way that is not immediately clear from the designations "bush warblers," and "Haerbin." We might have expected "bush warblers" to indicate the people in charge of sound and music, but instead these are the stage designer, program designer, and poster designer. It is also not clear what Hijikata meant by "Seedless testicles—won bag" (perhaps a joke about impotency?). Including elements in the poster that have no apparent referent indicates that the task was not just to interpret and reinterpret over time as more information became available, but also to accustom oneself to not knowing everything and coping with that state as well.

Interpreting the Poster

However, we must take the interpretation of this poster several steps further. Moreover, the use of the rebuses in and of itself constitutes an important technique because of what it says about Hijikata's use of language. Hijikata had been primarily focused on enabling the body to say more than hitherto possible, but the arbitrary use of a Chinese character that because of context can only be read as seven, speaks to an attitude toward language that Hijikata was to increasingly employ. It is a fundamental property of language that it is possible to understand "add" as indicating "seven," for it is only a matter of convention that there is anything seven-ish about the word "seven" or anything add-ish about the word "add," and in fact any collection of letters, Chinese characters, or sounds could be used to indicate "seven" as long as enough people agree. Here, then, Hijikata was remaking language so that it could say more than previously possible, while also bringing into relief the arbitrariness of all language.[63]

Garmela Mercantile (*garumeru shôkai*, but spelled in English "Garmela" on some of the fliers and tickets) was Hijikata's code name for Asbestos Hall—it was taken from a caramel treat (*karumera-yaki*—borrowed from the Portuguese *caramelo*) that Motofuji and Hijikata would make for the snow-cone shop they managed during the day.[64] The origin of the appellation "Garmela Mercantile" is important both for the glimpse it gives into the way that Hijikata created his art, and for the glimpse into the connection between his art and the surrounding economy. So often, Hijikata took something at hand and teased it into a different and sometimes totally unrecognizable shape.[65] In this case, parallel to the dance experimentation, Hijikata and Motofuji were forced to turn to other sources to make money. They set up a stand at a local temple and sold

treats (such as snow-cones and caramel crackers) to passersby. Hijikata, then, decided to call his dance troupe by the name of one of the snacks they sold.

In an orthogonal context, H. D. Harootunian has commented on the "various ways capitalism was bonded to local experiences" in the postwar era.[66] It is not much of a stretch to see in the use of a commodity (as both an artistic slogan and a production company name) a recognition of the embeddedness of the artwork in a newly energized economy. The use of the number forms presents a similar connection to the wider economy. The numbers have an archaic feel, but were designed and in some cases are still legally used to prevent forgery in financial documents.[67] In a very real sense, the name Garmela Mercantile and the use of archaic numbers serve as direct connections between Hijikata's art (which otherwise often seemed unconnected to the wider world) and the competitive economic sphere.

It is necessary to pursue this point one step further. Hijikata and Motofuji were certainly not making enough money to live from their inchoate butoh performances. They staged *Masseur* in 1963 and *Rose-colored Dance* two years later in 1965, and in both cases had to pay the theater owners to rent the space. In order to raise money for putting on shows and to live (with all that entails, including putting food on the table), in 1959 Motofuji and Hijikata had formed their own dance duo called the Blue Echoes (see figure 3.7).[68] They performed in nightclubs and jazz clubs around

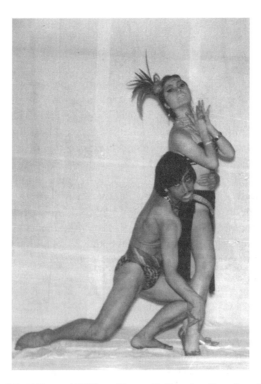

Figure 3.7 Motofuji Akiko and Hijikata Tatsumi's Dancing Duo (possibly Blue Echoes), photographer unknown. Courtesy of the Morishita Takashi Butoh Materials, NPO, and the Research Center for the Arts and Arts Administration, Keio University.

Yokohama, and eventually all over the country. Later, in 1962, they added more members to the dance team and renamed it Dancing Gorgui (see figure 3.8).[69]

Sometime in 1965 or 1966, roughly corresponding with the beginning of their association with Kara Jûrô and Maro Akaji, Hijikata and Motofuji had changed their nightclub dance routine into what they called the "Gold Dust Show," which was a nightclub act with costumes modeled after the 1964 James Bond movie *Goldfinger* (directed by Guy Hamilton) in which the character Jill Masterson is killed by epidermal suffocation after being painted with gold paint. The show featured dancers covered with gold paint (or other colors of paint) (see figure 3.9).[70] These shows were somewhat experimental in nature (including such things as improvisation based upon using the first letters of words to make a new word and then creating a dance based on associations with the new word), but they were also essentially burlesque music and dance reviews always featuring female nudity.[71] Garmela Mercantile was the name of the production company through which Motofuji managed these shows.

There are three things to note about the connection between Garmela Mercantile and burlesque shows. The nightclub circuit necessarily bolstered one side of Hijikata's performances. Because of the constraints of the nightclub, in which the attention of patrons may wander as they imbibe and talk with each other, the entertainment suitable for this kind of venue must require relatively little engagement, or at least

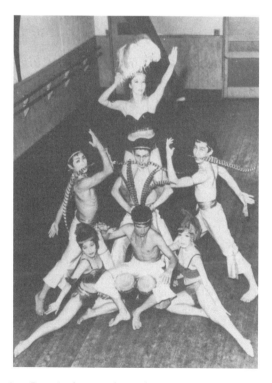

Figure 3.8 Dancing Gorgui, photographer unknown. Courtesy of the Morishita Takashi Butoh Materials, NPO, and the Research Center for the Arts and Arts Administration, Keio University.

84 *Hijikata Tatsumi and Butoh*

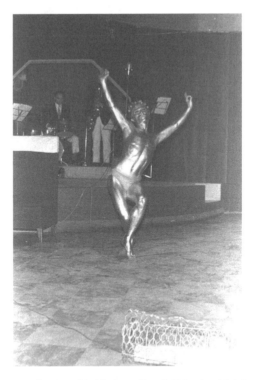

Figure 3.9 Ishii Mitsutaka in a "Gold Dust Show" (March 1968) by Nakatani Tadao. Courtesy of Nakatani Takashi and Morishita Takashi Butoh Materials, NPO, and the Research Center for the Arts and Arts Administration, Keio University.

non-constant engagement. Additionally, the city of Yokohama, where Hijikata and Motofuji often performed, housed many foreigners (including soldiers on rest and relaxation leave from the Vietnam War), so Hijikata and Motofuji often made shows that were tailored specifically to the desires of foreigners with whom they could not communicate. Strip shows, and dance and music reviews are ideal forms for such a situation—that is, they are shows in which bodies or spectacles predominate and narrative takes a back seat.

In addition, the shows gave Hijikata a forum for trying out new material, and the improvisational dances could yield material for subsequent performances. Moreover, it must have been important for Hijikata and his dancers to be able to perform once or twice an evening for a number of years. The opportunity to dance every night must have been indispensable for honing techniques and skills in stage presence that could never have been honed in daily rehearsal if they had only been performing once a year.[72]

The second thing to note here is the specifically gendered connection between Hijikata's art and the wider economy. In this case, it was not caramel crackers, but (female) flesh for sale. Hijikata and Motofuji could not escape needing to eat in the postwar competitive economy, and the way they found to do so was through providing the near naked (usually female) body for the visual delectation of nightclub and

strip show patrons. In a way that was uncannily similar to the Japanese economy as a whole (with its reliance on underpaid female subcontractors), the very ability of Hijikata to pursue of career as an experimenter in avant-garde dance was built upon a foundation of exploitative burlesque performance.

Moreover, the exploitation was gendered by the necessities of burlesque performance, which resulted in women being treated differently from men. The nude show must go on, even if an important guest comes to town, so while the male dancers could take a night off from time to time to join a party or meet an important artist, the women had display their bodies every night regardless of what other activities were available.[73] This speaks to an equally troubling problem. Later, I shall have occasion to examine the way that Hijikata remarks on societal treatment of women in his essays and dances, but these observations should serve as a counterbalance to my later analysis. Although, Hijikata and his male cohorts saw themselves as in a competition with each other and with the audience, they rarely engaged with women with the same intensity as they engaged each other. Of course, Hijikata collaborated with Nonaka Yuri, and later with Takai Tomiko, but Japan in the 1960s was still a man's world, and the avant-garde performers were not as avant-garde in their gender politics as they were in their performances.

The Program

Rather than a program on which information such as the name of the dance and the performers was listed, the audience members were given a cedar box with a lid covered with a chart of numbers that appeared to be some sort of puzzle or number game, making it seem once again as if the spectator had to solve a puzzle to gain access to the contents of the program. Nestled in the box was a "lickable program" designed by Kanô Mitsuo—three hardtack sugar candies in the shape of a hand, a phallus, and a pair of lips (see figure 3.10).[74] The "program" would have put the audience in the position of shaking hands with, kissing, or performing fellatio on the candy.[75] This is in keeping with the idea that the artists write themselves on the psyches of the spectators. In this case, the spectators would be interacting with the art in such a completely corporeal way that not only would they be touching the art (via a handshake or kissing), but they would be taking the art inside themselves as they ate the candy. Moreover, when the bodily incorporation was the act of performing fellatio on the program, perhaps it is not a stretch to suppose that some of the people would be likely to remember that part of the program long after they had forgotten shaking hands with and kissing the program, because many people may have paid more attention to the intimation of fellatio in a public setting than to the act of shaking hands or kissing.

The Stage

Rose-colored Dance took place on a stage designed by Nakanishi. He draped a semi-transparent cloth over a two-story structure at the back of the stage. Then he placed ten stagehands facing into the drapery with their backs to the stage. Someone also stole two life-sized "Nippers" (RCA Victor/Victor Company of Japan trademark dog) from shop-fronts and placed them on the stage as well (see figure 3.11). The

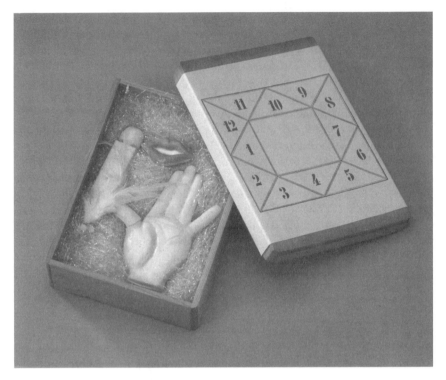

Figure 3.10 Sugar Candy *Objet*: Edible Program, *Rose-colored Dance*, (Sennichidani Public Hall, Tokyo, Nov. 1965) by Kanô Mitsuo. Photo courtesy of the Hijikata Tatsumi Memorial Archive, and the Research Center for the Arts and Arts Administration, Keio University.

stagehands look as is if they are urinating and as if they have turned their backs on the dance. The dogs look as if there is merely something more interesting happening behind the stage about which they are curious. Analyzing the men and dogs with their backs toward the audience provides a better understanding of two interrelated themes within Hijikata's dance, for both the men and dogs came equipped with their own prior histories.

A year before, in 1964, Hijikata's friend Shinohara Ushio held the neo-Dada Left Hook Exhibition from December 8th to 13th at the Tsubaki Gallery in Tokyo. At the Left Hook Exhibition, the sculptor Tsubouchi Itchû presented a work, "homo Sexual-Love," which consisted of a Nipper dog facing into a mottled pink wall.[76] It seems likely, given their connection to Shinohara, that Hijikata or Nakanishi borrowed the idea for the dog facing into the backdrop. Tsubouchi's Nipper appears to be the exact same style Nipper as that used by Hijikata and company, which leads one to the conclusion that more than one avant-garde artist was stealing dogs from record shops, or that Hijikata or Nakanishi borrowed the dog once the Left Hook Exhibition was over. Apparently, Tokyo of the 1960s was a dangerous time to be a Nipper guarding a record store, unless that is, you were a dog who yearned for something more than the day-to-day drudgery of supervising passersby. Thus, the

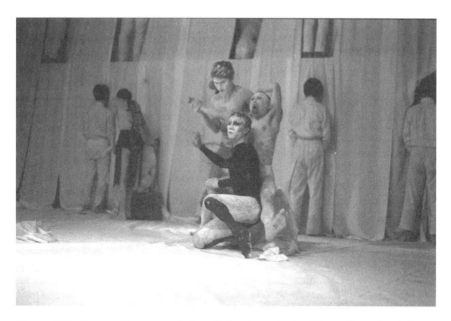

Figure 3.11 Stage with men and dogs facing into the backdrop, *Rose-colored Dance*, (Sennichidani Public Hall, Tokyo, Nov. 1965) by Nakatani Tadao. Courtesy of Nakatani Takashi and Morishita Takashi Butoh Materials, NPO, and the Research Center for the Arts and Arts Administration, Keio University.

Nipper dogs were connected in an oblique way to the themes of homosexuality and androgyny that had been one frequent aspect of Hijikata's dances.

The men standing with their back to the audience turn out to have a similarly thick history. Mishima had quoted Hijikata as saying that the back of a man urinating was a crisis prototype:

> The last time I saw him, Hijikata was constantly using the word "crisis"—saying that he must grasp the form of human crisis in its very rawness in the nakedness of dance. One example of this crisis is the strange example that Hijikata gave of "the back of a man standing urinating."[77]

Shibusawa provided a fuller explanation of what Hijikata might have meant in his collection of aphorisms for the second "Hijikata Tatsumi DANCE EXPERIENCE Gathering":

> The Roman emperor Caracalla died when he was stabbed by an assassin while peeing standing up on a pilgrimage to the moon palace. The Japanese dancer Hijikata Tatsumi discovers in the figure of the back of a man standing peeing, the form of human crisis. At the dawn of the latter half of the twentieth century.[78]

Vulnerability and lack of awareness certainly come together in this image of the back of a man standing urinating. The vulnerability is clear, because the subject is literally

caught with his pants down, rendering defense or flight difficult. At the same time, Hijikata clearly emphasizes the view of the man from the back. For Hijikata the prototypical crisis moment in the twentieth century was not just the moment of vulnerability while urinating, but of being unaware of any impending danger because one is facing the wrong way. Implicitly, there is an additional call to imagine oneself from behind—to imagine oneself from the vantage point of the other, to imagine what one cannot see—in order to fully understand the crisis. The men facing the back of the stage are certainly in danger of being assassinated, and this sense of crisis undoubtedly relates to the violence and competition of the postwar era.

There is another aspect to the complex genealogy of men facing into the back of the stage. Early in Hijikata's career, Hosoe Eikô proposed taking photographs of Hijikata and the other dancers, but while Hijikata wanted Hosoe to shoot standard shots of his dances on stage, Hosoe wanted to shoot an unrehearsed dramatic moment. Finally the two came to an agreement that Hosoe would shoot Hijikata and his dancers and a few of Hosoe's models at the Harumi wharves, but that Hosoe would publish his photographs under the title *Hosoe Eikô's Photographic Collection Dedicated to Hijikata Tatsumi* and that the collection would serve as the program for the first "Hijikata Tatsumi DANCE EXPERIENCE Gathering."[79] Two of the photographs show four men standing facing a concrete wall with their hands raised over their heads as if they are being arrested. A third photograph has five men facing the wall and leaning diagonally to the right. All the men have black bags over their heads. The depiction suggests hooded people on death row and thus rejected by society, the violence of police techniques, and the facelessness of the modern city.[80] In Hosoe's photographs, crisis is marked by being deprived of sight and possibly, of life.

What was the understanding of the men by the stage designer Nakanishi? In 1963, he created a life-sized scroll of blueprint photographs of himself and other artists called the *General Catalogue of Males '63*. The photographs were all of naked men taken from behind.[81] There is a sense of commodification and objectification of the men in his photographs, as if they were products for sale or appraisal. Recall that on the poster there was the following enigmatic line: "Meeting Place for Display and Sale of My Daughter." The phrase shares the same nuance of objectification and commercialization that one can find in Nakanishi's blueprints. The image was further updated on January 26th and 27th of 1964, when the members of the neo-Dada group Hi Red Center (Akasegawa Gempei, Nakanishi Natsuyuki, and Takamatsu Jirô) held a Happening called "Imperial Hotel Body: Shelter Plan." Guests went to a suite in the Imperial Hotel and were weighed, measured, and photographed for personalized bomb shelters. Jôno'uchi Motoharu's film *Shelter Plan* shows that Nakanishi had papered the walls of the suite with images from the *General Catalogue of Males '63*.[82] The guests were probably amused by the (partially) humorous proposal to construct a personalized bomb shelter—perhaps indicating the anxiety that many Japanese people felt at being the (nuclear) front line in the Cold War conflict between the United States and the Soviet Union—which would suggest that not only was local experience bonded to capitalism (as Harootunian would have it), but that it was also bonded to geopolitical struggle. In addition, the guests felt subjected to the same kinds of indignities that they would endure if arrested, or offered up for sale on the auction block.

Thus, by the time of *Rose-colored Dance*, three back-centered themes would seem to have come together. Both the Hosoe photographs and the Hi Red Center mixer point to the repressive and invasive measures taken by police during the arrest of criminals. The Hosoe photographs seem to document outcasts, people who have been deprived of a face by society. The Nakanishi photographs document humans as measurable quantifiable mercantile objects, and their use in the "Imperial Hotel Body: Shelter Plan" adds the nuance of fear over Japan's place in the (nuclear) geopolitical struggles of the Cold War. Overlaying those concerns, the way the men stand as though they were urinating highlights Hijikata's concern with crisis. In this case, if they were not precisely caught with their pants down, it does appear that they would have to finish up, shake, and tuck before they could respond to any situation.[83]

Going into such depths about the poster and also about the significance of the men and dogs with their backs to the stage should make two different, but related, points clear. First, Hijikata challenged his audience. In a way, this was nothing new. Hijikata made it hard for the audience to understand what was happening on stage in *Forbidden Colors* by setting the action in the shadows and only allowing light to spill over from one corner of the stage into the other corners. In *Rose-colored Dance*, the challenge facing the audience had changed. It was more like a succession of riddles or puzzles that the audience had to solve.

Second, in the case of the posters (as well as the "program" and, as we shall see, the dance), viewers had to accustom themselves both to solving riddles and to coping with not understanding everything when they could not solve the riddles. This meant that the not only was it difficult for the audience, but that the collaborative competition among artists or between the artists and audience created an environment in which the audience had to navigate its way through all sorts of confusing information, some of which was even impossible to understand. Competition and collaboration thus lead directly to the need for the audience to practice managing information.

A similar equation existed in the larger society in which there was a connection between the competitiveness of the society and the amount of information within the society. From there it is only a short step to the historiographical realization that understanding the stage art (then and now) required unpacking the various assumptions and concerns of an era or an individual artist, but also entailed the task of unraveling the inner workings of a coterie of artist friends, as each element within a work of art had its own history. That is to say, the problem of managing information included a temporal or historical element both because the society of the time was facing unprecedented information overload, and because each element that could be used in a dance already had a history to it (whether that was a widely known history or a history within a coterie).

The citation of posters, programs, and the stage design in determining the significance of a dance might seem counterintuitive. Yet, in a conversation with Shiraishi Kazuko, Hijikata said that he worked hard on all the "expressive techniques that are considered inferior in dance" such as tempo and stage decoration.[84] Thus, this dance makes two things clear. The first is that Hijikata was highly involved in aspects of the dance other than the choreography. The second is that he was also willing to allow other artists to bring their own vision to the dance. Thus, without even considering the dance, one can already see so much of what preoccupied Hijikata in one way

or another for his entire career: Intense engagement with and high demands placed on the audience, individual experience for each member of the audience, focus on aleatory or random processes and combinations, multivalent encodings, allusions to other (Western) artists, and collaboration between artists in which Hijikata does not control everything, all against the background of an economy and society which were increasingly competitive.

The Dance

Rose-colored Dance is preserved on a 10-minute film by Iimura Takahiko entitled "Immaculate Conception or *Rose-colored Dance*."[85] Once again, a 10-minute film that Iimura intended as an autonomous piece of art can only reveal so much about the dance. Yet, it is still invaluable as a record of the early Hijikata. The dance began with a real barber shaving the heads of Hijikata and four men wearing Japanese naval flags as bibs. On the first night, Hijikata spoke out in the middle of the dance to tell the barber that he should only shave off half of each head since they had to come back the next night and do it all over again. During the rest of the show, the four men sat offstage to the side of the audience with the box-programs in their laps and ate the lickable "programs," including simulating fellatio with the candy phalli.

This prologue was followed by various, seemingly unconnected actions. Yoshito beat his chest and screamed silently in the role of a baby who is trying to get its needs met. Two men caked with crumbling plaster and connected by tubes coming out of their mouths and going into their anuses danced a duet (see figure 3.12). One carried the other in his back and then let him off onto the ground and they intertwined and slowly crawled over and around each other in a homoerotic manner.[86] In addition, the two performed some strange ballet-esque hops and stances, alternated with jerky movements. A threesome attired in wigs and hats appeared on stage with two people carrying the other between them. The threesome performed a series of short pieces with ballet and modern movements in them include jetés and arabesques. They also congregated around a chair and covered it with cloth and knelt on it or stretched out sideways on it or stood on it. Dressed in long white dresses, Hijikata and Ôno Kazuo danced a duet in which they did arabesques together and embraced on stage (see figure 3.13). Ôno (who had the name Noringa painted on his back under his billowy gown) looked up Hijikata's dress, and after lying down, Hijikata sniffed Ôno's feet and then turned him over and stretched out on top of him in a position that recalled the intimation of sodomy in *Forbidden Colors*. Finally, Hijikata came out dressed in laborer's clothes pulling a rickshaw with Yoshito inside it (see figure 3.16). After circumnavigating the rickshaw, and peering out at the audience from behind it, the previously mentioned threesome took Hijikata and spun him on the ground.

There are some elements to add to this description from photographs of the dance. Other actions included the following: Hijikata peeking out to the audience from behind a large panel with a blown-up reproduction of the *shimpa* female impersonator Hanayagi Shôtarô, who had died earlier that year;[87] photographers or filmmakers joining the dancers on stage and photographing or filming them close up; and a trio of dancers dressed in letterman's jackets taking photographs of the audience.[88] At

A Story of Dances that Sustain Enigma 91

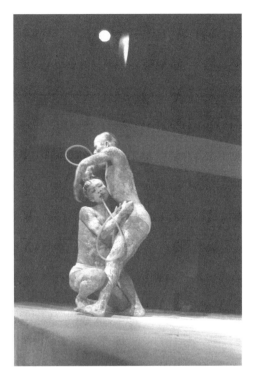

Figure 3.12 Ishii Mitsutaka and Kasai Akira in a rubber hose duet, *Rose-colored Dance*, (Sennichidani Public Hall, Tokyo, Nov. 1965) by Nakatani Tadao. Courtesy of Nakatani Takashi and Morishita Takashi Butoh Materials, NPO, and the Research Center for the Arts and Arts Administration, Keio University.

some point, Hijikata, dressed as a fencer, used a saber to attack a large poster created by Akasegawa that was covered with *I Ching* hexagrams and acupuncture-point diagrams, and then pulled the diagram on top of himself and wrapped himself in it.

Understanding Rose-colored Dance

Some themes in *Rose-colored Dance* were similar to those of previous dances. The use of the naval flags as bibs to catch hair in the barbershop resembles the disrespectful treatment accorded to tatami mats and the critical attitude directed toward the act of bowing in *Masseur*. There is also a hint of state-sponsored violence in the connection of the flags with the act of cutting hair[89]—the suggestion is that these men have been conscripted to fight in the Pacific war (which was alluded to in the poem by Katô Ikuya enclosed in the program box), and that the state now had the power to configure their bodies as it saw fit.[90] The androgyny and implied sodomy of Hijikata and Ôno's duet continues the subversion of gender categories manifested in Ôno's various solos.

The theme of the ideal spectator manifest in Kazakura's perch above the stage in *Masseur* was renewed by placing the men at the side of the stage (after having had

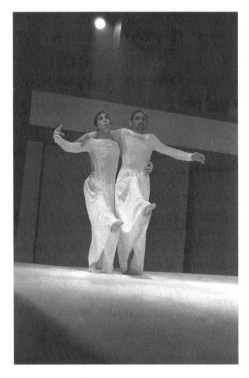

Figure 3.13 Hijikata Tatsumi and Ōno Kazuo in a duet, *Rose-colored Dance*, (Sennichidani Public Hall, Tokyo, Nov. 1965) by Nakatani Tadao. Courtesy of Nakatani Takashi and Morishita Takashi Butoh Materials, NPO, and the Research Center for the Arts and Arts Administration, Keio University.

their hair cut off) to watch the show as special spectators. Then Hijikata expanded on this theme by allowing photographers and a filmmaker to enter the stage and take photographs and film of the dancers; by having the dancers take photographs of the audience; and even by the use of the eight-foot-tall, four-foot-wide photograph of Hanayagi looking over to the left-hand side of the audience.

More than in any previous performance, the audience was watched, and this time it was also recorded. It was watched by the men who sat to one side of audience; it was watched by the huge photograph of Hanayagi; and it was recorded by the dancers who took photographs and film from the stage (see figure 3.14). The importance of being watched was likely connected to the sense of competition that pervaded the era.

In the discussion concerning *Masseur*, I connected Mishima's preoccupation with athletics—in which the encounter with the opponent also becomes an encounter with oneself and one's own properties—with the neo-Dada concern with finding the properties of objects, as both Mishima and the neo-Dada artists were concerned in their own ways with actuality. To return to Mishima's ideas about competition in *Sun and Steel* from a different angle, Mishima also singled out sporting activities (in his case, kendo and boxing) because the encounter with the opponent was also an experience of being seen: "When I looked the opponent was seen; when the opponent looked, I was

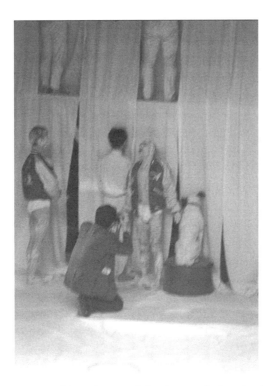

Figure 3.14 Cameraman taking pictures of the dancers during the dance, *Rose-colored Dance*, (Sennichidani Public Hall, Tokyo, Nov. 1965) by Nakatani Tadao. Courtesy of Nakatani Takashi and Morishita Takashi Butoh Materials, NPO, and the Research Center for the Arts and Arts Administration, Keio University.

seen," both belong to the world of "being seen." And further along, "Ideas do not stare back at us; things do."[91] For Mishima the mark of an opponent or a thing is its ability to look back at its viewer, and never to be reduced to verbal linguistic abstractions. Although the opponent who looks back at us is forever beyond our understanding, it is possible to respond effectively to the opponent by training the body to move without thinking—that is, to move without engaging in the abstracting quality of language. That is, for Mishima it is possible to train the body so that it can interact with other extralinguistic opponents in their same extralinguistic realm.

Hijikata shared this preoccupation with looking and being seen (and in part his preoccupation may stem from dancing in burlesque shows in which being seen is an important component of the show), but insisted that the proper response to an opponent included attempting to put oneself in the mental position of the opponent—to imagine the back of the man standing peeing, rather than just imagining a man standing peeing or to imagine one's own back from behind. That is, Hijikata did not share Mishima's supposition that the opponent is forever unknowable, but rather in phrases such as "the back of a man standing urinating" seems to have assumed that one can bridge the gap between oneself and the opponent by adopting the perspective of the opponent.

Although Mishima had assumed that some things also possess an extraverbal reality beyond our language, and thus can look back at us in a metaphorical sense, in *Rose-colored Dance*, Hijikata was concerned not only with having people look back at the audience, but also with things that can more literally look back at the audience. These experiments had begun with Mizutani's movable stage for *Disposal Place*, with its nuance of querying the real and disrupting the hierarchy between dancer and set, and then continued with Kazakura's action of watching the show and the audience from a privileged position in *Masseur*. There the experiment focused attention on what it meant to watch a performance and be watched. It is almost as if Hijikata was asking the audience to be aware that the performance was being watched, and to think about how, in the manner of the Heisenberg Uncertainly Principle or the Lacanian Gaze, the act of observing affects the performance.

Because Kazakura was a real human being wrapped inside of newspapers, rather than just a splotchy newspaper sausage, the people in the audience would have felt watched to an even greater extent than in the case of Mizutani's alter-audience. Kazakura was encouraging them to draw a connection between how they felt about being watched and how their gaze affected the performers on stage.

In *Rose-colored Dance*, still and filmic cameras formed a special subset of things that can return the gaze, because they were also recording devices that can freeze moments or scenes in time. Walter Benjamin famously theorized about ways that mechanical reproducibility alters the work of art, by destroying what he termed its "aura."[92] In *Rose-colored Dance* Hijikata can be seen as asking a parallel question about the effect on performance of using a technology of reproduction to extract a single moment or a series of moments from a performance and freeze them in time. He ensured that his audience felt this question by having the dancers film or take photographs to freeze the audience for one moment in time. Of course, in 1964, it was impossible to develop the film in time to incorporate it into the performance, so the larger than life photograph of Hanayagi also allowed the audience to experience the process in action, as they got to see the starting point of the action of taking a photograph (the person taking a photo of them) and the end point (a developed and enlarged photo). Thus the subtitle of this dance might just as well have been, "The Act of Watching Dance in an Age of Mechanical Reproduction."[93]

Despite some similarities with previous shows, several things stand out in this dance. One is the mixture of elements: dogs and people; ethereal arabesques and jetés; a dancer mimicking a baby screaming and beating its chest; grotesque, flaking, plaster-covered skin, fluffy white gowns, and kitschy letterman jackets;[94] photographs and filming (the most recent recording technology), and a rickshaw (a long-established and almost entirely superseded transportation technology); European fencing, and *shimpa* theater (a transitional art form between Kabuki and Japan's modern theater); Ôno Kazuo and Motoori Norinaga. In the experimental spirit of Happenings and neo-Dadaism, one of the points of this dance was to put these strange fellows into bed with each other, and see what would come of it.

Some have focused only on a subset of these scenes and elements and read *Rose-colored Dance* as a paean to premodern Japan or the Taisho era, but this discounts several elements within the dance.[95] One is the preoccupation with the most recent technology, such as movie cameras. Another is the internal evidence of the dance. For

example, the use of the acupuncture diagram might be taken as a return to Chinese medicinal principles, but the poster clearly offers the symptomatic characteristics of two males and two females with "caramel disease" (*karumerashôsô*), and further identifies this physiognomy as that of the "Person that Derives Pleasure from Destroying Art" (*Jutsuha kanshin jin*) (see figure 3.15).[96] Recall that Hijikata's production company name Garmela Mercantile was a doubly transformed version of "caramel," so "caramel disease" must be the disease that the dancers who belong to Garmela Mercantile (Asbestos Hall) have that makes them enjoy destroying art.

This frank and humorous declaration found in *Rose-colored Dance* of destroying art may seem at odds with the relatively extensive use of ballet and modern techniques. Morishita notes that if one makes an analogy from anti-art, then one could say that Hijikata's dance was anti-dance.[97] Yet, Morishita does not explore the facets of the anti-art position, which was always quite clouded. One only needs to return to Duchamp to realize that there was always a fissure in the anti-art position. One could easily read Duchamp's *Fountain* (the urinal signed "R. Mutt") in several ways. First, one could read it as an attack on the idea of art, that is, as a statement that art as such does not exist, and that art conceived of as a correspondence with some transcendent realm or set of requirements is a fiction driven by the art market. On this view, the act of putting something in a museum or gallery and proclaiming it art is what makes it so. Second, one could see it as an attack on the then-current institution of art for being too narrowly focused. When one looked at the graceful curves of the urinal and

Figure 3.15 *I Ching* acupuncture chart, *Rose-colored Dance*, (Sennichidani Public Hall, Tokyo, Nov. 1965) by Akasegawa Genpei. Photo courtesy of the Hijikata Tatsumi Memorial Archive, and the Research Center for the Arts and Arts Administration, Keio University.

began to appreciate the design elements incorporated there, then the sphere of activities and objects considered worthy of representation in or inclusion in the sphere of art widened considerably.[98] But those two responses are fundamentally opposed to each other. The second still maintains the criteria for some object, painting, sculpture to be included in the category of art, but merely underscores how certain items that have hitherto gone unnoticed also possess the attributes of art, while the first denies the category altogether.

In fact, Alexandra Munroe has shown that during the 1960s there were those who were worried about this disjunction between the two possible aims of "anti-art." Hijikata's friend Shinohara Ushio complained about the name anti-art because he thought that he and the other artists of the time were trying to broaden the sphere of art.[99] Hijikata and most other practitioners of butoh belonged squarely in the second faction of anti-art. In so far as dance was thought suitable for representing only a delimited set of scenes, ideals, and movements, Hijikata's dance was indeed anti-dance, and in that sense, Hijikata was doing everything he could to critique the then-current conceptions of dance. Yet, Hijikata and most others in the world of butoh only occasionally participated in the first line of questioning. In fact, he most often talked about butoh as if it did have trans-*des*cendental (to borrow the Nishitani Keiji term) requirements, and as if one could sense whether any particular dance fit or did not fit those criteria.[100] However, Hijikata was also likely experimenting with the effect of putting an action on stage and proclaiming it a dance. Whatever the attitudes of Akasegawa toward the institution of art, Hijikata was struggling with whether he himself was attacking the very institution of art, or widening the realm of acceptable artistic representation.[101]

The ballet and modern dance in *Rose-colored Dance* is also striking. It is likely that there were two reasons for the inclusion of so much preexisting dance technique. One was the training of the dancers: Ishii Mitsutaka had trained in ballet, and Kasai had trained in both modern dance and ballet. In part, Hijikata made use of what his collaborators knew. The second reason for the inclusion of so much ballet and modern dance likely related back to the surrealist principle of juxtaposition that Hijikata had inherited from Takiguchi. Two of the major studies of Japanese surrealism focus on the interest Japanese surrealists had in the surrealist principle of bringing together disparate elements to see what sort of reaction would take place between them.[102] Sas focuses on Takiguchi's reception of Reverdy's idea of "distant realities," and Hirata notes Nishiwaki's impatience with the mere comparison of things, and his desire to create sparks of energy by conjoining things not usually joined.

Crucial to an understanding of the role of ballet and modern dance within *Rose-colored Dance* is the realization that in order for the dancers to create a spark they needed at least two opposing things to put next to each other. If Hijikata wanted to alter, question, or even negate something (regardless of what that something was), he would have to bring it in contact with something else in order to do so. If he left the "something else" out, he would not be able to produce any spark. It is impossible to tell from the structure of a dance combination what is to be altered or negated by what, because both were necessary for the reaction and both would inevitably be altered.

Of course, we may assume that in 1965 there were far fewer chances to see chest beating, or fencers attacking acupuncture posters, or men scrambling over each other with tubes connecting them, so it is likely that there was a preferred element that was

thought of as the main one, the one that the dancers wanted to see spread through the dance and performance world, but they could not do without the antithesis for the creation of energy on stage.

Another thing that stands out in *Rose-colored Dance* is that the various riddles that the audience must solve have come to depend to a greater extent on insider knowledge than in *Leda* and *Masseur*. In *Forbidden Colors* one would not have been at any disadvantage without a background in Hijikata's previous dances with Andô, Imai, and Horiuchi. However, in *Rose-colored Dance*, one's prior knowledge of the events of a small coterie determines how well one understands the dance. That knowledge allows one to connect the pink and green gonorrheal blotches on the costumes in *Masseur* to the pink and green paint covering the d'Estree sisters, who peer out of silver ovals usually reserved for the emperor and empress. If one sees the Chinese physiognomy chart, but fails to understand that the kind of person who derives pleasure from destroying art has the Garmela Disease, and that that disease is the one contracted by people who live at Asbestos Hall, then one misses the point of the poster.

And one is not likely to know the connection between the Garmela disease and the caramel crackers that Hijikata sold at his sweets shop without being close to the action. In a way, the pieces begin to demand not just effort from the members of the audience, but repeated effort. The spectator needs to go to dance after dance after dance, and also to attend other Happenings, neo-Dada events, and photographic shows in order to understand the dance.[103]

Understanding these allusions and decoding these rebuses sometimes leads to something important, but the viewer must also be prepared to not understand some elements. Recognizing the connection between Garmela Mercantile and Asbestos Hall enables one to draw the connection between the physiognomy chart's caramel/Garmela disease and the anti-dance position of the "person that enjoys destroying art." Understanding the relationship of the name of the quasi-production company Garmela Mercantile and Hijikata's shaved-ice shop enables one to draw the additional connection between the dance and the caramel crackers that were clues to the dance's connection to the wider economy. However, some elements of the dance remain opaque to the viewer and serve primarily to exercise the viewer's ability to negotiate the demands of proliferating information.

For example, take the ending. Hijikata pulled Yoshito around the stage in a rickshaw, before being spun on the ground by three dancers (see figure 3.16). There is something curiosity-inducing and also ominous about this person who appears to be a working-class laborer being spun on the ground by three dancers wearing long white gowns who have been dancing Western-style dance forms such as ballet and modern dance. However, it turns out that this scene was a fake advertisement for an upcoming show.[104] Hijikata modeled the scene after the trailers in movies that tantalize the spectator with short scenes from soon-to-be released movies. However, he never intended to make a subsequent dance featuring a rickshaw puller, and had nothing specific (at least that he told anybody) in mind with this scene. Of course, the audience did not know that this scene was a teaser for an upcoming dance, let alone a fake upcoming dance.

Yet, the question of whether or not the members of audience knew about this fake trailer does not change the fundamental structure of the dance, in that it toyed with their expectations about knowledge. Either the audience must remain forever in the

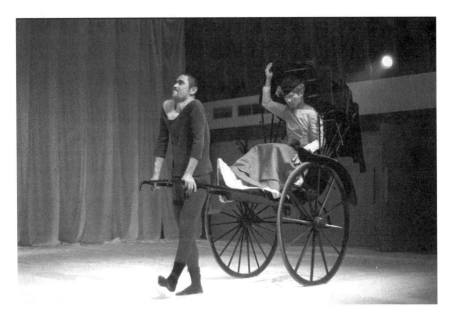

Figure 3.16 Rickshaw puller, *Rose-colored Dance*, (Sennichidani Public Hall, Tokyo, Nov. 1965) by Nakatani Tadao. Courtesy of Nakatani Takashi and Morishita Takashi Butoh Materials, NPO, and the Research Center for the Arts and Arts Administration, Keio University.

dark about something that seems like it could make narrative sense, or the audience must question the convention of the trailer—which usually gives the audience a small amount of knowledge about an upcoming event. That is, the spectators must cope with a moment in which they do not have enough information, or else question conventions concerning knowledge, perhaps causing them to be more wary of trailers in the future. Either way, the audience had to manage information.

Beyond any one element of this dance, it is necessary to theorize about the overall structure of the entire "dance" experience, which included the poster, flier, program, stage design, special spectators, costumes and the movement of the dance itself. Morishita Takashi insightfully reads *Rose-colored Dance* by noting that art and butoh invaded each other, and then amends himself to observe that butoh allowed art to invade it.[105] Allowing oneself to be invaded might be fruitfully considered as the obverse side of Shibusawa's idea of psyche-marking scandals in which the artists try to imprint themselves onto each other and into world history in the process.

One might consider the attitude of mutual invasion or mutual scandal as opposed to Clement Greenberg's now famous 1960 definition of modernism: "the essence of Modernism lies, as I see it, in the use of the characteristic methods of a discipline to criticize the discipline itself—not in order to subvert it, but to entrench it more firmly in its area of competence."[106] Greenberg saw modernism as the intellectual progeny of Kant's attempts to use reason to criticize itself and put itself on a more sound footing, even if that meant sacrificing some of its abilities if they could not be given a firm basis.

In practice, this turned into a movement to purify art forms—to eliminate non-painterly elements from paintings and nonarchitectural elements from architecture. By contrast, Hijikata was entirely disinterested in the achievement of pure dance.[107] He continually allowed and even encouraged encroachment from other spheres. This encouraged infringement ran the gamut of literature (Motoori Norinaga), paintings (the *I Ching* acupuncture poster and the Fontainbleau School painting of the d'Estree sisters), architecture (the two-story structure at the back of the stage), sculpture (the Nipper dogs), fashion (the letterman jackets), and modern dance and ballet, to name a few. Morishita's "invasion" was already present in butoh from the time of Yoshimura's "reverse intervention," which was derived from a combination of Mishima's and Takiguchi's ideas about artistic "synthesis" and Shibusawa's notion of psyche-marking events. Hijikata has been compared to Nijinsky and Diaghilev in that he combined an artist and impresario into one figure (himself), but it was not just Hijikata's genius to have attracted so many people work with him, it was also his genius to have allowed them to invade his art.

Hijikata would also not have recognized Greenberg's caveat that one uses the purifying methods not to subvert a discipline but in order to entrench it. Implicit in Hijikata's antipurity stance is the notion that within the competitive economy of arts (and the wider world), the way to fortify an art form (a person, or an institution) is not to narrow oneself to one solitary sterile strength (a closed-off core competency), but to open oneself up to the other. That is, judging from Hijikata's dances, Kant and Greenberg had it wrong: strengthening comes not by paring away, but by increasing complexity and becoming able to deal with that increase in complexity.

TOMATO

The next dance in Hijikata's oeuvre was the July 16, 1966 *Instructional Illustrations for the Study of Divine Favor in Sexual Love: Tomato*. For the backdrop, Hijikata engaged sign painters who usually painted signs for Asakusa strip clubs to come and paint an enlarged detail from Michelangelo's *The Creation of Adam* in which only the finger tips of God and Adam were visible.[108] Then Hijikata splashed paint over it after the manner of action paintings such as Shinohara Ushio's *Twist Dango*, and then someone smashed a chair through the backdrop so that its four legs poke perpendicularly out of the backdrop.[109] The stage was covered with various household objects (including a ping-pong table and a lantern that Ôno lit during the show).[110]

In the performance, Kazakura Shô replicated his spectator experiments by swinging on a swing above the audience and stage, eating bread, and yelling out, "I need a drink!" In a preview published a week before the dance, Donald Richie said that the first half was to include short vignettes with two brothers playing ping-pong, and fishing, and the second half was to concern itself with tomatoes—which Hijikata apparently told Richie he was not allowed to eat as a child.[111]

Photographs show an almost hobo-like Ôno dressed in a ratty white or tan suit with some sort of rubber plugs in his nose and a bag of fluid suspended from his armpit similar to the ones in *Masseur*. He looks as if he is lighting a lantern and fanning it with his hat, as if to feed the flame with extra oxygen. He was joined by two dancers,

Figure 3.17 Ôno Kazuo and unidentified dancers, *Instructional Illustrations for the Study of Divine Favor in Sexual Love: Tomato*, (Kinokuniya Hall, Tokyo, July 1966) by Nakatani Tadao. Courtesy of Nakatani Takashi and Morishita Takashi Butoh Materials, NPO, and the Research Center for the Arts and Arts Administration, Keio University.

Figure 3.18 Tezuka Osamu's Mickey Mouse bat from the graphic serialized novel (*manga*) *Beribboned Knight*, *Tomato*, (Kinokuniya Hall, Tokyo, July 1966) by Nakatani Tadao. Courtesy of Nakatani Takashi and Morishita Takashi Butoh Materials, NPO, and the Research Center for the Arts and Arts Administration, Keio University.

whose heads were almost completely covered with newspaper and whose pectorals were painted black as if they had been badly bruised. Another photographed scene included three dancers with clothespins in their hair and clad only in white flower-dotted pants doing lighthearted movements in unison, while other nearly naked dancers faced the backdrop. A third featured Ôno and another dancer sitting in arm chairs with two dancers standing behind them, one with a wind chime on his head. From the looks of the photographs, we might imagine that Ôno is relating a story, or that the action on stage takes place in his mind (see figure 3.17). A fourth scene shows several dancers seemingly pinned to the backdrop as if insects on display. A fifth scene portrays two nearly naked men doubled-up on the ground in a sexualized pose with the one on top entwining his ankles around the legs of the one on the bottom. In another set of photographs, four nearly naked dancers cavorted around a ping-pong table: one stood on his head on a ping-pong table, and other dancers performed various movements/poses on the table. One of the dancers has a Mickey Mouse Bat logo affixed to his back that looks like the bat that is the pet of Hecate in *manga* artist Tezuka Osamu's *Beribboned Knight* (Ribon no kishi) (see figure 3.18).[112]

We have another bit of information about this dance—a sketch (*esukisu*—esquisse, Motofuji also calls it a *konte*—a continuity or detailed scenario) of the dance that Hijikata had Motofuji write down:

DANCE OF A TOMATO WITH HAIR PARTED DOWN THE SIDE

Girl with hair parted on the side dances the white paper
Razorblade dagger
Tragedy of white paper
A hungry musical instrument calls Mr. Zubôno
Zubôno's part to be played by Fujii Kunihiko
The parts of the twins, with hair parted on the side, to be played by Yamanaka Tetsuaki, and Azuma Ikki
Resembles an internal disaster. The dance of the man who drank ink
A light bulb comes walking in and sweats under a baton
A psycho-historical rarity eats canned foods
Accelerating space, it is simultaneously unreal and graphically and dynamically grotesque
The hungry musical instrument laughs
Chicken
Christmas decorations
Brand on the head
Magnesium
A man skewered by a needle
Wandering woman
Man swinging a baseball bat
Liquid air
Person wearing a birdcage who has been caught by a fishing pole
Tomato
The sound of the beating wings of one fly[113]

It is hardly possible to connect anything in this sketch with anything in the photographs. There is only enough information available for *Tomato* to note that the emphases on athleticism and interacting with neo-Dada artists persisted in this dance as well (in the ping-pong table, head stand, and wind chimes), and that this dance must have been somewhat like *Masseur* and *Rose-colored Dance*. The citation of Tezuka's Mickey Mouse Bat extends the genre mixing beyond the kitschy letterman jackets of the previous dances and into the realm of popular culture. Interestingly, it seems that something like a story was going on in *Tomato* (perhaps in Ôno's mind); it is just not clear what that story was.

METEMOTIONALPHYSICS

We have even less information about the 1967 dance *Metemotionalphysics* Hijikata choreographed with Takai Tomiko, with a title taken from Katô Ikuya's book of the same name. From the photos we can observe that instead of having actual men stand facing the backdrop, it was draped with silk-screens from the *General Catalogue of Males*, and that the heads of the men have been blotted out so that only their torsos and legs appear to face the backdrop. From the photographs, the dance seems to have been divided into scenes featuring different dancers or different costumes. A gaunt Hijikata came out riding on a cart (wearing a white bikini and on his head a gaudy flowered hat).[114] Nakanishi had painted on Hijikata's back a folded back trapezius muscle further revealing vertebrae, ribs, the right scapula, and the left coxal bone. Hijikata danced a solo, marked by near continual contortion of his torso. A masked dancer rode piggyback on two other bent-over dancers wearing thick frayed blankets, and blew a trumpet, while another stood on his hands (see figure 3.19). Joined by other dancers, Ôno (in braids and a ratty kimono) was carried around like a small child, set on a low table (which was overturned) and then attacked by something that looks like sheers or an umbrella. Hijikata (now in tight dark pants) appeared with Ôno and affixed an obi to Ôno's neck and jerked him this way and that, whereupon Ôno returned the favor. Takai Tomiko danced two solos and a duet with Kasai in which she wore mirrors affixed to her breasts—perhaps to turn back the sexualized gaze that Hijikata had been preoccupied with (see figure 3.20). Three dancers in plaster of Paris were joined by a snare drummer and a dancer with bellows affixed to his chest. Ichikawa notes that they continued the tube experiments by costuming teams of dancers, with one in a gas mask and the other outfitted with a set of double bellows.[115] The dancers who had on gas masks were supplied air by the one's with bellows attached to their chests.

After the tube dance in *Rose-colored Dance*, and knowing the history of the men who stood with their backs to the stage (which included a glance back to *Imperial Hotel Body: Shelter Plan*'s Cold War personalized bomb shelters), it is perhaps not unreasonable to see the gas masks as betraying a concern with the use of chemical weapons in the Vietnam War. Considering Mishima's notion that pervasive social structures are embedded even more deeply in bodies than in language, I suggest that we can see in Nakanishi's skeletal structure a concern in *Metemotionalphysics* with making bare the structures that constitute the body in both their physical and discursive manifestations.

A Story of Dances that Sustain Enigma 103

Figure 3.19 Trumpeter riding another dancer, *Metemotionalphysics* (Kinokuniya Hall, Tokyo, July 1967) by Nakatani Tadao. Courtesy of Nakatani Takashi and Morishita Takashi Butoh Materials, NPO, and the Research Center for the Arts and Arts Administration, Keio University.

Morishita concludes that in these two dances (*Tomato* and *Metemotionalphysics*), Hijikata was not able to make any advancement beyond *Rose-colored Dance* and *Masseur*, and so turned in a different direction as a result.[116] However, *Tomato* presents an important moment for butoh. The performance was called the "Dispersal Performance of the Dance [*butoh*] of Darkness School," and while it was not the first time the word "butoh" was used, it was from this point onward that Hijikata and others around him began to use the word exclusively. In fact, the word butoh was originally used from the late nineteenth century for Western dance styles such as the waltz, and had previously been used in 1963 on the flyer for *Leda* in the phrase, "Doers—Hijikata Tatsumi Dance [butoh] of Darkness Faction."

However, this was a onetime occurrence, and Hijikata had gone back to using the standard word for dance, *buyô*, in the name the "Dance of Darkness Faction" (*ankoku buyôha*) for the following dances. Kasai claimed credit for the resurrection of the term. He said that in 1966 he wanted to designate a dance in which one paid as much attention to the body as one did to the creation of the dance, so he proposed that they exclusively use a different word from *buyô* in order to indicate that they were trying to create a different kind of dance.[117] Ironically, it was at this point that Kasai, favoring improvisation and a more organic connection between movement and meaning than

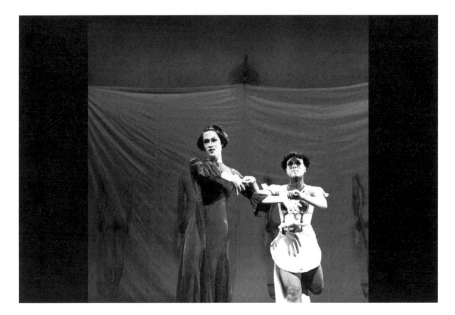

Figure 3.20　Takai Tomiko with mirrors on breasts, *Metemotionalphysics* (Kinokuniya Hall, Tokyo, July 1967) by Fujisaki Masaki. Courtesy of Morishita Takashi Butoh Materials, NPO, and the Research Center for the Arts and Arts Administration, Keio University.

even that implied by a dance called *Metemotionalphysics*, quit appearing in Hijikata's dances. However, both men continued to call their dance butoh.

In the previous chapter, I outlined the ways that Hijikata's dances changed as he began to struggle with how to expand the language of the body; how to fight the socialization of the body in an attempt to draw near to actuality; and how to hold the attention of the audience when he did not employ strong narratives in his dances. In the second phase of his career, in a society increasingly focused on athletic pursuits and coping with information overload in the context of economic competition and struggle, Hijikata turned to the question of how to use competition, both between artists and between artists and the audience, as an organizing principle and as a way to strengthen his dance. Undoubtedly the larger number of activities and the puzzles that the viewer was required to solve while watching a dance related back to that question. Just as the artists were implicitly exploring how to train and modify the body to prepare it for the competition it would inevitably face, the audience was required to be mentally malleable in the act of viewing the performance. The process of creating variety on stage and puzzles for the audience to solve allowed the various artists to invade each other's work, and at the same time burn themselves into world history.

4. Pivoting Panels and Slashing Space: Rebellion and Identity ❦

> *This seems a Home—and Home is not—*
> *But what that Place could be*
> *Afflicts me—as a Setting Sun—*
> *Where Dawn—knows how to be—*
>
> Emily Dickinson

The 1968 *Hijikata Tatsumi and Japanese People: Rebellion of the Body* was an outrageous spectacle, and it is seen generally to be a turning point in the evolution of Hijikata's dance. In truth, the dance does indeed occupy a middle position between the early dances and Hijikata's later, more complex and structured dances. It also marks a turning point in Hijikata's connection to his country of origin. However neither the transition in choreography nor in ethnic understanding has been sufficiently articulated. I begin by analyzing Hosoe Eikô's photographic exhibition that was advertised on the same poster as the dance, "Extravagantly Tragic Comedy: Photo Theater Starring a Japan Dancer and Genius (Hijikata Tatsumi)." I will then examine several comments by Hijikata about his sister and mother that have become well known in the study of Hijikata. I close with a reading of this important dance.

As explained in the introduction, the state along with the industrial-entertainment complex was grooming the Japanese people to fit into a small number of assigned roles in the creation of contemporary Japan. I argue that against the background of increasingly limited roles for Japanese people, *Hijikata Tatsumi and Japanese People: Rebellion of the Body* can be read as a rebellion against the wider citizen-as-consumer/producer molding-activities of the state and industrial-entertainment complex. The irony was that in the end, Hijikata was caught up in that vortex of mind-and-body malleation despite the high-water mark of bodily resistance that this dance represents. This irony is nowhere more obvious than in the contradiction in the dance between the rebellion of the body (which was being hemmed in on all sides), and Hijikata's use of the body as a musical, lighting, and projection instrument, and manipulation of the body and mind so as to increase their abilities. At the same time, the dance was an extended meditation on Hijikata's relationship to his country of origin and his fellow inhabitants, and an exploration of how he might begin to communicate with them.

"EXTRAVAGANTLY TRAGIC COMEDY: PHOTO THEATER STARRING A JAPAN DANCER AND GENIUS (HIJIKATA TATSUMI)"

It has now become almost axiomatic to argue that if Hijikata's rethinking of his relationship to Japan and Japanese people is manifest in the dance *Hijikata Tatsumi and Japanese People: Rebellion of the Body*, then this change stems from his trip to Tôhoku with Hosoe Eikô to shoot photographs in 1965. This may be accurate, but I would argue for a different reason than the one usually offered, which is that Hijikata had begun to celebrate his connection to Japanese ethnicity. In fact, the trip should be related to both halves of the title of the eventual dance, *Hijikata Tatsumi and Japanese People: Rebellion of the Body*, as the trip was conducted in a spirit of rebellion, a rebellion specifically aimed at one segment of Japan and Japanese people, the area and people of Hijikata's hometown in Tôhoku (northern Japan).

It may seem odd for scholars to have connected two events that were three years apart (the performance of the dance and the making of the photographs), but the photographs from this trip were eventually displayed at an exhibition entitled "Extravagantly Tragic Comedy: Photo Theater Starring a Japan Dancer and Genius (Hijikata Tatsumi)" in March and April of 1968.[1] The poster for the dance doubled as an advertisement for the photographic exhibition, so the dance and the photographs are connected despite the fact that many of the photographs were originally taken in 1965 and the dance was performed in 1968.

At the time, Hosoe Eikô proposed to Hijikata that they take a trip to northern Japan for a photographic shoot. During the carpet bombing of Tokyo in 1944, Hosoe had been evacuated to live with his relatives in Yamagata for his own protection, and he wanted to go back to the countryside to make a photographic record. Hosoe was not merely nostalgic. He wrote that while he liked the landscape, he "hated the country itself," because the kids from the country would tease the city-slicker evacuees. He also said, "I had the strange feeling, though, that I should not hate the land where my mother was born. If I hated it, I would hate my own mother." Thus, for Hosoe, the photographs were "an inner document of myself and my background in Japan."[2] In addition, Hosoe wrote:

> Can one really record memories with photographs? The only method that I have is through pictures. I am a photographer. However, the camera can only reflect the subject in front of it. Yet, there is a mountain of memories in the photographer who is behind the camera. Is not the true purpose of photographs to reflect what one cannot see with the eyes...? I had the deep feeling that I wanted at least to record my memories.[3]

We can see that Hosoe was even a little doubtful as to the success of the venture. Hijikata responded to Hosoe's request by taking him to a small town in the Akita prefecture called Tashiro in a larger precinct called Ugo-machi, about an hour away from where Hijikata had grown up. The Yoneyama family had originally lived in Tashiro, but Hijkata's branch of the family had long since left. However, the extended Yoneyama family still maintained an estate there.

Hosoe's pictures of Tashiro are electrifying. In one picture, Hijikata runs across the stubble of a rice field with a baby in his arms. In another, he seems to devour a

young girl among weeds and flowers. In yet another he leaps in the air in front of awed children. The kids' faces convey the sense that an unlooked for, yet precious, pied piper has disrupted their daily existence. The adults pictured also seem to enjoy the diversion from their daily grind. Hijikata sits with them by the side of the road, eating lunch and making faces, and later they carry him on a makeshift palanquin (perhaps a precursor to the later procession in *Hijikata Tatsumi and Japanese People: Rebellion of the Body*). Yet Hijikata also sits alone, hammer in hand, looking out from a house with tattered rice paper hanging from the windows. Is he there to repair the building or put more holes in it? He perches atop a *hase* (fence used for drying rice) looking intensely off into the distance. Is he there to face down the wind or to look longingly away from that small valley?

For three subsequent years, Hijikata and Hosoe traveled from place to place taking photographs: the foothills of Tsukuba Mountain, and Kame-ari and Shibamata of present-day Katushika-ku in Tokyo. A couple of photographs capture Hijikata's naked handstands by the light of the moon among the clods of a freshly ploughed field; in another he pulls a woman clad only in a skirt into a back alley. What is telling about the photographs is the stories they only half show. If Hosoe had come to record the country and the ambivalent feelings he had toward it as a child, he certainly got a slice of its life. Yet, as with so much else about Hijikata, there is an iceberg of detail left unrevealed.

One detail not shown is Hijikata's hometown. In three years of travel, they never made it to Akita, nor to Yonezawa in Yamagata where Hosoe had stayed during the war. Additionally, none of the participants in the shoot were acquaintances of either Hijikata or Hosoe. Tashiro was home to Hijikata's cousin, who happened to be the schoolteacher of the kids in the photographs.[4] No one knows if Hijikata was even aware that this cousin lived in Tashiro, but one thing is sure: Hijikata did not let anyone who was familiar with him know that he was planning to come, and, on arrival, did not seek out any acquaintances. Another observation is that the children are not in the same pictures as the adults (with a few exceptions). This is so because most of the adults had no idea that Hijikata and Hosoe had recruited the kids for a photographic shoot. The kids were too ashamed to say anything about their surreptitious day with the pied dancer from Tokyo. They were afraid that they would get in trouble for what they had done—apparently not realizing that the adults had been seduced as well.

At this point, one can see the outlines for the recipe of the Tashiro portion of the collection: the collection is not some unmediated contact between Hijikata and the countryside, but rather, it tracks the well-known narrative of a stranger disrupting a small town. This is in keeping with Hosoe's photographic philosophy. Hosoe takes photographs according to the principle of "putting one reality into another reality and creating a third reality." He likens photography to "the moment when a stone lands in water and begins to create ripples."[5] Elsewhere, Hosoe has also said that he forms hypotheses and then takes pictures as a way to test those hypotheses.[6] Thus, from Hosoe's perspective, we can begin to build up an understanding of this trip from three contradictory angles.

The photographs in the "Extravagantly Tragic Comedy: Photo Theater Starring a Japan Dancer and Genius (Hijikata Tatsumi)" were taken as an attempt to record

both the good and bad memories of a city boy being sent to the countryside—the loneliness he felt when mocked by the other kids, the scenic beauty he had seen, and the conflicting feelings he had toward the countryside because it was the hometown of his mother. It was also a hypothesis about Hijikata's dance and its origins (although the exact hypothesis was never clearly articulated), and finally it was an attempt to capture the moment of two realities colliding and forming a new third reality. Yet, by and large, what has been lost to those who have examined the collection (at least in so far as dance critics have been concerned) has been both Hosoe's clear and documented attempt to use the camera to examine his own past, and his advocacy of a photographic method that alters the world as much as it records it. This means that the only reading of this trip's place in butoh history is the one in which Hosoe proved a connection between butoh and Tôhoku, (or, in the more sophisticated versions, that Hosoe's reintroduction of Hijikata to Tôhoku caused Hijikata to begin thinking about Japan again).

Thus Hosoe. What of Hijikata? How did he see this photographic collection? Long before Hijikata and Hosoe made the trip to Tôhoku, Hijikata had already commented on Hosoe's craft in the 1960 essay, "Material":

> Hosoe Eikô, a photographer, showed up suddenly this summer at the "place of the body" and abruptly snatched me away. The seeds and I were packed in bags and, with cameras thrust against our chests, carried off to the Harumi wharves. His car seemed to be a Renault. Naked bodies, unpacked and lined up, willingly removed their underpants. Warehouses were sleeping at the stale scenes of murder. The huge spherical tanks of Tokyo Gas restrained terrorists' testicles to about the size of the glass balls in the necks of lemon soda bottles. In front of scraps and pieces of lauan in all shapes we were given an austere script of a myth. "To Algeria" was marked on our naked bodies and pebbles lodged between our toes. Our pace was quietly lowered. This man scrupulously shot the flowers in a vacant lot next to a slaughterhouse. The camera's eye is brutal. All the pores on our dancers' bodies were painted over with varnish and anything that could be called a hole stopped up. Pipes were installed in our buttocks and our breathing was likewise supplied by a Hosoe-style hand pump. Five inflated bodies flew over the Harumi wharves. The salty scent of the sea turned me into a foreigner. Beneath my eyes, the people of Tokyo were stains clinging to death. This young photographer, who is far removed from OB/GYN photographers, is fortunately an avid reader of the Marquis de Sade.[7]

Hijikata used the passive voice more than most other writers, but the use of the passive is especially marked in this passage.[8] Agency moves between the bodies themselves, the surrounding buildings, and the disembodied executor of all the passive sentences, but never resides with Hijikata and his fellow photographic subjects. The entire process, both the shooting of the film and the work of setting up the shots, renders the subjects of the photographs as passive. Hijikata also acknowledges that the "camera's eye is brutal." This brutality insures that rather than the photographer or the camera being a recorder of a preexisting reality, both either alter or create it.

Even photographing "flowers" in a vacant lot next to a slaughter house is not so much to record reality, as it is to append an interpretation onto reality, for, given the timing of the essay and the dance, the "flowers" of Hijikata's account probably correspond to either the photos Hosoe took in which he had the boys cover their genitalia

with flowers, or the embarrassed young high school boys that performed in the dance "Crowds of Flowers" at the first "Hijikata Tatsumi DANCE EXPERIENCE Gathering."

Hijikata was not dissatisfied with Hosoe's photographs because they failed to transparently record reality. On the contrary, he was delighted by them, for he was exactly interested in the ability of the camera to create something new. In a lecture much later in his life, Hijikata said:

> There is a photographic collection called *Kamaitachi* [Sickle-weasel] taken by Hosoe Eikô depicting me. This comes from a phenomenon of the skin ripping and blood spurting forth caused by a whirlwind resulting in a vacuum and differences in air pressure. The photographic collection was formed [on the assumption] that the pose of taking pictures was the sickle-weasel. It was not that I played the part of the sickle-weasel, but rather that the person who snapped the shutter was the sickle-weasel. Because it's a photographic collection taken with the purpose of slashing space, I have a real affection for it.[9]

Hijikata appears to be echoing Hosoe's understanding of how a photograph works. A "sickle-weasel" is the name for phenomenon in which one's skin is cut without having come in contact with anything. A folk explanation ascribes such wounds to a whirlwind (or a supernatural being such as an invisible weasel) lacerating the skin with a sickle.[10] Hijikata does not follow the folk understanding, but adopts a more scientific sounding explanation. In his version, the sickle-weasel is still a rending of the skin, but the phenomenon is produced by a vortex that produces a vacuum and variations in air pressure—that is to say, it is caused by introducing a whirlwind into a system. Hijikata goes on to say that in the case of the *Kamaitachi* collection, the photographer plays the part of the sickle-weasel. It appears that the photographer acts as the whirlwind, which in turn causes the rending of the skin. The photographer's whirlwind—the brutal eye of the camera—slices a rent in the current reality from which blood spurts forth.

It is clear that Hijikata thought of himself as merely Hosoe's stone thrown in the water that causes the waves to ripple outward, or as part of the tremendous variance in air pressure that goes into producing a fountain of blood. Thus, while part of Hosoe's purpose for going to Tôhoku was to record memories, Hijikata's purpose for going was to "slash space"—to be part of Hosoe's photographic process that would slash Tôhoku. Lest one think that this was only Hijikata's interpretation of the events long after they had happened, Hijikata made a similar comment to Suzuki Tadashi in 1977. Hijikata referred to his early crisis-demanding works in which Mishima had been involved, and then said, "later I went to a place where I was provoking the landscape."[11] The brutal eye of the camera, slashing space, provoking the landscape: over the span of twenty-five years, Hijikata's accounting of the photographic process was consistent in that he always understood the act of taking pictures as disruptive and always intended the act as an attack or provocation.

With that in mind, one has to go back to "Extravagantly Tragic Comedy: Photo Theater Starring a Japan Dancer and Genius (Hijikata Tatsumi)" and read it in light of the multimedia aspects of *Rose-colored Dance*. It is possible to see Hosoe's photographic exhibition as a successful multimedia hybrid performance, "unrestricted to

location in time or space."¹² As a record of what life must have been like for a city child confined by bombs to the country, it probably only half succeeds. It may convey some of the alienation that Hosoe felt at being relocated to the countryside, but Hijikata's character is too sure of himself to convey true alienation—although the photograph of Hijikata perched atop the rice-drying racks looking longingly into the distance perhaps comes close.

However, the exhibition succeeded in conveying precisely Hijikata's relationship with Tôhoku. It demonstrated that the roots of butoh lie in the desire to "slash space." It made obvious that a photographer and dancer can sneak into a community and convince the community to forsake its labors and routines for a day, which recalls Hijikata screed against production earlier in his career. It showed how the artists can incite children to misbehave. As a hypothesis about the connection between butoh and Tôhoku, one would have to say that it worked remarkably well. For it proved that Hijikata is at one level of air pressure and Tôhoku is at another, and that bringing them together will result in the spilling of blood.

The first trip to Tashiro was in 1965—the same year as *Rose-colored Dance*. Perhaps not coincidentally, that was also the dance in which photography and film played the most important role. A photographer and a filmmaker were allowed on stage to photograph and film the dancers close-up, and the dancers in turn photographed the audience. Thinking about slashing space allows us to revisit that dance to add a layer of nuance to our understanding. When the dancers photographed the people in the audience, they were trying to use the brutal eye of the camera to alter the audience in fundamental ways.

The fact that Hijikata wanted to use the camera to slash his Tokyo audience means that he was not just focused on critiquing or changing Tôhoku. He would have been fully aware of Tokyo and its range of humanity as well—of all its hypocrisies and its vitality. To say that Hijikata would not, could not, have felt comfortable with Tôhoku is not to say that he was somehow blinded by Tokyo. Hijikata occupied a liminal space; he knew the countryside and the city and took aim at both.

One can see the problem with Hijikata's and Hosoe's trip. If Hijikata had sent word to whomever was still around—old friends and remaining siblings—they would have looked for all sorts of fields where he could have frolicked at will on rice-drying fences. Yet, everything would have been different. Beyond the more obvious things such as catching up on ten years of old news (that would have cut into the time for artistic work) and having his cover blown (so he could not freely interact with the kids), there would have been the presence hanging over Hijikata of being watched by his family and old friends. There would have been the sense that sitting atop the rice-drying racks was a frivolous activity, one that would only have been engaged in by two city interlopers. Tôhoku would have been its own kind of vortex threatening to swallow Hijikata and to wring out of him everything non-Tôhoku, when it was just then that Hijikata wanted to wring the neck of Tôhoku instead. He would not have been able to slash or ravish Tôhoku because he would have been constrained by the reactions of the people around him; people who would not have been nearly as interested in provoking Tôhoku as he was.

Of course, Tôhoku remains a powerful vortex even today. Prophets are rarely honored in their own countries, especially if they come intending to rend skin and

spill blood. As such, certain elements of Tôhoku would like to heal Hijikata's rents and bring him back within a comfortable Tôhoku ambit.[13] However, undoubtedly Hijikata's butoh will continue to cause sickle-weasels and rifts of flesh to appear on the skin of both societies (Tôhoku and Tokyo) that spawned it.[14]

To return to the question of why Hijikata began to deal more directly with Japan in his works, one might conclude that this trip with Hosoe was indeed decisive. He had already been concerned with critiquing various elements of Japanese society or its conventions, and also implicitly aware of the background of competition and conflict within the society, but over time these two ideas were to be melded into a full-blown rebellion against society. This trip was the start of that process and it taught Hijikata two things. If he was going to slash Japan—to cause a sickle-weasel furrow to appear on the skin of Japan—he was going to have to engage Japan. As long as he created dances that were based on the novels of Lautréamont and Genet, or dances with people eating cake, there was going to be a sense in which people would think what he did was unrelated to Japan and Tôhoku. In addition, despite the fact that he obviously did not feel up to the fight of dealing with all his relatives and former friends, and despite the fact that it took him a long time to actually take the risk of exposing himself to the people of his past life, he learned that he could go to Tôhoku and slash it—begin the process of transforming it—and if, in the process, he himself was slashed, that was a risk he became increasingly willing to take.

"I KEEP AN OLDER SISTER LIVING INSIDE MY BODY"

During this period of his life, the topic of Hijikata and his hometown and his family came to be reflected in his public pronouncements as well. Sometime in 1967, Hijikata began to speak about one of his sisters, and in the following year, he began to speak about his mother. He was to revisit these themes over and over for the rest of his career, therefore, understanding what he was doing is crucial in understanding his wider project. These statements need to be seen in the context of Hijikata's visit to his hometown for the purpose of slashing space, and in the context of Hijikata's concern with how social forces manifest themselves on bodies.

Sometime in the mid- to late sixties, Hijikata first began to talk about an older sister having suddenly disappeared because she was sold into prostitution, and then having died. No one would deny that there were many women sold into prostitution during the prewar years. It was a common enough practice throughout Japanese history, but it turns out to be another of Hijikata's fictions.[15] The first time Hijikata mentioned this sister in print was in 1967, in a program for a dance that never took place.[16] In 1969, Hijikata published an essay that referred to his sister:

> Since my dead older sister started living within my body, things no longer work like that. My older sister, moreover, does not complain at all but only makes an inarticulate sound maybe twice a day. If she were to complain, she would no longer be a sister to me and, more than that, disaster would never again walk by my house.[17]

Here an uncomplaining dead sister, who can do little more than prattle like a baby, has taken up residence inside Hijikata. Strangely, were she to complain, disaster would cease to visit Hijikata. Given what Hijikata had said about death of male prostitutes making the choreographic task easier, it is not clear whether it would be good or bad for Hijikata if disaster never visited him again.

The more well-known version was written sometime before 1976:

> I keep an older sister living inside my body. When I am absorbed in creating a dance piece, she plucks the darkness from my body and eats more than is needed. When she stands up inside my body, I can't help but sit down. For me to fall is for her to fall. But there's even more to our relationship than that.[18]

Ever the recycler, Hijikata had already explored a similar theme in the 1961 essay "To Prison." In a discussion in which Hijikata says that he seeks out criminals because they are not part of the production-oriented society, he writes:

> First of all, I posit as a starting point a composition in which I stand and [the prisoners] are made to stand. I walk and they are made to walk. Suddenly they start to run and I too run. I fall down. They run. They get up without any injury from where they fell. Why does the place where I get up bleeding not match their place?[19]

The fact that Hijikata had already explored the same material in the context of writing about prisoners on death row is probably the strongest piece of evidence that he was being poetic rather than literal. In the 1961 version, Hijikata does not say that there is some direct tie between him and the prisoners, but rather that he conceives of a scenario in which how he acts impinges on how the prisoners act, and vice versa. Initially, they are forced to be imitative and reactive, but later they come to exercise their own volition, and he becomes imitative and reactive. Finally, the connection between the prisoners and him is severed, and he is left wondering why his actions have no effect on them.

After being depicted in 1969 as nearly mute, in 1976, it is his sister who has a reciprocal but inexact relationship with Hijikata in which some actions have exact counterparts in the other person while some actions seem to lead the other person to act, but in a different way. When Hijikata falls, his sister also falls, but when she stands, Hijikata rather contradictorily sits down—somewhat as with the prisoners. Here, Hijikata seems more interested in the question of how entities are related to and affect each other, rather than showing interest in some sort of shamanic possession of himself by his sister.

Considering the emphasis on the socialization of the body and the workings of force in *Forbidden Colors*, in which the man seems to be able to affect a change in the way the boy walks partly through the overt threat of violence, and partly through unseen power, the connections between Hijikata and the prisoners, or between Hijikata and his supposedly dead sister can be seen as another attempt to explore the ways that concepts and social forces connect and affect people and bodies.

Hijikata's imaginary plotline might be taken to point out the way that the actions of other people can affect us in ways that we do not totally control, and vice versa.

The issue of social forces and how they cause people to relate to each other enables us to unlock these passages as well as other passages. For example, in his pseudo-memoir titled *Ailing Terpsichore*, Hijikata wrote:

> There were also times when I became aware, when I suddenly looked inside the house, that a piece of furniture had disappeared. You have to pay attention to the furniture and utensils. It was from that time that the older sister that always sat on the veranda suddenly disappeared. I thought to myself: an older sister is the kind of thing that disappears out of a house suddenly.[20]

In this passage, the young narrator clearly casts the disappearance of the older sister in the context of poverty that impels people to sell all of their possessions. There is no mention in this passage of prostitution per se: it could easily be that older sisters "disappear" because they are married off without fanfare (also for economic reasons). Interestingly, after the narrator says that the older sister who sat on the veranda disappeared, he goes on to draw the conclusion that "an older sister is the kind of thing that" is apt to disappear. The sentence is striking for its nonspecificity. If you ran into this sentence out of context ("I thought to myself: an older sister is the kind of thing that disappears out of a house suddenly"), it would be easy to see it as a generalization about what happens to many older sisters. Interestingly, nowhere in Hijikata's discussions of his older sister does he ever use her name, perhaps adding to the sense that this is a generalization about the fate of more than one woman in his hometown.

Yet, there is a pointed critique here that does not even require the strategy of reading against the grain. By coupling Hijikata's generalization about the propensity of older sisters to disappear with his frequent claims that his family took him to modern dance performances, the fact that older sisters disappear becomes a vinegary commentary. It's almost as if Hijikata is obliquely suggesting the question: What kind of society or family sells an older sister to pay for the dance education of a younger son?

A similar dynamic holds for Hijikata's statements about his mother. In an interview conducted in 1968 by Shibusawa, Hijikata criticized Happenings, "Because there's no terror in what they do," even though he had certainly been involved in many Happenings in previous years. He continued:

> My father was a terrible ballad singer [*gidayû*], and he beat my mother. To my child's eyes, he seemed to be measuring the length of each step he took when he hit her. Now that truly was terror. And, in effect, I played the role of a child actor in it, with the neighborhood watching from a distance. When my mom ran outside, the neighbors would comment on the pattern of her kimono. I played a serious part in things like this for ten years.[21]

Shibusawa responds by designating this event as a "real Happening"—presumably because it incorporated terror—and Hijikata agrees. Again, we came up against the problem in evaluating Hijikata's statements about his pre-Tokyo life, but whether or not Hijikata's statements are factual, they still deserve to be taken seriously in terms of his performances, and here again, as is typical for Hijikata, this statement is packed with interesting elements.

It would certainly not be surprising if this were a report of the actual way that Hijikata's father treated his mother, and if so it is horrifying—and that horror is only

increased by Hijikata's confession that it looked like his father planned what he was doing ("he seemed to be measuring the length of each step he took"). Violence against women should not be more acceptable because it stems from blind rage, but Hijikata here seems to elevate his father's actions from third degree to coldly calculated first-degree violence. However, he does not stop there, but comments on the way that the community treats violent domestic disputes. When neighbors respond to a woman fleeing from spousal abuse by turning her plight into a fashion show, then perhaps a child learns to question whether or not the violence is all that harmful.

That is exactly the attitude with which the quotation begins: "My father was a terrible ballad singer, and he beat my mother" (*Boku no oyaji wa heta na gidayû o yatta no desu ga, ofukuro o naguru no desu*). The "and" here is *ga*, which would usually indicate a casual contrast or opposition between the first and second halves of the sentence captured by the word "but." However, in this case, the contrastive force is muted, leading to the use of "and." Either way, the attitude is strange. It could be "Although my father was a terrible singer, he beat my mother" (as if men who are poor singers tend not be wife-beaters), or "My father was a terrible singer, and he beat my mother" (as if this is just one more blithe example of some personal skill that Hijikata's father lacked). Either way, a troubling parity is evident between an artistic skill, and treatment of another person. However, the fact that the community turns the spousal abuse into an occasion for a fashion show makes the conflation of artistic skill and spousal treatment seem less surprising.

I argue that this event is transformed into a Happening, in the sense of incorporating terror, only at the moment when the neighbors ignore the violence and comment on the patterns on the mother's kimono. Their actions show that the actions of one individual (as horrific as they are) have a social basis beneath them that allows them to remain unquestioned. This leads to a crucial distinction. Aside from the issue of whether or not we can corroborate Hijikata's claims about his early years, Hijikata's point is more nuanced than "my father's hitting my mother caused me to make butoh" or "my sister's being sold into prostitution caused me to make butoh." It would be more accurate to say that, "the social environment that allows fathers to hit mothers without anyone remarking on it produces butoh"; "the social environment in which people turn spousal abuse into an occasion for fashion commentary produces butoh"; or "the social environment in which daughters get sold into prostitution to subsidize the dance education of sons produces butoh."

There is a further connection to draw between Hijikata's desire to return to his home town in Akita and slash space, and his statements about his older sister, the prisoners, and his mother. Given all the various ways in which Hijikata had been critical of elements of Japan up to that point, it is not surprising to find out that he was critical of the way that society treated women. His initial search for actuality was based on a notion that concepts were controlling the way people thought and acted, and Hijikata had been endeavoring to find a way beyond concepts to actuality. In these statements, concepts about the role of women certainly dictated how Hijikata presented this (possibly fictional) community's response to spousal abuse.

Thus, the search for actuality and the critical attitude toward socialization overlapped, because both involved understanding the process of socialization. Moreover, the yearning to find one's way beyond or outside of socialization could then extend in

principle to a kind of utopian dream of human interaction beyond these same socializations. Hijikata, however, was not only concerned with how the larger community was socialized, but also was clearly thinking through how he himself was affected by other people. So several ideas come together: criticism of the community, and socialization of self and community. The idea of specifically engaging Japan and in so doing slashing space was not because of some uncritical nostalgia for his youth, but stemmed from a deeply aware critical spirit that had no interest in laudatory description. Hijikata was committed to exposing the pain and suffering, either hidden or on fashion display in Japan, and then rebelling against it.

HIJIKATA TATSUMI AND JAPANESE PEOPLE: REBELLION OF THE BODY

It was into this era of change in Hijikata's personal life and in the wider society that *Hijikata Tatsumi and Japanese People: Rebellion of the Body* exploded in October 1968.[22] The major source of information about the dance is Nakamura Hiroshi's 8-millimeter filmstrip.[23] Obviously, for a program that probably lasted at least an hour and a half, twenty minutes is not a very comprehensive record, but Nakamura captures enough of the dance that we can appreciate its explosive nature. Although the filmstrip is silent, we know from other sources that the score for the dance combined harsh motorcycle engine noises with a person playing classical music on a piano at the side of the stage.

The stage was backed by six brass panels and flanked by a white upright piano and a black grand piano.[24] Four of the brass panels were raised up into the air and then allowed to crash to the ground, and then all were suspended in the air and could rotate freely. After a miniature airplane fastened to a wire circled above the audience and then crashed into the brass panels, Hijikata entered the auditorium lying on a cart carried through the audience by four stagehands, accompanied by a orchestral version of Ray Evans and Jay Livingston's "Mona Lisa." He was wearing a dazzlingly white full-sleeved bridal kimono backward and covered with a cape, and sported a goatee and long hair that was coiled tightly in a bun.

Spotlights affixed to the cart lit Hijikata from beneath once he stood up. His palanquin was part of a procession rounded out by stagehands carrying a revolving lighted barbershop pole, a crib with a live pig inside (which had a smaller canopy above it), a live rabbit in a wok atop a pole, and a Honda Port Club motorcycle engine (see figure 4.1). The procession progressed to a waiting canopy with four walls of sheer mosquito netting hanging from the sides, which was affixed atop the cart. Hijikata stood up and, holding onto the ropes of the canopy for support, swayed back and forth. He gestured out to the audience almost as if he were waving to them as would a beauty queen in a parade. At one moment in the procession, he bit one of the canopy cords. When the procession reached the stage, Hijikata dismounted and took his place on stage.

The dance proper can be divided (at least for the purposes of analysis) into discreet scenes based upon Hijikata's costumes, which presumably represented different characters, and were altered slightly from the first night to the second night. In the first

116 *Hijikata Tatsumi and Butoh*

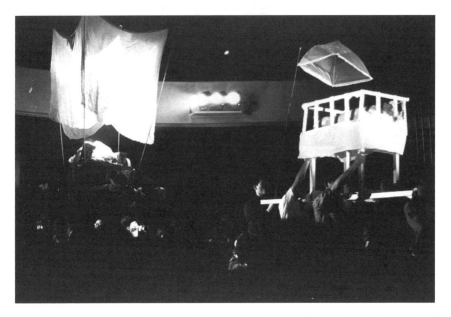

Figure 4.1 Procession with cart and pig, *Hijikata Tatsumi and Japanese People: Rebellion of the Body*, (Nihon Seinenkan, Tokyo, Oct. 1968) by Nakatani Tadao. Courtesy of Nakatani Takashi and Morishita Takashi Butoh Materials, NPO, and the Research Center for the Arts and Arts Administration, Keio University.

scene, after having dismounted from the cart, Hijikata spent several moments facing the audience with his arms held slightly away from his sides and his head hanging down. Then he danced in his white kimono—his shoulders often hunched close to his ears. Next, he reached behind his head and undid the bun and allowed his long hair to hang ragged (see figure 4.2).

Disrobing, he exposed a naked, gaunt, muscled body, a golden phallus about ten inches in length, and shaggy black pubic hair (see figure 4.3). He thrust the tip of the phallus over and over—body undulating, shoulders contracting and expanding, and arms flailing at his sides. The movements fluctuated in scope—sometimes his body would merely ripple, and sometimes he would bend almost in half and then thrust powerfully forward. He pranced around the stage, sometimes by the side of an upright piano, and also in front of five or six large brass panels hanging at the back of the stage that reflected his gyrations as if he was dancing in front of a mirror. Crashing into the panels, he set them spinning and swinging dangerously.

Next, he bent over and put his right shoulder and the side of his head on the floor, and using his shoulder as a pivot, ran his legs around his body, crawling and turning simultaneously as if to corkscrew himself into the ground. Finally he flattened out and, after having humped the ground for a moment, stretched out on his side with his legs held together and toes extended. When he arose, he approached one of the brass panels at the back of the stage and spun it, revealing a chicken hanging upside down on the reverse side. Hijikata grabbed at the rooster as if to pull on its neck and choke it. Then he resumed thrusting the phallus in and out beside the brass panel—his reflected doppelganger thrusting directly by his side.

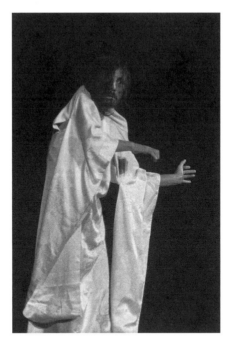

Figure 4.2 Hijikata Tatsumi in white backward bridal kimono, *Hijikata Tatsumi and Japanese People: Rebellion of the Body*, by Torii Ryôzen. Courtesy of Morishita Takashi Butoh Materials, NPO, and the Research Center for the Arts and Arts Administration, Keio University

Subsequently, he bent over and swung both arms back and forth as if he were a standing long jumper preparing to jump. Sometimes, the spotlight would be carefully trained on one of the panels. As he danced in front of it, lit from behind, only his silhouette (with erection) would show. Other accounts of this segment record Hijikata taking off the phallus and using it to flog the brass panels.[25]

After a costume change, he appeared in a sumptuous full-length shiny (satin?) red gown and black rubber gloves (see figure 4.4). Some of the movements in this section vaguely resembled flamenco, but there was also movement characteristic of the muscle atrophy and deformity of people who have polio or scoliosis. He spun, letting centripetal force fan the dress behind him, and fawned lasciviously over the side of the piano. After some time, he unclipped the bottom half of the dress, which fell to the ground. Clothed only in the top half of the dress, he danced similar movements as before, including returning to the panels, and setting them whirling. Then picking up the skirt, he flogged the ground repeatedly with it, first to one side and then to the other. He also hopped around and prostrated himself on the ground with his head hidden in the skirt.

In the next section, Hijikata appeared in a rather plain thigh-length red T-shirt dress worn beneath a girdle with a ruffled can-can skirt tied over the top (see figure 4.5). Some of the steps he took are reminiscent of the way The Monkees walked in their television show—lifting one leg forward, swinging it out to the side, dropping it, and repeating the process with the other leg. He repeated movements from the

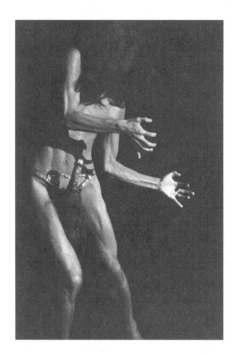

Figure 4.3 Hijikata with golden phallus, *Hijikata Tatsumi and Japanese People: Rebellion of the Body*, by Torii Ryôzen. Courtesy of Morishita Takashi Butoh Materials, NPO, and the Research Center for the Arts and Arts Administration, Keio University.

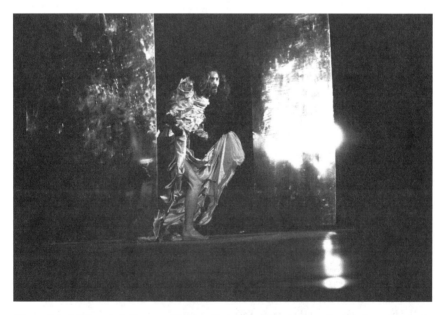

Figure 4.4 Hijikata in ball gown, *Hijikata Tatsumi and Japanese People: Rebellion of the Body*, by Nakatani Tadao. Courtesy of Nakatani Takashi and Morishita Takashi Butoh Materials, NPO, and the Research Center for the Arts and Arts Administration, Keio University.

Pivoting Panels and Slashing Space 119

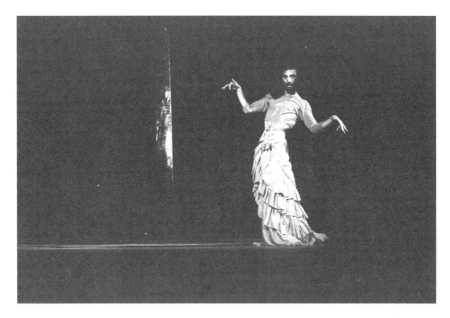

Figure 4.5 Hijikata in T-shirt dress and can can skirt, *Hijikata Tatsumi and Japanese People: Rebellion of the Body*, by Nakatani Tadao. Courtesy of Nakatani Takashi and Morishita Takashi Butoh Materials, NPO, and the Research Center for the Arts and Arts Administration, Keio University.

previous scene, including twirling the skirt, and after removing the skirt, flogging the floor. He also executed a strange leaned-back walk in which he brought one knee up while dropping his weight on his other leg, so that as his knee rose his pelvis dropped.

Yet another costume change resulted in Hijikata appearing in a short thigh-length kimono and knee-high athletic socks (see figure 4.6). One arm was threaded properly through the kimono sleeve, but the other arm was not, leaving the sleeve hanging behind him. He spent several minutes squatting on the ground—almost as if he had stopped to smoke a cigarette—and repeated the strange walk in which his leg came up as his center of gravity lowered. New movements then suggested a handicapped person, including one in which he used his hands with pinkie finger and thumb extended and other fingers clenched like a surfer's "hang loose" sign. Then he executed a bouncing movement (somewhat like American cheerleaders) in which he jumped up, leading with his left foot and then landed first on his left foot. He might then have followed this jump with another jump in which he again led first with his left foot (and landed on his left foot), or perhaps he would have altered that and led first with his right foot (and landed on his right foot).

Finally, Hijikata lay down on an outstretched panel and was strung up by three ropes—one on each arm and one binding both legs together—and raised above the seats of the auditorium (see figure 4.7). The ropes were not very steady, and thus he was pulled back and forth and raised higher and lower depending on how taut the

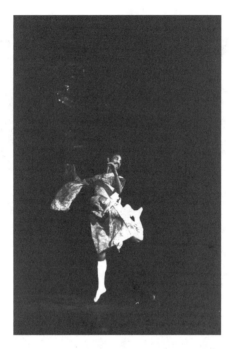

Figure 4.6 Hijikata as young girl, *Hijikata Tatsumi and Japanese People: Rebellion of the Body*, by Nakatani Tadao. Courtesy of Nakatani Takashi and Morishita Takashi Butoh Materials, NPO, and the Research Center for the Arts and Arts Administration, Keio University.

ropes were. On one night, one of the ropes broke and he sagged dangerously, but was not hurt. Finally, he was lowered to the ground, and remounted the cart waiting for him. He stood and was carried back onto the stage, where he held a fish in his mouth. Holding out his hands, he acknowledged the applause and gathered flowers thrown from the audience.

A look at the available photographs allows us to add at least one more scene to this mix. In this scene, Hijikata sported a sharp white suit and white top hat with streamers attached to the right shoulder (see figure 4.8). If the order of available photographs in various collections is to be trusted, this scene should come between the scenes with T-shirt dress and the short kimono. Also, some photos make it appear that Hijikata took off the short kimono at the end of the short kimono scene, which would have turned him back into an older looking man.

Using costumes and props to identify sections of the dance, we can outline the dance as follows:

Procession
White kimono and white cape
(Detach cape)
Naked with phallus
(Detach phallus)
Sumptuous red dress with black gloves

Pivoting Panels and Slashing Space 121

Figure 4.7 Ascension, *Hijikata Tatsumi and Japanese People: Rebellion of the Body*, by Hasegawa Roku. Courtesy of Hasegawa Roku and Morishita Takashi Butoh Materials, NPO, and the Research Center for the Arts and Arts Administration, Keio University.

(Detach skirt)
Red T-shirt dress and ruffled can-can skirt
(Detach skirt)
Sharp white suit with streamers
Short kimono with athletic socks
Outstretched on panel
Ascension
Procession/Finale

INTERPRETING *HIJIKATA TATSUMI AND JAPANESE PEOPLE: REBELLION OF THE BODY*

This book opened with a short description of *Hijikata Tatsumi and Japanese People: Rebellion of the Body*, but it now should be even more obvious what a striking and startling dance it was. In the introduction, I proposed the necessity of reading this dance in the light of all four terms of its title, *Hijikata Tatsumi and Japanese People: Rebellion of the Body*. The first term is Hijikata's full name. In an interview with Shibusawa in early 1968, Hijikata told Shibusawa,

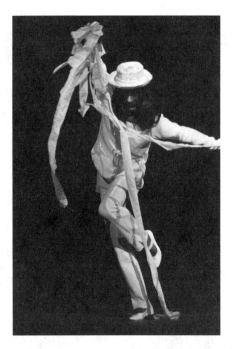

Figure 4.8 Hijikata in white suit, *Hijikata Tatsumi and Japanese People: Rebellion of the Body*, by Nakatani Tadao. Courtesy of Nakatani Takashi and Morishita Takashi Butoh Materials, NPO, and the Research Center for the Arts and Arts Administration, Keio University.

> I strongly feel that I've reached the age when I must definitely do Hijikata Tatsumi by Hijikata Tatsumi. But I am not at all the kind of person who stores up a plan in my gut for how to live my life. That is to say, I don't have a vision.[26]

Hijikata was commenting here on the June recital of Ishii Mitsutaka, *Excerpts from O-Genet*, in which he had danced two solos. Later in October, he turned these solos into sections of *Hijikata Tatsumi and Japanese People: Rebellion of the Body*. So, although he was not referring here to the October dance per se, the issue of what constituted Hijikata Tatsumi was on his mind—which is in keeping with his focus on thinking about how the actions of other people affect him, and how the conventions of the world socialized him—but it seems that Hijikata had no firm answer to what constituted Hijikata.

If Hijikata was exploring who he was, this allows a first stab at interpreting this dance. Who are these characters that appear one after another in succession in the dance? On the one hand, perhaps they were physical manifestations of parts of Hijikata or latent Hijikatas that had not materialized due to prevailing social norms. If so, then the rebellion of the title would be a rebellion against societal conventions (which squeeze a person down into one singular identity, rather than allowing a person to live a range of identities).

On the other hand, if considered in light of the second term in the title, "Japanese People," perhaps these characters were also dance representations of people who had affected Hijikata in some way. If so, it demonstrates that, in keeping with Hijikata's

concern with the effect of epistemic structures on bodies, he was interested in what aspects of his own life had been influenced by those around him. If that were the case, the dance could be thought of as the equivalent of Hijikata saying, "I keep numerous people living in my body, and when they move I also move. When they stand, I stand. When they writhe, I writhe. When they dance, I dance."

The possibility that this series of people represent those who have had an affect on Hijikata points us to a consideration of the second term in the title: "Japanese People." Implicit in any consideration of an ethnic group or people within a national boundary is the question of whether any of those people share unifying characteristics. If this series of characters who affected Hijikata is a series of Japanese characters, then one would have to conclude that there is not much that they all share. There would be the fragile Japanese old woman, the Japanese nude gyrating man, the flamboyant Japanese flamenco dancer, the Japanese man in a white suit, and the bouncy Japanese girl. To be sure there is nothing in the dance that definitively indicates that they are Japanese people, but that was likely Hijikata's point. Even a kimono is not a good indicator that the wearer is or is not Japanese.

We might even revisit the latter part of the title and retranslate it as "Rebellion(s) of Bodies," because it is not at all obvious that only one body (Japanese or otherwise) is indicated by the title, nor that the rebellion indicated is a unitary enterprise. More generally, it is a truism that the category "Japanese people" picks out a group that has about as much in common as the previously invoked surrealist formula of Lautréamont about an umbrella and sewing machine meeting on an operating table. Given Hijikata's surreal collocations of disparate elements, it would not be farfetched to substitute for the first half of the title "Hijikata Tatsumi and Japanese People," "Hijikata Tatsumi and umbrellas and sewing machines." It is true that the ethnic marker possesses a weightiness (perhaps against which Hijikata was rebelling), but Hijikata seems to have realized that even that ethnic marker did not encapsulate a homogeneous group of people, and presented a wide array of characters who could all fit under the category "Japanese."

In a contemporaneous interview with Tomioka Taeko, Hijikata asserted that "No one has yet defined Japanese dance," and then, "I am the origin of Japanese dance."[27] To make the audacious proclamation at this point in history that no one had yet defined Japanese dance and that he was the origin of it, perhaps shows that Hijikata did not think that it was possible to come up with one set of criteria by which one could define Japanese dance, and certainly shows that he wanted to take part in the definition of Japanese dance or Japaneseness.

The possibility that Hijikata was dancing representations of many Japanese people and that thus more than one person is part of the rebellion of the body brings us to the "rebellion" of the title.[28] It is not immediately obvious from the title or the dance exactly what Hijjikata intended for the dance to be a rebellion against. However, there are certain clues that can provide possible referents for Hijikata's rebellion.

Heliogabalus and Western Dance Movements

The Roman emperor Heliogabalus/Elegabalus (Marcus Aurelius Antoninus, 203–222 B.C.E., regnant 218–222) was apparently one of Hijikata's starting points when making *Hijikata Tatsumi and Japanese People: Rebellion of the Body*.[29] It appears that

the direct source for Hijikata's knowledge of Heliogabalus comes from the works of Shibusawa, who in 1962 had published a translation of Joris-Karl Huysmans' *À Rebours* (in which the narrator muses on the contrast between the monastic Tertullian and the supposedly decadent Elagabalus).[30] In 1962, Shibusawa also wrote an article about the Roman emperor.[31] Shibusawa had gained much of his information about Heliogabalus from Antonin Artaud's book, *Heliogabalus, or The Anarchist Crowned* (*Héliogabale, ou, l'Anarchiste couronné*). The lens of Artaud (and his version of Heliogabalus) can aid us in understanding much of the complex and contradictory elements of this dance and some of the characteristics of Hijikata's dances in general.

Kurihara notes that Artaud's *The Theater and its Double* was translated into Japanese in 1965, and widely read by a generation of performers.[32] Given the ways that Hijikata and his cohorts were seeking to narrow the distance between themselves and their audiences through a total theater of shocking, engaging multisensory performances (including sounds, lights, and smells), it seems as though these avant-garde dancers must have been aware of Artaud from early on.[33] Certainly, Artaud's idea of a total theater, or a theater of cruelty, that "wakes us up: nerves and heart" finds a counterpart in Hijikata's dance.[34] However, as Hijikata did not specifically cite Artaud until this point in his career, I have chosen to wait until this moment to address the relationship between Artaud and Hijikata.[35]

Artaud's vision of Heliogabalus is of a cross-dressing, self-prostituting, bisexual ruler who tries to undermine the very institutions that supported him in his rise to power including the police force, the legislature, the military, the aristocracy, and the charisma of the position he holds. He appoints a dancer to lead the police force, tries to humiliate the monarchy, banishes men from the senate and replaces them with women, forsakes war, reveals himself to all eyes (thereby dispelling any mystique that might have accrued to him as emperor), reminds the senators that they are slaves in togas, and castrates and flogs nobles, aristocrats, and other parasites of the palace.[36] As we might expect, there is nothing comforting about Hijikata's citation of Artaud's Heliogabalus. To situate Hijikata's dance against the background of Heliogabalus is to ratchet up the rebellion to the level of a screaming motorcycle engine. It is not just that Artaud's Heliogabalus stands for an upheaval of norms, but that he stands for a rebellion that has the potential to affect every aspect of life. We need to read Hijikata's appropriation of Artaud in *Hijikata Tatsumi and Japanese People: Rebellion of the Body* as indicating a rebellion against a similarly wide range of targets including gender roles, social mores, political structures, national identity, and nation-state relations, and as threatening all of them with fundamental transformation or even destruction. In short, the rebellion of the body should be thought of as directed toward the conventions of any part of Japanese or Western culture that binds the body.

In his discussion of postwar Japanese theater, Peter Eckersall points out that we no longer put much faith in Artaud's "primal expression that is unmediated by culture," and in that sense, a rebellion that is patterned after that of Heliogabalus is as destined to fail as Heliobgablaus himself did when he was assassinated after four years on the throne.[37] In a sense, Artaud advocated reducing everything to flashing lights and a

primal scream, but failed to account for the mechanism by which the scream and flashing lights would bring about the change he desired. Hijikata, by contrast, was not only at a period of his life in which he was propelled into a rebellion against the hurtful conventions around him, he was also thinking about his relationship to other people. Relationships with others always take place on a temporal axis with a past and a future, and so Hijikata was going to have to think about how to step beyond a primal scream in order to communicate with other people.

Nevertheless, Hijikata's use of Heliogabalus can provide another answer to the question: "Who are these characters? This naked gyrating man; this young girl wearing socks." Perhaps this is the celebration of the coronation of Heliogabalus, or just any celebration from his four-year reign. Artaud envisions Heliogabalus, "his member dipped in gold, all gold-covered, immovable, rigid, useless, innocuous," in a triumphal procession toward Rome accompanied by "flautists, pipers, lutanists, and the smiters of Assyrian cymbals" and guarded by 50,000 cavalrymen.[38] Perhaps Heliogabalus comes by on his palanquin and people join the spectacle. A young girl hops up and down in excitement. Two older women take off their skirts and wave them wildly. A man with a top hat joins in the merriment.[39]

Whether these characters were aspects of Hijikata, fellow Japanese people, or onlookers of a Roman procession, the most striking thing about this dance was clearly the figure of a naked man, sporting a golden phallus, gyrating and running about the stage. Murobushi Kô remembers the section in which Hijikata danced with the phallus as the longest section of the work (and it is clearly the longest section of the surviving footage), and he thought of Hijikata's use of an erect phallus as a commentary on the then current idea of the eternal revolution (*eien no kakumei*).[40] Yumiko Iida traces the idea of the "eternal revolution" in Japan to noted political scientist Maruyama Masao, who thought of democracy as continually "adjusting itself to an ever changing set of social circumstances and demands…" through the actions of a "subject motivated to improve his or her condition by partaking in politics."[41] It is standard to suppose that the failure of the protests against the United States–Japan Mutual Security Treaty drove a wedge into the political participation of many of the artists of the era, but connecting Hijikata's eternal erection to Maruyama's eternal revolution can aid us in reading this dance and understanding how Hijikata reacted to that era of protest.[42]

If Murobushi's interpretation is correct, it is interesting that the naked man could not maintain an eternal erection by himself, but needed a prosthetic device, and also interesting that Artuad saw Heliogabalus' erect gold-coated member as "useless, innocuous." This invites the question: What does one need to carry on the erection/revolution over an extended period of time? Eventually the phallus fell off (or Hijikata took it off), and Hijikata used it to flog the brass panels. But even that use of the phallus was not sustainable, and Hijikata left the phallus by the wayside and began to cycle through other characters. The fact that the naked man stops gyrating and changes costumes might indicate another way to see all these characters. The dance would indicate that at some point the eternal revolution must proceed by other means and include other people—even those who might not be thought of as prime candidates to assist in the struggle, for example, young cheerleader types, or

flamenco dancers. If Murobushi is right, it is possible to read Hijikata's transformations as indicating the various possible comrades in a widening rebellion. The first part of the title of the dance could mean something like "Hijikata Tatsumi and Fellow-Rebels"—ideally fellow Japanese rebels since that was the society he was in.

Using the Body "You can't just use"

The second half of the title advertised this dance as not just a simple rebellion, but as a "Rebellion of the Body." However, the body occupied strange place in this dance. From the time of the performance Hijikata was interpreted as having found a way to access the pure primal body. Morishita Takashi notes that the following year, Kanai Mieko read Hijikata's twitching and convulsing in light of the phenomenology of Merleau-Ponty, and argued that Hijikata was attempting to perform a phenomenological reduction of the body to return it to its pristine state before all the accretions of convention.[43] Donald Richie recalls Hijikata saying "You can't just use the body, you know. It has its own life, you see, a mind of its own."[44] Refusing to use the body may have been Hijikata's intent, but there is a gap between this goal (if it was his goal), and the actual execution, and to understand that gap, a look at the brass panels is in order.

Another remarkable aspect of the dance was the spinning brass panels and the man clanging into them. One can reach far back into Hijikata's career to find the seed for these panels. Motofuji reproduces a plan Hijikata had for a dance early in his career (the exact year is not known, but given the experimental nature of the proposal, probably at the end of 1960). Motofuji writes that Hijikata was unable to implement the plan at the time, but that he recycled it for *Hijikata Tatsumi and Japanese People: Rebellion of the Body*.[45]

> —As orchestra—30 [male and female] Japanese high school students a piece for a total of 60.
>
> —Costume—shoes, socks, pants, belt, jacket, collar, and hat. It is acceptable if the students wear the uniforms from the schools to which they belong, however, they must polish the jacket buttons.
>
> —The female students enter in female uniforms (as above) with their ribbons properly tied. Head, chest, both boys and girls will wear exercise shoes. In case of those who take off their jackets, both boys and girls will wear white shirts or blouses. They will fold a perfectly clean white handkerchief and place it in their breast pocket.
>
> —Male and female high school students will carry brass panels of 3 millimeters thickness, 60 centimeters width, and 1 meter 10 centimeters length. [20 inches by 44 inches]
>
> —We will also need ten brass panels of 2 meters length and 1.5 meters width. [6 feet by 4.5 feet]
>
> —Pursue with spotlights small metal planks tied to the feet of ten birds. Render visible and perceptible the music conveyed in that space. Bird chasing music.
>
> Aim
>
> A. In this dance performance, which will be carried out as if being watched by the body, dance-ness provided externally as exercise will be completely expelled from the surface of the body.

Because it is a reduction to the pure body, it is probably appropriate to think of this dance performance as providing an address in the body as we uncouple from the individuals the names and addresses that they belong to. It is not a matter of what to do, but rather a matter of what has been done to them. You can interpret this as the body being plunged into by the world in this case. In this work, we do not command the body, we have the intention of making a body and for this reason we use high school students.

B. Japanese grade school songs, and a chorus of brass panels held in the hands of high school students.

C. The small metal panels suddenly become a screen. The images that are shown will be continually refreshed as images by being severed, carried, multiplied, buried, run, and thrown by these disconnected panels. This is not a depiction of the corpse of actions; it should be possible to grasp for the first time there [on the screen] the scattered body which was dissected and recombined by the screen itself. The students that have the small screens should fulfill the function of a projector. Because the screen consists of the small brass panels, a simultaneous improvisational broadcast will also take place.

—The music carried throughout the space by birds will inevitably begin to move through the reverberations of the brass panels and the echo of the body-ology. We will use spotlights to make these float distinctly.

—Two people will be assigned to carry each large aluminium panel, and two panels will form a paired enclosure. In between pairs, high school students with their jackets stripped off will smash their bodies against the brass panels. At this juncture, modern music is desirable. The aim is to expand the reverberations of the brass panels and the raw flesh by blending it with modern music. The mirror-esque racquet-like brass panels and the bodies of the high school students that get thrown back and forth like a ball between the brass panels will be able to clearly delineate the fever and confusion of young bodies.

—The handkerchiefs are only for wiping away sweat.

—The work will take shape concretely at the point at which the overlapping of doing nothing and fierce motion surpasses the ideal superfluous experiment. One of the goals of this plan is to capture the bodies of the clear and unparalleled Japanese high school students, but the main point of the project is to create the body as a music instrument, a dance instrument, a lighting instrument, and a projection instrument.

—This work will be extinguished after 45 minutes, but the catch is that night students with batons will repeat the exact same movements in the dark continuing to perform their flashing movements in the light of the polished brass panels. Total time will continue for one hour and ten minutes.

As impressive as *Hijikata Tatsumi and Japanese People: Rebellion of the Body* was, it would indeed have been even more momentous in dance history if Hijikata had been able to pull off this vision of sixty high school students flashing, clanging, and bouncing off brass panels while ten birds fluttered around the stage with tiny brass panels bound to their legs.

Some of the issues that must have been preoccupying Hijikata from early on are reflected here, as well as some of the goals he must have had for *Hijikata Tatsumi and Japanese People: Rebellion of the Body*—one of which was, in the words from his earlier

plan, "to create the body as a musical instrument, a dance instrument, a lighting instrument, and a projection instrument." In keeping with Hijikata's aim to expand the vocabulary of the body, he sought to enable the body to be a musical instrument, lighting instrument, and a projection instrument.

One might observe that it was not the body per se that was a musical, lighting, or projection instrument, but rather it was the brass panels that filled that role, with the caveat that in both cases Hijikata conceived of using the body to play the panels much as if the body were a violin bow or a drumstick to be used to elicit sound from a musical instrument. In order for the brass panels to be musical instruments, the body was to smash into the brass panels, creating sonorous bongs. Similarly, for the purposes of lighting or projection, the body would have to serve as the focusing element—the body would do the job of orienting the panels so that they could reflect light or images in the proper direction, or spin the panels so that the light would reflect all over the hall.

This vision of dance is in line with Artaud. His screed against Western theater in *The Theater of Cruelty* attacked it for having become overly focused on sterile eat-your-spinach significance at the expense of spectacle. Hijikata's response was to propose (and later mount) an unsurpassed spectacle, perhaps showing that he been thinking about Artaud long before he publicly cited him. However, there was something contradictory about the way Hijikata conceived of the body (and this points out a general problem in Hijikata's oeuvre). There was often a gap between Hijikata's stated goals with respect to treatment of the body, and his actual practice. Specifically, I refer here to thinking of the body as the equivalent of a violin bow. Hijikata had claimed that his original plan would result in "a reduction to the pure body." It is contradictory to say that the body has a life of its own, and that you are going to achieve a reduction to the pure body, and then use the body as a drumstick or a focusing element.

It may well be that the second part of the title of the dance, "Rebellion of the Body," was intended to indicate a rebellion against using the body without recognizing that it has "a mind of its own" (as Hijikata had asserted to Donald Richie), but in this dance the body found itself in a position where once again it was utilized for purposes other than expression of its own reality—that is, Hijikata used the body to create a spectacle of light and sound. Perhaps despite the title, Hijikata was more attuned to the task of creating a memorable spectacle through the flashing of lights and clanging noises than he was to liberating his own body from its strictures.

The same gap is reflected in a conversation Hijikata had with Shibusawa. In it he attacks other artists for overlooking the element of dance-ness in the various arts, and then continues:

> HIJIKATA: They forget it, then wallow in the indiscriminate use of the word "body." And in their works I can see devices to use the body for some actions. When I listen to people who express themselves through words talk about the "body," I'd have to say offhand there's not much that I can do for them. Butoh dancers have got to position their bodies so that no one is able to guess their next movement.
> SHIBUSAWA: What do you mean by "use the body for some actions"?

HIJIKATA: It's what you see in Happenings or in the current *Shingeki* [new theatre], where the body is used as a kind of detonating power, which I find pretty questionable.[46]

Later in the conversation, this exchange occurs:

HIJIKATA: When I seriously consider the training of a butoh dancer, I think that what's important are the kinds of movements which come from joints being displaced, then from the disjointed leg striving to reach the other leg for two or three steps.
SHIBUSAWA: Does a dancer then become an *objet* of sorts?
HIJIKATA: That's right.[47]

After having first criticized those who "use the body for some actions" or as a "detonating power," Hijikata turns to his butoh training in which joints are displaced. It is not immediately clear how one can manipulate the body in order to displace the joints without at the same time using the body. When Shibusawa asks for clarification on whether the body becomes an *objet*, Hijikata replies in the affirmative. Hijikata's commentary on the displacement of joints might be seen to indicate that even movements that are taken to be most natural—such as the way an arm rotates in the shoulder socket—are also subject to cultural or social pressures, so it takes a concerted effort to break out of those patterns, and in order to do so the dancer must become an *objet*.

Moreover, when considered in light of the earlier impression that each joint of the body worked as a separate entity, and Hijikata's earlier idea of "not bending joints in the way they are used to," it appears that the attempt to find actuality beyond conventions (that hem in the body) is related to the drive to find the real primal body. It is ironic that finding actuality (and the primal body) entailed the paradoxical necessity of using the body. One does not have the leeway to accept the body (or its joints, which, unlike muscles, fat, or skin, which can be altered at will, might seem to be a more natural part of the body) as a given, but must work actively to use the body in ways that the joints would not seem to allow.

Miryam Sas notes that Artaud was an "inspiration and an impossible standard for Hijikata," and that Artaud himself tried to do something impossible: access the absolute.[48] Hijikata's attempt to access the primal body was similarly impossible. The primal body is not available for anyone to access. But pursuing the idea of a primal body by using of the body, while paradoxically repudiating the use of it, could enable one to find one's way beyond some conventions.

Sympathetic Response

Using the body and thereby increasing its capabilities was not limited for Hijikata to bending joints in the wrong way or turning the body into a musical instrument. Hijikata was also trying to use the body in other ways. The final scene in the dance (with the ascension-crucifixion of a Jesus-like figure) offers a window into this attempt. Hijikata did not originally intend to reproduce an ascension-crucifixion. Tanikawa Kôichi writes that originally he was in charge of the pig that

was to be a part of the procession for the King of Fools.[49] Nakanishi and Hijikata had the plan to string the pig up by its four legs with ropes covered in bells as if to rend the pig limb from limb. When they did so, the ringing of the bells as the pig struggled, and the noise of the pig squealing in fright or pain would be a suitable way to herald the King of Fools. However, the pig handler told them that if they wanted to treat the pig that way, they would have to buy the pig outright. They did not have that kind of budget, so Nakanishi proposed painting the pig fluorescent green, but this only enraged the pig-handler all the more. Finally, Hijikata decided to take the place of the pig. As they worked through the plan, they decided that rather than simulating rending Hijikata limb from limb, they would approximate the ascension-as-crucifixion of Jesus. Despite Tanikawa's revelation of the inner workings of the process that went into Hijikata's ascension-crucifixion, it would be a mistake to think that the Christ theme only came about by accident. Hijikata had already danced a solo entitled "Christ" in the June 1968 recital of his student Ishii Mitsutaka.[50] Clearly Hijikata was thinking about Jesus before the brouhaha over rending the pig, and in part his thinking owes much to the philosophers he was reading.

As discussed earlier, Genet looms large in the first decade of butoh. Considering Hijikata's use of Genet's character Divine in such dances as *Forbidden Colors* 2, understanding what Genet does with Divine provides a way to understand Hijikata's dance better. Genet bookends his novel *Our Lady of the Flowers* with two descriptions of Divine:

> Divine died yesterday in a pool of her vomited blood, which was so red that…she had the supreme illusion that this blood was the visible equivalent of the black hole which a gutted violin…revealed with dramatic insistence.… The other aspect, ours…makes her death tantamount to a murder.[51]
>
> ….
>
> Filth, an almost liquid shit, spread out beneath her like a warm little lake, in which she gently, very gently…was engulfed, and with this relief she heaved up another sigh, which rose to her mouth with blood, then another sigh, the last.
>
> Thus did she pass away, one might also say drowned.[52]

In the opening of the book, Divine has one last moment of consciousness after she has already begun coughing up blood. Then 250 pages later, the description shows that she has lost control of her bowels at the moment of death, and simultaneously suffocated on her own blood. The death of Divine is not a romantic moment. The deaths of prostitutes rarely are. Eking out a living without a safety net, when they die, they often die poor and in great pain. Genet's genius is to make us care about the death of this prostitute, for whom most people would have little sympathy.

How does Genet do this? Quite simply, by mobilizing our sympathies for her by showing that her suffering occurred undeservedly. Here is a "Divinariana"—a character note by Genet that helps us understand who Divine is:

> But to punish herself for being mean to the man, Divine goes back on her decisions and humiliates herself in the presence of the pimps, who fail to understand what's going on.

Nevertheless, she is scrupulously kind. One day, in the police wagon, on the way back from court…she asks an old man:

"How many?"

He answers:

"They slapped me with three years, What about you?"

She's down for only two, but answers:

"Three years."⁵³

Divine cannot return bad treatment with bad treatment. Nor can she make someone feel bad about being sent to prison for a longer term than she has, so she lies about the length of her prison term. However, the world does not treat Divine as well as Divine treats it, and that includes her alter-ego author. Genet tells us: "Slowly but surely I want to strip her of every vestige of happiness so as to make a saint of her;" "But Divine needs a few jolts which squeeze her, pull her apart, paste her back together, shatter her, till all I have left of her is a bit of essence which I am trying to track down."⁵⁴ The way Genet makes Divine into a saint is to subject her to jolts of betrayal and desertion, and all the usual kinds of societal disdain that come with being gay and impoverished in the French society of the 1940s.

Hijikata seems to have taken from Genet's treatment of Divine a hint for the kind of dance he wanted to create: Genet wanted us to feel for Divine, so he mobilized our sympathies for Divine in order to draw us in. It was going to take some time for Hijikata to sort completely through the implications of this sympathetic reaction, yet the inclusion of a quasi-crucifixion indicates that he was clearly thinking about it in 1968. Hijikata's preoccupation with the crucifixion likely stemmed from the combination of shock and empathy that a depiction of the crucifixion could still mobilize.

Tempting the Other

In May of 1969, Hijikata published the essay "To Me Eroticism Comes From Being Jealous of a Dog's Vein." Here are the opening paragraphs:

> When, despite having a normal, healthy body, you come to wish that you were disabled, or better yet, had been born disabled, you take your first step in butoh. A person who dances butoh has just such a fervent desire, much as longing to be crippled goes with the territory in kids.
>
> When I see children pursue a lame dog trying to slink from sight with sticks and stones, then corner it against a wall, and mindlessly beat it, I feel a kind of jealousy toward the dog.
>
> Why? Because it is the dog that derives the most benefit here. It is the dog that tempts the children and, without considering its own situation, exposes itself completely. One kind of dog may even do so with its intestines hanging red from its belly.⁵⁵

Here the important connection between pain and butoh is not that pain produces butoh, but rather that a desire to experience pain will produce butoh.⁵⁶ In the case of being jealous of the dog, this is understandable enough. We already saw in the case

of Hijikata branding Kazakura that one of the functions of pain is that of engrossing the recipient—putting the recipient in a state of sensory overload that does not admit of split consciousness. The dog would certainly seem to be in that state.

However, if that were all there was to Hijikata's understanding of pain, it would contradict the sense of undesirable pain that gave the dances and writings their force. If the plight of a poor starving artist or gay male prostitute trying to get by in France in the 1930s (as with Genet) or Tokyo in the 1950s is not perceived as undesirable, then something significant would be lost from Hijikata's presentation. Alternatively, if the quandary of gay male prostitution—which is connected to an economic system that structurally needs prostitution but relegates it to the margins of society—cannot appeal to a sense of injustice, then once again, Hijikata's dances would seemed to be stripped of what gave them force. I argue that the idea of being jealous of an injured dog is more than just a reversal of the idea that pain produces art, or that art is a response to pain.

Let us look at this scenario from the side of the dog ("it is the dog that derives the most benefit here"). Hijikata stresses that there is a kind of (obviously imaginary) dog that already has its intestines hanging out when it tempts the kids into beating it. It has already gone through some initial pain and now is coming back for a second helping. In the context of the centering quality of pain, it is not that the dog is looking for a centering experience—of course, the dog probably wanted that as well, (and may even want it again), but that moment is already passed. Now the dog is consciously planning to put itself back into that position. I suggest that the dog might be thinking about how it can use that situation for its own purposes.

To tempt is to cause an alteration in the actions of the other through some enticement. Yet, what is the basis of this enticement? Given the background of Jesus and Genet, perhaps what is at stake here is the dog's ability to use pain to produce a sympathetic response. That is to say, we are back to the issue of mobilization, but from a new perspective. Previously, Hijikata wanted to employ pain to mobilize the transformation of society—either by exploiting the desire of people to escape suffering or by using the ability of pain to harden soft people. Here he adds on one more facet of mobilization—utilizing the reactions that people have when they see pain.

In this respect, Hijikata's conception of pain was similar to that of Gandhi. When Gandhi and the other leaders of the salt satyagraha sent Indians to the salt fields of Dharsana knowing that they would be beaten, they did so with the understanding that either on the part of the guards of the salt mine, or the leaders of the British Empire back home, or the general press-reading public, there would be a sympathetic response that they could mobilize for their cause.[57] I suggest that the nuance of Hijikata's idea of being jealous of a injured dog is analogous to a hypothetical situation in which one was jealous of the wounds of a beaten and bloodied member of the salt satyagraha who was able to use those bloody wounds as a way to bring about a change in the policies of the British Empire.

At the time of the making of *Hijikata Tatsumi and Japanese People: Rebellion of the Body*, Hijikata was still feeling his way through this idea, but his preoccupation with how bodies relate to and cause physical alterations in other bodies and his use of the ascension-crucifixion are steps in his feeling his way toward an important principle of his dance, the creation of sympathetic response on the part of the audience.

Moreover, they point to another way in which Hijikata was exploring how to magnify the capabilities of the body. It was not just that Hijikata enabled the body to take on the extra role of serving as a musical instrument, but he also tried to use the body the invoke sympathetic responses in the audience as another way of increasing the abilities of the body, (even though those roles contradict his assertion that he was not going to use the body, but allow it to exhibit a life of its own). Explicit in Gandhi, and implicit within Hijikata's strategy of tempting the other, is the fact that increasing the ability of the body by increasing its ability to appeal to a sympathetic response was not just a theatrical technique that could hold the attention of the audience (although it was certainly that), but that it was also connected to the wider world of conflict, competition, and rebellion that Hijikata lived in.

At this point, Hijikata began to move beyond the idea of athleticism that had preoccupied the artists through the mid-sixties. This is ironic, given the explosive bodily nature of this dance – it was an overtly athletic composition. Implicit in this idea of athleticism (the wind-sprints, fencing, Mishima's weightlifting and Shinhara's boxing) was the idea that one must strengthen and hone the body in preparation for efficacious competition in the wider (cultural and economic) struggles of the time. That orientation was never to totally disappear from Hijikata's dance, but he was beginning at this point to question that conception of the body, and to move toward a conception of the body that would rely less upon muscle and more upon the ability of a person to influence and tempt others through the use of the body.

Seeing the world through other viewpoints

The essay "To Me Eroticism Comes from Being Jealous of a Dog's Vein" can also aid us in understanding a different but related aspect of this dance. Puzzlingly, Hijikata assumed in the essay that children wanted to be handicapped. Why would a child long for that? In terms of the experiential quality of pain, there is nothing particularly centering or engrossing about being handicapped, particularly the kinds of handicaps that Hijikata often mentioned, such polio or Hansen's Disease (leprosy). As polio does not affect cognitive abilities in any way, polio patients can have either a split consciousness or a unified consciousness, just like anyone else. Hijikata, however, mentions children twice. Once, in terms of children wanting to be handicapped, and once, in reference to children who beat a dog. Let us examine both situations. Beating a dog both breaks a norm and causes pain, and therefore we can presume that it provides children with a centering experience, (albeit one that is ethically troubling and thus highly disturbing to the observer). What more could children gain by trading their current experientially fulfilled lives for the lives of disabled children (in other words, children who are restricted by physical impediments)?

The answer to this question lies in recognizing that, in their current state, the dog-beating children are forever prohibited from achieving (through the centering of self-consciousness) the subjective space of the handicapped person. What if these same children are curious about what it is like to be handicapped? What if someone is so curious that she wishes to have been born disabled because she wants to thoroughly

inhabit the world of disability? The notion that pain centers people or makes them feel more alive may be true, but what if one's desires go beyond finding out what it is like to beat a dog, and extend to wanting to know what it is like to be a beaten dog? No amount of transgressing norms can ever aid one in the second task.

Hijikata has thus identified a shortcoming in the philosophy of centering the self in a nondualistic experience, in that, while it allows you to fulfill a large number of your own desires, or while it may result in a unified consciousness, it cannot solve the problem of the other, and particularly, it cannot help you get inside the head of the other. It is an existential truism that we are all forever cut off from other people, but this verity discounts the return available to those who make the effort to understand others and see the world from other viewpoints. Further along in the essay, Hijikata says, "I have to prepare myself in various ways before entering that dimly lit world that fish see each day."[58] Entering other dimly lit worlds is perhaps a good way to describe the situation of healthy people wanting to become disabled, and the preparation that is necessary for becoming a fish is no doubt similar to the preparation that goes into dancing many of the other entities that Hijikata tackled.

Returning to the dance *Hijikata Tatsumi and Japanese People: Rebellion of the Body*, we can see that Hijikata was interested in exploring the uses and facets of pain. Genet might have been willing to squeeze, pull and shatter his character Divine, but in his essay, Hijikata went one step further and advocated wanting to put oneself in the position of a dog whose intestines are dripping out.[59] Recognizing this, we can revisit the status of the characters in *Hijikata Tatsumi and Japanese People: Rebellion of the Body* to remark that they may represent an attempt to reenact the dances of other people in order to experience their pains and subjective states. The attempt to enact the subjective states of other people caused or dovetailed with Hijikata's increasing interest in the ability to transform himself into something or someone else.[60]

My analysis of *Rose-colored Dance* sought to demonstrate that Hijikata's way of inviting invasion of himself and his art was diametrically opposed to that of Clement Greenberg's purification of art. In *Hijikata Tatsumi and Japanese People: Rebellion of the Body*, Hijikata was concerned with the related issue of how to make the body a musical or lighting instrument. The attempt was to find out how much percussion or lighting could be incorporated into dance. Reading Hijikata in light of Artaud allows us to expand our understanding of this mutual invasion principle. Paradoxically, given his advocacy for a total theater, Artaud himself can be seen as a representative of a purifying impulse. He refers to "what the theater should be, if it knew how to speak the language that belongs to it," and "ought to be allowed to speak its own concrete language." Artaud's emphasis on spectacle and his bias against a message-oriented theater of logos (as with Greenberg's purity principle) could lead to forswearing the communication of meaning altogether.

Yet Artaud's own books (and *Heliogabalus* is as good an example as any), are fundamentally concerned with examining many ideas. In Artaud's version, Heliogabalus is a member of a different ethnicity from the main Roman ethnicity; he cross-dresses; he intentionally tries to discredit the imperial institution; and he is finally assassinated for doing so. That is to say, *Heliogabalus* is a book that deals with ethnicity, anarchy, compassion, power, and gender. Of course, the book is literary spectacle, but if one ignores the ways that the book addresses the problem of the intersection of

gender, power, and ethnicity, then one would miss half of the book. In a similar manner, while Hijikata certainly wanted to allow art, sculpture, percussion, and lighting to invade the world of dance, he was constantly experimenting with ways to let meaning back into his dances, without letting it totally control them.

This speaks to a broader concern for Hijikata (and one already faced by Artuad, but which was to grow more pressing over time): the ability to navigate a world of proliferating information. In "The Theater of Cruelty (First Manifesto)," Artaud advocated labeling, cataloguing and "making a kind of alphabet" of the "visual language of objects, movements, attitudes...gestures;" the "ten thousand and one expressions of the face"; "the particular action of light upon the mind, [and] the effects of all kinds of luminous vibration."[61] This sounds similar to the German Expressionist attempt to catalogue a language of the body, which was important for orienting Hijikata to the task of increasing the language of the body. Artaud goes on to advocate organizing a "language of sounds, cries, and lights," but paradoxically wants to organize this "language into veritable hieroglyphs." Artaud qualified his use of the term hieroglyphs by defining them as "immediately readable symbols." An alphabet is a set of units that can be used to convey content. Hieroglyphs were similarly usable by ancient Egyptians, but despite Artaud's attempted redefinition, to his audience in 1938, they could only signify something that has the appearance of meaning and the weight of age, but is indecipherable.

What we see here is Artaud de-emphasizing the text and speech (and thus skirting the edge of denying representation), but proposing the creation of a catalogue of all the other tools that might be used to convey content, and then hoping that they would be able to serve as magical means of direct communication ("immediately readable symbols"). That is, he proposed the painstaking acquisition of a vast reservoir of information (the "ten thousand and one expressions of the face"), but then waffled about whether one can use that information to convey content. This is no where more obvious than when he address musical instruments. He starts in the same vein as before by emphasizing research "into qualities and vibrations of absolutely new sounds," but then turns to research into "instruments and appliances which, based on special combinations, or new alloys of metal, can attain a new range and compass, producing sounds or noises that are unbearably piercing."

I argue that Artaud's theater risked turning into noise, fusillades of light, and a gamut of bright colors. Hijikata was certainly drawn to a theater with that power, but was really looking more fully into Artuad, or beyond the limits of Artuad's conception of theater to the possibility of communicating ideas with other people. Of course, for Hijikata it would be a waste of time to imagine a return to easy communication. That dream had long since passed, but in its place was the harder task of imagining what a new kind of communication would look like amidst the noise and flashing lights.

Looking back at *Hijikata Tatsumi and Japanese People: Rebellion of the Body*, we see that Hijikata accomplished the goal of allowing significance a partial place in his dances by choosing a strategy of juxtaposition and overlapping of disparate elements. If all the possibilities that I have presented are correct, *Hijikata Tatsumi and Japanese People: Rebellion of the Body* presents the procession of an anarchist ruler, and the celebrations of several different people on that occasion. Hijikata also attempts

to put his body in the position of several different people, either for the purpose of seeing the world from their viewpoint, feeling their pain, or for the purpose of understanding how their bodies (or his) were bound by social structures as a means of revolting against those structures. A further goal of the dance was the use of the body to create strobe lights and a musical instrument. Finally, if Murobushi is correct about the overlap between the eternal erection and the eternal revolution, then Hijikata also indicated that the revolution must include a wide variety of Japanese people, and Hijikata was dancing the roles of the people who would ideally join him in the rebellion.

Revolutions are always risky. If you slash someone, there is a risk that you will be slashed back. The risk of being slashed corresponds to the attitude that Morishita Takashi identified in *Rose-colored Dance* when he indicated that butoh allowed itself to be transgressed by other realms of the world of art. Hijikata was better at slashing than he was at allowing himself to be slashed. Most people are. But from time to time, he opened up enough to allow himself to be transgressed by the other, whether that other was an artist who did set or costume design, a Western author, or a fellow "Japanese" person. These last were the ones that he wanted to enlist in maintaining the eternal revolution, because he had come to realize that he needed to include in that group more than just naked men, and so decided that he needed to take the revolution outside Tokyo.

5. My Mother Tied Me on Her Back: *Story of Smallpox*

You can't kill history. You can't shoot it with a bullet and watch it recede into whatever lies outside of memory. History is tougher than that—if it's going to die, it has to die on its own.

Leif Enger

Hijikata's 1972 tour de force dance performance, "Great Dance Mirror of Burnt Sacrifice—Performance to Commemorate the Second Unity of the School of the Dance of Utter Darkness—Twenty-seven Nights for Four Seasons," was a high point for Hijikata.[1] Held over 27 days from October 25th to November 20th at the Shinjuku Culture Art Theater, the dance attracted approximately 8,500 viewers. There were five different performances, each repeated five or six times in succession. In order, they were *Story of Smallpox* (*Hôsôtan*), *Dissolute Jewel* (*Susamedama*), *Thoughts of an Insulator* (*Gaishikô*), *Avalanche Candy* (*Nadare-ame*), and *Seaweed Granny* (*Gibasan*). This series of performances marked an early presentation of Hijikata's attempt to build an entirely new dance vocabulary that could produce new kinds of movements and effects, and encode multiple narratives.

Until *Hijikata Tatsumi and Japanese People: Rebellion of the Body*, the movements had largely been of two types: shocking or bizarre movements introduced to the stage (intimating sodomy or killing a chicken, running on tatami mats, dancing with tubes, thrusting with a phallus); and everyday or athletic movements defamiliarized by placing them on stage (throwing baseball, fencing, dancing like a young girl). The new dance vocabulary was based upon movements gleaned from various new sources (hitherto untapped in the dance world) and subject to a set of operations to further transform them. These operations included surrealist principles that Hijikata had been nurturing for years, such as juxtaposition and multivalence. A full examination of his new choreographic method, his new dance vocabulary, and the effects produced therein, will occupy this and the following chapter by examining the choreographic method from different overlapping viewpoints: first the choreographer's, then the dancer's, and finally the audience's. The remainder of this chapter examines the choreographic method from the viewpoint of Hijikata Tatsumi himself, in the context of presenting one of the dances of the series—*Story of Smallpox*.

Hijikata's experiments with the body continued in *Story of Smallpox* as he explored how to make the human physique twist, bend, and strain more than ever before. However, when compared with the thoroughgoing strategy of juxtaposition found in *Hijikata Tatsumi and Japanese People: Rebellion of the Body*, the dance *Story of Smallpox*

does not outwardly feature contradictory elements to the same extent (although the sound accompanying *Story of Smallpox* is often at odds with the movements), but, as will become obvious, the juxtaposition found in Hijikata's dances gradually moved inside the mind of the dancer, as the dancer was asked to play several roles and narratives at once or to do several things simultaneously. This meant that in addition to the physical stress put on the dancers, Hijikata began putting tremendous mental stress on them as well. In addition to expanding the abilities of the body, Hijikata was expanding the abilities of the mind.

PRECEDENTS

Hijikata may have started experimenting with this new form of dance as early as 1967 or 1968 when Ashikawa Yôko joined his dance troupe. Schwellinger notes that one of Hijikata's hand positions in the second scene of *Hijikata Tatsumi and Japanese People: Rebellion of the Body* matches the later hand position that Hijikata taught Tamano Kôichi in *Fin Whale* (Nagasu kujira), so he was likely already doing experimenting on himself in *Hijikata Tatsumi and Japanese People: Rebellion of the Body*.[2] He continued working through his ideas in a series of performances during 1969 and 1970. Hijikata's dancers continued to appear in burlesque shows as many as three times a night, but in addition, in 1969 Hijikata and Motofuji received a request to start a long-running show for a new venue called Space Capsule. The Space Capsule shows would be geared to a slightly different audience seeking a more "high art" theater experience, so, between March and December in 1969, Hijikata and Motofuji presented a weekly show at Space Capsule with Kara Jûrô's Situation Theater and Itô Mika's Bizarre Ballet Group.[3] The following year in 1970, Hijikata and Motofuji switched venues to the Shinjuku Art Village, where they presented another series of shows.[4]

Yamada Ippei tells of a dance in which a woman wore a chastity belt and a kind of headdress with blinking lights on it. When the woman spread her legs, a flashlight glared into the eyes of the spectators. In one of the Space Capsule performances, Nakamura Hiroshi made slides of some of his own paintings and of commercial design projects of Nakanishi and projected them onto the bodies of dancers to the sounds of the Beatles, Janis Joplin, and Jimi Hendrix (see figure 5.1).[5] Photos of the Art Village performances show the nearly naked dancers Ashikawa Yôko and Kobayashi Saga with acrylic window panes (modeled after Duchamp's *The Bride Stripped Bare by Her Bachelors, Even* (*The Large Glass*)) strapped to their bodies with accordion straps (see figure 5.2).[6] One important technical note is that Motofuji said that during the Art Village performances, in order to force his dancers to improve drastically, Hijikata began to require them to change the dance routines everyday, or to incorporate new elements into the fixed choreography on a daily basis.[7]

STORY OF SMALLPOX

Finally, everything came together in "Great Dance Mirror of Burnt Sacrifice (*Hangidaitôkan*)—Performance to Commemorate the Second Unity of the Dance

My Mother Tied Me on Her Back 139

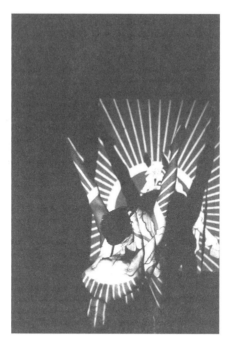

Figure 5.1 Kobayashi Saga and Tamano Kôichi, *Space Capsule Show*, (Space Capsule, Akasaka, Tokyo, Feb. 1969) by Nakatani Tadao. Courtesy of Nakatani Takashi and Morishita Takashi Butoh Materials, NPO, and the Research Center for the Arts and Arts Administration, Keio University.

of Utter Darkness Faction—Twenty-seven Nights for Four Seasons." Only the first of the dances in this show, *Story of Smallpox* , is preserved on film. It is such a phenomenal work that it is quite impossible to do it justice on the page. Like all of the dances since *Leda* it lacks an obvious narrative structure; however, for the purposes of discussing the work it may be split into roughly nine segments or scenes divided by fadeouts and marked by costumes, movements, music, and the like.[8]

The dance opened with an announcement only in English:

> "Ladies and gentlemen, tonight's performance is the second show in commemoration of the formation of the Ankoku Butoh-ha Dance Troupe. The play 'Hangidaitôkan's' first part is entitled Hôsôtan. Directed by Tatsumi Hijikata. Thank you."

Thus, right from the opening moment, the predominantly Japanese audience would have sensed that they were in a strange place as the announcement was presented in English—as if the announcement was supposed to serve as a marker of the international aims of the dance, or as if to purposefully make the performance difficult to understand for the Japanese audience.[9]

The lights came up only enough to reveal Hijikata standing alone among tall free-swinging wooden posts. He wore a thick padded kimono called a *dotera*, and his hair was done up in the *marumage* style—used by married women (see figure 5.3). The grey lighting made it seem as though it was early in the morning or that Hijikata

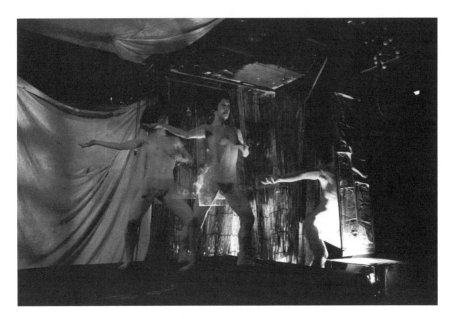

Figure 5.2 Kobayashi Saga, Ashikawa Yôko and one other unidentified dancer, *Dissolute Jewel*, (Shinjuku Art Village, Tokyo, June 1971) by Onozuka Makoto. Courtesy of Onozuka Makoto and Morishita Takashi Butoh Materials, NPO, and the Research Center for the Arts and Arts Administration, Keio University.

stood enshrouded in mist. The sound of a cold wind or a storm and the cawing of crows pierced the selenian air. For several minutes, Hijikata stood on one leg with his arms tucked inside his kimono. Finally he began to move almost imperceptibly. He raised one foot, extended it, and stamped on the ground. He brought his feet back together by pulling the extended foot back to his straight leg in a way somewhat reminiscent of how a sumo champion wiggles his feet together. Then he repeated the process. The lighting became brighter, and the sounds of the blowing wind and the crows were replace by a *goze* song *Arrowroot Leaves* (*Kuzu no ha*).[10]

The brighter light revealed that Hijikata wore his obi tied in the front and that a *hainarashi* (an instrument for leveling ash in a fireplace) hung from his wig. He was bent over, but often on half point. As he walked the stage, his movements were somewhat jerky, and had a strange quality of misdirection. From time to time, other dancers shot across stage in front of him to the sound of horses' hooves. He fell to his back, crawled on the ground—looking like a monkey—stood again, and proceeded stage right to a raised dais. As he walked, he was bent far over with his hands hanging under him, but he walked on tiptoes.

As he reached the dais, the sound of the wind picked up and momentarily blotted out the sound of the *goze* singing. The music returned, transformed into a powerful rhythmic strumming of Tsugaru-jamisen.[11] At the same time, six almost naked and heavily tattooed dancers entered from the right wings, and came up on the dais in front of Hijikata and then proceeded across the stage (see figure 5.4). They were bent almost

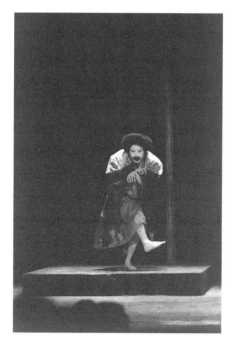

Figure 5.3 Hijikata Tatsumi in a *dotera*, *Story of Smallpox*, (Shinjuku Culture Art Theater, Tokyo, Nov. 1972) by Onozuka Makoto. Courtesy of Onozuka Makoto and Morishita Takashi Butoh Materials, NPO, and the Research Center for the Arts and Arts Administration, Keio University.

double with their hands in close to their chests, and they undulated up and down on half point as they made their way across the stage like a pack of animals. At a different moment, they ran from stage right to left with their torsos facing the back wall and their heads and legs oriented toward the side of the stage in profile. They led with their right arms somewhat stretched out in front them and their left arms trailing behind, and when they got to the edge of the stage, they wheeled around once more and began back toward the other side with strange swimming motions. They spun, fell over, gesticulated wildly with their hands, made karate poses, and even did front and back flips.

The strident strumming of the *shamisen* was replaced by the sounds of a puppet chanter telling the story *Terakoya* (Temple School). Three women clad in kimono and wearing geta[12] clattered around the stage (see figure 5.5). They tottered like old women, and lifted their right legs and balanced on their left geta, waving their legs back and forth. Later, sitting on the ground in the middle of the stage, they pulled their geta into their faces and poked at the bottoms of their geta with their noses. They took one geta off and then they stamped across stage with one geta-clad foot and one bare foot—clap, thud, clap, thud. Or, while sitting on the ground, they beat the geta on the ground using their hands.

While Ashikawa occupied a prime spot on a stage right dais the other women were replaced by men stamping in unison in animal-inspired movements. The women

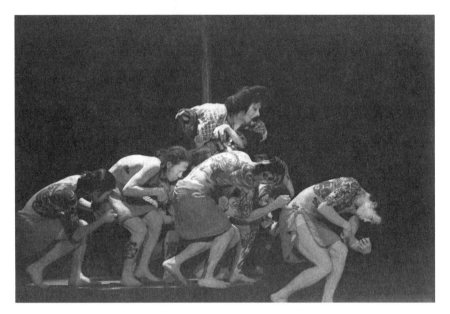

Figure 5.4 Hijikata Tatsumi, Tamano Kôichi, Waguri Yukio, et al, *Story of Smallpox,* by Onozuka Makoto. Courtesy of Onozuka Makoto and Morishita Takashi Butoh Materials, NPO, and the Research Center for the Arts and Arts Administration, Keio University.

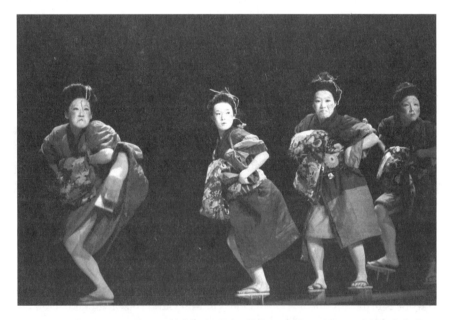

Figure 5.5 Courageous Women (Ashikawa Yôko, Kobayashi Saga, Nimura Momoko), *Story of Smallpox,* by Onozuka Makoto. Courtesy of Onozuka Makoto and Morishita Takashi Butoh Materials, NPO, and the Research Center for the Arts and Arts Administration, Keio University.

then returned and the music changed to a waltz while they continued tottering and stamping their geta. They were joined by Waguri Yukio wearing a train conductor's hat and a sash. At the crescendo at the end of the waltz, Ashikawa leaped onto the shoulder of Waguri, and he held her there perched on his shoulder.

In the next scene, Hijikata sat on the floor, clothed only in a loin cloth and wisps of thin cotton batting. The melodic strains of Joseph Canteloube's "Baïlèro" formed a stark contrast to Hijikata's emaciated and anguished body. He walked the knuckles of his right hand away from his body, and at the same time, slid his left heel in the opposite direction. He then stretched up, seemed to lose strength, and collapsed back down. He then rolled slowly on the floor. Having collected himself back into a sitting ball with his right knee tucked up close to his chin, he gradually leaned back and stretched out his legs somewhat as if he was stretching after having just woken up, or as if he was trying out limbs he had not used for some time (see figure 5.6). After gradually sitting up again, he came forward partially onto his feet, but suddenly sprang toward the right, balanced on his left foot and left hand for a moment, and then crumbled down onto his left side. Pushing himself back up, he then tumbled forward and onto his right side, smacking his head on the floor in the process. For the third time, he tried to rise and was actually up on one knee and one foot, when his knee slipped from under him and he again toppled over, this time backward. About 12 minutes into this solo, the tattooed men returned to the sounds of a waltz (see figure 5.7). They prostrated jumbled up on the floor stage left, and crab-walked back and forth as a kind of accompaniment to the latter half of Hijikata's solo.

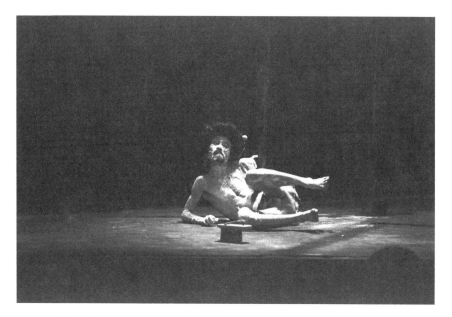

Figure 5.6 Hijikata Tatsumi, *Story of Smallpox*, by Onozuka Makoto. Courtesy of Onozuka Makoto and Morishita Takashi Butoh Materials, NPO, and the Research Center for the Arts and Arts Administration, Keio University.

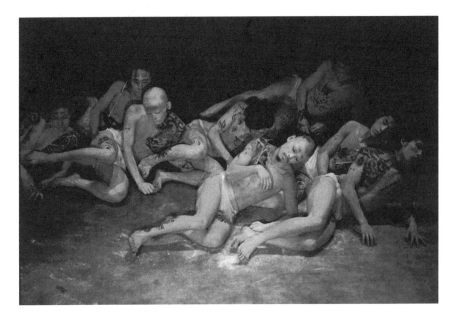

Figure 5.7 Stage left from Hijikata's solo. Tamano Kôichi, Waguri Yukio, and others, *Story of Smallpox,* by Onozuka Makoto. Courtesy of Onozuka Makoto and Morishita Takashi Butoh Materials, NPO, and the Research Center for the Arts and Arts Administration, Keio University.

The women returned to the stage, now cluttered with old futons. They were barefoot and in rags, accompanied by a waltz and cheerful bird chirps. They tottered, staggered, and lay on their sides. Hijikata joined them for a short solo, running through them, and taking off the cloak he wore. Hijikata then took his place half-sitting and half-kneeling on the raised dais, accompanied by strange sounds, as if metal was being rubbed together or stretched out of shape. He no longer appeared to be so obviously covered with wisps of cotton. He lifted his arms above his head as if to claw at something, made as if to rub tears or sleep from his eyes, and peered intently at something on the ground. Then he rose without difficulty, though still hunched over and contorted, and made his way off the dais. Finally he stood straight up, but looked like a puppet again, with his left heel raised stiffly to his right knee, and his leg opened outward. He began to walk, and looked as though he was walking for the first time. He led with his heels and each time one of them touched down, it hit the ground too hard and shocks reverberated up his entire body.

In the last segment, five women stood and looked upward, their mouths agape. Old futons littered the floor echoing the thin covering of tattered gauze that wrapped their bodies, and "Bailero" floated over the stage again. The women twitched and stepped aimlessly. Gradually sinking to the ground, they leaned back on their right elbows in an offset pattern with a woman lying out front and two rows of two women lying behind (see figure 5.8). There they trembled. When they stood up, they were joined by the other dancers, and without losing character they flowed into a choreographed ending in which they came forward, bowed, retreated, and then repeated the cycle.

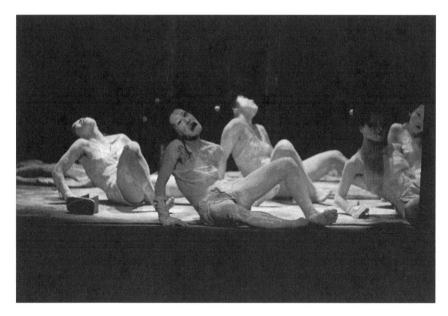

Figure 5.8 Reclining dancers, (Ashikawa Yôko, Kobayashi Saga, Nimura Momoko, Yoshino Hiromi), *Story of Smallpox*, by Onozuka Makoto. Courtesy of Onozuka Makoto and Morishita Takashi Butoh Materials, NPO, and the Research Center for the Arts and Arts Administration, Keio University.

Movement Vocabulary

Story of Smallpox was a rich and engaging performance featuring an astonishing array of new dance movements and poses, a complex compositional structure in which movements were varied and repeated in different contexts, and the production of emotionally intense and novel effects. It is clear that Hijikata's conception of the body had evolved. This evolution is manifest in the unifying characteristics across the bodily vocabulary for the dance. Whereas the emphasis before had been on mixture of athleticism (running and throwing a baseball in *Masseur*) and defamiliarized and shocking movements in (sodomy in *Forbidden Colors*, and *Hijikata Tatsumi and Japanese People: Rebellion of the Body*), now the bodily vocabulary featured fragmentation, tension, instability, disequilibrium, and misdirection.

For example, in *Story of Smallpox* there is often a fragmentation of the legs, torso, and head into a contorted multiaxial orientation. In the opening segment, the lights come up on the motionless Hijikata. He raises his arms—the left one slightly in front of him, and the right one slightly behind—and at the same time, almost like a marionette, his right leg lifts and crosses his body. Moments later, after dropping his right leg back to the ground, he flings his right arm across his chest and his left arm far behind himself, simultaneously bringing his left leg across his body to his right.

In the first movement, his torso is turned toward the right while his right leg is as far to the left across his body as possible. His head looks back toward the left—matching the movement of his right leg and left hand. If we think of Hijikata as

standing on an X, then his head, left arm, and right leg are oriented on one axis, and his torso and right arm are oriented on the other axis about sixty degrees in the other direction. Then, in the next moment, his torso and both arms are twisted toward the left, while his head and left leg both angle toward the right. All of this happens while the weight-bearing leg is slightly bent, and he is leaning forward. It is as if Hijikata isolated the basic dance pose from a kick-line, set it off balance, and warped it out of shape.

When the dancers make swimming motions as they advance across the stage, they share this multiaxial orientation (see figure 5.9). The dancers' bodies are oriented along the axes of a plus (+) sign. The dancers' legs and heads face the sides of the stage, while to the maximum extent possible, the dancers' torsos and arms face either the back or front of the stage, (but usually the back—remember Hijikata's preoccupation with showing the back of the dancer, and allowing it to be used expressively). The torso has to be twisted like a double helix in order to achieve this rotation. The right arm extends forward, the back of the hand toward the audience, and the left hand trails behind opened out as far as is possible, with the back of the hand also facing the audience. This way we simultaneously see the face in profile and the back or chest directly.[13] Hijikata seems interested in the tension, instability, and disequilibrium in these movements.

Two examples that add misdirection to the tension, imbalance, and contortion can be seen in dancers' use of half point or geta while stooping over. These poses (or movements) consist of three elements. The back is hunched, the knees are bent deeply, while the feet are raised either by elevating the heels off the ground or wearing

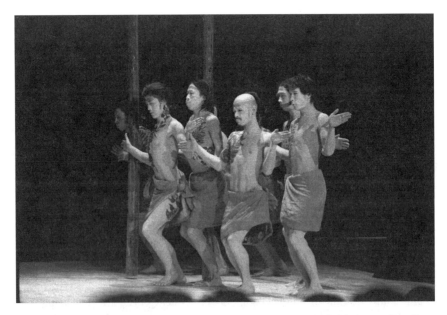

Figure 5.9 Multiaxial torso (Tamano Kôichi, Waguri Yukio, and others), *Story of Smallpox*, by Onozuka Makoto. Courtesy of Onozuka Makoto and Morishita Takashi Butoh Materials, NPO, and the Research Center for the Arts and Arts Administration, Keio University.

geta (see figure 5.10). The poses might seem somewhat contradictory in that crouching is usually oriented toward the ground and greater stability, while standing on tiptoes is usually for the purpose of being taller or reaching higher and is usually more precarious. Here, the use of half point or geta while crouching combines a downward orientation (the crouch) with an upward orientation (the raised heels or the added height of the geta) and results in a misdirection in the pose and undermines the stability of the crouch. Any elevation gained by the geta or the half point is offset by the hunched back.

The geta Hijikata used were relatively tall—the crossbars were about four inches high—and Hijikata used that height as if to employ the geta as stilts. Watching these dancers on geta generates an amazement akin to that of watching a circus performer on stilts. In several scenes, the women stand on one geta, and bring their other knee up above their waist and then wave their leg back and forth almost like an elevated rond de jambe, or like the side-to-side wave of an American beauty queen in a parade. The wearing of kimonos further accentuates the precariousness of this position by accentuating the upper body (because of the fullness of the kimono) and consequently making the single leg look spindly by comparison. The dancers end up looking strikingly like flamingos. What is more, the dancers often tuck their hands inside their kimonos as if they are cold, which precludes them from using their arms to maintain balance, further increasing the impression of imbalance in the pose.

The oppositional orientation of the movements is echoed in moments when dancers move parts of their bodies simultaneously in opposite directions. For example, as

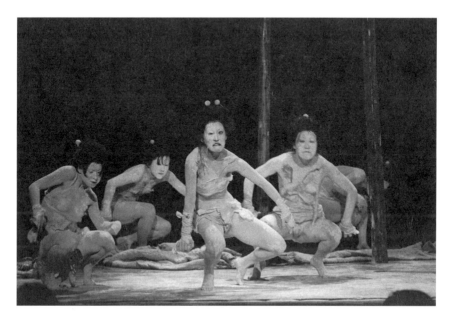

Figure 5.10 Bending over on half point, (Ashikawa Yôko, Kobayashi Saga, Nimura Momoko, Yoshino Hiromi), *Story of Smallpox*, by Onozuka Makoto. Courtesy of Onozuka Makoto and Morishita Takashi Butoh Materials, NPO, and the Research Center for the Arts and Arts Administration, Keio University.

Hijikata sits on the ground he walks his hand to the right and slides his heel to the left. As the right hand and left heel walk away from his body, Hijikata goes from being huddled in a ball to occupying a triangle on stage that is roughly six feet wide. Then he pulls his leg and arm in to return to his huddled position and repeats the process. The reader will recall the description that Tanemura gave of the dance, *Seed*, in which Tanemura said that it appeared that Hijikata tried to move in two directions at once. The movements in *Story of Smallpox* share that orientation in the opposition between heels elevating while the back hunches over, or the hand walking in one direction while the leg slides in the opposite direction.

These movements (in which the body is fragmented, contorted or moving in two directions at once) required a great deal of effort, but even the less obviously contorted and multidirectional movements required protracted tensing of the muscles. For example, when Hijikata attempts to rise repeatedly but fails and collapses, he does not fall to a position of rest; rather, he falls to a lower tensed position. Similarly, at the end of the dance, the five women lie on their backs with their legs, arms, and heads slightly raised. Reclining could have been a moment for relaxing, but in this case the women constantly hold legs, heads, and arms off the ground. Thus falling and reclining do not serve as a respite from tension, but as a continuation of it.

The twisted, tensed, oppositional, and unbalanced character of the movement was possibly related to Hijikata's efforts to expand the vocabulary and abilities of the body. At the same time, his preoccupation with the contorted and unstable body and with moving in more than one direction speaks to the condition of the body in this era. Hijikata implicitly asks the question: How much can a body twist, how many different directions can it go, how long can it bear up under tension, and how out of balance can it be, before it crumbles or breaks apart? Furthermore, his dance can be seen to expand the abilities of the body—to remain precariously unstable for longer and longer periods of time, to twist more, to move in more different directions simultaneously, and to bear up under ever increasing amounts of strain.

Movement Sources

It would not have been at all obvious at the time, but these new movements were the result, in part, of the development of a new method for creating dance vocabulary. This method has become known in recent times as the "Hijikata method."[14] It will take some time to elucidate this method, but for the moment, suffice it to say that Hijikata and Ashikawa Yôko (an art student before joining Hijikata's dance troupe) embarked on a program of studying paintings and other art works and observing various entities not usually thought worthy of dance representation (such as animals and the elderly) in order to elicit new poses and movements from them.[15] It is impossible to enumerate all the poses and movements that were created by this new method, but one can give a sampling of the breadth of Hijikata and Ashikawa's research. Hijikata preserved in his notebooks at least 340 images that he consulted during the time he created "Twenty-seven Nights for Four Seasons."[16] These images served as starting points for some of the poses or movements.

For example, Kobayashi identified a string of movements in the September, 1972 dance *Fin Whale* (some of which were subsequently incorporated into *Story of Smallpox*) based upon Francis Bacon paintings—such as *Head II* (1949); *Study*

after Velazquez's Portrait of Pope Innocent X, (1953); *Study for the Nurse in the film "Battleship Potemkin"* (1957); *Chimpanzee* (1955); *Portrait of George Dyer and Lucien Freud* (1967); and *Painting* (1946).[17] In this case, Hijikata took successive poses from the paintings and translated them into bodily movements or poses and then connected them together with other movements, not necessarily taken from the paintings (or possibly taken from different sources), which he deemed of the correct quality to connect the poses.

Sometimes the connection between the image and the resulting movement was quite simple. One movement came from Bacon's *Painting* (1946), in which an obscured character holds an umbrella in front of a slaughtered cow. From the notion of an umbrella, Hijikata conceived of having Kobayashi Saga mime opening an umbrella, and then added to this action raising one knee. Kobayashi brought her right knee up to her chest with her arms outstretched in front of her and her fists one above the other in line with her knee. While raising the knee and the two fists, she accelerated her top fist upward faster than the knee or the bottom fist. This was the action of opening an umbrella. Then she lunged forward onto her right leg and spread her arms out wide.[18] The Bacon image of the umbrella was incorporated so fully into the dance that the viewer would find it difficult to see in the action of separating the fists the opening of an umbrella.[19]

Hijikata may have been drawn to some images for thematic reasons. In a notebook entitled, "Beggars: Material for Hanako," Hijikata pasted reproductions of Hieronymus Bosch's sketches *Beggars* and *Beggars and Cripples* (both possibly by Brueghel the Elder).[20] He made his own sketches patterned after Bosch of two of the beggars: one hobbling on crutches with one leg heavily bound with bandages, and a reclining double amputee (compare with figure 5.8).[21] In this case, Hijikata seems to have either wanted to replicate the poses of these indigent characters in much the same way he replicated an umbrella (with no thought of indicating "beggar" to the audience), or to have specifically picked between six and nine beggars for portrayal on stage, precisely because they were beggars and thus not usually depicted in modern dance.

At other times, Hijikata was drawn to images that matched his movement palette (and in these cases, movements could even have more than one source). For example, when the six heavily tattooed dancers made their way across the stage, their legs and head were held off-center from their torsos and arms. This was called the "Maya" (see figure 5.9). Hijikata apparently got the idea for this dance movement by looking at depictions of Mayan and Egyptian art.[22] As in Hijikata's dance, the Mayan and Egyptian artists had twisted the torsos of their subjects in order to present the face in profile and a full frontal view of torso. In addition, Hijikata also appears to have studied Adolph de Mayer's photographs of the Russian ballet dancer and choreographer Vaslav Nijinsky's 1911 *L'Après Midi d'un Faune*.[23] For that dance, Nijinsky had copied poses taken from Grecian urns that he saw in the Louvre. It is not possible at this remove to say whether Hijikata already had the idea of twisted torsos before looking at Mayan and Egyptian art and the Mayer photographs, or got the idea from these sources, but whatever the case, there is correspondence between the torso alignment of the images and the torso alignment of Hijikata's dance palette.

Hijikata may have elicited from images new ways to think about movement. When Hijikata walked his hand away from his body, he was using a movement known as

"Bellmer's High Heel." Hijikata took the movement of the right hand from drawings by the artist Hans Bellmer in which a hand and a high heel overlap with each other.[24] Hijikata's movement seems to question the function of an appendage, and make one appendage do the work of another—turn a thumb into a heel and let a hand walk across the stage. Again, it is likely that Hijikata either got the idea of transferring function from one appendage to another from Bellmer's image, or else was corroborated by Bellmer's image in his ideas about function transfer.[25]

Characters

Sometimes, Hijikata's use of images went beyond finding new bodily positions or movements, and included experimenting with creating characters or roles for his dancers. This is already suggested in considering whether Bosch's beggars functioned formally for Hijikata, or whether they also had thematic content in his mind. Were the dancers enacting the roles of beggars or merely copying movement taken from Bosch's beggars?

Take the threesome clattering on geta, sitting on the ground, and seemingly sniffing their own geta (see figure 5.11). When they clatter sideways across the stage, as they move left, their heads look in the direction of motion, even though their legs are oriented toward the front of the stage. As they move back toward the right, their heads remain focused over their left shoulders, looking back to where they have been. During this movement, each of the dancers lowers her pelvis about ten inches, and

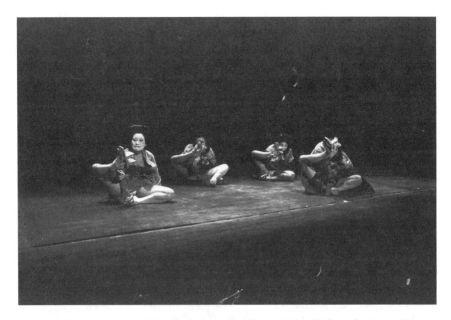

Figure 5.11 Courageous Women, seated, (Ashikawa Yôko, Kobayashi Saga, Nimura Momoko, Yoshino Hiromi), *Story of Smallpox*, by Onozuka Makoto. Courtesy of Onozuka Makoto and Morishita Takashi Butoh Materials, NPO, and the Research Center for the Arts and Arts Administration, Keio University.

pulls her left shoulder back so that once again her feet are oriented on one axis of an X and her torso and face are in line with the other axis. As the women sit on the ground, each hooks her right ankle with her right hand, and simultaneously pulls the foot toward herself and extends her neck out toward her foot so that her nose comes almost in contact with the geta. Then they release their ankles, pull their heads in, and relax their backs, and thus contract and expand themselves with pulsations like those of a jellyfish. Their movements and postures fit within the multiaxial, multidirectional, multi-use movement vocabulary that Hijikata created for this dance.

However, there was more to this movement than formal properties. The dancers were also playing at least three different roles. One was that of old prostitutes having a conversation with their own feet. Another was that of *goze*.[26] They were also playing the role of courageous woman (*yûfu*) as inspired by a woodblock print by Utagawa Kuniyoshi, *The Courageous Woman Okane of Ômi Province*.[27]

Analogous to the use of images for formal or thematic reasons, Hijikata's choice of these characters or roles was partly related to Hijikata's movement palette, but he may also have had thematic reasons for their portrayal. The *goze* were conceived as walking through deep snow and thus needing to stamp their geta into the snow and twist them to ensure stable footing. Kuniyoshi's print depicts Okane subduing a horse by stamping on its reins (thus echoing the stamping of the *goze*). She is shown facing away from and looking back over her shoulder at the horse, and her left foot is pointing opposite the direction she faces. Hijikata may have been drawn to the idea of playing these characters because of the torso contortion in the print and the stamping the *goze*, but he also may have wanted to elevate *goze* to be worthy of representation on stage.

Hijikata may have also used the idea of playing roles to give more depth to the dancers' performance. He had drawn the Maya movement from three different sources. It may be that having three different images to look at had helped the dancers execute the movement more easily than if he had only showed one image. In a similar manner, it is unlikely that prostitutes and *goze* typically move in the ways that Hijikata choreographed, but it may have been that playing the role of both an old prostitute and blind musician functioned to deepen the dancers' performance.[28]

Underlying Narratives

These multifaceted characters were also expected to enact doubled narratives or a succession of mini-narratives. In *Story of Smallpox*, Kobayashi Saga says that there was a narrative element to the scene of the three women—it depicted a mother carrying a child on her back. Predictably, there is no scene in which any of these women carries a child on her back (although there is one scene in which a child carries a mother as perhaps a transposition of the underlying narrative). The idea of a mother carrying a child probably refers to a scene in Hijikata's writings in which he alternately describes his mother carrying him on her back to the doctor, or carrying him on her back fleeing from his father's abusive wrath and violence. Hijikata wrote:

> When I was just three years old I contracted diphtheria. At night, I had a strange cough. So, without saying a word, my mother tied me on her back and ran all the way to the doctor, her feet pounding the night path. While riding on her back, there was this moment,

when I thought, "This is it"—this is what it means to be a mother and child. But it was only the child who was thinking "This is it," and it appeared that the mother didn't feel it at all. She just panted when she got to the hospital.

My dad was a scary man. He would throw stuff at the kids, but the first person hit was my mother. She would try to scamper away, but he would chase her, his feet rapping on the floor. My mother would just sit there quietly being hit.

One day, as usual, my parents had a huge fight. She left in a daze. Since I was very small; I must have been still quite young. She put on a shawl and put four of us in it and started to walk. She walked all the way to the neighboring Tentoku Temple over five miles away. Half way there, I got tired, but I hung on for dear life. If she was a usual mother, you might underrate her, but I was afraid that she might tear each of us to pieces or leave us by the side of the road. In the end, my dad came and we were taken home.[29]

Nothing in the dance, or any subsequent information provided by the dancers helps us to know which of the two (possibly fictional) carrying-on-back scenes is intended, or rather if both of them are intended. In typical Hijikata fashion, in his essay he presents these two carrying-on-back episodes in succession. It is likely that the serial placement is an invitation to read them in light of each other.

The first passage presents the (stereotypically) heroic efforts that the mother makes to care for a sick child by strapping him on her back and running to the hospital. Perhaps this heroic representation dovetails with the character assignment in the dance to play these women as courageous women (*yûfu*), and the use of Kuniyoshi's print of Okane may indicate that Hijikata was drawn to the image of the strong woman. The subsequent passage presents a situation in which it seems like the mother is doing the same thing—finding strength to remove her children and herself from a dangerous situation by carrying them all over five miles—but the young narrator doubts the mother's good will toward him, and instead fears that the mother will rend him to shreds.

Between the first description of the heroic mother and the second featuring the dubiousness of the narrator's doubt as to the mother's solicitousness, Hijikata inserts an account of the way that the father would beat the mother (with the implication that the children may also subsequently be hit). I suggest that Hijikata is signaling to us that spousal abuse itself prevents the mother from behaving in a way that is protective of her children. Tellingly, finally, the father comes and takes everyone home, and in fact, there is almost a sense of relief on the part of the narrator, as if the uncertainty of the behavior of the mother has come to outweigh the danger posed by the father. In addition, there is no indication that anyone at the Buddhist temple put up any resistance to her being taken back home. Despite that fact that she has fled to what should be a place of refuge, she ends up reinscribed in the patriarchal social order.

If we consider the basic vocabulary of Hijikata's movement of tension, contortion, fragmentation, and disequilibrium in light of the intended narrative, it becomes clear that these movements are not incidental to the underlying narrative, but rather, are critical for it. Hijikata may have drawn to these movements for formal reasons—either in an attempt to expand the vocabulary of the body, or because he wanted to find movements not usually featured in Japanese modern dance. However, if Hijikata's account of a mother piggybacking a child is an indication of the concerns Hijikata had in *Story of Smallpox*, then the instability of the dancers may serve as

a physical corollary to the precariousness of a woman with no refuge from spousal abuse. Likewise, the tension of the dancers may echo the tension a child might feel when watching one parent strike another.[30]

Return to Japan?

There is a further point to be made about this basic body and movement orientation; it has to do with Hijikata's increasingly complex relationship with his origins. People were certainly surprised by the extent to which Hijikata had taken the presentation of "Japanese" elements in this dance. Of course there were the Japanese clothes (the *dotera* and kimono), the *marumage* hairstyle, the ash-leveler, the music (the singing of the *goze*, and the chanting from the puppet theater). But there were also movements taken from theater, martial arts, and sumo. Hijikata found himself within another firestorm of debate. This time, the two sides concluded essentially the same thing—that Hijikata had "returned to Japan."

The concept of "returning to Japan" (*Nihon e no kaiki*) has a long history. Usually, an artist becomes enamored with some element of Western art, philosophy, food, or fashion during his (it is usually a male) younger years, but then comes to appreciate the true virtues of Japanese life (often including the virtues of the "traditional Japanese woman") during his waning years and casts off his youthful infatuation. In Japan, the supposed "returns" have been greeted with either disdain or welcome, depending on the politics of the observer. So it was with Hijikata. Some people criticized his use of elements that could be marked as Japanese, while others eagerly sought to reclaim a prodigal son.

There are reasons for both sides to reconsider. First, these ethnically coded movements compliment Hijikata's core movement palette. For example, one basic martial arts stance consists of turning one foot out 90 degrees from the other foot. While the torso remains in line with the stable foot, the head and arms are in line with the turned-out foot, leading to a similar biaxial orientation as we saw above. The purpose of the stance is to provide the fighter with stability and to present to the opponent as small a target as possible (by angling the breast away from the opponent). However, in *Story of Smallpox*, the dancers raise their back heels to half point and squat so low as to nullify any stability of stance. A movement that tended to stability was contorted into instability while preserving the biaxial torso rotation.

It is fruitful to contrast Hijikata's use of the body with the torso alignment of the Kabuki actor Nakamura Matagoro—an instructor of Kabuki technique. Robert Bethune refers to Nakamura's torso as a "solid one-unit block," and says that when Nakamura moves his head, his torso does not follow, and when he turns, he completes his turns before moving so there is no overlap in the gestures.[31] In Hijikata's movements, the upper torso and lower torso frequently move independently of each other, and there is frequent overlap of movements or gestures. The comparison between Hijikata's dance and the basic postures of martial arts and theater demonstrates that, to the extent that Hijikata was interested in martial and theatrical poses, he seems to have been interested in them in part as hints to multiaxial bodily positions.

Hijikata's use of geta and Tsugaru-jamisen function in a related way. Hijikata had the dancers run back and forth on geta, and jeté from one foot to another, and even

had one leap into the arms of another. In short, the dancers use geta in ways that one would not usually expect from someone wearing geta, so there must be something besides ethnic citation in the use of geta.

In addition to using the geta as stilts in order to increase the precariousness of the dancers while they bent over, Hijikata also turned the geta into percussion instruments, (in much the same way he turned his own body into a musical instrument in *Hijikata Tatsumi and Japanese People: Rebellion of the Body* when he smashed into the brass pillars). When the dancers use geta in their hands to rap on the floor, or when they clatter sideways across the floor, the effect is one of almost pure percussion. The strident triplets of the Tsugaru-jamisen echo the percussiveness of the geta. It is as if the *shamisen* have been turned into rat-tat-tatting machine guns. The use of the body as a musical instrument was connected to the attempt to increase the abilities of the body. In *Story of Smallpox*, it is not the body per se that serves as a percussion instrument, but it is likely that Hijikata sought to turn other objects and musical instruments into percussion instruments.

The second thing that should have given pause is the simple question: What Japan was Hijikata supposedly returning to? Hijikata had already shown an interest in ethnically marked costumes and in his own area of origin in northeast Japan (from the time of the shooting of "Extravagantly Tragic Comedy: Photo Theater Starring a Japan Dancer and Genius (Hijikata Tatsumi)" and *Hijikata Tatsumi and Japanese People: Rebellion of the Body*). In those cases, I have argued, his interest lay in slashing space or rebelling against ethnic identity. So those who thought that they were gaining a nostalgic ally of "traditional" Japan should have been more careful what they wished for, and those who lamented Hijikata's turn perhaps should have instead welcomed it instead. If the narrative of a mother carrying a child on her back points to Hijikata's two written accounts of a mother and child (including one of the mother fleeing an abusive father), then there is a disturbing homology between this dance and Hijikata's account of a mother who is mocked by Japanese rural fashionistas when fleeing from spousal abuse.

The end result was an amazing performance that surely references "Japanese" elements. However, it is likely that Hijikata was defamiliarizing these "Japanese" movements or costumes, similar to the way that he had put cake-eating or bowing on stage. As with the previous performances, this defamiliarization pointed toward increasing the abilities of the body and making movements, objects and sounds do different work from that expected of them. In addition, he found in these ethnically marked movements hints of the imbalance and precariousness he explored in other movements. That same instability could also point narratively to a critique of at least one part of Japan—a woman fleeing from danger.

MULTIVALENT MOVEMENTS AND NARRATIVES

What lead to this use of multivalent elements, and layered combinations of movements, phrases and narratives? Early on, the scenes in many of the dances do not seem to cloak any deeper meaning. Men sprinting on tatami mats in *Masseur* may have disturbed the viewers, who were used to treating the mats as sacrosanct, but

they seemed to be just men running on tatami mats.³² On the other hand, there were certainly opaque moments. In *Masseur*, the dancers wore Japanese army hats in one scene, and in another scene Hijikata balanced the testicles of the other dancers on the back of his palm. Hijikata may have intended some sort of narrative, which will likely be forever lost, but even in these cases, if these men were enacting soldiers for one scene, there is no indication that they were simultaneously enacting something else.

Similarly, when Hijikata and Ôno danced a duet of arabesques in *Rose-colored Dance*, it seemed as though they were presenting an androgynous dance solely in order to toy with the gender expectations of the audience. However, though it was not visible when Hijikata and Ôno were dancing this duet, either before or after the duet, the audience would have seen Ôno with the name "Norinaga" written on his back in black tape. Of course, this was not the only multivalent image of the dance. The men and dogs that faced into the backdrop had long and complex histories, which made for a multifaceted reading of those objects. Moreover, Yokoo's poster for *Rose-colored Dance* had been full of riddles. There were layered elements in the mid-sixties performances, but the movement was often the least dense part of spectacle.

Part of the reason for this density was the desire to tax the audience by presenting them with riddles to solve without marking which riddles were important and which would lead merely to self-satisfaction at having solved a puzzle. Let us revisit this issue. On the poster for *Rose-colored Dance*, the year of the dance was designated as "Sno4 Tea" (泗拾), which included the Chinese character"泗"which was homophonous with and looked like the word "four," and simultaneously meant "snot" and "four." One Chinese character could have two different referents; as could one sound.³³ Similarly, Ôno's dancing could look like gender bending, but if Nakanishi spelled out "Norinaga" on Ôno's back with tape," then Ôno's character could have dual significance. Rather than just see this as a depiction of homoeroticism, one could ask what it means for Hijikata to have intimated the sodomizing of "Norinaga."³⁴

Hijikata also placed men with their backs to the audience and, depending on one's background knowledge, these men could function in several different or overlapping ways. Mishima had argued that compared with written language, the expressive language of the body was limited, and Hijikata had been working to expand the language of the body. My supposition is that the ability of characters (in both the sense of dancers on stage and ideographs with which to write Chinese) to have more than one referent was not lost on Hijikata, and he began to look for ways to manipulate bodies that were similar to his games with Chinese characters and similar to ways to replicate the historical density of the men facing the backdrop. Writing "Norinaga" on Ôno's back was a first step. In *Hijikata Tatsumi and Japanese People: Rebellion of the Body*, he possibly expanded on these experiments by overlaying the depiction of a celebration of Heliogabulus with the representation of several different Japanese characters, who might have been the representation of several different latent Hijikatas who were prevented from developing by the prevailing social conditions.³⁵

With regard to this layering, Kurihara notes the impact that Proust had on Hijikata.³⁶ It seems that Hijikata assumed that Proust's novel was autobiographical, and drew a connection between the dense layers of Proust's life (the density every person carries), and the layers he could create on stage. By the time of "Twenty-seven Nights," Hijikata was coming to realize that there was a vast ocean of layers available

to him if he could just figure out a way to tap into it. If a Chinese character could convey both snot and four, and if the backs of the men could hint at Hosoe's photographs of alienation and penal violence, the commodification of Nakanishi's *General Catalogue*, Hi Red Center's Cold War angst, and Hijikata's crisis situation of the back of a man standing urinating, then imagine how many valences he could convey if he could just capture the totality of a human on stage.

However, there was already a dense set of layers inscribed in every body on stage, and these layers had worried a generation of artists. Those strata were the sum of all the habits, customs, and concepts that had taken control of the body, and they were what the artists were rebelling against. That these customs and habits were on Hijikata's mind is evidenced by considering anew the passage of the mother carrying a child on her back.

In the same way that Hijikata focused on the underlying social structure that allowed the neighbors to ignore spousal abuse and comment on the fashion choices of a woman who was fleeing that abuse, Hijikata went beyond highlighting the spousal abuse of the mother and ended with the Buddhist temple allowing the woman and children to be taken back by the man who hit them ("In the end, my dad came and we were taken home."). The fact that nobody at the temple stood up to the father indicates a similar societal problem. The social structure assumed in Hijikata's essay does not provide women a room of their own, does not endow the temple with enough strength or the resources to provide a room for those fleeing violence, and implicitly supports the ideology that the woman's place is back in the home. Hijikata was faced with a strange conundrum of trying to highlight the socially constructed layers of a society that was beyond his control, and at the same time, supply an alternate density for his dancers that would be open to various interpretations.

In 1960, long before this dance, Hijikata had proclaimed, "I don't care what gets expressed. Interpretation is the right of the viewer."[37] Certainly this attitude toward interpretation speaks to the empowerment of the viewer already discussed, and to an era-wide disinclination to dictate a unitary reading for the dances, and it is likely that this attitude carried over into *Story of Smallpox* as well. Thus, it is likely that Hijikata created the complex structure of doubled narratives (delivered by doubled characters enacting movements and poses gleaned from various sources) to present dances as multivalent as Chinese characters and narratives amenable to various interpretations. At the same time, according to Kobayashi Saga, Hijikata clearly had at least one narrative in mind—that of a mother carrying a child—and this narrative was critical of Hijikata's hometown. To say this is not to imply that this narrative be exclusively privileged over all other interpretations, but to argue that a minimum understanding of this dance must take this one interpretive possibility into account.

Several things had come together in "Twenty-seven Nights for Four Seasons." Hijikata arrived at a technique for soliciting better performances from his dancers. He examined the socialization of his own body by investigating various memories of his youth. At the same time, he delved into ways to combat the socialization of bodies by highlighting a narrative in which the social structures ensured that a woman would be returned to the very person who abused her.

To be sure, much of this new method and this latest dance remind us of Hijikata's efforts in previous dances. He was still trying to expand the capabilities of the body— to enable it to contort more, to be further out of balance or off balance longer without falling, to be tensed for longer. But he was gradually turning his attention to the capabilities of the mind as well—to its ability to account for its own social structures, to its ability to negotiate more than one narrative at a time or to create narratives given little information. He kept working at these goals as he honed his new choreographic and training method, which is the subject of the next chapter.

6. The Possibility Body: Embodying the Other, Negotiating the World

…be more of an artist, and "load every rift" of your subject with ore…

—Keats

In the performances in (and leading up to) "Twenty-seven Nights for Four Seasons," Hijikata presented a layered choreography that allowed him to make allusions to many things and to reinsert narratives into his dances. He kept expanding and fine-tuning this technique for the next several years. At the same time, he worked to increase the number of performances and standardize his performance schedule. During the 1960s, his dancers had been performing in burlesque shows nightly, but only performing in avant-garde dance concerts one or two nights a year. Starting in 1969, Hijikata's dancers began performing weekly at a venue known as the Akasaka Space Capsule in experimental works that straddled the line between burlesque and butoh. In 1970, Hijikata switched to performing in Shinjuku Art Village, and then to Asbestos Hall in 1974, after the renovation of his dance studio. Generally, the performances ran for two weeks at a time, every other month. During these six years of performances, Hijikata brought his layering experiments to fruition.

This chapter examines Hijikata's new method from the vantage point of both the dancer and the viewer, in the context of Hijikata's aim to increase the range of possibilities of the body and mind. From the perspective of the dancer, this chapter will focus on butoh's three main emphases: becoming (or transformation); allowing movements to emerge from the body; and using imagery to modify movements. These training techniques were supposed to produce dancers who could do a wide variety of things, and assume different identities in different situations. From the perspective of the viewer, these techniques yielded a dance that both invited practice in constructing narratives, and was simultaneously open to many different readings.

BECOMING/TRANSFORMATION

One of the most repeated observations about butoh is that it requires the dancer to "become" something, rather than act like or express something. In the world of butoh, that something could be animal, vegetable, mineral, human, ghost, ogre—really anything at all.[1] Ashikawa Yôko maintained, "If the dancer is a good receiver and has the physical facility to realize the image, then the dancer can be anything

regardless of personal origins."[2] If the "something" was unlimited in scope, the "becoming" was thought to be total or complete. At times the artists pursued the idea of "becoming" to such an extent that it seems that they blurred the line between literal transformation and a more metaphorical understanding of the concept. Mikami's assertion is typical:

> When I first visited Hijikata's training studio, he said, "I'm raising a chicken" and pointed to Ashikawa Yôko. Ashikawa was wearing a roomy men's shirt and long underpants and was going around the studio clucking—she really had become a chicken.[3]

As Ashikawa was still wearing human clothes, it is difficult to know what Mikami meant by "really had become a chicken," but perhaps Mikami thought that Ashikawa was no longer conscious that she was acting like a chicken and instead was (momentarily) completely convinced that she was a chicken.

Various elements led to an aesthetic of becoming or transformation. Many were specifically tied to the attempt to portray marginalized people or things on stage. Consider Hijikata's notion, "Only when, despite having a normal, healthy body, you come to wish that you were disabled or had been born disabled, do you take your first step in butoh," and Hijikata's requirement that his dancers imagine their bodies under the constraint of being seen from a bird's-eye view.[4] Both required the dancer to see from other perspectives, which implied a step beyond mere acting. It was not enough to act as if disabled. It was not even enough to want to be disabled for a moment in order to understand that worldview. The dancer had to want to see the world from the perspective of disability so badly that she wished she were born that way. She needed to wish that she did not even have any memories of not having been disabled. As the goal of seeing from other perspectives came to prominence, only complete transformation was acceptable.

Hijikata's choice to engage Japan in *Story of Smallpox* added another reason for total transformation. Hijikata staged parts of his own (possibly fictional) history or parts of the history of his disenfranchised mother. To his dancers, his own viewpoint was alien (and the viewpoint of a Tôhoku child, still more alien) and only the effort that could enable the dancers to see the world from the vantage point of a handicapped person could enable them to see the world from Hijikata's point of view. When Hijikata attempted to stage his own history, transformation techniques would help his dancers see the world from his perspective.

Canceling the Self

As his reasons for transformation multiplied, Hijikata came up with ways to assist his dancers in the tasks that he demanded of them, which included seeing the world from different viewpoints. One of these was the cancellation of one's individual personality or selfhood.[5] Recall in the discussion of experience in chapter 2, there was the notion, broadly inherited from the Japanese philosophers, that it was possible to decrease the level of distortion that one was appending to perceptions. In the case of becoming something else, there seems to have been a corollary assumption that one's current personality would deter one from successfully seeing the world from a different perspective. Thus, the task of seeing from another point of view had to begin with the task of canceling the distortion that one brings to any perspective.

In helping the dancers cancel their own personalities in order to inhabit other mental states, Mikami saw the white face and body paint as crucial, because it effaced some markers of individuality. In fact, the white paint has a long history. It may appear to be an updating of Kabuki and courtesan makeup, yet it did not start out as a reference to tradition. The first butoh body paint was actually grease or olive oil to make Hijikata's skin look even darker on stage during *Forbidden Colors*.[6] This, as well as the later white body paint, supposedly hid a scar that Hijikata had received during a blast furnace fire at the Akita Steel Works in 1947.[7] However, in the 1961 dance *Mid-afternoon Secret Ceremony of a Hermaphrodite*, the costume designer, Yoshimura Masunobu sought to discomfit Hijikata by wrapping his body with plaster and gauze so it looked like a mummy in order to achieve a "reverse intervention" on the choreography.[8]

Similarly, Yoshito recalls that in *Masseur* in 1963, after diluting the plaster with glue, they applied a thick layer over the dancers and let it dry. The thick coating prohibited them from moving smoothly, and the paint cracked in distinctive patterns.[9] Additionally, both Yamada Ippei and Gôda Nario say that the plaster sculptures of George Segal provided the inspiration for this thick plaster and gauze.[10] Gôda thinks that the final evolution to white makeup was aided by the desire of the early male butoh dancers to contest gender roles by playing the roles of transvestites or hermaphrodites on stage.[11] Ironically, when Hijikata began to focus more on female performers, the custom of white body and face paint continued. If the male dancers could suggest a subversion of gender categories by using the white makeup of courtesans and female impersonators, then the use of similar makeup by women might alter the subversive force of the makeup.[12]

Thus, white body paint seems to have had a variable significance in Hijikata's dances. Initially it was used to hide a deformity, but later was used to cause or represent a deformity. Its gender-bending possibilities have been well noted, and it was also employed to help the dancers suppress their personalities. By preventing the dancer from moving in certain ways, it could cause a transformation in movement, or by helping the dancer to cast off some mental baggage that was impeding the dancer, it could help the dancer to metamorphose into something else.

EMERGENCE

A related goal was to allow movements to emerge from the body organically. Hijikata wrote:

> In other forms of dance, such as flamenco or classical dance, the movements are derived from a fixed technique; they are imposed from the outside and are conventional in form. In my case, it's the contrary; my dance is far removed from conventions and techniques...it is the unveiling of my inner life.[13]

Here Hijikata rejects imposing movement from the outside, with the implication that movement should well up from the inside. The idea for emergence seems to have stemmed in part from Huysmans and Proust.[14]

Hijikata extensively studied Shibusawa's 1962 translation of Huysmans's *Against Nature*.[15] Huysmans's narrator, Des Esseintes, engages in a synesthetic exercise of creating musical tones through mixing various flavors of alcohol. By chance an Irish whiskey

recalls to him the tang of dental work, and then, unbidden, a vivid memory wells up in his mind of an excruciating toothache and of having the tooth pulled without anesthesia.[16] It is as if Des Esseintes feels the exact same feelings when drinking whiskey that he felt when having the tooth extracted. Des Esseintes goes one step further and assumes that with the proper preparation (mixing the correct odors, sounds, and motions) he could get his imagination to conjure up an indistinguishable substitute for any reality.

Similarly, in one of the most remarked upon passages of *Remembrance of Things Past*, Proust's narrator relates the story of sipping a spoonful of tea mixed with madeleine crumbs. A "shudder" runs through him at the moment that the tea touches his tongue. After minutes of casting around in his mind for the source of the shudder, the narrator recognizes the taste of the tea as being identical to the tea he drank as a child, and with that realization an entire vision of his childhood home rises in his mind.[17]

Hijikata was likely drawn both to the synesthetic creation of one kind of sensation by another sense, and to the unexpectedness of the scenes, which catch the narrators completely by surprise. For artists worried about the effects of socialization on the body, Huysmans's and Proust's novels must have provided a potent suggestion for how to sidestep the customs and habits that constricted them. This is also in keeping with the surrealist hypothesis that random acts and unconscious responses could go beyond the limits of conscious responses. Committed to subverting social customs, Hijikata and a whole generation of artists were on the lookout for such unforeseen phenomena.

However, it was not easy to trick the unexpected into happening. Mikami argues that Hijikata tried to overload the dancers in order to induce his own version of Huysmans's Irish whiskey. She quoted Hijikata as saying that he thought of butoh as something that "comes out when one is squeezed"(*oshidasarete, detekuru*).[18] Considering Hijikata's quotation above, one might think that "the unveiling of my inner life" would indicate the expression of some core mental reality, but the example that Hijikata gives is instructive: He continues: "Take these fingers....I've asked myself in an extreme situation what their function could be between one articulation and another."[19] When Hijikata professed interest in unveiling his inner life, he was interested in how his body would move when subjected to extreme conditions, and this is related to the idea of emergence.

There is a tension between emergence and becoming. Emergence implies something that is unplanned and involuntary, but, in fact, Hijikata's choreography was carefully planned. Moreover, usually, one has to decide consciously whom to transform into, and when to do it. Thus, the problem with these two ideals was their seeming incompatibility. How could one coax a total transformation to emerge from the body? Could one become the product of something that spontaneously emerged from the body? In a sense, becoming took precedence, because if one became something else (if one were to have been born in the squeezed state of disability), anything that came out would emerge organically.

ALTERING MOVEMENTS THROUGH IMAGERY OR SOUND

Whether the goal was becoming or emergence, Hijikata's dancers could not be reborn as different people. Moreover, if we consider Hijikata's dances, it seems obvious that

not every movement was the product of "what comes out when squeezed." Hijikata needed to find movements and the dancers needed techniques to achieve the performances that Hijikata desired of them. In the previous chapter, I presented Hijikata's use of characters and underlying narratives and his use of images as sources for new movements. Here the focus is on how to execute movements and create even more of them. The structure of his experiments remained more or less unchanged, but grew progressively more complex and abstract, particularly in terms of how a movement could be created or modified.[20]

Here is a movement and its set of instructions:

Cow
- weight is carried
- foot-hoof (knees, bent)
- hand-hoof (fingers, bent)
- horns (from the nape)
- tail
- flexibility of the back—add hips
- close flanks
- bend forward stretch neck out[21]

Each of the bulleted items is one instruction or modification in the overall execution of the movement or pose that Hijikata called "Cow." In this case, the instructions are relatively physical in nature: "hand-hoof (fingers, bent)" tells how to configure a part of the body—the hands. In this case, Hijikata used observations of a cow to create a fresh movement.

Movements or poses could be strung together in phrases such as the following:

Rose Girl
- rose blossoming in mouth
- dandelions in ears, valerian on soles of feet
- wings on hips
- right hand has bottle with deadly poison

↓

Bird of Light—Rabbit
- nerves that stretch out above the head in a plane parallel to the ground
- nerves that stretch from nape of neck to ceiling
- bathed in light, a rabbit squeals

↓

Young girl wearing mantle of light
- mantle of light hanging from back, it stretches out forever in a plane
- rarified small girl
- that young girl walks on the mesh of the light

↓

Twin
- belt of light that widens from hips backwards to ceiling
- belt of light widening backwards below the ground alternately widens
- a noble woman wore silk gloves in the midst of the eternally widening belt of light
- a butterfly of light flutters out of her nose and dances its way up to the right ceiling

↓

Beardsley 1
- person made entirely from nerves
- noble woman wearing thin silk skirt with long hem
- line of sight pursues the nerves that extend from finger tips of left hand
- nerve extended from back part of top of head to the ceiling

↓

Beardsley 2
- noble woman walking in the dark following a wall
- instability of footing
- eyes affixed to the finger tips of the right hand, which touches the wall
- nerves extending to the ceiling

↓

Beardsley Peacock Lady
- incredibly thin feathers extend out from back of head
- long silk skirt (=the peacock wings that extend out of hips)
- as the woman spins, the long skirt comes after
- not that the woman is spinning, but the skirt is spinning
- the nerves from the nape of neck that cross over the back of head and extend to the ceiling pull on the skirt's hem
- stare at the skirt that follows the spins
- wind puffs from below
- noble woman holding skirt does half turns
- it is as if there is a deer there

↓

Beardsley 4
- gazing at partner from over shoulder
- left hand seeking to shake hands
- nerves extending to the ceiling so that one cannot run away to the rear[22]

↓

Beardsley 3
- nerves extending as if the jaw is seeking help from the ceiling
- resting hands

↓

Rose Girl[23]

This sequence is the titles of series of movements and poses ("Rose Girl," "Bird of Light—Rabbit") and instructions ("rose blossoming in mouth") for how to execute the movements or poses.

The instructions functioned in increasing complex ways. Take the following list:

Michaux—Person of Light
- the sensation of light extends—under the nose, elbows, joints of feet, knees
- manteau of light—transparent, infinitely transparent
- walk on a rope
- the sensation of light extends, crouch 4 meters in front—melt into the plane
- razor blades on the soles of feet—walk
- strong smell under nose—the nape of the neck extends
- be pulled from behind and to the right
- left leg raises
- fan in hand
- be observed from a bird's-eye view
- softness from below
- ◉directionality disperses[24]

Here, the instructions can be divided into different types. One set of instructions is similar to the physical kind encountered in "Cow." Items such as "left leg raises," "fan in hand," or "walk on a rope" indicate physical movements presumably demonstrated to the dancers.

Another kind of instruction sought to establish tone or quality. An instruction such as "softness from below" is a relatively straightforward attempt to alter the quality of the movement by getting the dancer to move in a soft manner. Other instructions were indirect but very concrete. For example, an instruction such as "in the mud storehouse, in the dark, it [one's shadow] becomes chilly and spreads out," may be asking the dancer to imbue a movement or posture (or the entire space) with a dark and chilly feeling by imagining a dark chilly shadow spreading throughout a cellar.[25] An instruction could be indirect and abstract: take "manteau of light—transparent, infinitely transparent." This may be asking the dancer to alter the quality of the performance by imagining wearing an evanescent overcoat, or it may be an attempt to create a mood by infusing an entire motion with a feeling of ethereality or light.

Hijikata's also experimented with imagining novel combinations to discover new movements. Presumably, while all the dancers knew what is was like to cut themselves, none of them ever really walked on razor blades, so "razor blades on the soles of feet—walk" required the dancers to imagine something they had never done (walking on razor blades) and then move in accordance with how they thought they would move in such a situation. The number of novel combinations is theoretically limitless, so this use of imagery should lead to a limitless number of new movements.

However, there were limits on how much the dancer was allowed to pursue her own imagination. Kurihara says that imagining razor blades encouraged the dancer to not press down with force on the foot, but instead walk on the side of the foot. Kurihara's comment demonstrates that the dancers were not free to imagine their own response to affixing razor blades to the soles of their feet, but rather were to understand how Hijikata imagined this and to replicate that by imagining something similar.

Next, consider, "be observed from a bird's-eye view." This instruction requires another level of abstraction. It is one thing to imagine stepping on razor blades and allow that to affect your body because presumably everyone has been cut once or stepped on a nail, so it's a manner of multiplying what it feels like to have your finger cut and transferring it to the bottom of your foot. It is another thing to imagine being looked at from a different angle and let that affect your body-mind, because while all dancers have been looked at, and can presumably transfer what that feels like from one place to another, it is not as clear what observing does to a movement. It is impossible to know the desired effect without actually watching a dancer execute "Michaux—Person of Light" while imagining herself being observed from a bird's-eye view, and then having her do it without imagining being thus observed to see what changes.

That said, instructions such as these were common and were typically used by Hijikata as a means to reject the audience-facing orientation of the proscenium theater and to help his dancers to project in all directions at once.[26] In this respect, "directionality disperses" may be thought of as an amplification of being observed from a bird's-eye view. Being observed from a bird's-eye view calls one's attention away from the audience in a single direction (upward), while "directionality disperses" forced the dancer to focus in all directions.

The technique of dispersing directionality can be compared to instructions requiring the dancer to append eyes on other places of the body, for example: "eyes on soles of feet" or "eyes in jaw."[27] Transferring the eye to another body part calls attention to that part and thus makes one more aware of it, and also causes one to attempt to sense the world from the viewpoint of that body part, or under the constraints of that part. Such instructions advance Hijikata's concern with seeing the world from other perspectives.

Kurihara has an extensive section about dispersing concentration using "insect bite" (*mushikui*) exercises. The exercises began with the dancers imagining one insect crawling along their body, while the teacher would rub a drumstick across a drum to make a slithering sound. Then the dancers would imagine more insects crawling over more of the body, and thus be forced to pay attention to a greater and greater number of parts of the body. If the number got too large and she lost track of them, the teacher would have her practice with a smaller number of insects and gain control over that number and then proceed to the larger number. She says that while she thought that from the outside her body could not have looked very different, on the inside she felt completely different after the exercise.[28] However, she also says that to the discerning eye, (and certainly to her teachers who would catch her immediately if she slacked off and started moving without the accompanying mental effort) the minute differences were visible.[29]

Concentration could be extended outside the body. For example, in the case of "nerves assailed by weak electrical currents" and "nerves extending to the ceiling," one instruction extends the concentration throughout the body, while the other extends the concentration beyond the body.[30] The instruction "the sensation of light extends—under the nose, elbows, joints of feet, knee" asks the dancer to be conscious of various spaces outside her body. In practice, the dancer will hold her body differently when trying to maintain an awareness, not just of her nose, but of the space under her nose.

The idea of being aware of various spaces is common to butoh. Rather than employing a facile assumption of empty space, Hijikata appears to have assumed that space has properties, and experimented with altering the quality of space. The theater expert Eugenio Barba watched Hijikata's dancer Nakajima Natsu and identified the way in which Hijikata would ask the dancers to transform the spatial environment (the background medium) of a movement. Barba writes:

> Nakajima Natsu... is explaining and demonstrating her way of working (Bologna, ISTA, July 1990). She chooses a series of images for each of which she establishes an attitude, a figure for her dance. She thus has available a series of immobile poses sculpted into her body. She now assembles the series of immobile poses one after another, passing from one to another without interruption. She obtains a precise design of movements. She repeats the same sequence as if meeting three different types of resistance, which must be overcome with three different types of energy: it is as if she was moving in a space as solid as stone; in a liquid space; and in the air. She is constructing, on the basis of a limited number of poses, a universe of images, a choreography.[31]

Thus, the dancer might be asked to do "Michaux—Person of Light" inside of a stone or under water. This concern for the materiality of the surrounding space may have allowed Hijikata to avoid mere mechanical movements. Rather than telling dancers to spread a movement over four beats, different background media might cause the dancer to move more quickly or slowly. Doing "Michaux—Person of Light" in stone might entail moving more slowly in smaller total amplitude, while doing the same "Michaux—Person of Light" in air might be marked by a quickness and expansiveness of the overall pattern of movements. In one instruction, Hijikata says, "the density of the rock is 90% one must pass through the density of the rock."[32] This is the kind of imagery that Nakajima must have had in mind as she performed. Here, the task was to alter the imaginary surroundings of the movement in order to modify it.

Hijikata experimented with altering the sound that enveloped a movement. Perhaps recalling the synesthesia of Des Esseintes's experiments with trying to create musical tones by mixing alcoholic drinks, Hijikata tried altering the imagined sound accompanying a movement. They might imagine moving to the sound "gacha gacha." They would repeat the movement while imagining the sound "kacha kacha," to see if the aspiration would alter the movement.[33] Sound alternation was not limited to the dancers' imagination. Several dancers report that they might learn a sequence to one kind of music, but that Hijikata often altered the music on the day of the performance.

Hijikata might also alter what could be called the character type. In *Story of Smallpox*, Hijikata had already experimented with something close to character types

in calling the three geta-stomping women, "courageous woman." Gradually, he came to pay strict attention to the character by whom a movement is carried out, under the assumption that transforming a movement from one character to another would transform the movement as well. Some examples of characters were "Old Woman," "Beggar Girl" and "Pariah Girl."[34] An old woman would obviously move differently from a young girl, because her movement would be slower, and more bent. The task was not to alter the background so much as to alter the body doing the movement. To sum up his methods, Hijikata required the dancers to concentrate on various places on, in and beyond their bodies simultaneously, look at the world from various viewpoints besides that of their own eyes, imagine themselves being viewed from various angles, imagine themselves moving through diverse media, and as various characters. Mikami spoke of the point where "concentration and diffusion mix together," and this nicely describes the dizzying matrix Hjikata placed the body within.[35]

Eventually, Hijikata went beyond even the abstract categories described above. For example, consider his instruction: "Is the mask a face or is the face a mask?"[36] At this point, the word "instruction" truly strains to cover this oddity. Of course, one may well hold the face differently, if one is unsure whether the face is a mask or not, but it seems that in addition to getting the dancer to execute or alter a movement either directly or indirectly through the imagination or redirection of concentration, this is a philosophical question inviting the dancer to reconsider her self and what she takes for granted about her world.

THE FRUITS OF THE IMAGINATION

The dance scholar Sakurai Keisuke compared Hijikata's techniques with those in William Forsythe's *Improvisation Technologies*, in which Forsythe demonstrates procedures for how to discover new movements.[37] Forsythe experimented with transferring a movement from one body part to another, or transferring the plane or fulcra of a movement. Imagine your hand going around in a circle with your wrist as a fulcrum somewhat as a traffic cop motioning traffic onward, and then imagine your whole arm going around in a wider circle with your shoulder as a fulcrum as if in the wind-up for fast-pitch softball. Now imagine pointing your knee out in front of you with your toe pointed down to the floor and then using your knee to make a circle with your hip as a fulcrum, as if you had a pencil protruding from your knee and were trying to draw a circle on the wall in front of you. In Forsythe's system, these could be the basis for new movements. If you then rotated your leg ninety degrees out, you could draw that same circle in a different plane and perhaps discover another new movement.[38]

Hijikata was finding new movements by experimenting with various kinds of transformation, so it is easy to see how he could have approached this task from different angles. First, he could transform the underlying character (go from being a pariah girl, to a cow, to an old women). Next, he might transform the medium of the movement—move in stone or water. He could then create a matrix of permutations of background media and character media to access to a wide range of movements. Moreover, once he had established the principle that altering one's mental

state changed the quality, tone, energy, and amplitude of one's movements, it logically followed that merely altering what one imagined—such as electrical currents, or insects crawling through one's pores—would yield a new movement.

Unlike Nakajima's series of figures with three different types of resistance, Hijikata had a phenomenal number of basic poses or movements at his disposal. By subjecting that number to this movement matrix, the possibilities for new movement became endless, because the instruction "rose blooms inside of one's mouth" affects a base movement differently from the effect realized by imagining "bugs come crawling up from one's feet," which in turn is going to feel different from having a "slug crawling on one's neck." In a note appended onto the movement "Horse," Hijikata counseled his dancers:

> Sense the weight, stupidity, and shortness of the neck of a cow, if you put the horse head in the middle of the "Yardstick Walk," it creates a kind of strange mysterious person. If you put it into things like "Maya," from the neck down is object and from the neck up is animal, through these numerous variations, bodily expression is carried out.[39]

In Hijikata's distinctive style, this is as close as one gets to a clear-cut statement of artistic method. These "numerous variations" are the ways in which Hijikata came up with creating a new dance with new movements. Hijikata was fond of telling Ashikawa that she had one ton of butoh movements stored inside her.[40] It is easy to see what he meant—Ashikawa had hundreds and hundreds of basic movements stored inside her, and she could subject those movements to the modification matrix in order to create thousands more. When considering Hijikata's quest to increase the language of the body, it is difficult to avoid the conclusion that the use of imagery exercises for the mind was the next step to increase the vocabulary of the body.

It is likely that these instructions were not just for the purpose of creating new movements. As outlined in the introduction, Hijikata adhered to the surrealist practice of juxtaposing ideas and elements to see what the outcome would be. Even though these ideas would struggle with each other within the mind, observers were not to let one element win over others; rather they were supposed to hold them in tension. The dancers also could not focus on one instruction at the expense of the others, but needed to be able to manage all the instructions simultaneously. In sum, the dancer needed to be able to hold instructions in tension in the same way that surrealism said that an observer needed to be able to hold a coupling of distant realities in tension, and it is likely that multiplying instructions to as many as seventeen served as mental training.

HIJIKATA IN THE WORLD OF PERFORMANCE

Hijikata was not the only one to experiment with different ways to create new movements, and access deeper levels of performance. In order to further elucidate Hijikata, it is fruitful to compare him with other dance and theater practitioners. For example, let us return to Barba's citation of Nakajima, which was in the context of a discussion about energy. The previous example Barba had given was of the different kinds of energy that Stanislavski had while acting as if he was buying a newspaper under

three different conditions: when he has time to kill an hour before a train departs, after the first call for the train, and after the train has already begun moving. Barba notes that this thing called "energy" is nothing more than a metaphor, but he stresses that it is a metaphor that helps actors and dancers talk about something that is real.[41] Hijiikata's instructions may be thought of as analogous to the adjustments of the type that Stanislavski used to alter his energy, but beyond the general use of restrictions to modify performance, Hijikata may have been interested in exploring the different energies that come with dancing under different imaginary constraints, or in the concrete straining of muscles that would have been required in order to drag one's limbs through imaginary media of different densities.

System and Method Acting

The comparison can be further widened to theatrical innovations of Stanislavski's System, and American Method Acting. Stanislavski employed what he called the "creative if": if you were in the particular circumstances of the play, how would you behave, what would you do, how would you feel, how would you react? Stanislavski's contemporary Vakhtangov reformulated the question: "The circumstances of the scene dictate that the character must behave in a particular way; what would motivate you, the actor, to behave in that particular way?"[42] American Method innovator Lee Strasberg, wrote: "The important thing is…not that what the actor deals with is an exact parallel to the play or the character, but that when the character thinks, the actor really thinks; when the character experiences, the actor really experiences—some-thing."[43]

Building on these developments, but also stemming from Proust (and very likely Huysmans before him), Vakhtangov's student Boleslavsky created the technique of "affective memory" or "emotional memory": a technique for actors to access an emotion from a previous time in their lives by recalling the details that led to that emotion. The actor remembers concrete details like the air temperature, her wardrobe, the smells, and the tones of people's voices at the time she recalls. The actor then begins to reexperience the emotion that she originally felt. Finally, the actor practices bringing this emotion up at will so that she can use it during a performance.[44] The actor supposedly grieving over the loss of a loved one reproduces an emotion that she felt when she lost the high school state championship tennis match many years before. The audience interprets her emotion in the context of the play, and assumes that she was crying over the death of a family member; she alone knows that she was still saddened (or re-saddened) by losing a championship match.[45]

Hijikata exploration of his past was similar to the excavation of past memories in affective memory, but ironically, he also pursued the idea of canceling the self in order to more fully approximate the experience and viewpoint of another. Hijikata seems to have supposed that individual personality provides a drag on the process of transformation. Meanwhile Method Acting evolved in the opposite direction. There are moments when Method actors try to inhabit the target world as much as possible (think of this as replicating the distortion that the Other appends onto sensory data), but Method Acting innovators seem to have assumed that the elements of personal history are so strong that it was foolish to try to contest them. Hence, they

developed a means of tricking actors into bringing more of their history to the stage. At the risk of setting up too large a dichotomy, Method Acting essentially tells actors to go deeper inside themselves, and bring out their past emotions with no regard for whether those emotions match with what is on stage. Butoh technique attempts to tell dancers to shut off their past so that they can have access to the mental universe and viewpoint of someone or something else. Of course, butoh depends on memory as well—you need to remember what it was like to be cut by a piece of glass in order to imagine walking with razor blades on the soles of your feet—but its emphasis on memory and concept of selfhood is different from that of Method Acting.

The comparison between butoh and Method Acting is not simply for the heuristic purpose of showing how two people solved a similar problem in opposite ways. It highlights the fact that the performers faced similar problems in different parts of the world. Stanislavski had developed his system out of frustration with the varying level of performances—one night the actors would be "on" and the next night they would be "off," or one actor would act well, while another would not act convincingly.[46] So, he created techniques for eliciting uniformly powerful performances from night to night and from actor to actor. Competition within the marketplace of the theater forced directors to develop techniques so that the production of theatrical affect would not be left to chance.[47] Hijikata was also working within a competitive theatrical environment and a competitive wider society (in which, as noted, he had to manage burlesque shows to put food on the table). So it is not surprising that he also looked for ways to create convincing and uniformly powerful performances.

Somatics and Noguchi Exercises

Kurihara offers an alternate cross-performance comparison. She cites Mabel Todd and Lulu Sweigard's theory of ideokinesis—in which one uses images to modify body movement—as a way to understand Hijikata's experiments.[48] Todd and Sweigard might fruitfully stand in for the entire field of somatics and body therapy.[49] Todd and Sweigard took it as axiomatic that the human body was not currently in a state of correct alignment, and does not necessarily move in the most effective way, but rather builds up ways of moving either by happenstance, or according to local custom (which may itself be rooted in happenstance). To achieve correct posture and bodily alignment, and efficiency of movement, they advocated using imagery in order to find better ways of moving.[50]

It is not clear whether Hijikata was aware of ideokinesis or other similar disciplines (although given his breadth of interests it would not be surprising if he was), but he encountered something very similar from a local source. In 1949, while dancing with Eguchi and Miya, Ôno met a fellow dancer and physical education instructor, Noguchi Michizô (1914–1998), founder of Noguchi Exercises (*Noguchi taisô*). It is not clear whether the two of them maintained contact, but sometime after 1965, two of Hijikata's friends and disciples—Maro Akaji and Kara Jûrô—also met Noguchi, and in time, Noguchi came to Asbestos Hall to teach movement classes.

Somewhat like Laban or Todd, Noguchi attempted to understand the full range of ways in which the body moved and used imagery to assist the body in moving in more beneficial ways.[51] He based his ideas on the mechanics of movement—in particular,

he focused on gravity, inertia, and the principle of an equal and opposite reaction for each action. He thought we shared with our coacervate progenitors a fundamental liquidity, but that from the time proto-mammals began to live on land, bodily movements and structure had been inextricably shaped by gravity. He supposed that bodies were fundamentally liquid and thus interconnected, and that the law of inertia ensured that movement naturally reverberated from one part of the body into adjacent bodily regions. Finally, he assumed that overuse of any faculty rendered it insensate. From these assumptions, he built up an exercise and movement program that sought to increase the sensitivity of humans and the ability to respond to any situation by reducing the amount of unnecessary work placed on muscles. Noguchi thought that as their muscles recovered from overwork, humans would then possess a correspondingly greater ability to sense minute gradations in the environment, which would, in turn, increase their responsiveness to their environment even further.

The first step in this process was, in part, borrowed from yoga and involved adjusting one's center of gravity to carry as much weight as possible on vertical supporting bones, with the rest hanging freely (*burasagaru*) from the skeletal frame. This minimizes the muscle used in carrying one's weight. The next step was to check for stiffness in the body. For Noguchi, stiffness indicated that the muscle was needlessly tensed, and therefore would cause premature fatigue and a loss of sensory abilities. In addition, as movement rippled through the body, stiff muscles would catch the movement, causing them to work even more to absorb the force of the movement. Take, for example, an arm swinging back and forth like a pendulum. It does not cost a swinging pendulum any energy to return to a motionless state, although it does require energy to artificially slow it down. Noguchi concluded that in a supple body, movement would be able to dissipate without tiring the body.

Conversely, after a dancer expends energy initiating a movement, stiffness necessitates an additional expenditure of energy to continue the movement. To return to the pendulum, in order to maintain amplitude, a pendulum needs an input of energy with each swing to counteract the effects of gravity. However, stiffness requires additional energy each time to overcome the tightness in the muscles in order to ensure that a swinging arm continues at its initial amplitude. Noguchi's solution was removing force (*chikara wo nuku*), or loosening (*hogusu*). To achieve his desired bodily state or convey the experience of a movement, he used imagery work, and Noguchi can seem like a tamer version of Hijikata with his "Slither Roll," "Sleeping Slither," "Buttocks Walk," and "A new arm is born from the womb."[52] The goal was a supple body-mind integration in which one could perceive subtleties about the environment and respond to any situation. He even argued that in this state, one's senses could become so attuned that one would be able to respond to the exigencies of the next moment unconsciously.

Hijikata owes a large debt to Noguchi, but he was also doing something very different from Noguchi. Where Noguchi advocated loosening the body, Hijikata required his dancers to maintain tenseness for interminable periods of time, and made them artificially contract their muscles. While Noguchi advocated carrying weight vertically over load-bearing bones so as not to overwork muscles, Hijikata required his dancers to hunch or lean in ways that shifted their center of gravity away from their core, which in turn required protracted physical strength.[53]

Noguchi emphasized the flow of movement through an interconnected liquid-body, but Maro Akaji has said that they studied the way movements flowed in order to be able to interrupt the movements.[54] Maro's observation speaks to the fragmentation or compartmentalization of the body in butoh. Perhaps, as an extension of Hijikata's focus on moving each part of the body independently of all the others, the technique demands that the dancer slice and dice her own body into innumerable discrete parts, which she should be aware of distinctly and able to move independently. This was not workshop rhetoric. One common exercise is to imagine a ball moving to various places inside one's back.[55] It is possible to watch an experienced butoh performer move a ball anywhere on her back. Another exercise is to insert nearly imperceptible pauses into a fall in order to make the movement look fresh and exciting. The act of falling, which Noguchi would have thought of as uncontrollable once gravity took over, and thus consist of one continuous movement, is dissected into many short movements punctuated by tiny pauses. These examples point to two sides of the fragmentation of the body—the ability to move individual parts of the body independently, and the ability to interrupt movements or break them down into minute constitutive parts.

Hijikata and Noguchi share a common purpose in seeking the ability to minutely sense the world. Either as a side effect of concentrating on so many things at once and holding them all in tension within the mind, or as the goal behind this concentration, the dancers became more and more able to sense minute variations within their body and in the world around them. Hijikata's instruction, "person made entirely from nerves," must have been intended to help the dancers achieve this heightened awareness. In a body entirely consisting of nerves, each part can sense equally well. In dance practice, Kurihara was told to place an eye on the middle of her forehead. When she tried to stop looking with her usual two eyes, she reports that she was able to "see without focusing on anything in particular," and that she was more physically aware.[56] One can get a similar sensation by focusing on the peripheral reaches of one's vision. One suddenly becomes aware of a vast amount of detail that one normally misses when one is focused on whatever is directly before one's eyes. The heightened sense of awareness that butoh dancers develop surely stems from a combination of being told to look anew at things they may have overlooked, and being required to develop their ability to concentrate to such extraordinary levels.

Noguchi Exercizes, ideokinesis/somatics, and Stanislavski System/Method Acting shared the use of imagery to help the body move in more efficient ways. In contrast, Hijikata was not interested in efficiency and in fact purposefully created movements that were incredibly inefficient such as contorting the spine while leaning over and elevating the heels. That said, his use of imagery to help his dancers achieve new movements paralleled the somatic/ideokinetic use on the assumption that imagery work can help people expand their abilities.[57]

BECOMING DIFFERENT SELVES

Mikami argued that butoh dancers had to cultivate the ability to become many different things in quick succession and, in this, butoh shares a concern with, but goes beyond, Stanislavski and Method Acting.[58] We need to expand on Mikami's

observation and recognize that butoh's emphasis on becoming or transformation (and the acclaim with which butoh's transformation strategies have been received both in Japan and in other countries) echoes a world in which we are required by our circumstances to inhabit many different selves in different moments. In these situations, it may be sufficient to act differently, but acting can bleed into becoming someone or something different. Thus, butoh training functions as successive iterations of self-creation (which is perhaps best demonstrated in the virtuoso displays of quick transformation in such dances as *Hijikata Tatsumi and Japanese People: Rebellion of the Body*).

However, there was in Japanese society a specific element that likely accounted for the distinction between Hijikata's new method and other acting methods. People have always felt it necessary to tell white lies, or put on a good face in front of a person in power, and in that sense most people know how to adopt different subjectivities at different moments. In the case of Japan, many Japanese people refer to the distinction between *honne* (real intention, true feelings) and *tatemae* (outward manifestation), and the attention paid to that distinction in Japan may indicate that the inhabitants of Japan feel that gap to be a particularly large part of their mental universe—particularly in an environment in which social conformity is often demanded.[59] In addition, the Japanese language comes equipped with its own signaling devices by which users can signal their hierarchical status in a particular interaction by their choice of predicate suffixes, and this may mean that Japanese people are more accustomed than others to using their language strategically and contextually, and thus to presenting themselves as different at different moments.[60]

Another facet of Japan in the late 1960s and 1970s likely added to the concern for inhabiting different personas. David Harvey has argued that one of the features of the world at that time was a compression of space and time by which people, products, and images had gone to and come from the far corners of the earth.[61] The postwar period was marked not only by a huge influx of ideas, but by a huge influx of people, among whom occupying American soldiers and returning Japanese soldiers were only a fraction. When the occupation ended in 1952, many in Japan anticipated the end of the imposition of outside values and modes of thinking, but many of the newcomers did not go home. Soldiers remained in permanent bases in Japan, and many others flocked to Japan for economic-, artistic-, or fantasy-fulfillment purposes.[62] Couple that with large-scale migrations within Japan, which saw tens of thousands of rural farmers relocate to the cities in hopes of finding employment, and also with the subsequent tourist campaigns to take Japanese people back to the countryside for rest, relaxation, and refitting in a Japanese mode, and the picture that begins to emerge is one of Tokyo as a city of transplanted people[63] This was a time and place when people had to present different selves to different people in successive moments.

THE POSSIBILITY BODY-MIND

Mikami argues that this kind of dance training was intended to create what she calls the "possibility body" (*kanôtai*)—a body that can do many different things very quickly.[64] Mikami's observations about the "possibility body" are related to

the ways that Hijikata had been thinking about the abilities of the body from early in his career. My argument is that athleticism of *Masseur* was an outgrowth of the role of athletics in postwar Japanese society (including surfing and sailing in Sun Tribe films, and boxing, fencing, and weightlifting by Mishima, Shinohara, and Terayama), and in turn, related to a sense of the body's role in conflict and competition within Japan during the postwar years. I suggest that we see Hijikata's new method as indicating a transformation, in which wider conceptions of the role of the body and mind were gaining precedence, and thus we need to expand on Mikami's "possibility body." By the seventies, no one was under the illusion that weightlifting would be sufficient to meet the challenges of the decade. Each part of the body would need to be isolated and studied in order to make it contribute to the whole. In addition, the mind would have to be strengthened to be just as capable of bearing burdens or bending in new ways, leading to conclusion that what Hijikata desired was a "possibility body-mind."

The idea of a "possibility body-mind" can guide thinking about broader concerns such as the role of becoming (or transformation) and emergence in increasing one's abilities. Compare the involuntary nature of Huysmans's and Proust's flood of memories, or Hijikata's idea of squeezing the body to see what emerges, with Noguchi's emphasis on the ability of the body to respond unconsciously to the next situation. Noguchi thought that unconscious processes were better at activating faculties of the body or responding to events than conscious ones, because he believed that overuse of faculties dulled them. He shared this notion with many martial artists and athletes, who felt that a conscious response to a situation would be too slow to be efficacious. As we have seen, dancers trained in somatics had a similar notion. In the case of the conscious mind, Noguchi thought that its continual overuse had rendered it insensate, and that allowing it to relax by delegating some of its work back to the unconscious would be just the thing to enable it to renew and increase its sensory powers. Somatics practitioners activated bodily responses through indirect suggestions that engaged more parts of their brains.

I want to emphasize that this era was not just a time when people needed increased physical and mental flexibility, but it was also an age when both random processes and the unconscious could no longer be allowed to escape control.[65] We might say that actors, dancers, and artists sudden woke up to the fact they could no longer afford to let the unconscious realm and a slew of random events escape their control. They sought to develop techniques to do three things: harness the potential of random occurrences by planning for them, and providing an environment in which they can happen; finding a way to bring the power of the unconscious to bear on problems by tricking it into revealing itself; and activating more parts of their brains and their muscles more fully.

Another interesting thing about Hijikata's version of butoh is the contradictory way in which techniques for increasing physical and mental ability in dance training necessitated a method of maximal control over the body, and were used to depict physically and mentally unfree marginalized characters. These techniques could have worked against each other. If one of Hijikata's goals was freedom from discursive strictures, then the technique of canceling the self in order to approximate the mental state of the other might work against that goal. Also, if a goal was to find a way to

ensure that the unconscious or the body will spontaneously produce modifications in art that the conscious mind cannot produce, and the way to achieve that spontaneous emergence is to practice something over and over until it becomes second nature, then of course a new discursive (and possibly unquestioned or un-sensed) structure has been created right where one thought to free the mind. Hijikata's methods were full of such contradictions, but they contributed to making his butoh such an electric art form. However, these contradictions have only been able to make butoh interesting to the extent that the artists have struggled with them. When Hijikata best negotiated the balancing act between becoming, emergence, and freedom, his performances were some of the most riveting of his time.

THE AUDIENCE

Hijikata presented these dances not to fellow dancers but to an audience. Thinking about what this structure meant to them can help round out our understanding of the dance. After the creation of movements and phrases, Hijikata would combine the phrases into entire scenes or into an entire work, in order to convey a narrative. A narrative was not a list of phrases from which one could backtrack to individual forms and instructions. Rather, a "narrative" was either a kind of vague overall plotline for a scene, a plotline for the entire dance, such as the one Kobayashi revealed for *Dissolute Jewel*—that of a mother carrying a child on her shoulders—or a kind of "prose poem" or script that included forms, phrases, and various "narrative" elements such as settings and scenic descriptions that could not fit into the taxonomy of gestures, forms, and phrases.[66] I quote an example from Mikami at length:

Grave Watchman

 it is spring fragrant flowers are blooming all over the area an unseasonable wind is blowing in the blue sky under a high flying lark
 a sea of yellow vegetable flowers
 trembling in the wind, a conspicuous wave rolls, and a white man appeared
5 he has birdlime and nears here with a light gait
 his feet came to a dead stop flying dust the lark in the sky and the vegetable flowers also fell silent
 as if it is a picture the man's eyes stare over yonder
 rather if you look closely he is looking at a certain point
10 it is a bird's nest taking care not to be noticed, he advanced two steps
 there is a bird's nest in the tops of the tall trees he is just looking at it
 the color the chirping of the chicks the sweet grandness
 as if he has been possessed by a demon
 [he carefully studies] each individual feather even the down also the color
15 of the beak
 like a child that has gone out to capture cicadas and rather been captured by them
 the thing that looks in the mirror is an empty shell, reality is the thing that reflects

20 there is nothing in the man's eyes now but nest
 the chick that is screaming under a stone is a high flying secret
 the nest is reflected in his eyes rather, in his eyes the nest is complete furthermore, in his head, his head is filled to the brim with the nest
 it is Bosch he is truly hopeless
25 in his head, the unseasonable wind blew
 along with the cries of the cicadas, summer passed away rain all around is like mist
 all of a sudden the scene changed completely
 there was a young man possessed by a demon and drenched with rain
30 cemetery gravestones faintly visible in the mist
 the young grave watchman his head beaten by a blunt object there is a gloomy grave watchman with blood running from his nose
 he has a harelip after one summer has passed half of the man's face is disfigured by pus
35 underneath the eye on the disfigured side, another new eye has formed
 he was burnt because he was distracted by the intense heat you can hear the sound of meat boiling on the surface of the rotting mixture of pus and blood
 it is a hunchback with rain-drenched hair plastered to his face
 it is because he was captivated by the cicadas in the dark forest and spent one
40 summer there
 his back is ugly and bent his legs are crooked
 the gloomy grave watchman flees away from a small barking dog in the sloppy mud
 a never-before-seen season arrives[67]

The above narrative provides what might be thought of as the surrealism-inflected story behind the dance. Here the basic outline seems to be of Hieronymus Bosch hunting birds on a sunny day and then suddenly being transformed into a disfigured cemetery watchman. Some of the elements of the narrative might be taken as specific dance instructions of the kind already familiar from our look at forms and phrases: "taking care not to be noticed, he advanced two steps" (line 10), "underneath the eye on the disfigured side, another new eye has formed" (line 35), or "the thing that looks in the mirror is an empty shell, reality is the thing that reflects" (line 18). The first might well correspond to walking two paces. The second might correspond to the types of redirection of attention that Hijikata often achieved by requiring his dancers to imagine an eye in a different place, or to imagine nerves connecting various parts of their bodies with various places on or off the stage. The third seems like the kind of philosophical statement already identified as one of the elements of the instructions. Other elements cannot be so easily subsumed into the classification system thus far enumerated: "cemetery gravestones faintly visible in the mist" (line 30), or "it is a hunchback with rain-drenched hair plastered to his face" (line 38). One sets the scene—it tells us that we are in the cemetery. The next tells who the character is and how he looks. One thing is sure—this is like no dance script ever before. Now look back for a moment at the strange and insightful metaphysical comment on what it meant

to look in a mirror in line 18. For Hijikata to interrupt his contorted narrative to make a comment to the effect that nothing has an essence, and that reality is a mirror must mean that his narratives functioned radically differently from other dance or theater scripts, and it also means that we should think differently about what his performances might mean.

Reading Butoh

At this point, we can set up reading strategies for butoh. Hijikata said "Interpretation is the right of the viewer," however, it is possible to see Hijikata's dance structure as inviting certain interpretations while not dictating one correct interpretation. The viability of these interpretations rests on determining the kind of evidence admissible for interpreting Hijikata's dances. One option is to base a reading on statements by Hijikata (as I have done with the passages concerning a child on a mother's back). Here I am less interested in specific readings of Hijikata than establishing general principles for how one might go about reading his dances. Mikami suggests various reading strategies. Having described the dizzying structure (of movements, adjustments, and narratives), she singles out some elements as more important than others in Hijikata's system. For example, she refers to the "Ash Pillar Walk" (*haibashira hokô*), a way of walking that she quotes Hijikata as saying formed the basis for his dance.[68] He identified it with the walk of death row inmates on their way to the gallows. The "Ash Pillar," she explains, is a human sacrifice that has been burned completely so that the only thing left is ash ready to crumble at any moment—it is all form with no faculties. When this ash figure walks, it has lost the power to control itself, and so moves in unpredictable ways.

Mikami reads this movement as combining aesthetic and ethico-political concerns. In her reading of the "Ash Pillar Walk," state-sponsored violence such as capital punishment has an effect on the body of the condemned (and this is so whether the person is guilty of a crime or not). When Hijikata examined the body of the person subject to this state control, what he reportedly found was that the person had lost autonomy and only resembled other humans in superficial ways, and thus, that such a person acted in an unpredictable manner. The ethico-political side of this interpretation highlights Hijikata's unerring sense of how the actions of the state have decisive and devastating effects on individual bodies. The aesthetic side is that Hijikata turns this into the basis for a dance movement. However, for the moment, the specifics of this point are less important that the fact that Mikami disassociates a movement from the context of any particular dance and accords it its own right to interpretation based upon Hijikata's connection between the walk and capital punishment. In any dance in which Hijikata used the "Ash Pillar Walk," an informed spectator would be justified in thinking about capital punishment, state (ab)use of power, and bodies that have had autonomy stripped away.

Mikami also mines the backgrounds of Western artists cited by Hijikata in order to find clues about forms. In analyzing the movement "Goya—Pope of Pus," she cites both Goya's loss of hearing, and loss of sinecure, as well as his efforts to break down boundaries between the holy and the vulgar.

Goya—Pope of Pus

- pus, saliva, otorrhea, shifting flesh, darkness
- brain dripping out of the mouth
- drawing in the vestments of pus with one's elbows
- shifting flesh—shifts there—shifts here
- Pope of pus receding into the darkness
- ◎management of time to stagger shifts—dispersion[69]

According to Mikami, in these instructions, Hijikata sought to call the dancer's attention to the surface of the body as pus dribbles down skin, brain fluid drips into one's mouth, and flesh shifts. At the same time, he sought to dissolve the strong distinction between the inside and outside of the body—to render the body more receptive to what was outside it. Where we might have thought that in a list of deliquescent substances, otorrhea would be merely one more thing to provoke an effect, Mikami reminds us that in Goya's case an ear discharge might have been a daily reality, or might have resulted in him losing his job. Mikami treats the events in Goya's life as providing meaningful information about Hijikata's dance movement, regardless of the context of this movement in a dance. If we accept Mikami's additional information, in a dance featuring "Goya—Pope of Pus" one would be justified in drawing connections to unemployment, hearing loss, religious authority, and perhaps the ways that each affects bodies.

Kurt Wurmli offers an important caveat, observing that since Hijikata was looking at so many images, if one were to research the backgrounds of every artist and image Hijikata appropriated, one would literally have tens of thousands of artworks and biographies to study, and it would be impossible to determine which of the multitude of details Hijikata sought to incorporate into his work.[70] However, Wurmli agrees with Mikami that Hijikata often tried to transform a technique used by a visual artist into a bodily technique (as with Hijikata mimicking Bellmer's doubling of hand and foot by turning his own hand into a foot in Bellmer's High Heel).

Wurmli then argues for reading Hijikata's dances based on studying the artwork or artists that Hijikata used, if that reading can be corroborated by formal details in the artwork or in the dance in question. He notes that in *Avalanche Candy* Hijikata used three dancers to recreate an image from Francis Bacon's "George Dyer Riding a Bicycle" in order to approximate in dance the acrobatic and vertiginous feeling of Bacon's cyclist seemingly looking in several different directions while cycling on a high wire. Wurmli notes the subtext of Bacon's paintings of his lover, George Dyer. Bacon sought to capture the instability of a man who led a volatile life, and this instability may have been exacerbated by Dyer's status as a gay man in a world that did not always look fondly on homosexuals.[71] Considering the way that Hijikata drew portraits of people in a vertiginous balancing act within customs and conventions, Wurmli accepts the use of extra information gleaned from studying Bacon and George Dyer in trying to understand *Avalanche Candy*.

However, Wurmli's modified caveat is overly cautious when thinking about how to read Hijikata. His dances were attempts to stage multivalent works that had as

much depth as Chinese characters or the even greater depth of an entire life, so it makes sense that he would have explored ways to further enable the multivalence of his works. In addition, as will become clear in the next chapter, Hijikata was increasingly concerned with vast interconnected webs of knowledge and causality, so rather than say, as Wurmli does, that to consider Hijikata's sources would provide so much information that it would take us away from understanding Hijikata's dances, we should see these multitudinous sources as invitations to find out as much about each one as possible.

I have already noted the hesitancy on Hijikata's part to dictate a correct reading for his dances and Hijikata certainly obfuscated routinely. However, it would be an overstatement to assert that the dances point nowhere at all. Hijikata's choreographic structure provides several different windows into his dances. We have already seen two windows: Mikami and Wurmli provide readings of both Hijikata's movements and poses, as well as his sources, in the cases of those movements and poses that derive from another artist. We could expand on this, by taking the example of *Story of Smallpox*, in which one could read the dance on a level of personal history (even with the caveat that such personal history may be in part fictional)—a mother carrying a child.

Mikami's technique of reading from the level of artworks that Hijikata mined to create his dances, then allows one to consider Kuniyoshi's woodblock print of a woman subduing a horse. This points to a theme running through many of Hijikata dances—a preponderance of strong women. Bosch's mendicants point to ethical themes in Hijikata—that of beggars and others left behind by the economic advances of postwar Japan. Bacon's figures both point us right back to Hijikata's penchant for recycling images, as Bacon was himself modeling paintings after Velazquez and Eisenstein, and also point us to a tactic of humanizing the divine that can be seen in Bacon's Pope Innocent X series.

We could divide these themes into two categories—the philosophico-technical (Hijikata citing Bacon because he recycles images or because Hijikata was copying a technique from the plastic arts into his four dimensional dance) and the ethico-political (Hijikata citing Goya because he possibly lost his job due to an ear discharge or citing Bacon because of the vertiginous lifestyle of George Dyer). Beyond those themes lie hundreds of others packed into each movement or phrase and the instructions for the execution of such, and Hijikata's dance structure should be seen as an invitation to explore each at length.

These levels of interpretation permit a comment on butoh and the body/mind. Butoh does not elicit some natural body, nor is it merely a cerebral exercise in which one merely imagines various new constraints on the body. Understanding the complex layers of the dances allows us to observe that Hijikata's focus on the body was a focus on specific types of bodies—Hansen's disease patients (lepers), pariahs, prostitutes. In a country where forced confinement in leprosaria was not outlawed until 1996, a focus on the specific body of the Hansen's disease patient not only concretizes what might sound like an abstract mental exercise, but also reinforces my proposed varied levels of reading, which include the ethical, political, technical, and historical.[72] It is due to this focus that Kuniyoshi Kazuko says, "Butoh is not only performance but

also the embodiment of one of the most precise critical spirits in the history of the consciousness of the body."[73]

Hijikata's dancers came into contact with these movements and poses differently from the audience because they had made their own notebooks and studied the images, but knowing the instructions and forms that the dancers had to learn puts us in a position to accentuate our interpretive possibilities by narrowing this gap. Jill Dolan writes that "theater creates an ideal spectator carved in the likeness of the dominant culture."[74] Hijikata's dances (and burlesque shows) often presuppose a spectator gendered male, but I want to flip Dolan's idea on its head, and imagine what would be the ideal spectator for butoh.

I suggest that commentators and spectators should require of themselves a similar level of commitment to Hijikata's dances as the dancers have—that is, observers should put themselves in the position to see the dance from the point of view of the dancers. The dancers were required to spread their consciousness and concentration out to many different places. If the dancer is to imagine an eye in a different place on the body, similarly the spectator might explore an extra level of meaning by injecting Michaux or Bacon into a dance about an old woman. The eye in a different place allows one to see the world differently, while Bacon in the middle of a Tohoku dance allows one to see Tohoku differently. Just as for the dancer to ignore the instruction about the eye would make it impossible to move properly, so also for the audience to ignore Bacon would be to ignore one crucial part of the composition of the dance.

It is as if Hijikata was literally trying to approach cubism from the opposite side. Rather than trying to bend or multiply an object so that we can see more facets of it from a unitary position—thus reminding us of the limits of our perspective—Hijikata required his dancers to add extra eyes so that they could see the world from different viewpoints.[75] Similarly, he invited us to add extra levels in our approach to his dances. Just as cubism fails if the extra angles are taken to be a full representation of an object, so butoh fails if the extra eyes are taken as a means to grasp the world completely. If the multiplication of eyes can suggest an invitation to the task of approaching things from many angles while remembering that extra approaches only yield at most asymptotic nearness to the complex world, then butoh will have succeeded.

To point out that Hijikata's choreographic technique seems to allow for many different possibilities of interpretation, is not to privilege interpretation over other means of accessing Hijikata's dances. Rather, it is to provide a way to think about an art form that is saturated with meaning and yet resists finalized interpretation. Hijikata was always working at the boundaries of expression and representation, and his immediate concerns came from the contemporary context of a philosophical debate about the limits and variability of interpretation, and the structure of significance. Any attempt to establish how butoh works is going to have to account for the multiple formal qualities of an incredibly complex work of art. Here, my claim is that one of the ways we can read such a plethora of overlapping elements is as an invitation to multiple points of entry into any one dance. It is exactly the form that invites us to answer the question—what does it mean?—with several answers, without at the same time prioritizing meaning as the only access to Hijikata's dances.

However, we cannot end our analysis with the supposition that butoh provides an invitation to many levels of interpretation. In some cases Hijikata gave his dancers clues to this structure, but in other cases he refused to provide a crib sheet for his dances. Hijikata did not clearly provide the help to get as far as we have come. He was more interested in providing puzzles than answers. Indeed butoh is full of puzzles but without the full answer to any of them. If we put this in Saussurean terms, we could say that Hijikata created hundreds and thousands of new signifiers and only supplied the signifieds or referents for a portion of the total, and what is more, supplied the referents to different people. Moreover, in many cases, Hijikata did not tell the dancers what he had in mind. So we do not yet know the underlying narratives for each dance.

This is in keeping with the idea that the right of interpretation devolves on the viewer. At stake here is the reconciliation of an invitation to a multiplicity of political, historical and philosophical interpretations with a refusal to clearly provide all the necessary material for those interpretations. By once again drawing a connection between the perspective of the dancer and the audience, we can begin to understand another facet of butoh.

Walter Benjamin wrote about impressionistic art and the new experience of urban space:

> The daily sight of a lively crowd may once have constituted a spectacle to which one's eyes had to adapt first. One may assume that once the eyes had mastered this task they welcomed opportunities to test their newly acquired faculties. This would mean that the technique of Impressionistic painting, whereby the picture is garnered in a riot of dabs of color, would be a reflection of experiences with which the eyes of the big-city dweller have become familiar.[76]

Benjamin proposes a precise historical-materialist connection between an art or entertainment form and the society around them. The variegated sights of the metropolis first prove difficult to process. Once city dwellers grow used to those sights, impressionistic stipples give them the chance to practice the skill of organizing and coping with the volume of information and stimuli that the urban space provides. Pleasurable pursuits or works of art succeed because they require similar skills as those needed in the world around them.

If we return to Hijikata armed with this notion of how an artwork functions, we might ask, what kind of skill did Hijikata's dances presume in the Tokyo of the sixties and seventies. I suggest that we can grasp the contours of a society in which the real skill to be mastered was coping with insufficient information. Butoh has always been a dance form in which one is free to or forced to append a private narrative on what one sees. This even includes some of the early dances that do not share the structure outlined here. In the case of the later dances, it appears that there is a narrative of some sort for every dance, and therefore it is reasonable to guess at that narrative, but one must always keep in mind that whatever narrative one appends on top of the action on stage is provisional and might have to be changed given new information. Occasionally, the choreographer has offered various hints, but generally the audience has been left to its own devices, and it is precisely this state of being left to one's own devices that butoh assists one in mastering.

The requirement that the dancers spread their concentration more and more widely in order to encompass more of their bodies and more of the space outside their bodies mirrored the requirement of the spectators to spread their concentration more widely to account for a greater and greater number of elements in the structure of Hijikata's dance. So also, the requirement for the dancers to dance with incomplete information mirrored the plight of the audience who watched the dance with incomplete information and also participated in the world around them with a similar lack of information. One of Hijikata's instructions says, "standing silently when there is nothing to be done, when it's bad to try to do something and it's also bad not to do it."[77] The dancer stood poised on the cusp of a problem—with the knowledge that to act was bad and not to act was bad. This surely reflected the world in which Hijikata lived. How would the dancer act? This was and is the crux of butoh.

At this point one can recognize that Hijikata's choreographic structure shouldered conflicting philosophical aims. However, those competing aims produced great depth in the dances. Recognizing the depths of these dances, however, is not to accord them some transcendent aesthetic dimension. Mishima had spoken of one of Hijikata's early dances as a "heretical ceremony," and Shibusawa had been interested in mysticism, perhaps suggesting that the depth in Hijikata's dance stemmed from contact with an aesthetic sphere.[78] However, in Hijikata's later dances, the depth does not come from ceremony, but from loading the dance with so many elements and layers that if it seems that there is more than meets the eye; this is literally true.

Both butoh's strength and its weakness lie in this combination of a scarcity and an abundance of information. We could react to this paradoxical combination in one of three ways. We could throw up our hands in the face of it and assume that butoh is impossible to understand. We might then give ourselves over to whatever sensation that a dance produced. However, Hijikata's dances were not just sensory feasts (although they were certainly that). They explored sensations associated with social problems: gay men being beaten, and spouses being abused. The third option is that we could try to explore the sources of those sensations in unequal social relationships, with the knowledge that we will only ever arrive at provisional readings of Hijikata's dances. We know today, despite all our mistrust of grand narratives, that solid work on mini-narratives will yield results. Investigative reporting will uncover the connections between the politician and the corporate donor, or the connections between Occupation policy and conservative Japanese politics. The world is not just a fuzz of information, but rather information can be ferreted out if one is willing to look hard enough.

Hijikata's unapologetically multivalent aesthetic make his art feels so proactive on so many levels. When we have become more relativistic, less certain of being able to make definitive statements about the nature of the world, and less certain that we can concoct a grand unified narrative that will explain everything in the world, strategies for coping with ambiguity are a necessary part of society. It is just that the aesthetic focus that requires one to exercise skills in living with ambiguity, also threatens to overlook the moments when a measure of clarity is possible.

Just as butoh fails if those extra viewpoints are an indication of a totalizing viewpoint, so also butoh fails if those extra eyes are an indication of the impossibility of understanding anything. It succeeds if it teaches us to spend our time, when we

have either too little or too much information, sifting our way through what we have, gradually weeding out things that turn out to be dead-ends after a look from a second and third perspective. Hijikata's butoh offers both plenty of information and not enough. In participating in its invitation to co-creation, how we deal with that abundance and lack reflects who we are.

7. Metaphorical Miscegenation in Memoirs: Hijikata Tatsumi in the Information Age

The body after all is a mountain and words are a mist—
I love the mist.

—Kenneth Koch

Hijikata Tatsumi's dances have been an important part of a revolution in aesthetics even though many of them have never been seen, but only known through reputation from afar. However, it is possible that Hijikata's literary endeavors may someday be taken as tours de force equal to that of the dances, and thus it is to his writings that I turn. Usually, one approaches the writings of performers in order to more fully understand the performances. Yet, I argue that his writings constitute a parallel artistic activity that can color how we look at Hijikata's other artistic choices. In fact, to read his writings as a simple commentary on his dance would result in overlooking some of Hijikata's most savvy contributions to the literary world of Japan during the sixties and seventies.

Here are the opening passages of *Ailing Terpsichore* (commonly taken to be Hijikata's memoirs):

> "Look at that! Bugs live without breathing. Look at that over there! There is a smoke-bug with hollow hips walking this way. That bug is probably the midpoint in the reincarnation of something." I was raised in a manner of clouding the kind of body that will be parceled out through observations of the kind that I was told. It was probably because the shriveling and consideration of old people (who knew the uselessness of the body) were hovering around me. My young persona would also suddenly come to seem foolish for no reason whatsoever, and preserved a strange brightness as if just living. For that reason, he had an excessive curiosity for nameless lead balls and string, and his gaze fell on things that seem creepy and cursed. The lead ball and the string are just faking like they are resting—he would work his spy-like eyes.
>
> I did things such as poke my fingers in fish eyes and talk to young girls who were holding doves, and afterwards lived with that, but I developed with the feeling of always having my pulse actually taken. I was constantly eaten by snow; and during the autumn, bitten by locusts. During the rainy season I was cut by catfish; during early spring drunken greedily by a river; and I guess my vision was naturally oriented toward those sorts of things.[1]

So much of Hijikata's project is woven into these initial moments. Here, he fires out a pyrotechnic display of the rhetorical maneuvers that he will use throughout much of his writings.

SOURCELESS QUOTATIONS

The opening sentence of *Ailing Terpsichore* is marked as a quotation. The speaker is unidentified, yet this seems like an observation that a child might hear from an adult—possibly an elderly adult, considering the informal tone and the ensuing reference to old people. It has an air of authority and wisdom—the voice takes it for granted that it is in a position to command its audience ("Look at that!"), and it feels that it has the right to make commentary on the nature of things ("Bugs live without breathing").[2] What is the wisdom emanating from this voice? It is that insects do not have the same respiratory functions as humans do, but that does not mean that they are not alive. The voice continues—narrowing its general remark on insects to focus on a specific insect. It conjectures that this insect might be in limbo between points on a karmic cycle of reincarnation.[3] The voice, which declaims about the way things are, says that looks can be deceiving: things that do not breathe can be alive, and a thing that looks like a simple insect is probably a much grander creature only temporarily occupying a spot in the hemipterous order. Yet, for all the voice's authority, as it narrows its focus it also backs off from surety—covering its bets with the "probably" (*darô*). Thus, the wisdom of the elderly: things are not as they seem. However, this wisdom hints that this is only tentative.

The quotation itself carries substantial weight, but is also not as authoritative as it seems. In the version of *Ailing Terpsichore* serialized in *Shingeki* [*New Drama*] from April 1977 to March 1978, Hijikata begins the narrative with the following quotation: "Look at that. That bug that is flying around the warm steam of the bathroom is probably the midpoint in the reincarnation of something."[4] Many of the elements are the same: the tone of an adult addressing a child, the authority to command, and the knowing air that allows the voice to tell what is what. However, two authoritative quotations that share enough material—the "look at that," the "that bug," and the "probably the midpoint in the reincarnation of something"—cause us to question their authority. A quotation usually implies an original utterance, but if there were an ur-utterance, we are justified in wondering which of the present quotations more closely approximates it. It is more likely that there was no original at all. It is not necessary to maintain strict fidelity to a fictional quotation. In that case, one alters the quotation to suit the requirements of one's endeavor.[5] Right from the opening line, these "memoirs" are marked as different from normal memoirs—things are not going to be as they seem.

THE CLOUDED BODY

After the sourceless quotation, Hijikata continues by telling the reader how he was raised: "I was raised in a manner of clouding the kind of body that will be parceled

out through observations of the kind like I was told." The core of this sentence is the narrator saying he was raised in a "clouding manner," and this clouding manner is further identified as one that functions as if to parcel out the body on the basis of observations that were relayed to the narrator. Hijikata takes up the theme of the socialization of the body.[6] Observations cloud the body. Things that the narrator was told cloud the body. Perhaps the wisdom of the elderly clouds the body. The body is already covered, socialized; it is bound by convention, custom, and place. The possibility of getting back to the original body turns out to be as elusive as that of getting back to the original utterance of the quotation that opens the text.

The clouded body is then dispersed through observations.[7] "Parceled out" here is *osusowake*, which has the connotation of redistributing a portion of a gift, but also that of divvying up property after a death. Thus, we have a body that is obscured, and then split into pieces. Yet, the observations, the basis for parceling out the body, turn out to be as difficult to pin down as the original body and quotation. The body (perhaps the already dead body) will be shared out (for purposes not necessarily its own) on the basis of some observations, but those observations are always already conditioned by other explanations and persuasions, just as the body had been clouded in the way it was raised.

Here, "I was told" renders *iikikasareta*, which could also be "to be persuaded," or "to have something explained." Coming on the heels of the command to look at insects, the modification of observation means that even when charged to look, the "I" does not observe the insect—it does not see the world—free of preconceptions, but rather that the observations are also clouded by various preexisting persuasive, explanatory, and discursive structures.

That observations are always influenced by prior persuasions (or by competing sets of quotations) echoes the use of passive and active voice in Hijikata's writings. Observation belongs in an active category. One goes out into the world and observes, uses one's gaze to understand the world, order facts, and draw conclusions. Yet Hijikata points out that the idea of active observation is at least half incomplete. Just a few sentences after this oddly passive observation, we find: "I was constantly eaten by snow; and during the autumn, bitten by locusts. During the rainy season I was cut by catfish; during early spring drunken greedily by a river." Literally being bitten by insects is not conceptually problematic. With a little work, each of the others might be given a literal interpretation. Certainly when it's cold and snow is being driven with stinging force into one's face, it might feel as if one were being eaten by snow. However, it is probably not necessary to go to the work of supplying a literal interpretation for each of these claims. Rather, we can see this as another way in which Hijikata expands on the themes enumerated thus far: the active-passive inversion of the observations influenced by persuasion, and the clouded body that is affected by its surroundings.

DIFFERENT SELVES

To further destabilize this narrative, Hijikata adopts a technique for distancing the narrator from the narrator's younger incarnation by frequently referring to that

younger version in the third person. The narrator writes, "My young persona would also suddenly come to seem foolish for no reason whatsoever." "My young persona" is literally "my youth" (*watashi no shônen*). However, "my youth" is roughly synonymous with "my young self/persona" and not with "my younger years." The subsequent sentences talk about that youth as if it is an entity entirely different from the narrator, thus necessitating the use of the third person "he." This "he" is clearly the young persona of the narrator, but to translate this as "I" would be to distort the distance opened up by the text between the narrator and the young persona.

Even when the narrator does not specifically mention such things as the age of the younger protagonist, he often uses strategies to distance that "I" from the narrator. Take the following passage:

> That kind of I comes to mind who felt nostalgic while hooking on a nail and pulling the long hair of the woman who fell on the tatami mat. Having come this far, the I that wanted to be doing something was also no longer lonely.[8]

The first sentence has a strange split through which Hijikata specifically distances the entity that pulls the hair—"that kind of pulling I" (*hippatte iru, sonna watashi*)—from the (unmentioned) narrator who experiences the flood of memory. It is as if Hijikata wants to indicate "that was a different self." Grammatically, the Japanese language allows the direct modification of nouns by verbs, producing noun-who/which-verbs or a verbing-noun form. Thus, Hijikata could have written, "*hippatte iru watashi*"—"the pulling I." A smoother translation might render this as, "I remember when I hooked the long hair of the women...," or "I remember myself hooking...," in order to avoid an overly stilted text. Hijikata insists, however, on "that kind of I." This means that what comes to mind is not directly equated to a "hair-pulling I," but is an "I" that is like something else—an "I" that is like a hair pulling "I." Think of the implication of "that kind of" in the sentence, "I'd like to become that kind of an "I" (or, like an "I") who doesn't flinch in a dangerous situation." The implication is that such an "I" does not yet exist. There is a similar ambiguity about Hijikata's "that kind of I." It comes to the surface of memory, and yet it comes to mind as an imagined possibility rather than as an accurate transcription of some actual scene from Hijikata's youth.

In the next sentence, the narrator achieves a similar effect by marking the desires of the "I" as exterior to the narrator through the use of the Japanese *tagaru*: "Having come this far, the I that wanted to be doing something was also no longer lonely." *Tagaru* and the related *garu* (another of Hijikata's favorites) are respectively verb and adjective endings that mark the desires, wants, wishes, and experiences of someone else.[9] On the rare occasions when they are used for one's own desires, they indicate that the speaker adopts the viewpoint of the listener. An example might be the reproachful sentence that demands a negative answer: "Do you really think I am the kind of person who would want to do such a thing?"[10] In Hijikata's hands, while the narrator sometimes speaks directly about himself, he also often refuses to speak directly about his desires—substituting for "I wanted something," which would be consistent with the past perspective of a memoir, the (*ta*)*garu*-modified "I who wanted (to do) something."[11]

Contrast this kind of narrative tactic with that of the so-called I-novel, the *watakushi-shôsetsu* or *shishôsetsu*, as proposed by Edward Fowler in *The Rhetoric of Confession*.[12] Fowler's argument hinges on the same problem of referring to the desires of others, and he concluded that there was a predisposition to writing novels that purported to be about one's own experiences precisely because the Japanese language comes equipped with tools for differentiating between the inner experiences of the self, and the outer experiences of others. Fowler argued that in Japanese one cannot speak with complete certainty about the wants, needs, wishes, and inner feelings of others. Hence, Fowler saw the desire not to fill the narrative with too many *-garus* as the impetus behind novels that are nominally centered on one's own experiences. Considering the early emphasis on experience, Hijikata's choice was strange. He undermined the status of this work as a factual account of his own experience with the use of *-garu* and the third-person-I.

Fowler identified this concern with avoiding *-garu* with a grammatical-epistemological attitude within which "knowledge founded on personal experience is the only kind worth relating."[13] That is, personal experience has unique value. One moment after a personal experience happens, however, it has already happened to our past self. It races away from us even as it happens. Hijikata's narrator seems cognizant of this and thus, while the narrator values that personal experience, the narrator also recognizes that his connection to that past self is unreliable. He does not presume that his current self maps neatly on to his past self, and does not suppose that he can speak with complete confidence about its desires. In this manner, Hijikata undercuts a connection between the events depicted in the book and his own childhood.

The status of the younger persona in these memoirs is brought into relief by looking at another passage that addresses memory specifically. The narrator writes,

> There are parts of my memory where gaps have appeared to some extent, but by working out in a rough manner these diseased memories and confusion, I can create various things like tortoise shell candy. Dog howling candy, fickle candy, one-eyed candy, third-class candy, daybreak candy, ventriloquist candy, metal basin candy, also in some way or another limit candy, this kind of thing.[14]

Here the narrator acknowledges frankly the gaps in his memory, but then lists the kinds of (obviously fictional) candy he can create by kneading the materials of his memory into rough shapes. Thus it would seem that the work of these memoirs (and perhaps the memory itself) is that of poetic creation rather than accurate replication.

THE INCOMPLETENESS OF LANGUAGE

If quotations, selves, and memory are questioned in this narrative, this is only a reflection of Hijikata's general attitude toward language. Let us return to the second sentence. "I was raised in a manner of clouding the kind of (*yô na*) body that will be parceled out through observations of the kind (*yô na*) like I was told." Two times in one sentence, Hijikata uses the phrase *yô na*, which can be translated as "like," or in this case, "kind of." In the first of the similes, Hijikata employs *yô na*

to qualify the body as being *like* a body that will be parceled out or apportioned. In turn, the observations through which the body will be distributed are modified again by *yô na* as being *like* the ones that were explained to him. Skip a sentence, and Hijikata writes: "My young persona would also suddenly come to seem like (*mitai*) a fool without any inducement whatsoever; he preserved a strange brightness as if (*mitai*) just living." Following closely on a sentence in which Hijikata had used *yô na* (like, kind of) twice, he uses *mitai* (looks like, seems like, as if) twice. The youth comes to seem *like* a fool who preserves a brightness that makes it seem *like* he is just living. The words *yô* and *mitai* can be subsumed under the concept of likeness (*rashisa*), which Hijikata uses extensively. In Hijikata's writings, things always look like or are like something else. Anything and everything can and will be modified by being likened to something else. His literary works are built around the idea that nouns, verbs, adjectives, and adverbs are never sufficient by themselves but need to be supplemented with more words in order to expand their abilities.

A contrasting technique follows in the next paragraph: "I did things such as (*tari*) poke my fingers in fish eyes and talk to young girls who were holding doves made of rubber...." Here both clauses conclude with *tari*, a verbal suffix called the "representational" or "alternative" in Japanese linguistics. It indicates that the action is a representative example of various actions taken, or that the listed action is merely one among several alternatives that could have been chosen. A literally complete, if awkward, translation might include the coda: "And did in addition other un-enumerated things." Hence, the fact that Hijikata lists two things that the "I" did—poke fish eyeballs, and engage young girls in conversation—should not be taken as an indication that these are the only things he did, but merely as an indication that these are two representative examples of things he did. Hijikata's text is full of reminders that it is not a complete account, and that there are many other alternative versions that would be acceptable.[15]

Combinations of similes and the representative also abound in *Ailing Terpsichore*. There are sentences such as "and in addition other un-enumerated things like X," or "like this and in addition other un-enumerated things."

> No matter what frame of mind you look at it from, I was determined to live turning my eyes and body away from the kind of educational precepts that turn the sky, a spatula, or a rice paddle into pickles. Despite that, there was still a part of me that did things like laugh glitteringly at the leaves of midsummer as well as other un-enumerated things.[16]
>
>
>
> On account of the light, that person who looked something like a little baboon made a punching sound and did such things as presenting postures like a folding fan hinge as well as other un-enumerated things.[17]

In these sentences Hijikata brings the two rhetorical strategies together in order to suggest simultaneously the inability of language to accomplish his project without bending back on itself, and the incompleteness of what he has managed to wring out of language.

This usage of language is not merely an idiosyncrasy of Hijikata. It follows from the problems that Hijikata already faced. Mishima had suggested that the body is

limited in its language and more hemmed in by purposefulness and concepts than anything else (including written and spoken languages).[18] So Hijikata had been trying for a decade and a half to increase the abilities and language of the body while freeing it from conventions and purposefulness. But Hijikata could not help but observe that not only the language of the body, but also written and spoken languages (Foucault's sign systems) themselves were covered in concepts and customs. As a consequence, written and spoken languages were being used by people (or using people) to overlook bodies in general and bodies in distress. Therefore, it was not enough to focus solely on increasing the abilities of the body. Hijikata had to highlight the problematic nature of existing sign systems.

Hijikata's rhetorical strategies can thus be seen as demonstrating that the current languages (which have been used to turn spousal abuse into a fashion show) are groundless and insufficient. This counters any claim that these languages are currently adequately representing reality and highlights the way that they are used to harm people. Thus quotations are presented as sourceless, selves as contingent, memories as unstable, and words as deficient and needing to be modified by other words (using *yô na*, *mitai*, *rashii*). And even when deficient quotations are modified by other words, Hijikata indicates that the modifications are incomplete (*tari*).

TRANSFORMING LANGUAGE

As a counterweight to all of his efforts to bring the current status of language (and the clouding conventions or persuaded observations of society) into question, Hijikata continually tried to transform language and create new forms of language (new sign systems). In part, his use of modifiers should already be seen as accomplishing this. Even though *yô na* and *mitai* suggested the inadequacy of current units of language, the result was additions to the language enabling it to say new things.

In his writings, Hijikata borrowed two other techniques for remaking language from surrealism. The first was the use of association or stream of consciousness to allow his unconscious to produce elements his conscious mind could not have produced. The second technique was the poetic creation of new things through the collocation of elements. This technique was not exclusive to *Ailing Terpsichore*. Sometime before the performance of *Hijikata Tatsumi and Japanese People: Rebellion of the Body* in 1968, Hijikata met with the neo-Dada artist and Hi Red Center member Nakanishi Natsuyuki to discuss the stage design for an upcoming performance. Nakanishi reports that Hijikata gave him a list of words to use as a sort of brainstorming aid in coming up with the stage art for the upcoming dance. The list was as follows:

> thistle—hunting dog—translator of the wind—first flower—dog's teeth—dog's teeth burning—mirror—that which covers the back of a horse: a saddle—cooperative meal—seventeen years old—frog—tooth mark—artichoke—sulfur—round worm—laughter—bubbling—ball of love—tomato—large Japanese bladder cherry—jimson weed—imaginary liquid—comb—green house—armored insect—ladybug

薊・猟犬・風の翻訳者・最初の花・犬の歯・犬の歯は燃えている・鏡・馬の背に蓋をするもの一鞍・共同の食事・十七才・蛙・歯型・朝鮮薊・硫黄・回虫・笑い声・沸騰・恋の球体・トマト・大ホーズキ・朝鮮朝顔・空想的な飲み物・櫛・温室・甲冑の虫・天道虫[19]

In commenting about the list, Kuniyoshi Kazuko notes how Hijikata plays with language.[20] Several elements reference dogs, and teeth, and other elements are not obvious in English, but if one reads the Japanese, then one can see more examples of the kind of language play that allowed a process of association to dictate word choice. In Japanese "roundworm," "armored insect," and "ladybug," all are compound words the latter part of which is "-bug." So if I had translated these as "round bug," "armored bug," and "heavenly path bug," then the associations would be more obvious. Additionally, Chinese characters often have a distinct left and right side. Thus, the character for "frog" (蛙) actually has two constitutive parts. The left hand side is a pictograph for "bug" (虫) and the right hand side has a phonetic representation of the sound a frog makes (圭, *kei*). So, "frog=bug that says *kei*" belongs to the associative list of bugs.[21] Similarly, the progressive tie between "thistle," "artichoke," and "jimson weed" would be more obvious if I had translated these three as "thistle," "Korean thistle," and "Korean morning glory." Then if "Korea" were rendered following the original meaning of the Chinese characters as "morning brightness," then one might see a tie between "Korea"—as in "morning brightness" and both "morning glory" and "first flower."

This list also contains a diametrically opposed use of language from that of stream of conscious association: juxtaposition of words that do not seem connected in any way such as "thistle—hunting dog—translator of the wind." Kuniyoshi remarks on Hijikata's use of "fresh combinations" to "create novel images," and in addition, speaks of Hijikata's words "struggling with each other to bind strange images together," and says that this struggle produces in the reader "shocks in the sense of sight and touch."[22]

In her book on Japanese surrealism, *Fault Lines*, Miryam Sas points out that Hijikata's mentor Takiguchi Shûzô and his collaborators had translated European texts concerning automatic writing during the 1920s and 1930s.[23] As part of the postwar generation that revisited surrealism, Hijikata's combinatorial experiments can be referenced back to those initial efforts to expand the expressive potential of language. It would seem that Hijikata straddles two sides of surrealism.

His associative processes certainly recall Breton's experiments in automatic writing. Breton describes he and Phillippe Soupault covering sheets of paper with writing on the assumption that unconscious psychic mechanisms would produce something that rationality and existing aesthetic and moral categories could not.[24] Hijikata's writing suggests that, at certain moments, word-choice is dictated by prior word choice in an associative manner similar to automatic writing. Yet there is also something altogether more active and calculating in much of Hijikata's work—a conscious attempt to draw disparate elements such as "hunting dog—translator of the wind" together to see what will result from the juxtaposition—the combining of distant realities to create a spark.

This forced juxtaposition by Hijikata has two results. As Kuniyoshi points out, the struggle between two radically different things creates the conditions for a new physical experience inside the head of the reader. It also shows that Hijikata was not

only trying to call attention to the current inadequacies of language, but also trying to make language more expansive.²⁵

In trying to broaden the expressive potential of language, the various modifying structures such as *yô na* allowed Hijikata to indicate the inadequacies of language—not the absolute inability of language or artistic works to say or to represent, but the inadequacy of language as it is currently constituted. With the *tari* he acknowledged that he still only managed, despite his attempts, to say a small percentage of what could be said. But his surrealistic experiments allowed Hijikata to approach the same problem from two fresh perspectives. On the one hand, the process of association (in which, for example, subsequent uses of words containing "bug" elements were likely dictated unconsciously by prior uses) allowed Hijikata to freshen his writing, and on the other hand, butting different words against each other (hunting dog—translator of the wind) caused the mind to struggle with the result and explore new connections.

RELATIONSHIPS

Hijikata concluded *Ailing Terpsichore* with a chapter that seems as though it is not about him at all. It begins as follows:

> The relationship between black manteau and white manteau became better than even the imagination of the abyss and they no longer needed reciprocal eyeballs. White manteau would say to black manteau, who would get excited and mistakenly leave her body somewhere—If you don't fake like you are a little sick, that willow planted over there looks pitiful. Then proclaiming that she was going to sing a song, she sang:
>
> The gallstone of a ragged crow
> Boiling it down and drinking it is not enough
> Be laughed at by the heel of a fly
> If you stroke a sleepy feeling, you'll slim up
> Melted brazier also slims up
> Even if you sprinkle on pepper, you'll slim up
> Even if you sprinkle on beefsteak leaves, you'll slim up
> Touch your tongue smoothly to a thread
> You can't manage on the appearance of a tongue
> Eating the starved stomach
> Of a scrap of paper affixed firmly somewhere
> Sprinkle bones on a chilled mat
> Suck up those bones and scatter them
> There is nothing that hangs on
> Sporadically tighten our sashes on flesh
> Torturing to death is too halfhearted
> Let's tighten our sash on hesitation
>
> Because she babbled out such foolish and strange words while dancing, Black Manteau also stood up and the two of them started dancing. They danced coupling and rolling as if they were kicking the falling snow.²⁶

Hijikata ends his "memoirs" with an account of two overcoats who sometimes sing songs to each other. The black and white overcoats refer to two (possibly homeless and senile) women who wear them. Thus, Hijikata turns a series of already destabilized recollections away from himself (although these could conceivably be people he observed as a child) and toward song and an obviously fictional narrative.

Perhaps this turn toward song mirrors the use of memory to create different kinds of fictional candy. Others have postulated that this description is an outline for a dance. If one compares it with the narrative of Hieronymus Bosch going bird hunting, then one can certainly see the possibility that this is a surrealist script for a dance.[27] Whatever the case, Hijikata did not choose to close his memoirs with some (pseudo) factual thing about himself.

In his memoirs, Hijikata disavowed quotations, the wisdom of the elderly, the clearly defined self, and personal experience. If an author has gotten rid of all of these, then what remains? In Hijikata's case, song (or poetry), fiction, and the relationship between two overcoat-clad women lingers. In this regard, it is significant that White Manteau says to Black Manteau: "If you don't fake like you are a little sick, that willow planted over there looks pitiful." White Manteau is concerned with the conditions for being able to see the willow as pitiable. It appears that a concern for interpersonal relationships here replaces concern for historical facts and even personal experience, and that art and ethics are prized over factual accuracy.

LETTING THINGS HAVE THEIR SAY/*SEI*

However, it is not quite right to say that Hijikata ignores factual accuracy in *Ailing Terpsichore*. To claim that language does not accurately represent actuality (and to advocate a turn toward poetics and relational ethics), is not at all to say that it is impossible to draw nearer to actuality or even that language is incapable of getting closer to actuality. Hijikata, despite his distrust of current and past states of language, was still concerned with actuality, and this concern is manifested through the narrator's obsession with things (in the broadest sense of the word), their causes, relationships, and measurements.

To take the first of these, *Ailing Terpsichore* is preoccupied with why events happened, and how they ended up. In the third paragraph of *Ailing Terpsichore*, we find: "I was constantly boiling bugs in my stomach, and the bugs always squirmed slowly in my anus. Sometimes they would come out my butt. It was probably on account of eating too many greens from the field out back."[28] The idea of "boiling bugs" in the stomach could perhaps be interpreted metaphorically to describe the way one's stomach feels when it is upset by a cold, flu, or parasites, as the word "bug" (*mushi*) can also be used for microscopic organisms.

For my purposes, exactly what it means to boil bugs or have them come crawling out of his anus is less important than what follows—a provisional explanation for why this should have happened. Here Hijikata introduces a major theme of the work: causality. In this case, the reason seems to have been that he ate too many (perhaps unwashed) vegetables. The "on account of" here is *sei* (which could also be translated as "outcome," "consequence," "result," "guilt," "fault," and "blame"). This

is a major pattern in the text; over and over, the narrator provisionally assigns fault or the responsibility for some state of affairs.

Conversely, the narrator also observes one or more things that were not at fault in a particular incident, such as in this lengthy excerpt (owing to the length, I have omitted the prior referent—the incident that was caused):

> It was probably not on account of the photographic plate of the chart outlining my inner world being cracked, nor was it the consequence of being quickly separated from the kind of thought that was exposed as if it lacked sufficient viewing power. It was not that kind of overly simple lack, but my brain was sucked up by the desolate spy-like thought that there was no one who resembled me but me. A muzzled dog ran around. Things also were on the verge of falling even farther. My insides quickly sniffed out a scent like a bib, but the wind always helped out my "cylindrical tail" voice. That was not only on account of my being unskilled at calligraphy. It was the kind of situation in which I became that way on account of people who don't even know me at all, but all the same, it was enough for my identity to be quickly revealed, but a surprisingly weak wind also blew in the vicinity.[29]

I have only quoted the end of the passage—the *sei* clauses—rather than try to parse out the particulars of the problem. From the preceding passage (not quoted here), it appears that the antecedent could be a child that was killed suddenly, human voices that suddenly became coquettish, or a multicolored albino that walked near sour gestures. Hijikata discounts two possible causes of the phenomenon before finally settling (perhaps?) on the real cause. The first is that the phenomenon was not caused by a crack in the photographic plate in his mind. The second is that it was not caused by quickly being separated from certain thoughts. Hijikata never definitively identifies the *sei* (the fault) after proposing and discarding two candidates. He just states simply that his brain was sucked up, and we are left to infer from the first half of the sentence—"It was not that kind of overly simple lack"—that the cause of the original problem was his preoccupation with the thought that he was the only person who looked like himself.

The issue of causes and effects provides further insight into Hijikata's concerns. It is useful to compare Hijikata's *sei* with Hitchcock's use of a device called the McGuffin—an object in a film that sets into play a series of events.[30] In the age of chaos theory, the McGuffin stands in for the flapping of butterfly wings or the waving of a hand that causes flood or famine half a world away. In a typical Hitchcock narrative, a person's life gets turned upside down on account of a single misplaced tchotchke, and this is comforting to the cinematic viewer who does not have to dig through the complex set of causes and effects that turn real lives upside down. Hijikata takes the opposite tack. Rather than locate the single object (the McGuffin) that causes everything else, over the course of the book, the narrator hunts for hundreds and hundreds of *seis* but with little surety as to whether the right one has been identified.

Continuing, the narrator says, "The wind always helped out my 'cylindrical tail' voice." This would seem to be the kind of observation to which one would not need to assign causality. Yet, Hijikata continues, "That was not only on account of my being unskilled at calligraphy. It was the kind of situation in which I became that way on account of people who don't even know me at all. . . ."[31] Whose fault is it that

the narrator ended up the way he did? It turns out that it was the fault of people who had absolutely no idea who the narrator was. How could the narrator have been so affected by people who did not know him at all? It must have been through the connections between him and hundreds of people who did not know him, produced by hundreds and thousands of *sei*—that is to say, by all the choices, thought patterns, and societal structures that constitute the life-forming and identity-forming space surrounding him. The concern with *sei* (on account of what) when multiplied over and over is the same as the concern with the socialization of the body and mind by customs, concepts, and purposiveness.

The use of *sei* by Hijikata is related to his obsession with actions and entities that affect things. For example, the narrator frequently calls attention to things that wrap or envelop other things such as mist, shimmers, smoke, fog, sleet, hail, and leaves.[32] The narrator also focuses on the actions analogous to these things: wrapping (*tsutsumu*), entwining (*karamaru*), being clad (*matou*), or being involved (*karamu*), and these action words are used in Hijikata's narrative to describe both physical and metaphorical states. Following are just a few examples (among hundreds) of the use of wrapping, entwining actions, and entities:

> Leaning, as if having given up on being whole, with a squashed face as if the sun is dazzlingly bright, my chewing gum—which was churned into a pulp of mutually entwined (*karamiau*) twisted things—reminded me of the effort to pull a cart through the mud. I see. That is like a synthetic memory. While feeling that I was being suspended in mid-air, after having been drawn in, tangled up by (*karamari*), and thrown into confusion by the pale vapor that rises from the peach-colored kitten's tongue protruding out one millimeter, I grabbed for that air.[33]

Later he writes, "Shimmering air called out to me and entwined with my walking feet."[34] The narrator considers his chewing gum—which has been thoroughly entwined with other unmentioned stuff within his mouth—and through a process of association thinks of pulling a cart through mud—which is presumably similarly mixed with other things. Then he becomes mentally tangled up (or entranced) by the small slip of steam rising from a kitten's tongue. In such quotations, the narrator repeatedly notes that one thing is wrapped in another thing, entwined with another thing, or involved with another thing. These things then affect each other—the act of wrapping and the mist that wraps become part of the *sei* that will subsequently shape things.

Hijikata's physical preoccupation with things that envelop, such as mist, haze, gossamers, odors, and clothes, and the way that they wrap, cloak, and involve other things, is a counterpart to his metaphysical (but in fact equally physical) preoccupation with how things are connected to and related to other things. The narrator asserts: "The kind of thing that has a relationship with miso bread is the kind of thing that has drenched trouser cuffs, but aluminum lunch boxes have a slight relationship with candy bags."[35] Hijikata's narrator does not elaborate on the relationship between miso bread and someone in wet pants, or between lunch boxes and candy bags. The narrator just maintains that such relationships exist. Of course, lunch boxes have a relationship with candy bags, just as miso bread has a relationship with drenched trousers, and flapping butterfly wings have a relationship to flood and famine half a world away (although not a single obvious causal relationship). It is easy to imagine the relationship between a lunch box and a bag of candy—a lunch box might contain a bag

of candy—but it is by no means easy to pinpoint the relationship between someone in drenched trousers and miso bread. The narrator, however, maintains that such relationships are no less real for not being easily comprehensible, and *Ailing Terpsichore* can be seen as inciting the reader to explore what those relationships might be.

The idea of a relationship between miso bread and drenched pants allows us to revisit Hijikata's increasing concern with Japan and Japanese identity. If everything is in a relationship with everything else, it follows that Hijikata was already in a relationship with all other Japanese people and this relationship was inescapable. Miso bread cannot cancel its relationship with drenched trousers even if it should feel like doing so; it can only alter its relationship to them. In the same way, Hijikata began to acknowledge his relationship with the rest of the inhabitants of Japan, but began to explore ways to alter his relationship with them. One way was to engage them in the rebellion and the other was to attack the very foundations of their identity.

Furthermore, Hijikata's preoccupation with relationships in his memoirs is the flip side of the collocations. In his dances, as in his writing, Hijikata put two things together to see how they would react to or compete with each other, or how the combination would create a spark in the mind of the observer. But, he also thought of all things (no matter how distant) as already within relationships, so there was no need to collocate them to see how they would react to each other, because they already were reacting to each other. It is the job of the observer to figure out what those reactions are.

THE DEVIL IS IN THE DETAILS

In the previously cited passage, the narrator sees a faint vapor of steam rise from the kitten's tongue—which is only protruding one millimeter out of its mouth—and becomes entranced and mentally tangled up by this wisp. The size of a vapor that rises off one millimeter of a kitten's tongue must be exceedingly small, but it is not too small to escape the narrator's attention. This passage is related to another of Hijikata's concerns—that of minute detail. Here the narrator is thrown into a vertiginous confusion when confronted with such minute detail, but nonetheless reaches out to that detail. Elsewhere, the narrator writes:

> At that time, I have no idea why I chose to sing only this song, but since I sang it, I'll record it here:
>
> Fly fly black kite
> High in the sky
> Cry cry black kite
> In the blue sky
> Twitter
> Twitter
> Twitter
> Twitter
> Merrily
> Make circles[36]

The only reason for recording this song is because the narrator sang it. It is presented as if it has value in its own right, independent of any motivation the narrator had

to sing the song at a previous time. Valuing a song for its own sake is similar to the narrator's confession that his younger persona had "an excessive curiosity for nameless lead balls and string," and these two examples are only the tip of the iceberg in a book full of attention to detail.

MEASURING THE REVERBERATIONS OF MOLD

So much may depend upon the ability to notice and appreciate the detail of a red wheelbarrow glazed with rainwater beside white chickens, but in Hijikata's writings, noticing and appreciating details are not enough. The narrator is also concerned with measuring things. In the opening passage, the narrator confesses that "in fact, I developed with the feeling of always having my pulse taken." It seems that the narrator feels that he is always being measured. In turn the narrator constantly thinks about measuring things. The narrator writes: "This conviction of the I that wanted to become a mold-like young man was heightened to the point of becoming physiological, and I had the feeling that I would like to measure the reverberations of mold with a pair of scales."[37] It is not clear what reverberations of mold are, but it is clear that the narrator would like to be able to measure such minute detail.

This orientation to fine detail, and focus on causality, relationships and measuring may seem to contradict the other elements of Hijikata's writing, such as the use of *tari* to indicate that not everything has been said about any one thing, or the use of simile (*rashisa*) to indicate that language is not currently up to the task of expressing actuality. However, behind Hijikata's writings is a wider debate about how and whether we can know anything at all. We need not rehearse all the particulars of this debate, but suffice it to say, Hijikata was trying to pick a path between a rejection of the possibility of knowing anything, and an overly facile reliance on evidence and rationality (the positivistic assumption that detail transparently equals truth). He did this by returning to his surrealistic premise of collocation.

Of course, with Hijikata, understanding is marked as provisional, and things always compete with each other and fight within the mind of the observer. The observer, in turn, needs to maintain the details, quotations, and causal explanations in tension, and needs to keep in mind the provisional nature of any conclusion and thus revisit conclusions with the addition of each new detail. In *Ailing Terpsichore*, Hijikata is by no means throwing knowledge overboard and retreating completely into the realm of affect, or ethics and relationships.

Up to this point, my argument has been that Hijikata was interested in finding actuality and increasing the language or abilities of the body (and that he was trying to do that with the body that was limited in its means of expression and bound by convention). *Ailing Terpsichore* makes obvious that Hijikata had come to realize that the problem of finding actuality was considerably harder than he might have ever supposed, because his body had been covered in observations and persuasions right from day one (which was just a confirmation of what Mishima had already told him nearly two decades before), because his memory was unreliable, because language was inadequate (and also covered in conventions), and because one can never say enough—there is always be more to be said. However, that did not mean that Hijikata needed to give up on finding actuality, it just meant that he was realizing that negotiating

conventions and customs was as important as strengthening the body or increasing its abilities, and that that in turn meant negotiating language and information.

THEORIZING HIJIKATA'S STRUCTURAL THEMES

It is often difficult to identify what any one element of Hijikata's dances or writings means. However, attention to the structure of his writings and dances has revealed that there are some meta-themes that run through his works. It is not at all clear how we should interpret "hunting dog—translator of the wind," and it is also not clear what it means for Hijikata to say that the "photographic plate of the chart outlining my inner world being cracked" was not the cause of some phenomenon. Yet, by focusing on how the mind reacts when it encounters "hunting dog—translator of the wind," and on Hijikata's extensive use of *sei*, similes, and forced collocations, we can begin to articulate some larger concerns.

One is that this surrealist text, with its concern with causes, effects, detail, and measurements, should alert us to an underlying issue. This is how much surrealism itself is a product of the information age and modern science. It may seem odd to say this, but Hijikata was fundamentally a scientist. The attempt to stick two words together such as "hunting dog—translator of the wind" is guided by an implicitly experimental attitude: let's see what will happen (in the mind of the reader) when those words or actions come together. It is true that Hijikata was operating under a surrealistic postulate that the law of chance guarantees that some of the match-ups will yield new and exciting results, but even in this, he was no different from much of the scientific world.

The standard operating procedure for much scientific discovery is called the "random search method" or the "stochastic method." In science, because it is physically impossible to test all potential solutions, the technique consists of screening as many solutions as possible and waiting for random hits that indicate useful solutions, and then using those successful hits to further iterate toward more robust results.[38] In this respect, the familiar scientific story of the accident that leads to a new invention is actually the standard story and not an anomaly. It is not that one accident leads to an advance, but that scientists set up thousands of "accidents" with the hope that one will yield results. However, those thousands of accidents are a mere fraction of the trillions of accidents that they could have set up. It is no exaggeration to say that each set of experiments should come with a *tari* attached to it to indicate that it is merely representative of the total number of experiments that could have been conducted, and that much invention is neither more nor less than planned accidents.

It should be noted that the addition of replication and controls (as well as the use of prior hits to guide future research) makes science fundamentally different from butoh. Hijikata was continually searching for actuality, and many of his methods match other methods for searching for actuality, including (in this case) experiments that make use of randomness. But he did not adopt all of the available techniques of searching for actuality. On some level, then, science starts out as surrealism, and the surrealistic techniques of Hijikata's choreography and writing are the beginnings of a new branch of science. Hijikata's twist on this was to be concerned only with the continual production of new combinations. It is as though he spent half of his

time setting up a thousand experiments, but never bothered to set up controls or to replicate a single one of them. Then he spent the other half of his time asking after the results of experiments that he never set up. Both of those activities (replicating his experiments, and setting up new experiments to figure out if he had identified the correct causes for a known result) were left for others, should they care to pursue Hijikata's forays.

Hijikata carried this program of experimental surrealist science across genres, and it is this attitude that informed and allowed much of his collaboration between artists, designers, and musicians. It also governed how he choreographed dances. When he put a horse's head into "Yardstick Walk" in order to create new movements, or modeled one pose after a mendicant in a Bosch painting and followed that with a pose patterned after a character in a Bacon painting in order to create a dance that was supposed to tell the story of a mother carrying her son on her back, he was doing something much like coupling "hunting dog—translator of the wind": he was altering "Yardstick Walk" by the addition of a horse's head or altering Bosch by juxtaposition with Bacon. This technique causes us to see Bacon or Bosch in a different way. In the same vein, when Hijikata required his dancers to imagine having eyes on their fingertips, or to imagine being eaten by insects, he was conducting an experiment in movement modification that mirrors the way *yô* or *mitai* changes the meaning of words. In his writings he explored similar techniques and themes that can make clearer his entire project.

BUTOH AND THE ATOMIC BOMB

Hijikata's concern with diffuse causality and the way that conventions and customs shape bodies also casts doubt on one major reading of butoh thus far—the supposed connection between butoh and the atomic bomb. Although in Japan virtually all butoh practitioners and most commentators repudiate a direct tie between butoh and the atomic bombings of Hiroshima and Nagasaki, Kurihara Nanako notes that Western dance critics have stubbornly seen butoh as a direct outgrowth from or response to the atomic bombs.[39] Considering the way that many butoh choreographers encoded elements in their dances with two or more meanings, and considering the way that Hijikata's narrator maintains connections between seemingly disparate things, it would be strange to deny the Western viewpoint altogether. In the same way that miso bread is connected to drenched trousers, butoh must be connected to the atomic bomb in some distant way. However, while the butoh-bomb thesis has the virtue of being catchy, it unfortunately also has the potential to overwhelm all other theses, giving it a totalizing strength that should be approached with caution.

One can rightly grant the Holocaust and the bombing of Hiroshima/Nagasaki their status as among the most heinous actions that humans can visit upon humans, and still be correct in saying that to think of butoh only as a post-atomic spectacle is to rob it of much of its ethical, political, and philosophical force. This is because the factors that go into the dropping of an atomic bomb and the factors that go into producing the environment to which butoh is responding are fundamentally different. Atomic bombs are characterized by being out of the ordinary. Hijikata dealt with the kinds of suffering that were all too ordinary. Atomic bombs and programmatic

genocides are (for all their institutional inertia and despite the fact that they must be carried out by willing executioners) fundamentally the product of conscious choices made by people in positions of authority. A person must give an order to drop an atomic bomb. Another must receive the order and press a button. Conversely, the use of *sei* articulates a concern with diffuse causes—the hundreds and thousands of events and things that go into creating a situation. Butoh's suffering is a product of hundreds and thousands of everyday choices by everyday people (such as neighbors turning spousal abuse into a fashion show).

As a counterpart to Hitchcock's McGuffin, often in cinema, phenomena such as racism, sexism, and homophobia are depicted as being the product of a single deranged mind.[40] This technique lets society as a whole and the individual viewer off the hook. These problems are not seen as the products of widespread social structures, nor of everyday choices by otherwise decent people. It also has the effect of granting the society a temporary (and false) relief from the dynamic of the racism, or sexism, etcetera, in that when the antagonist is arrested, killed, etcetera, there can be a sigh or relief—the bad guy is behind bars, and evil has been expiated.

This is what made Eddie Murphy's *Saturday Night Live* skit "White Like Me" so biting and funny. A black man disguises himself as a white person and finds out that the bank is ready to lend him money without even a signature. Later on a bus, when the last black person gets off (excluding the incognito Eddie Murphy), the remaining white people break out champagne and have a party.[41] There is a subtlety to the sketch that might be masked by its humor. In a Hollywood movie, a black person might not be able to get a loan because of one obviously racist raving lunatic (that is to say, a lunatic McGuffin). In Murphy's view, black people cannot get loans because of a widespread difference in treatment between white people and black people. Murphy presents a comic exaggeration of all the individual, often unconscious but at times conscious, choices (the hundreds of *sei*) that go into creating the collective treatment of blacks, and thus of all the little ways that white people in America benefit from their race.

In a strange way, the atomic bomb has functioned like a McGuffin in Japanese society. It has allowed many Japanese people to feel as though they were the victims in a war in which they had engaged in many atrocities.[42] If Japanese suffering and Japanese problems can be attributed to the atomic bomb, then that suffering and those problems can be attributed to a racist lunatic American McGuffin. The attitude of most artists that butoh has nothing to do with the A-bomb can be seen as a manifestation of the fact that butoh artists do not seek to evade responsibility for the problems and pain they see in Japan by assigning the responsibility to the deranged choices of a few Japanese or American leaders.

Rather, Hijikata locates Japan's problems within a wide web of interconnecting relationships, choices, conventions, and customs. And these are fundamentally what Hijikata was responding to. The atom bomb was not the only (or even close to the most important) *sei* that led to butoh, and neither was the society that produced butoh (nor butoh itself) created by any one grand *sei*.[43] In this respect, Hijikata's oft-quoted statement, "There is Tohoku in England," does not mean that the atom bomb also fell in England, but rather that one can find the conditions for all sorts of similar problems in England, and what makes butoh universal is unfortunately the universality of suffering.[44]

KNOW THYSELF

The attention to detail and to diffuse causes connects Hijikata's various efforts, and returns us to the issue of socialization. *Ailing Terpsichore* can be seen as Hijikata's attempt to understand everything that went into his socialization over the course of his entire life. This was partly a strategy for finding his way to actuality—however hard that would be to find, and whatever that should turn out to be. It was also a strategy to enable him to recognize all the layers of his own socialization so that he could see the world from other viewpoints; because he would need to neutralize the static he brought to observations in order to see the world from someone else's perspective. There is something simultaneously epically heroic about this task and also deeply troubling. On the one hand, only a gargantuan effort to cancel the distortions that one appends to observation will genuinely help someone see the world from other viewpoints or draw near to actuality. On the other hand, the same effort could end up reifying the self, or being used against the self.

In his essay, "Technologies of the Self," Foucault suggested that there was a transformation in Christianity over time from "taking care of yourself" to "knowing yourself." Of course the texts and communities that Foucault described were far away from Hijikata in the 1960s and 1970s. However, Foucault was describing the way that forms of power transform in far-reaching and long-lasting ways, which continue to evolve in the present. About the new configuration, Foucault writes,

> each person has duty to know who he is, to try to know what is happening inside him, to acknowledge faults, to recognize temptations, to locate desires, and everyone is obliged to disclose these things either to God or to others in the community and hence to bear public or private witness against oneself.[45]

Foucault identified an era in which, for religious reasons, each person was required to carefully examine their internal universe for imperfections that would render them guilty, and then confess them to a religious leader who was supposed to know about the inner life of each member of his flock. In Hijikata's case, the technique for being able to see the world from other viewpoints amounts to a secularization of the Christian imperative to know yourself. From Hijikata's perspective, it is not that one needs to know oneself in order to confess every particular of the self, but that one needs to know oneself because one is inevitably raised in a body-clouding manner, and any attempt to interact with another body will entail the necessity of examining one's own cloudedness, or risk that the attempted communication might end in failure. The Christian ethos already included the need to thoroughly examine one's mental world, but with regard to Hijikata, it is as if within his training and choreographic method, Foucault's "all and each" has expanded to include each thought, joint, muscle, nerve, and cell of each, and the surrounding area of each. For that is the sum of the territories that each dancer is responsible for focusing on, knowing, and controlling.[46]

This transformation is double-edged. In Hijikata's case, knowing oneself was directly connected to taking care of oneself, because knowing oneself was one essential step in achieving the goals of communicating with others (and bringing them into the rebellion he envisioned), seeing the world from other viewpoints, and seeing the

world more accurately. In that sense, knowing the self (in Hijikata's sense of knowing the entire sum of everything that has shaped the self) functions as one of Foucault's technologies of the self—"which permit individuals...to transform themselves in order to attain a certain state of happiness...."[47] However, this effort to know the self so minutely may also open the self to external control as well, to Foucault's technologies of power that objectify the subject, because rarely have body-minds ever been objectified as much as in butoh.

Hijikata may be taken to partially sidestep the problem of objectification of the self due his attitude toward his own self and his past, and due to his broader attitude toward information. For Hijikata, it is only when one gives too much credence to any one conclusion that studying the self will lead to a thoroughgoing objectification. Some of his "memories" were the artistic product of kneading raw material into such shapes as pleased him, and therefore not to be taken as reifications of preexisting selfhood. Furthermore, Hijikata went out of his way to indicate the provisional nature of his knowledge of himself. Hijikata used *sei* to explore the causes of various known results. The miscegenation of ideas that he offered through the use of simile (*yô na*), and collocation ("hunting dog—translator of the wind") amounted to experiments in saying more than had been possible before, and attempts to explore different discursive configurations. In his exploration of social effects or discursive structures, Hijikata brought together various past-directed "on account of's" (and the underlying question "on account of what (social forces), are X and Y together?"), and then plumbed future-directed alternative combinations (with the underlying question "what will happen (to the social fabric) if I put X and Y together?"). Then the *tari* assured the reader that Hijikata had tried only a fraction of the possible combinations, or explored only a fraction of the possible *sei*.

REWRITING HISTORY AND PLACE

However, it should be obvious that Hijikata did not suppose that he or his hometown of Akita, or Japan writ large, represented some set of pure unadulterated bodies or bodily movements as opposed to the discursively contaminated bodies and movements of residents of Tokyo and the West. In this manner, he may be fruitfully compared with the philosopher Kuki Shûzô. Karatani Kojin has observed that Kuki tried to repudiate modernity and Western metaphysics in the process of articulating the essence of Edo-period red-light district chic (*iki*), but in doing so, used the categories of Western metaphysics.[48] In the words of Leslie Pincus, Karatani argued that "even as Kuki discovered the distinctiveness of Edo, he had already buried it beneath epistemological categories derived from the West."[49]

Lucia Schwellinger observed that Hijikata did something similar—create movements not from direct observation, but from international image sources that were subsequently ethnically marked with props, costumes and music as a kind of ethnic window-dressing.[50] Wurmli refines Schwellinger's point in arguing that Hijikata even took costumes and props seemingly ethnically marked as Japanese from international images.[51] Wurmli notes that Hijikata used Bruegel's torture wheel from *Road to Calgary* (1564) to depict what appears to be an indoor scene in *Dissolute Jewel*; and copied an Iranian bas relief from the Sassanian era (~500 CE) to indicate an interior

in the same *Quiet House* (Shizuka na ie, 1973). This might make it seem that Hijikata had a similar aim: to use international sources to create an "authentic" Japan.

However, Wurmli's research shows that Hijikata differed from Kuki, because he used the technique even when there was no ethnic marker of authenticity intended. For example, Hijikata used a 1914 image from a Ringling Brothers' Circus poster depicting the meeting of Solomon and the Queen of Sheba as a visual vocabulary source for the creation of the procession of Heliogabalus, leading Wurmli to write of Hijikata's finding "the visual clues for the quotation of Artaud's text" in a circus poster.[52] That is, Hijikata used an early twentieth-century North American conception of an ancient Hebraic and Sheban procession to present a Roman/Emesani procession. It cannot be the case that Hijikata was concerned with authenticity in presenting a Roman/Emesani procession by quoting an American circus poster. Considering Hijikata's technique of collocation, it appears that we should see Hijikata as having used this surrealist technique as a way to rewrite history and identity, by depicting images constructed of temporally and spatially impossible sources. That is, Hijikata not only subjected words to forced collocation as in "hunting dog—translator of the wind," he also forced history and spatiality themselves into strange collocations like *Muher de Azul—Quiet House*.

In this he can be seen as a surrealist analogue to the historian Amino Yoshihiko, the Marxist historian and folklorist who sought to rewrite Japanese history by focusing on "women, townspeople, artisans, outcastes, minority groups, and geopolitical spheres that have only infrequently figured in major ways in traditional histories."[53] Drawing on (and quoting from) Susan Napier's discussion of Amino's rewritten history, John Tucker writes that "re-envisioning 'the conventions of Japanese history,' in effect assists Japanese in negotiating a major change in national identity."[54] We can see Hijikata as going one step beyond Amino. He did not just focus on historically marginalized figures; he constructed those figures by quoting historically impossible materials, and thereby wrote into Japanese history and identity a more international perspective than could have been possible in reality.

By means of such reenvisioning methods, Hijikata took pains to avoid the reifying dangers of a focus on himself or his upbringing. Rather, he focused on the socialization of bodies or the effects of epistemic structures and strove to explore those within his dances and his writings. Although Sakai and Pincus were concerned with the attempt to use premodern Japanese elements in order to overcome the modern, Hijikata did not present his hometown Akita (or the premodern) as an unproblematic locus of modernity-conquering bodies or ideas.[55] He and his hometown could serve as one item in a forced collocation—that is, as half of a constructed metaphor such as "Akita—Genet"—which would transform both of the items in the collocation as the viewer struggled with the combination, and which would write a geographically and temporally impossible international focus into his home town. Like the surrealism to which it is partially indebted, there is something utopian about this project. It holds out the promise of consciously or unconsciously different (and perhaps less repressive) iterations of the body and society.

That being said, in science (or sports, economic competition, war, evolution) the goals are tightly defined, and so a successful hit or a positive advancement is also easy

to recognize. In art, the criteria for positive advancement are murkier. If one were to reduce art to an economic activity, then an advancement would be merely what sells more units, or brings in a larger audience (and certainly that was never far from Hijikata's mind). However, in lieu of that kind of yardstick, the measure of the fruit of a surrealistic juxtaposition is the afterlife of the combination. If one side is overpowering and eclipses the other side, the juxtaposition is not successful, because the juxtaposition comes to equal the whole of the stronger term. However, if the two can remain in tension, then the forced coupling can persist as the object of wonderment that may help people better understand and respond to their world.

8. Epilogue: The Emaciated Body in the World

when it's over, let my body
be useful, let little bears
nose through my guts
for grubs

Patrick Donnelly

The evolution of butoh slowed after Hijikata consolidated his multilayered dance structure, and in 1973, Hijikata left the stage. Hijikata choreographed more than thirty dances after *Story of Smallpox*. I cannot consider them all, but a look at one of them allows us to see that while many of Hijikata's concerns continue unabated, the way he approached those concerns had changed drastically since *Forbidden Colors* and had even changed from *Story of Smallpox*.[1]

Human Shape (*Hitogata*) was performed from June 10–23 in 1976. In the dance, Ashikawa Yôko appears to play a succession of characters including one perhaps nonhuman character with a tail (compare with figures 3.1 and 3.2). She looks by turns dejected, angry, disgusted, giddy, senile, sad, pained, and silly. She also seems to cycle through various ages from infancy to advanced age nonsequentially. The music included opera, rumbling noises (including one that seems to resolve into an air-raid siren) and instrumental versions of the 1972 US pop hits "Summer Breeze" by Seals and Crofts and "I Can See Clearly Now" by Johnny Nash. The sets included a plain backdrop, and four backdrops made out of movable panels—depicting waves, cherry blossoms, golden screens, and a wooden wall. Ashikawa sported a new costume for each scene, of which there are a total of fifteen scenes (not counting the choreographed finale). She appeared by herself in ten of them, did not appear in one of them, and was joined by other dancers in four scenes. Following a pattern found in other dances of the time, for two-thirds of the dance, she appeared on stage alone.

In general, the movement palette in this dance took a back seat to character creation. Ashikawa sidled from side to side, stood slightly swaying, squatted, rose, crouched, caressed something imaginary, knelt with her head almost on the ground, prostrated herself on her left side, turned away from and back to the audience, flattened out and rose again, and mimed smoking. There were only three short moments in which she moved extensively. In the third scene, Ashikawa appeared in a red form-fitting dress with a red flower in her hair. Compared with the previous two scenes, she looks young and happy. Against the backdrop of waves, and accompanied by the sound of an aria, she flitted in a clockwise arc from center stage with her hands at her buttocks as if she has sprouted wings from her hips. She is so light that it seems she

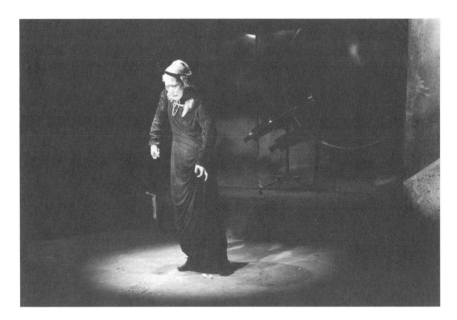

Figure 8.1 Ashikawa Yôko, *Lady on a Whale String*, (Asbestos Hall, Tokyo, Dec. 1976) by Nakatani Tadao. Courtesy of Nakatani Takashi and Morishita Takashi Butoh Materials, NPO, and the Research Center for the Arts and Arts Administration, Keio University.

might fly. In the fifth scene, she was naked from the waist up with a rope wrapped around her torso covering her nipples, and she wore a skirt. The soundscape was an ominous rumbling noise. She knelt facing the front, doubled all the way forward with hands and face about six inches off the ground. She then began flapping, waving, and swimming her hands. She stood and rose onto the balls of her feet while still hunched over with her hands straight down at her sides. In the eleventh scene, she wore a red billowy outfit with tails and bags of material hanging from her armpits and a cream-colored short skirt. Seals and Croft's "Summer Breeze" wafted cheerfully over the stage, and Ashikawa leapfrogged around the stage and effortlessly backward up onto the dais at the back of the stage. She then sat on the floor with one leg outstretched and her arm casually draped over her foot. Rising and facing the audience, she made all sorts of weird hand motions including some that seem to approximate the vibrant outstretched hand motions of a jazz dancer. She leapt into the air and repeated the posture of the leg and arm outstretched together. She then stood on one leg with the other foot resting on her knee and executed a movement vaguely like a salute.

When Ashikawa was joined on stage, the other dancers' movement palette was even more circumscribed than hers. Usually her fellow dancers seem to be no more than motionless observers. In scene five, a dancer stood right behind her. Sometimes he was invisible because she was lit from in front and below, but for a moment, he stood menacingly above her while she squatted on the ground. In scene six, five dancers formed a stretched "W" with a line of three of them downstage and the two of them upstage. They all wore full-length kimono with black and grey swaths, and had their hair parted into long braids framing their faces. They faced forward, crouched,

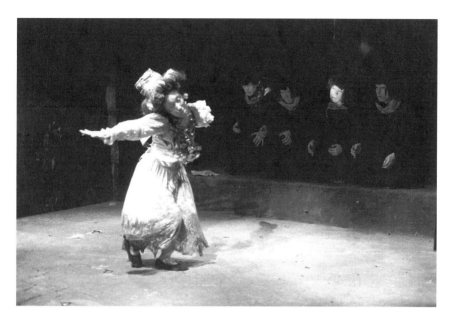

Figure 8.2 Ashikawa Yôko backed by nearly motionless dancers, *Lady on a Whale String*, (Asbestos Hall, Tokyo, Dec. 1976) by Nakatani Tadao. Courtesy of Nakatani Takashi and Morishita Takashi Butoh Materials, NPO, and the Research Center for the Arts and Arts Administration, Keio University.

rose and crouched again. Then they turned in unison and raised their right arms while looking down and held that pose.

In scenes ten and thirteen, Hijikata broke up the panels that had been used to form the backdrop and began to toy with them. Unseen stagehands moved the panels back and forth across the stage, and sometimes the dancers moved with the panels, keeping themselves in front of them. At other times they maintained their position while the panels moved behind them. In scene thirteen, the panels were staggered so as to form different planes, and Ashikawa moved back and forth laterally between the panels so that sometimes she was hidden by a panel. Then she embraced a panel and successive dancers sidestepped from behind a panel and into view for a moment before moving behind an adjacent panel. (One these dancers wore a dunce cap, one was nearly naked, one stood with hands thrown out in a jazz dance pose, one squatted on the ground, and one wore a red form-fitting dress.) In sum, the movements of the other dancers were restricted to standing, crouching, squatting, moving back and forth in front of panels, and moving in and out of panels.

Each of the three dances followed a similar pattern: Ashikawa, in the starring role, cycled through transformations into various characters. For the most part, complex group choreography disappeared, and Ashikawa occupied center stage through her various transformations. To cheerful music or bizarre sounds, she stood, sat, or reclined in the center of the stage, mostly motionless, her face contorted, and stared out at the audience (sometimes backed by other equally motionless dancers). The background music for each of the three dances was globally diverse music such as

Western classical music (Pachelbel's "Canon in D major"), Indian sitar music, salsa, rumba, American gospel ("Amazing Grace"), German "space music" (Klaus Schultz' "Timewind"), and finally, various kinds of noises and experimental music such as air raid sirens, cicadas chirping, grinding metal, orchestra tuning sounds, rumblings, and clicks like the winding of a winch. We do not yet know the identity of any of the characters that Ashikawa played, but they probably all had their own backgrounds, stories, and histories. Each of the scenes and movements likewise came with a set of instructions that outlined the movements, imagery, character-type, background medium, and intended narrative.[2]

In her analysis of *Human Shape*, Kurihara explains that the "Human-Shape" (*hito-gata*) of the title was originally a kind of proxy doll (also called a *katashiro*) that was used to absorb the sicknesses of diseased people.[3] The dolls were then put into the river to be washed away. Kurihara cites Gôda's claim that the dance was about a *karayuki-san*—the name given to women who were sold into overseas prostitution from the late Tokugawa era until World War II.[4] According to Gôda and Kurihara, Hijikata depicted one of these prostitutes as she reflected on her life during her final moments (in much the same way that Divine had supposedly reflected on her life in Genet's *Our Lady of the Flowers*). This reading is bolstered by the final scene, in which Ashikawa sits on the dais at the back of the stage dejectedly smoking a cigarette.

Kurihara points out that Japanese entrepreneurs used these prostitutes as a way of amassing seed money for starting businesses, and argues that "Japan was pimping the women for economic" purposes. She then continues, "*Karayuki*-san were sacrificed for Japan's modernization."[5] Kurihara's claim is interesting for its resonance with Hijikata's first performance—*Forbidden Colors*. In that performance, the killing of a chicken had been the means of accomplishing a social interaction—the ticket for the boy to join the man's club. Similarly, the *karayuki* were the ticket for Japan to join the modern world of nation-states. Kurihara goes on to draw the tie between the *karayuki* sacrificed on the altar of Japan's progress, and the "comfort women" of World War II, who were forced by the military to provide sexual services for the Japanese soldiers. For Kurihara, the *karayuki* become not just the basis of Japan's economic and military advancement, but also the receptacles (human shapes) of Japanese prejudice—disgraced and despised for practicing a profession into which they had been sold by their own families.

The irony of the image of the human shape is that rather than imagining a healing doll into which one transfers aches and ailments, one sees these *karayuki* as unwilling repositories for the worst of societal prejudices. Thus, Hijikata bends the idea of the proxy doll (a human shape) to a bitter purpose. The cheeriness of "Summer Breeze" and "I Can See Clearly Now" (with the lyrics "the rain is gone…It's gonna be a bright, bright, bright sunshiny day") and the cherry blossoms painted on the backdrop are similarly ironic. Perhaps no motif is more closely associated with Japan than cherry blossoms, which ideally should be appreciated on a bright sunshiny day, but here, as a background for a woman who has been sold into prostitution and become the receptacle for the worst prejudices of society while at the same time being used to economically prop up society, these cherry blossoms may be just as oppressive as the endlessly looping muzak versions of pop music. Kurihara goes so far as to suggest that this woman hangs herself from a cherry tree.[6]

It is possible to add one more element to the Gôda/Kurihara interpretation of *Human Shape*—the moving panels that obscure and reveal the dancers. The stage art was designed by Yoshie Shôzô. Hijikata had long been open to collaboration with other artists, but it is not clear whether the idea of the moving panels came from Yoshie or Hijikata. Regardless, the panels need to be seen in the context of Hijikata's other experiments in stage art, such as the dogs and men's backs in *Rose-colored Dance*, and the swinging panels in *Hijikata Tatsumi and Japanese People: Rebellion of the Body*.

Usually one thinks of the backdrop as a setting for the more important action on the stage, but the moving panels in *Human Shape* function to veil or expose the characters. More broadly speaking, the backdrop affects the action and characters rather than providing the sets on which they determine their own fate. The stage art suggests that these characters are shaped by their environment and possibly even obscured by it. In a dance that appears to concern a woman who is both the receptacle of societal prejudice and the foundation upon which the society stands, the moving panels suggest that very society, with its ability to shape her or even obliterate her.

In looking at these dances, it is obvious that Hijikata's concerns had not changed much in seventeen years, but these dances did not meet with the same acclaim as Hijikata's previous dances had. Viala and Masson-Sekine go so far as to say that Hijikata's later dances lost the power of his earlier dances, and attribute this to his preoccupation with the Japanese body rather than with universal themes and improvisation.[7] However, as we have seen, their attribution is based upon a misconception, because Hijikata rarely improvised even from the beginning (although such things as the wind-sprints or cake-eating of *Rose-colored Dance* were not fully planned out), so any change in the quality of his dances cannot have been due to the amount of improvisation in them. As always, he was simultaneously trying to question the body and Japanese identity, and mark the way both were the product of discursive forces. However, it is true that *Story of Smallpox* is more compelling than most of the later dances, although each is fascinating in its own right.

My supposition is that Hijikata's dances lost the power to move audiences, because as the internal component of the dance become more and more complex, there was less and less reason for anything to happen on the outside, and Hijikata's dances became externally less complicated. That is to say, Hijikata's butoh became slower and more focused on a single person, Ashikawa (who was considered to be the master of transformation). There may have been other reasons for the slowness as well. In the long-term reaction against modern dance, Hijikata and his company could not have helped but notice that along with such things as jumping and spinning, often dance was predicated on expansive movements and speed. As they reacted against the rest of dance, they would have certainly come to view these two as problematic as well. On occasion, butoh dancers have been so successful at suffusing their faces with the internal complexity of the dance or with an emotion (often pain), that audiences have been satisfied to watch the faces for protracted periods of time without their interest flagging. However, there have even been butoh performances in which the dancer faced away from the audience, completely motionless, for extended periods of time, and the audience was deprived of even the sop that a face could provide.

The polar opposite of speed and expansive movement is stillness. This tendency reached an endpoint when Tanaka Min began to coach his students in "micromovements."[8] In part, the emphasis on micromovements and complexity of the mind can be explained by the requirement for the dancer to have an experience while dancing. In this case, the dancer would be coached to have increasingly finely detailed and minute experiences as an exercise of personal discrimination—moving one's finger one millimeter to the right while imagining oneself being eaten by insects, and so on. This matched the concern for detail in *Ailing Terpsichore*, in which Hijikata's narrator was entranced by a wisp of vapor that rose from one millimeter of a cat's tongue. Yet, as the external movement became less and less noticeable, the experience available to the audience became less and less palpable. To the extent that members of the audience were able to discern the micromovements, they may have been able to participate in the experience of detailed discernment, but at times, the experience of the audience became more and more a function of boredom. Moreover, if micro-movement-oriented butoh artists ever moved beyond theaters that seated one hundred people, they would have automatically ensured that a large percentage of their audience could not discern the micromovements, and thus could not participate in the detail of the dance. Thus, while Hijikata was still focused on rebellion against convention, custom, and on Japanese people and their socialization, he had expanded his focus on detail to such an extent that it paradoxically took the focus away from the body as something that moves.

There were other factors that contributed to this loss of focus on the moving body. One was Hijikata's new concern with the emaciated body (see figures 8.3, 8.4 and 8.5). In a lecture originally entitled, "Collection of Emaciated Bodies," Hijikata gave

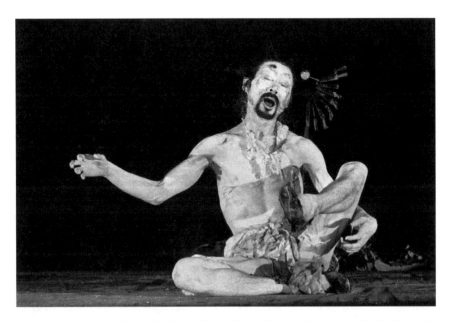

Figure 8.3 Hijikata Tatsumi, *Quiet House*, (Seibu Theater, Tokyo, 1973) by Onozuka Makoto. Courtesy of Onozuka Makoto and Morishita Takashi Butoh Materials, NPO, and the Research Center for the Arts and Arts Administration, Keio University.

his fullest accounting of his ideas.⁹ Hijikata opened this rambling lecture with the confession that he had caught a cold, and noted that sometimes paradoxically when people catch colds they are much more likely to get along, and proposed that perhaps it would be possible to introduce a common cold into a neighborhood as a way of getting people to come closer together. Immediately, he noted the danger of such a plan as it could snowball into various serious illnesses.

Hijikata had already been thinking along these lines since his 1969 essay, "To Me Eroticism Comes from Being Jealous of a Dog's Vein," when he had theorized that a dog can derive benefit from being beaten by children. The dog was possibly using pain as a way to achieve a sympathetic response, and in the same way, Hijikata noted that sickness can lead to such a response. Later in the lecture, Hijikata says that he prefers soggy crackers, and then says, "I've come to rely on a body in the state of being soggy and soft."¹⁰ As was typical for Hijikata, although the lecture was entitled, "Collection of Emaciated Bodies," Hijikata did not spend most of his time talking specifically about emaciated bodies, but perhaps, the emaciated bodies of the title and the idea of relying on the soggy body are related ideas.

Of course, Hijikata was no longer young by the time he gave this lecture, and thus may have been thinking about emaciation and sogginess because his own body was no longer as strong and spry as it once was. However, in general, despite the rhetoric of the rebellion of the body, the trajectory of Hijikata's career began with a focus on athletic muscled bodies and ended with thoroughly fragmented emaciated

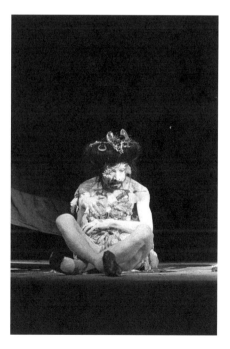

Figure 8.4 Hijikata Tatsumi, *Quiet House*, (Seibu Theater, Tokyo, 1973) by Onozuka Makoto. Courtesy of Onozuka Makoto and Morishita Takashi Butoh Materials, NPO, and the Research Center for the Arts and Arts Administration, Keio University.

nearly motionless bodies. As he matured, Hijikata also paid less attention to the gross motor skills of the body (wind-sprints, helicopter spinning) and more attention to the ways he could compartmentalize muscles and movements by paying attention to the body on an increasingly minute scale. This included inserting fractionally small pauses into movements, seeing how the use of mental imagery could modify the body, and seeing how the emaciated body could evoke sympathy in the viewer. It should be obvious that the fragmented emaciated bodies were in very real ways more capable than the muscled bodies of the earlier period. Hijikata's early friend Mishima had turned to weight lifting but was eventually greeted with laughter and derision when he attempted to incite a coup by the Japan Self Defense Forces. In contrast, the emaciated body of Hijikata's long-time collaborator Ōno Kazuo astounded audiences worldwide for three decades.

These fragmented and emaciated bodies were suited to the era. The critic Takeda Ken'ichi argued that butoh should be seen as a manifestation of a time when bodies are no longer useful. He wrote: "When I think back on it, [the rebellion of the body] was a strange rebellion. It was like a rebellion directed against a vacuum. Now, computers and robots have become a normal part of our labor and lives, and it is clear that the body has become almost useless."[11] In fact, the body had not at all become useless. As is demonstrated by the proliferation of sweatshop and in-home labor practices during the seventies and eighties, the body was still very much in use. Notwithstanding, Takeda continues: "What the bodily techniques of butoh point out is not the reconstruction of a center or idée that will once again control the entire

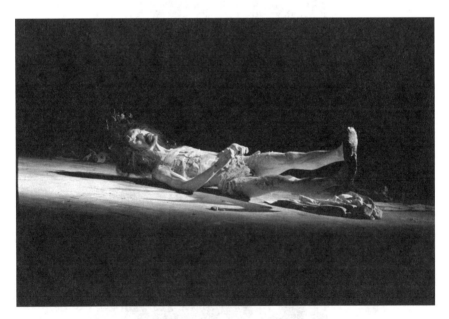

Figure 8.5 Hijikata Tatsumi and the "emaciated body," *Quiet House*, (Seibu Theater, Tokyo, 1973) by Onozuka Makoto. Courtesy of Onozuka Makoto and Morishita Takashi Butoh Materials, NPO, and the Research Center for the Arts and Arts Administration, Keio University.

body, but a management of the dispersion of the body." Certainly, despite the continued usefulness of body, Takeda's impression and the change in Hijikata's art form both speak about new status of the body in the seventies and eighties in Japan.

Takeda raises the question of the viability of Hijikata's rebellion, particularly when Hijikata's means of rebellion had evolved from smashing against things to relying on a soggy body or a sympathetic response to an emaciated or sick body. How useful were his means of rebelling against bodily constraints such as notions of Japaneseness, or his own socialized identity as Hijikata Tatsumi?

As a means to answer to that question, allow me to present an ethnograpy conducted by Tamah Nakamura of the group Seiryukai based in Fukuoka, Japan, and lead by Harada Nobuo (a student of Kasai Akira). Nakamura focuses not so much on butoh's method and philosophy (although these are never far from her thoughts) as on how participants use butoh in their lives.[12] Nakamura danced with the group for several years and conducted formal and informal interviews with all of the members during that time. In her interviews it is interesting that the members of Seiryukai feel that they have become more perceptive during their time dancing in the group, while Seiryukai has become an alternate locus of value for the participants, who in turn take that revaluation back out into their non-dance lives.

One dancer in the group, Mineo Kaori, says that before she practiced butoh, she felt as if she was completely apart from nature, humans, and the world. After she had practiced butoh, she felt that she was now in the same sphere as nature, humans, and the world. It is as if Mineo has imbibed Hijikata's surrealist principle of relationality and conflict between things, but was in no position to present any sort of opposition to the much stronger forces around her and was completely overpowered by them until she practiced butoh. Only then could she set herself up as a more nearly equal partner with society.

There is something surreal about an individual by the name of Mineo Kaori having the temerity to consider herself the equal of nature, humans, or the world. Given the strength of many of the power structures around her, it would be much more realistic for her to suppose that they will continue to dictate her life although they are unavailable to her. But she has begun to imagine that she is in an interaction with them. In part, Mineo feels this because Seiryukai has become an alternate source of value.

Another woman, Matsuoka Ryoko voices a similar feeling: "Values were made for us at school in our education system. But at Seiryukai, we can experience our own movement as beautiful; our own feeling is beautiful. From doing Butoh I have learned to sense parts of my life and things around me more carefully."[13] As opposed to the values of school and society (the productive society), Matsuoka uses her time with the butoh company Seiryukai to find a different set of values. Matsuoka goes on to say that she prizes her time at Seiryukai as "time to face each other" (*mukai-au jikan*).[14] Certainly, the idea of facing each other reflects Matsuoka's assumption that other dancers will watch her and accept her self-evaluation, and her willingness to watch others dance and accept their respective self-valuations. This reciprocal facing also implies a standpoint of more strength than if she were just her thinking about herself and her place in society, and watching someone else. At stake here is Matsuoka's ability to look back at society and to reciprocally face society (in an

analogous way that Mineo felt that she could now be included in the same sphere as society). Mishima had been preoccupied with an opponent that looked back at him, but never remarked on the fact that he was already in a position to look at (and strike) the opponent. These two individuals were attaining the ability to look back for the first time.

Equally at stake is Matsuoka's new willingness to face the world and notice it. It is as if Hijikata's original idea—to spread one's focus out to notice more things—made its way through three generations of butoh dancers. So Matsuoka may be seen as trying to access the actuality about the world outside herself and about herself as well. Not surprisingly, Matsuoka reports being more open to new things than she was before she practiced butoh. This attitude of Matsuoka's is the corollary of Mineo's attitude toward herself and nature. Before, she thought of herself as separate from nature, but now, Mineo imagines that nature is accessible to her as well. She can face it, look at it, and while it would certainly face back at her, she can begin to understand it, if she is attentive to its details.

Facing each other takes strength, but it also takes openness. Nakamura interviews a person for whom this openness is of paramount importance. Ideta Hiroshi is a postal worker, in charge of fielding customer complaints, who has low job satisfaction. He speaks of the attitude "in the business world [that] human beings are numbers," but then tells Nakamura that his time in butoh helps him to interact with customers "without armor," whereas he used to interact with customers from a standpoint of an "armored self."[15] Nakamura reads this as Ideta's being able to "enjoy social interactions without the armor imposed upon him by social norms" and surely the alternate value system offered by Seiryukai contributed to Ideta's being able to slough off the armor of social norms. However, when considered in light of the broader concerns of butoh, surely this armor has to be considered from the vantage point of Ideta's willingness to open himself to an interaction with something else. By disarming, Ideta manifests a stronger sense of self, but at the same time acknowledges that his self may be so locked into one way of seeing things that it is unaware of the distortion that has appended onto his observations. So opening the self provides the flexibility for drawing nearer to actuality because considering other viewpoints may lead to something previously overlooked.

However, each of these three people had to find a group that was willing to accept them in their respective states. They did not fit into the socialized system they were caught in, but they did not have the strength to change the system. So they sought out a group that claimed to be value-neutral and would thus accept them as they were.[16] They could share with that group their troubles and would be validated within that group rather than judged as wanting. In other words, they found a group that was willing to extend a sympathetic response to them. None of them went out into the world and demanded acceptance; they did not give the world an uppercut as Shibusawa had encouraged, in order to write themselves into the world's psyche. Perhaps it is unreasonable to imagine that the products of socialization will be able to change the world, and this may indicate a limit to the effectiveness of Hijikata's strategy of relying upon the sick, soggy, or emaciated body. Such a strategy is predicated on the assumption that all bodies will respond to emaciation or sickness with understanding, but all bodies may not respond this way.

It is also useful to return to Mishima and athleticism. Mishima became more and more distrustful of his own burgeoning intellect and opted for muscle and athleticism, but in the end obliterated his own body in an attempt to induce a sympathetic response.[17] Hijikata started with the well-oiled muscled athletic body, but became preoccupied with how the mind can modify the body and how the mind can engage a world of proliferating information. In part he was goaded into action by Mishima's dual argument that the body was limited in its language and that it was covered in conventions and customs. Since Hijikata was trying to access actuality, he gradually moved away from muscle and athleticism. To find his way to actuality and to an expanded vocabulary of the body, he adopted principles from surrealism.

One was contained in the idea that miso bread is in a relationship with a person wearing drenched trousers—the understanding that everything is already in a relationship with everything else. However, some relationships are so distant as to make discerning their relationship exceedingly difficult. By bringing distant realities in closer contact with each other, Hijikata could see how they would interact and compete with each other. Hijikata found himself in a relationship with his audience, and he felt comfortable pushing them to see how much he could challenge them with riddles and puzzles. Moreover, he discovered that the visceral reactions of the audience would contribute to the affects he desired to explore on stage, and he took that avenue of exploration to one logical conclusion—the emaciated body. As another aspect of this juxtaposition, he also found it useful to imagine all sorts of things in order to alter his own body or the bodies of his dancers. However, the use of this relational and surrealist combinatory principle did not end there.

What really marked Hijikata's art as surreal is the number of things that came together at one point. Hijikata's best dances were marked by the willingness to spin an impossible number of plates at once. The breadth of Hijikata's attempted endeavors was astonishing, and conservatively would include the following list: contesting socialization and gender roles; bending joints in unfamiliar ways; providing a dizzying number of riddles for the audience; inducing dance or the dancer to be as multivalent as Chinese characters could be; allowing himself to be invaded by other artists; using the body as a musical instrument; slashing space and taking the risk of being slashed as well; expanding the revolution to include everyone; constantly working muscles by leaning over while crouching; bringing the center into contact with the periphery; spreading concentration out to the maximum extent possible; coping with insufficient and overly abundant information; seeing the world from other viewpoints; using random processes and the unconscious; transforming into or inhabiting different subjective positions; depicting handicapped and unfree states; setting up hundreds of experiments to say more than has been said; indicating that he had not managed to say even a small portion of what it is theoretically possible to say; and asking after the diffuse causality of seemingly everything.

In the end, what made Hijikata's art so engaging is precisely that he was spinning so many plates at once, and what made it lose power late in his life is that he let some of the plates fall to the floor. Bodily percussion fell away, group movements fell away, and humor fell away. This is not to criticize Hijikata with the cliché that he privileged dead technique at the expense of life-filled improvisation or expression of one's true essence; it is only to note that when he was only spinning the plates of transformation

through imagination exercises and layered and had ceased to pay attention to the other plates, his dances were less interesting to watch.

Butoh is always an unfinished project, but at the same time it is always in danger of losing what makes it butoh. Properly speaking, in so far as butoh has any essence at all, butoh is an art form that demands that artists put themselves into continually new relationships and allow themselves to be invaded by others as a way to tirelessly search for actuality. Most of all, it demands that the artists express and experience the pain of others and particularly those who have been hurt by the diffuse customs and conventions of society. To do that, the artists will have to learn to see the world from other vantage points and to understand how their own outlook is subject to distortions and persuasions. It is in that sense that butoh is unfinished, because there is always a new relationship to entwine oneself in, a new person to allow into one's life, and there is always new pain to understand. Paradoxically, the way to ensure the vitality of butoh is for the individual artists to expose themselves to the risk of being hurt, and to spin as many plates as possible. The way for us to understand butoh is to match the effort the artists bring to the dance in the spinning of plates even if that should mean that we risk having one fall and slash us.

Appendix: Original Japanese Names, Terms, and Dance Titles ~

Words that are already glossed in the text are listed alphabetically under their glossed romanization. Dance titles are listed alphabetically under the English translation given in the text, followed by the romanized Japanese title and the original Japanese. Following the convention adopted in the text, performance names are enclosed in double quotation marks, dance names are rendered in italics and scene or act names are enclosed in single quotation marks. Japanese performance names are bracketed with double diamond 《》 brackets, dance names are bracketed with single diamond 〈〉 brackets, and scene and act titles are given squared ［］ brackets. Japanese book titles are enclosed in thick L 『』 brackets and chapter and article titles are enclosed in thin L 「」 brackets.

"6 Avant-gardists: Steptember 5th 6:00 Gathering" (Rokunin no avangyarudo: Kyûgatsu gonichi rokuji no kai), 《6人のアヴァンギャルド：9月5日6時の会》
650 EXPERIENCE no kai, 650 EXPERIENCEの会

A

Admiring La Argentina (Ra aruhenchîna shô), 〈ラ・アルヘンチーナ頌〉
Akasegawa Genpei, 赤瀬川原平
All Japan Art Dance Association (Zennihon buyô geijutsu kyôkai) 全日本芸術舞踊協会
"All Japan Art Dance Association: Sixth Newcomers Dance Recital" (Zennihon buyô geijutsu kyôkai: Dairokukai shinjin buyô kôen), 《全日本芸術舞踊協会・第6回新人舞踊公演》
Andô Mitsuko/Sanko, 安藤三子
"Andô Mitsuko, Horiuchi Kan Unique Ballet Group Performance" (Andô Mitsuko Horiuchi Kan yunîku barê gurûpu kôen), 《安藤三子・堀内完ユニーク・バレエ・グループ公演》
"Andô Mitsuko Special Performance of The Dancing Heels," (Andô Mitsuko danshingu hîruzu tokubetsu kôen), 《安藤三子ダンシング・ヒールズ特別公演》
angura, アングラ
ankoku butô, 暗黒舞踏
ankoku buyôha, 暗黒舞踊派
Asbestos Hall (Asubesutokan), アスベスト館
Ashikawa Yôko, 芦川羊子
Atsugi Bonjin, 厚木凡人

B

"Banquet to Commemorate Losing the War" (Haisen kinen bansankai),《敗戦記念晩餐会》

"Beginning of the Summer that will Freeze and Wane in the Non-melodic Metropolis" (Non merodiasu tokai no naka de kogoete iku natsu no hajimari). 〈ノン・メロディアス都会の中でこごえて往く夏のはじまり〉

Birth of a Jazz Maiden (Jazu musume tanjô),《ジャズ娘誕生》

Black Point (Kokuten), 〈黒点〉

Blue Echoes (Burû ekôzu), ブルーエコーズ

butôfu, 舞踏譜

buyô, 舞踊

C

chikara wo nuku, 力を抜く

chitaikensha, 馳体験者

Clothespins Assert Churning Action (Sentaku basami wa kôhan kôdô wo shuchô suru),『洗濯バサミは撹拌行動を主張する』

Contemporary Theatre Arts Association (Gendai butai geijutsu kyôkai), 現代舞台芸術協会

Costume en Face: a Primer of Blackness for Young Boys and Girls (Shômen no ishô--shônen to shôjo no tame no yami no tehon), 〈正面の衣装--少年と少女のための闇の手本〉

The Courageous Woman Okane of Ômi Province (Ômi no kuni no yûfu Okane), 近江の國の勇婦於兼

Crowds of Flowers (Hanatachi), 〈花達〉

D

daiji, 大字

Dairakudakan, 大駱駝艦

Dance of the Burial Mound Figurine (Haniwa no mai), 〈埴輪の舞〉

Dancing Gorgui (Danshingu gôgî), ダンシング・ゴーギー

Dark Body (Antai), 暗体

'Death of Divine' (Divînu no shi), 〔ディヴィーヌの死〕

'Death of the Young Man' (Shônen no shi), 〔少年の死〕

deshuannu, デシュアンヌ

Disposal Place--Extract from the Song of Maldoror (Shorijô--Marudorôru no uta yori bassui) 〈処理場 マルドロオルの歌より抜粋〉

Divinariana (Divînushô), 〈ディヴィーヌ抄〉

dokata, 土方 see TUTIKATA

dotera, 褞袍

Duchamp (dushan), デュシャン

Duchenne (Dushannu), デュシャンヌ, but cf. 'deshuannu'
Duchenne muscular dystrophy (Dushannu gata kin jisutorofî shô), デュシャンヌ型筋ジストロフィー症

E

Eguchi Takaya, 江口隆哉
eien no kakumei, 永遠の革命
Excerpts from O-Genet (*Ojuneshô*), 〈おじゅね抄〉
experience, 経験(keiken), 体験(taiken), エクスペリエンス
"Extravagantly Tragic Comedy: Photo Theater Starring a Japan Dancer and Genius (Hijikata Tatsumi)" (Totetsumonaku higekiteki na kigeki: nihon no butôka, tensai (Hijikata Tatsumi) shûen shashin gekijo) とてつもなく悲劇的な喜劇―日本の舞踏家・天才〈土方巽〉主演写真劇場」

F

Fin Whale (Nagasu kujira), 長須鯨
Forbidden Colors (Kinjiki), 「禁色」
Forbidden Colors 2 (Kinjiki nibu), 「禁色二部」
fumajime, 不真面目

G

Gaishikô, 〈碍子考〉
garumera shôkai, ガルメラ商會
General Catalogue of Males'63, (Danshi sôkatarogu '63), 男子総カタロク '６３
geta, 下駄
Gibasa, 〈ギバサ〉
Gibasan, 〈ギバサン〉
Gold Dust Show (kinpun shô), 金粉ショー
goze, 瞽女
Grave Watchman (Hakamori), 「墓守」
"Great Dance Mirror of Burnt Sacrifice--Performance to Commemorate the Second Unity of the School of the Dance of Utter Darkness--Twenty-seven Nights for Four Seasons" (Hangidaitôkan dainiji ankoku butôha kessoku kinen kôen--Shiki no tame no nijûnanaban), 《燔犠大踏鑑第二次暗黒舞踏派結束記念公演・四季のための二十七晩》

H

Haerbin, 哈爾賓
haibashira hokô, 灰柱歩行

hainarashi, 灰均し
Hanako, 花子
Hanayagi Shôtarô, 花柳章太郎
Hanchikik, 〈ハンチキキ〉
hangidaitôkan, 燔犠大踏鑑
Hijikata Genet, 土方ジュネ
Hijikata Kunio, 土方九日生
Hijikata Nero, 土方ネロ
Hijikata Nue, 土方ぬえ
Hijikata Tatsumi, 土方巽
Hijikata Tatsumi and Japanese People: Rebellion of the Body (Hijikata Tatsumi to nihonjin: Nikutai no hanran), 〈土方巽と日本人―肉体の叛乱〉
"Hijikata Tatsumi DANCE EXPERIENCE Gathering" (Hijikata Tatsumi DANCE EXPERIENCE no kai), 《土方巽 DANCE EXPERIENCEの会》
Hi Red Center (Haireddo sentâ), ハイレッド・センター
Hitogata, 〈ひとがた〉
hogusu, 解す
Horiuchi Kan, 堀内完
Hosoe Eikô, 細江英公
Hosoe Eikô's Photographic Collection Dedicated to Hijikata Tatsumi (Hijikata Tatsumi ni okuru Hosoe Eikô shashinshû), 「土方巽に送る細江英公写真集」
Hôsôtan, 〈疱瘡譚〉

I

igata no hokô, 鋳型の歩行
Iimura Takahiko, 飯村隆彦
Ikeda Tatsuo, 池田龍雄
Imai Shigeyuki, 今井重幸
"Imperial Hotel Body: Shelter Plan" (Teikoku hoteru no nikutai: Sherutâ keikaku), 帝国ホテルの肉体：シェルター計画
"Inner Material" (Naka no sozai), 「中の素材」
Instructional Illustrations for the Study of Divine Favor in Sexual Love: Tomato (Seiai onchogaku shinanzue: Tomato), 〈性愛恩徴学指難図絵―トマト〉
"Inu no jomyaku ni shitto suru koto kara," 「犬の静脈に嫉妬することから」
Ishii Baku, 石井漠
Ishii Mitsutaka, 石井満隆
Itô Mika's Bizarre Ballet Group (Itô Mika bizâru barê gurûpu), 伊藤ミカ・ビザール・バレエグループ

J

Jazz Cinema Experimental Laboratory (Jazu eiga jikkenshitsu), ジャズ映画実験室
Jôno'uchi Motoharu, 城之内元晴

junsui keiken, 純粋経験
jutsuha kanshin jin, 術破歓心人

K

Kamaitachi, 『鎌鼬』
Kanemori Kaoru, 金森馨
Kanô Mitsuo, 加納光於
kanôtai, 可能体
Kara Jûrô, 唐十郎
karamaru, 絡まる
karamu, 絡む
karayuki, 唐行き
Karumera, カルメラ
karumerashôsô, 軽目乱症相
Kasai Akira, 笠井叡
kasanaru mesôdo, 重なるメソード
katashiro, 形代
Katô Ikuya, 加藤郁乎
Kawara On, 河原温
Kazakura Shô, 風倉匠
"Keimusho e,"〔刑務所へ〕
kesu kao, 消す顔
Kobayashi Saga, 小林嵯峨
kojiki no shôjo, 乞食の少女
Kuroki Fugoto, 黒木不具人
Kusama Yayoi, 草間彌生
Kuzu no ha, 〈葛の葉〉

L

Lady on a Whale String (Geisenjo no okugata), 〈鯨線上の奥方〉
Left Hook Exhibition, (Refuto fukku ten), 「レフトフック展」
Love for Sale (Bai rabu), 〈売ラブ〉

M

Maro Akaji, 麿赤児
marumage, 丸髷
Masseur: A Story of a Theater that Sustains Passion (Anma: aiyoku o sasaeru gekijo no hanashi) 〈あんま：愛欲を支える劇場の話〉
Masuda Kinpei, 升田金平

Masumura Katsuko, 増村克子
"Material" (Sozai), 「素材」
matou, 纏う
Mavo, MAVO (マヴォ)
Metemotionalphysics (Keijijôgaku), 形而上学
Mid-afternoon Secret Ceremony of a Hermaphrodite: Three Chapters (Han'in han'yosha no hiru sagari no higi--sanshô), 〈半陰半陽者の昼下がりの秘技参章〉
Mishima Yukio, 三島由紀夫
Mitsukuchi Tateo, 兎口立男
Miya Sôko, 宮操子
Mizutani Isao, 水谷勇夫
moji, 文字
Motofuji Akiko, 元藤燁子
mukai-au jikan, 向かい合う時間
Murobushi Kô, 室伏鴻
mushikui, 虫食い
mushi no iki, 虫の息
Music Concrete's Maiden of Dôjô Temple (Mûjikku konkurêto musume dôjôji), 《ミュージックコンクレート・娘道成寺》

N

Nadare-ame, 〈なだれ飴〉
Nagata Kiko, 長田紀子
Nakajima Natsu, 中嶋夏
Nakamura Hiroshi, 中村宏
Nakanishi Natsuyuki, 中西夏之
Navel and A-Bomb (Heso to genbaku), 『へそと原爆』
nihonkaiki, 日本回帰
"Nikutai no hanran," 〈肉体の叛乱〉
Nishida Kitarô, 西田幾多郎
Nishitani Keiji, 西谷啓治
Noguchi Michizô, 野口三千三
Noguchi taisô, 野口体操
Nonaka Yuri, 野中ユリ
Norinaga, 宣長

O

Oikawa Hironobu, 及川廣信
Okamoto Tarô, 岡本太郎
Ôno Kazuo, 大野一雄
Ôno Yoshito, 大野慶人
Onrai Sahina, 音来サヒナ
oshidasarete, detekuru, 押し出されて、出てくる

P

pariah girl (eta no shôjo), エタの少女
Poinciana, 〈POINCIANA〉

R

Ribon no kishi, リボンの騎士
Rose-colored Dance: To M. Shibusawa's House (Barairo dansu: A LA MAISON DE M. CIVEÇAWA), 〈バラ色ダンス: A LA MAISON DE M. CIVEÇAWA 〉

S

'script of welts' (*mimizubare no moji*), 蚯蚓腫れの文字
"Second 6 Avant-gardists" "Dainikai rokunin no abangyarudo," 《第2回6人のアバンギャルド》
Seed (Shushi), 〈種子〉
sei, せい（所為）
Seiryukai, 青龍會
seisan, 生産
seisansei, 生産性
senkensha, 先験者
Shibusawa Takahiko, 澁澤龍彥
"Shiki no tame no nijûnanaban," 《四季のための二十七晩》
shikkônin, 執行人
shingeki, 新劇
Shinjuku Art Village (Shinjuku âto birejji), 新宿アート・ビレッジ
Shinjuku Culture Art Theater (Âto shiatâ Shinjuku bunka), アートシアター新宿文化
Shinohara Ushio, 篠原有司男
shinpa, 新派
shishôsetsu, 私小説
Shizuka na ie, 静かな家
shôjo, 少女
shônen, 少年
Situation Theater (Jôkyô gekijô), 状況劇場
Snipe (shigi), 鴫
sôgô, 総合
Space Capsule (Supêsu kapuseru), スペース・カプセル
spontaneous inevitability (jihatsuteki ni hitsuzensei), 自発的な必然性
'Stillness and Motion' (Sei to dô), 〔静と動〕
sukajan, スカジャン
Sunohara Masahisa, 春原政久
Susamedama, 〈すさめ玉〉
sutajan, スタジャン

T

taiken mokuroku, 体験目録
taikensha, 体験者
Takamatsu Jirô, 高松次郎
Takiguchi Shûzô, 瀧口修造
Tamano Kôichi, 玉野黄市
Tanemura Suehiro, 種村季弘
Tanikawa Kôichi, 谷川晃一
Tashiro, 田代
Terakoya, 《寺子屋》
Terayama Shûji, 寺山修司
"Theatre Human/Contemporary Theatre Arts Association Joint Concert" (Gekidan ningenza, gendai butai geijutsu kyôkai gôdô kôen), 《劇団人間座・現代舞台芸術協会合同公演》
Three Phases of Leda (Reda santai), 〈レダ三態〉
Tomioka Taeko, 富岡多恵子
Toritachi, 〈鳥達〉
Tsubouchi Itchû, 坪内一忠
Tsuda Nobutoshi, 津田信敏
Tsugaru-jamisen, 津軽三味線
tsutsumu, 包む
TUTIKATA (tsuchikata), 土方

U

Ugo-machi, 羽後町
Utagawa Kuniyoshi, 歌川国芳

W

Waguri Yukio, 和栗由紀夫
Wakamatsu Miki, 若松美黄
watakushi-shôsetsu, 私小説
"Watashi ni totte erotishizumu towa: Inu no jomyaku ni shitto suru koto kara," 「私にとってエロチシズムとは――犬の静脈に嫉妬することから」

Y

Yameru maihime, 『病める舞姫』
Yasuda Shûgo, 安田収吾
yokoku-en, 予告演
Yokoo Tadanori, 横尾忠則

Yoneyama Kunio, 米山九日生
Yoshie Shôzô, 吉江庄蔵
Yoshimura Masunobu, 吉村益信
Yoshino Tatsu'umi, 吉野辰海
Yoshito, 慶人 see Ôno Yoshito 大野慶人
young man, see shônen
yûfu, 勇婦

Notes

Japanese books without a specific place of publication were published in Tokyo.

1 INTRODUCTION: AND, AND, AND

Epigraph: Anne Stevenson, *Elizabeth Bishop* (New York: Twain Publishers, 1966), 66.

1. Anna Kisselgoff, "Japan's New Dance is Darkly Erotic," *New York Times*, July 15, 1984.
2. Mark Holborn wrote: "*Revolt of the Flesh* had a subtitle, *Tatsumi Hijikata and the Japanese*." Mark Holborn, "Tatsumi Hijikata and the Origins of Butoh," in Ethan Hoffman et al. eds., *Butoh: Dance of the Dark Soul* (New York: Aperature, 1987), 13. For more on the title of the dance, see chapter 4.
3. An overview of arguments for and against seeing Hijikata as making a statement about his connection to Japanese identity can be found in Morishita Takashi, "Nikutai no hanran: kîwâdo no idiomu o yomu: Hijikata Tatsumi no sainêji kenkyû 1," in Maeda Fujio et al. eds., *Nikutai no hanran: Butô 1968: Sonzai no semirojî* [Rebellion of the Body: Butoh 1968: Semiology of Being] (Keio University Research Center for the Arts and Arts Administration, 2009), 18–23. Also see other contemporary commentary on this dance on pages 56–58 in the same booklet. See also the discussion in Mikami Kayo, *Utsuwa toshite no shintai*: *Ankoku butô gihô e no apurôchi* [Body as Receptacle: An Approach to the Techniques of Ankoku Butoh] (ANZ-Do, 1993), 24–26.
4. For Breton's general surrealist principle, see Gérard Durozoi, *History of the Surrealist Movement*, trans. Alison Anderson (Chicago: University of Chicago Press, 2002), 63–74. For the understanding of Breton and this principle of surrealism by Japanese surrealists, see Hosea Hirata, *The Poetry and Poetics of Nishiwaki Juzaburô* (Princeton: Princeton University Press, 1993), 151–52; and Miryam Sas, *Fault Lines: Cultural Memory and Japanese Surrealism* (Stanford: Stanford University Press, 1999), 16.
5. I take the idea of "imagined communities" from Benedict Anderson, *Imagined Communities: Reflections on the Origin and Spread of Nationalism* (New York: Verso, 1991).
6. Ascertaining Hijikata's aims is tricky. Hijikata's writings and statements are inflected by surrealism, by a promoter's penchant for exaggeration, and by an avant-garde tendency to intentional obfuscation. I have looked at what Hijikata actually did (what was actually on stage), and tried to infer what he was trying to do, and tried to understand how that related to the society around him. Then, and with a great deal of suspicion, I have looked for corroboration in so far as is possible in his twisted prose. Here I draw on the critic Takeda Ken'ichi who reads butoh specifically as a response to the information age. Takeda Ken'ichi, "Yôzumi to natta nikutai to shintai no rika" [The flesh that has lost its usefulness and the parting song of the body], *Gendaishi techô* [Modern Poetry Cahiers] 28, no. 6 (May 1985): 106–8. See also Kuniyoshi Kazuko's idea that butoh is a dance form that is structurally "oriented towards entropy." Kuniyoshi

Kazuko, Setagaya Public Lecture Series, February 26, 2001; and Kuniyoshi Kazuko, "Shômetsu suru kôzô" [Perishing Structure] *Kikan shichô* 4 (April 1989): 81.
7. Hijikata Tatsumi, "Keimusho e" [To Prison], *Hijikata Tatsumi zenshû* [Hijikata Tatsumi Collected Works] (hereafter *HTZ*) ed., Tanemura Suehiro et al. (Kawade Shobô, 1998), 1: 197.
8. Ozasa Yoshio, *Nihon gendai engekishi*, (Hakusuisha, 1985) vol. 1, 27–28.
9. Judith Hamera, "Silence That Reflects: Butoh, *Ma*, and a Crosscultural Gaze," *Text and Performance Quarterly* 10 (1990): 55.
10. Anne Allison, *Millennial Monsters: Japanese Toys and the Global Imagination* (Berkeley: University of California Press, 2006), 95, 99, 100–1.
11. Michael Raine, "Ishihara Yûjirô: Youth, Celebrity and the Male Body in the Late-1950s Japan," in Dennis Washburn and Carole Cavanaugh eds., *Word and Image in Japanese Cinema* (New York: Cambridge University Press, 2001), 223n7.
12. Michel Foucault, "Technologies of the Self," in Luther Martin et al. eds., *Technologies of the Self: A Seminar with Michel Foucault* (Amherst: University of Massachusetts Press, 1988), 18. I have followed Foucault in using the terms "technique" and "technology" interchangeably.
13. For bodily languages, see the discussion in chapter 2 of the bodily and intellectual roots of butoh in German expressionist dance. For the moment, it suffices to point out that there were various attempts to theorize a language of the body in German expressionist dance starting with Rudolf Laban (1879–1958), and that butoh artists picked up a general orientation to thinking about language and the body from Laban et al., even if they were not completely aware of what Laban and his contemporaries were doing.
14. Julio Cortázar, "Swimming in a Pool of Gray Grits," in Gregory Rabassa trans. *A Certain Lucas* (New York: Knopf, 1984), 80–3. Original in Julio Cortázar, "Nadando en la piscina de gofio," *Un Tal Lucas* (Madrid: Ediciones Alfaguara, 1979), 105–8.
15. The fact that the Japanese swimmer has two names (Tashuma/Teshuma) must speak to a perceived transformation in how identity functions in the present era.
16. Arjun Appadurai, *Modernity at Large: Cultural Dimensions of Globalization* (Minneapolis: University of Minnesota Press, 1996), 59. Cortázar, "Swimming in a Pool of Gray Grits," 82.
17. This is not to argue that Hijikata had read Cortázar, but to argue that the forces driving Cortázar were also driving Hijikata. For "pass through the density of rock," see Mikami, *Utsuwa*, 146.
18. This is not to say that Appadurai was unaware of the body. He observes:
 All lives have something in common with international athletic spectacle, as guest workers strive to meet standards of efficiency in new national settings, and brides who marry into households at large distances from home strive to meet the criteria of hypercompetence that these new contexts often demand. The deterritorialized world in which many people now live...is, like Cortázar's pool of grits, ever thirsty for new technical competences and often harsh with the unprepared.
 And he follows with a chapter on the ways in which the British sport of cricket indelibly marks the "bodily practices and bodily fantasies of many" Indian males. Appadurai, *Modernity at Large*, 59–61, 104.
19. The term "actuality" (taken from English and rendered *akuchuariti*) was used by the artists of the time. See chapter 2 for more information on this term.
20. When communicating with others, he would also try to understand everything that had formed them as a way of understanding their viewpoints.

21. Perhaps it goes without saying, but the spoken and written languages of Japan (although related) are not the same languages.
22. Philip Auslander, *From Acting to Performance: Essays in Modernism and Postmodernism* (New York: Routledge, 1997), 127. Auslander quotes Andrew Murphie, "Negotiating Presence—Performance and New Technologies," in Philip Hayward ed., *Culture, Technology and Creativity in the late Twentieth Century* (Bloomington, IN: Indiana University Press, 1990), 224.
23. Michel Foucault, "Technologies of the Self," 47.
24. The information for this short history was taken from the "Hijikata Tatsumi nenpu" [Hijikata Tatsumi Yearly Chronology] in Morishita Takashi, ed., *Hijikata Tatsumi no butô: Nikutai no shururearisumu, shintai no ontorojî* [Tatsumi Hijikata's Butoh: Surrealism of the Flesh, Ontology of the "Body"] ("Okamoto Tarô Museum of Art" and Keio University Research Center for the Arts and Arts Administration, 2004), 174–86; and Motofuji, *Hijikata Tatsumi to tomo ni* [Together with Hijikata Tatsumi] (Chikuma Shobô: 1997), 21–26. However, one of the major problems in dealing with Hijikata is the uncertainty involved in studying him. The dean of Japanese theater scholarship, David Goodman, once described Hijikata as "notoriously unreliable" because of his tendency to exaggerate or embellish details of his life (personal conversation, Sept. 19, 2003). This problem will come up frequently, and in due course it will become obvious why the problem arises, but for the moment, the reader should be suspicious of any material for which the only source is Hijikata himself.
25. Mikami specifically says that Hijikata was "raised in economically and culturally rich circumstances." See Mikami, *Utsuwa*, 41.
26. Hijikata (土方) literally means "Soil Person," but is commonly pronounced "dokata" or "tsuchikata" and means "laborer/construction worker." In the pamphlet for the October 1960 premier of Hosoe Eikô's 16-millimeter movie *Navel and A-Bomb* (Heso to genbaku) at the Jazz Cinema Experimental Laboratory, there is a short biography of Hijikata under the name "TUTIKATA" (*tsuchikata*) indicating that initially Hijikata may have been drawn to the idea of thinking of himself as a laborer. Hijikata Tatsumi Archive ed., *Hijikata Tatsumi "Butô" shiryôshû dai ippo*, 56.
27. For Genet and Nue, see Kasai Akira, "Hijikata Tatsumi wo kataru: Ishiki no henkaku wo mezashita butôka" [Talking about Hijikata: A Dancer who Aimed to Change Consciousness] in Morishita, *Hijikata Tatsumi no butô*, 63. For "Nero" see Yamada Ippei, *Dansaa* (Ôta Shuppan, 1992), 56. Yamada Ippei danced under the stage name Bishop Yamada.
28. Motofuji was an accomplished dancer in her own right, having placed fourth in an international dance competition in Vienna in 1955. However, there is currently not enough information to say with any certainty how she affected Hijikata's art.

2 FORBIDDEN EROS AND EVADING FORCE: HIJIKATA'S EARLY YEARS

Epigraph: Modified from Zhuangzi, *Wandering on the Way: Early Taoist Tales and Parables of Chuang Tzu,* trans. Victor Mair (Honolulu: University of Hawai'i Press, 1994), 71.

1. Mark Holborn, "Tatsumi Hijikata and the Origins of Butoh," in Ethan Hoffman et al. eds., *Butoh: Dance of the Dark Soul* (New York: Aperature, 1987), 11.
2. Jean Viala and Nourit Masson-Sekine, eds., *Butoh: Shades of Darkness*, (Tokyo: Shufunotomo, 1988), p. 64.

3. Bernice Yeung, "Dancing with the Butoh Masters" *SF Weekly* July 17–23, 2002, p. 14–22.
4. See Gennifer Weisenfeld, *Mavo: Japanese Artists and the Avant-Garde 1905–1931* (Berkeley: University of California Press, 2002).
5. Kuniyoshi Kazuko, *Yume no ishô: Kioku no tsubo* [Costume of Dreams: Receptacle of Memory] (Shinshôkan: 2002), 173–78. Kuniyoshi also asserts that Hijikata must be placed at the end of the line starting with Mavo's Murayama and progressing through Tsuda (185).
6. Kamizawa Kazuo, *Nijûisseiki buyôron* [A Dance Theory for the 21st Century] (Oshukan Shoten, 1995), 232.
7. "Kinen subeki 'wakaki seishin' no bakuhatsu" [A Memorable Explosion of 'Young Spirit'"], *Daily Sports* undated May 1959. Both Kuniyoshi and Kurihara attribute this article to Gôda Nario. See Kuniyoshi, *Yume no ishô*, 182; and Kurihara Nanako, "The Most Remote Thing in the Universe: A Critical Analysis of Hijikata Tatsumi's Butoh Dance." (Ph. D. dissertation, New York University, 1996), 59.
8. "Hyôgenryoku no busoku ga medatsu: Zennihon geijutsu buyô kyôkai dairokukai shinjin buyô kôen" [Sixth Newcomers Dance Recital of the All Japan Art Dance Association: An Insufficiency of Expressive Ability Stands Out] *Tokyo Shimbun* May 25, 1959. In what may have been an oblique reference to Hijikata's dance, the reviewer castigates some dances for being "drowned in conceptual themes" and "top-heavy."
9. Stephen Barber writes that Oikawa Hironobu "believed that it was actually himself who had assembled the essential elements of Ankoku butoh, which Hijikata had then surreptitiously maneuvered out of his grip, in a Genet-like act of thievery." See Barber's *Hijikata: Revolt of the Body* (London: Creation Books, 2005), 28. Barber does not give a source, but interviewed Oikawa on at least one occasion. Certainly, Oikawa was vital to the creation of the new dance form.
10. Except where otherwise noted, all information including the in-depth description on the following pages comes from Gôda Nario, "'Hijikata butô': Sakuhin nôto 2" [Hijikata's Butoh: Notes on the Dances 2], *Asubesutokan Tsûshin* 5 (Oct. 1987), 38–43.
11. For other short summaries, see Motofuji, *Hijikata Tatsumi to tomo ni*, [Together with Hijikata Tatsumi]. (Chikuma Shobô, 1997), 56; and Isozaki Arata, "Bamen—Hijikata Tatsumi" [Scene—Hijikata Tatsumi] *W-NOtation* 2 (July 1985): 87–89.
12. Interview of Ôno Yoshito by author July 12, 2007. There are two photographs of the actual performance (figures 2.3 and 2.10) and ten more taken of a studio performance or rehearsal at the Tsuda Nobutoshi Dance Studio (figures 2.1–2.2, and 2.4–2.9). Additionally, there are four (or possibly five) photos from *Forbidden Colors 2* which may have bearing on *Forbidden Colors* (figures 2.11–2.15), although it is impossible to tell how closely *Forbidden Colors 2* mirrored *Forbidden Colors*. The studio pictures were taken by a photographer sent on assignment with Mishima. In them, Hijikata has sufficiently lengthy hair to indicate that they must have been taken at least one month after the performance. Mishima Yukio (and Ôtsuji Seiji, photographs), "Gendai no muma: *Kinjiki* wo odoru zen'ei buyôdan" (Contemporary Nightmare: An Avant-garde Dance Group Dances *Forbidden Colors*), *Geijutsu Shinchô* (New Currents in Art) 10, no. 9 (Sept. 1959): 130–31. I have not reproduced two of the Ôtsuji photographs because they are nearly identical to figures 2.1 and 2.6. For one of the missing photographs that corresponds to figure 2.6, see Mizohata Toshio ed., *Ôno Kazuo to Hijikata Tatsumi no 60 nendai* [Kazuo Ohno and Tatsumi Hijikata in the 1960s] (Yokohama: BankART 1929, 2005), 18.
13. In Mishima's novel, the seduction scenes are generally of two types. One is a relationship based upon the satisfaction of mutual sexual desires: Two gay men of equal (or

mutually unknown) economic status meet in a public place and after sizing each other up proceed to some private place to consummate their relationship (for example, Eichan and Yuichi, 62–63—full citation at the end of the note). The other is an exchange of sex for economic benefits: An obviously rich and powerful older male makes an overt proposition to a younger man who accepts it, knowing that he will be showered with gifts and may have opportunities for employment or social advancement (Kawada and Yuichi, 253–54). There is also a scene which is more properly categorized as a rape in which an American forces himself on Yuichi (312–13). As we shall see, none of these scenes resembles Hijikata's version of *Forbidden Colors*, although a combination of the economic one and the rape may be close. Mishima Yukio, *Forbidden Colors*, trans. Alfred H. Marks, (New York: Berkeley Medallion Books, 1974). Note that Norbert Mauk reads the relationship between the man and the boy as Hijikata's attempt to distill the unequal relationship between the young and beautiful Yuichi and the older and ugly Shunsuke. Norbert Mauk, "Body Sculptures in Space: Butoh Retains Its Aesthetic Relevancy," *Ballet international/Tanz aktuell* 8 (Aug./Sept. 1994): 57.

14. In the world of butoh, Ôno Yoshito (the son of Ôno Kazuo) is often known by his given name rather than his family name (which is the usual practice in Japan) in order to avoid confusing him with his father.
15. Motofuji, *Hijikata Tatsumi to tomo ni*, 56.
16. Perhaps to mitigate the outrage that might result from a description of this dance, both Motofuji and Yoshito continually reminded people that the chicken had not actually died, but had gone on to live a productive egg-laying life. It seems that in the indigence of the postwar, killing the chicken was beyond the financial means of the participants. See Motofuji Akiko and Ôno Yoshito, "Otto toshite no Hijikata, shi toshite no Hijikata" [Hijikata as Husband; Hijikata as Teacher], *Geijutsu Shinchô* 49, no. 579 (March 1998): 19.
17. See Kurihara, "The Most Remote Thing in the Universe," 57.
18. Yoshida Yoshie, "Sengo zen'ei shoen aragoto jûhachiban: nikutai no hanran no yochô" [The Best of the Postwar Avant-garde Connections: Portents of the Rebellion of the Body], *Bijutsu techô* 24, no. 358 (Sept. 1971): 227.
19. My thinking here is informed by Benjamin's notion of shock as both a characteristic of modern life, and a technique which artists use to break through a consciousness desensitized by shock. Walter Benjamin, "On Some Motifs in Baudelaire," in Hannah Arendt ed., *Illuminations*, trans. Harry Zohn. (New York: Shocken, 1969), 155–200.
20. Gôda Nario, "'Hijikata butô': Sakuhin nôto 2," 40.
21. Benjamin, "On Some Motifs in Baudelaire," 162–63.
22. It is likely that Hijikata was aware of the larger turn away from narrative in the dance world, although, owing to the relative difficulty of reproducing a performance as opposed to a painting, he was probably more familiar with movements in literature and painting then he was in developments in performance. In any case, I hold that larger movements are always refracted through local sources, so as I trace Hijikata's turn from narrative, I shall primarily concern myself with what was happening in Japan and among his colleagues. For the turn away from narrative in dance, see Roger Copeland, *Merce Cunningham: the Modernizing of Modern Dance* (New York: Routledge, 2004); and Sally Banes, *Democracy's Body: Judson Dance Theater, 1962–1964* (Ann Arbor, MI: UMI Research Press, 1983).
23. Jooss's *Green Table* depicts diplomats declaring war, then aspects of the war such as: families parting, the war itself, the wounded survivors, and then the diplomats again posturing with no regard for the effects of the war. Kuniyoshi Kazuko makes a similar point in connecting butoh to previous forms of dance in arguing that butoh is like ballet in her

"Butôfu shiron: Hijikata Tatsumi no shiryô kara" (An Essay on the Butoh-fu: From the Scrap Books of Tatsumi Hijikata), *InterCommunication* 29 (Summer 1999): 85.
24. Oikawa had trained in mime in France, and was the founder of the Artaud-kan (Artaud Studio). For Oikawa teaching Hijikata, Ôno, and Yoshito mime, see: Oikawa Hironobu, "Naimen no kattô" [内面の葛藤], Hironobu Oikawa [Blog], July 28, 2007 (http://scorpio-oik.blogspot.com/2007/07/blog-post_28.html) and "1956–60 nen no Hijikata Tatsumi 3—Zushi Akiko and Ohara Atsushi" [1956–60年の土方巽(3)—図師明子と小原庄] Hironobu Oikawa [Blog], August 18, 2007 (http://scorpio-oik.blogspot.com/2007/08/blog-post_5650.html) (accessed May 31, 2011).
25. Donald Richie writes of an unnamed scholar who, on seeing Hijikata, was reminded of Harald Kreutzberg who had come to Japan in 1934 during the interwar years. Hijikata would have been six at the time, so it's unlikely he could have absorbed anything from that visit (although Ôno saw Kreutzberg dance), but there may be more to the connection than just two shaved heads, for Kreutzberg also studied with German Expressionist pioneers Laban and Wigman. Donald Richie, *Japanese Portraits: Pictures of Different People* (North Clarendon, VT: Tuttle Publishing, 2006), 111. For Kreutzberg's visit, see Kuniyoshi Kazuko, *Yume no ishô*, 203. Miryam Sas explores other possible parallels between butoh and Kreutzberg such as slowness, informality, precise movements executed in a casual manner, detailed hand movements, convulsions, and gender fluidity. See Miryam Sas, "Hands, Lines, Acts: Butoh and Surrealism" *Qui Parle* 13, no. 2 (Spring/Summer 2003): 26–27.
26. The sentence literally reads, "I opened the throat that first danced my self portrait in a dance studio in Nakano, and started crying," with the "first danced . . . Nakano" clause directly modifying "throat," but this is possibly a typo.
27. *HTZ* 1: 190; *WB* 39.
28. The conflation of the father and the chicken Hijikata slept with in the opening lines may be an oblique indication that Hijikata was sexually abused by his father in a similar transaction, but we have no independent way of corroborating this.
29. "Kinen subeki 'wakaki seishin' no bakuhatsu" and Gôda Nario, "Ankoku Butô ni tsuite" in Hanaga Mitsutoshi ed., *Butô: Nikutai no suriarisutotachi* (Butoh: Surrealists of the Body) (Gendai Shokan, 1983). The unpaginated essay is located at the end of the book. It is reprinted in Gôda Nario, "Sen kyûhyaku gojû kyû nen go gatsu nijûyon nichi—Hijikata Tatsumi ga shitto wo kaishi shita hi" [May 24, 1959—the Day that Hijikata Tatsumi Began to Run], *W-Notation* [Daburu nôtêshon] 2 (July 1985): 90. See also the translation "On Ankoku Butoh" in Susan Blakely Klein, *Ankoku Butoh: the Premodern and Postmodern Influences on the Dance of Utter Darkness* (Ithaca, NY: East Asia Program, Cornell University, 1988), 83.
30. Susan Blakely Klein pointed out that this method of "suffocation" might have been useful for keeping the chicken alive, given the financial constraints on the performers, because it may have served to shield the chicken from full view of the audience. (Personal communication)
31. Much later in his career under the influence of surrealism, Hijikata would exploit the gap between what might be called the signifier and the signified, and try to convey narratives with a seemingly arbitrary set of movements, but *Forbidden Colors* stems from a time before Hijikata's full encounter with surrealism.
32. Gôda, "'Hijikata butô': Sakuhin nôto 2," 40.
33. Gôda, "'Hijikata butô': Sakuhin nôto 2," 40–41.
34. I am following Gramsci and Bourdieu here in thinking about social forces. See for example, Antonio Gramsci, *Selections from the Prison Notebooks* (New York: International,

1971), specifically 42–43. Pierre Bourdieu, *The Logic of Practice*, trans. Richard Nice (Stanford: Stanford University Press, 1990).
35. Earlier in the essay, Hijikata professed an interest in "hard dance." "Fourteen years ago, I became affiliated with a woman dance teacher in my hometown.... I hesitantly asked her about [foreign] dance, while at the same time thinking I would just quit if it were not what I wanted. 'My dance is German dance.' I immediately took steps to become a disciple, figuring that since Germany was hard, its dance too would be hard." Hijikata Tatsumi, *HTZ*, 1: 187; *WB* 36.
36. Michel Foucault, *The History of Sexuality: An Introduction* (New York: Vintage, 1990), 78.
37. Of course, heterosexuality is also marked by pervasive social structures, and identifying same-sex eroticism as also so marked in no way means that it is more or less natural or social than heterosexuality. Given Hijikata's appropriation from Genet, it should not be surprising that Hijikata concluded this. Kate Millett writes, "Together with the rest of his prose fiction, [the novels *Our Lady of the Flowers* and *Thief's Journal*] constitute a painstaking exegesis of the barbarian vassalage of the sexual orders, the power structure of 'masculine' and 'feminine' as revealed by a homosexual, criminal world that mimics with brutal frankness the bourgeois heterosexual society.... In this way, the explication of the homosexual code becomes a satire on the heterosexual one." *Sexual Politics* (Champaign Urbana: University of Illinois Press, 2000), 18–19.
38. See for example, Johan Galtung's idea of "cultural violence" in *Peace by Peaceful Means: Peace and Conflict, Development and Civilization* (London: Sage Publications, 1996), 196–210; and Marc Pilisuk and Jennifer Tennant, "The Hidden Structure of Violence," *ReVision* 20 (Fall 1997): 25–31. For a related but different view of the issue of systemic violence, see the argument of Maria Mies that "the exploitation and oppression of women are not just accidental phenomena but are intrinsic parts of the system," in her *Patriarchy and Accumulation on a World Scale: Woman in the International Division of Labour* (New York: Zed Books, 1998), viii, ix, and 44–58.
39. David R. Roediger, *The Wages of Whiteness: Race and the Making of the American Working Class*, revised ed., (New York: Verso, 1999), 12–13.
40. See also, for example, Naoki Sakai, "Two Negations: The Fear of Being Excluded and the Logic of Self-Esteem" in Richard F. Calichman ed., *Contemporary Japanese Thought* (New York: Columbia University Press, 2005), 171. Sakai describes "humiliated [Taiwanese who] regain their honor and self-esteem by displacing and externalizing the aggressivity of the nation as a whole onto outside victims" and thus "volunteer" to die for the Japanese empire. Although Hijikata would give us no reason to take our reading of this specific dance this far (because he has in mind the workings of broader male-male sexual or criminal relationships), we could line the characters in the dance up in terms of Sakai's essay as the Man = Japanese person, the Young Man = Humiliated Taiwanese Person, and the Chicken = (South) Asian Victim of Taiwanese person as a means for Taiwanese to gain entry into the classification of Japanese through voluntary army service.
41. Eguchi Baku, Kageyasu Masao, Yamada Gorô, "Sekusu buyô nitsuite," *Gendai Buyô* 7, no. 7 (July 1959): 7. They singled out both the depiction of same-sex eroticism and the simulation of female masturbation on stage, but it is not clear who simulated female masturbation on stage.
42. It is unclear whether the actual impetus for leaving the association was Hijikata's dance or Tsuda's anti-Association articles in a pamphlet he sponsored for the 20 Female Avant-gardists Society. Regardless, subsequently, the rumor arose that Hijikata and

his cohorts were expelled from the association, but this is once again myth-making at work. See Kuniyoshi Kazuko, *Yume no ishô*, 180

43. Mishima Yukio was a successful novelist and public intellectual who eventually attracted wide fame by committing suicide in front of the Japanese Self-Defense Forces in an attempt to motivate them to stage a coup and seize control of the country and restore the emperor to power.

44. Some sources have it that Hijikata was already well acquainted with Mishima, having waited where he knew Mishima would pass and then introduced himself, but Mishima does not write as though he knew Hijikata in his newspaper article about *Forbidden Colors*. See Yamada Ippei, *Dansaa* (Ôta Shuppan, 1992), 199, 56.

45. See for example, Tanemura Suehiro, "Shizuka na daisôdô: Hijikata Tatsumi to bijutsukatachi" [A Quiet Commotion: Hijikata Tatsumi and the Artists], *Geijutsu Shinchô* 49, no. 3 (March 1998): 64.

46. Looking at Hijikata and Mishima's relationship with the hindsight of Mishima's (1968) later support for a private fascist army, and his subsequent suicide in front of the Japanese Self-Defense Forces (in a failed attempt to incite a revolt against the postwar constitution which stripped the emperor of power) may make it hard to understand the role Mishima played in Hijikata's life at the time. It may incline us to see Mishima as a purely reactionary influence on Hijikata, but the reality is more complicated. Mishima described his own role in improvisational exercises at the studio. The dancers would ask him to suggest topics from which they would improvise dances. He writes that he suggested Dali's "Melting Clock" and the "Marquis de Sade" (Mishima, "Gendai no muma,"128). The anecdote shows how Mishima initially functioned for the dancers, for along with being a potent resource for publicity and innumerable artistic connections, Mishima was a source of new (nonclassical) motifs and ideas for the dancers, and was a strong supporter of the avant-garde. Subsequently, by 1964, Mishima's right-wing tendencies were somewhat solidified. He was writing plays for the theater company, Bungaku-za (Literary-Theater), and wrote a play considered by some to be an anticommunist play, *Yorokobi no Koto* (The Joyful Koto). Then, in 1966, with the publication of *Eirei no koe* (Voices of the Heroic Dead)—in which he lamented the fact that the emperor had been forced to recant his divinity after the war—Mishima's journey to the right was clear to everyone. See Henry Scott Stokes, *The Life and Death of Yukio Mishima*, revised ed., (New York: Farrar, Straus and Giroux, 1995), 175–76, 198–203; and Brian Powell, *Japan's Modern Theatre: A Century of Change and Continuity* (London: Japan Library, 2002), 169–71.

47. Morishita Takashi, "Hijikata Tatsumi no butô sôzô no hôhô wo megutte—butô no honshitsu to sakubu ni okeru shururaarisumu no shisô to hôhô" [In Search of Hijikata Tatsumi's Creative Method: The Essence of Butoh and Surrealistic Methods and Thought in the Choreographic Process], in *Jenetikku âkavu enjin—dejitaru no mori de odoru Hijikata Tatsumi* [Genetic Archive Engine: Hijikata Tatsumi Dancing in a Digital Forest] (Keio University Research Center for the Arts and Art Administration, 2000), 51.

48. This set of titles may be confusing, but Hijikata routinely named the performance, the separate dances in the performance, the troupe of dancers that was to dance, and sometimes even the group that was analogous to a production company. It is similar to going to the evening of performance entitled As I Was Saying to see the Bill T. Jones Arnie Zane Dance Company perform the dance *Chaconne* and noting the name of the production company. However, in Hijikata's case, it appears that he did not maintain continuity in the practice. There are cases of the name of the dance troupe changing even though all the participants remained the same, and analogous cases in which the name of the troupe stays the same despite turnover in dancers. This has given rise to

some confusion about the names of dances and the names of performances. In the current case, the "650 EXPERIENCE Society" was either the collective name of the six artists whose work appeared on the program, or the name of a temporary production entity that was not actually legally incorporated. The name of the evening of entertainment was "Six Avant-gardists: September 5th 6:00 Gathering." In order to maintain as much clarity as possible, I enclose performance titles in double quotation marks, render individual dance names in italics, enclose scene or act names in single quotation marks, and leave dance troupe or production company names unmarked but capitalized. Incidentally, the flyers, tickets, and programs uniformly print "experience" in English and in capital letters, so I retain that usage. The same applies to the Hijikata Tatsumi DANCE EXPERIENCE Gathering referenced later in this chapter.

49. All information unless otherwise noted comes from Gôda, "'Hijikata butô': Sakuhin nôto 3," 40–46.
50. Ôno Kazuo, *Ôno Kazuo butôfu: goten, sora wo tobu* [The Palace Soars through the Sky: Kazuo Ôno on Butoh] (Shinchôsha, 1998), 208.
51. Yoshito says that Ôno reprised this scene as the opening scene in the later *Admiring La Argentina*. See, *Ôno Kazuo: Tamashii no kate* [Ôno Kazuo: Food for the Soul] (Firumu Aato Sha, 1999), 217; translated in Ohno Kazuo, and Ohno Yoshito, *Kazuo Ohno's World from Without and Within*, introduced by Mizohata Toshio and translated by John Barrett (Middletown, CT: Wesleyan University Press, 2004), 150.
52. Of course, if Hijikata intended the essay as an aid to understanding his dance, then it means that he had abandoned the very thing which Gôda found most radical about *Forbidden Colors*—the refusal to use any aids to help out the audience and the requirement that they strain to understand what was happening. Whatever the case about his intentions for this essay, he was certainly being partially obfuscatory.
53. Hijikata Tatsumi Archive ed., *Hijikata Tatsumi "Butô" shiryôshû dai ippo*, [Hijikata Tatsumi "BUTOH" Materials] (Keio University Research Center for the Arts and Arts Administration, 2004), 56.
54. Gôda, "'Hijikata butô': Sakuhin nôto 4," 25.
55. Hijikata Tatsumi Archive ed., *Hijikata Tatsumi "Butô" shiryôshû dai ippo*, 56.
56. Hijikata may have been moved to articulate this distinction because of his friendship with gay men such as Mishima and Donald Richie, who would likely have been troubled by the equation of same-sex eroticism and nonconsensual sex.
57. Gôda, "'Hijikata butô': Sakuhin nôto 4," 25.
58. In Ôno's 1977 *Admiring La Argentina*, Divine dies and then is resurrected as a young girl with a yellow flower in her hair. This is seen as the fulfillment of the lifelong wish of the young Divine (Culafroy) to become a girl. As the first act of *Forbidden Colors 2* was choreographed by Hijikata and reprised by Ôno, the argument is that rather than Ôno playing both the part of the wizened Divine and also the part of the young girl, in 1959, Ôno played the part of Divine, and his son Yoshito played the part of the resurrected boy (Gôda, "'Hijikata butô': Sakuhin nôto 3," 43). See also Ôno Yoshito's account of "Admiring La Argentina" in Ôno Yoshito ed., *Ôno Kazuo: Tamashii no kate* 216–34; translated in Ohno Kazuo, and Ohno Yoshito, *Kazuo Ôno's World from within and without*, 143–72.
59. Gôda, "'Hijikata butô': Sakuhin nôto 4," 27. However, Gôda raises the possibility that the darkness of the original *Forbidden Colors* was not intentional, but rather the result of squeamishness on the part of Matsuzaki Kunio—the person in charge of the lighting (28). Motofuji does not indicate that Hijikata was dissatisfied with the lighting or the performance. She says that after the performance she found Hijikata petting a chicken and smiling with satisfaction. Motofuji, *Hijikata Tatsumi to tomo ni*, 59.

Yoshida says that Hijikata yelled for the lighting designer to cut the lights in *Forbidden Colors*. Yoshida, "Sengo zen'ei shoen aragoto jûhachiban," 227.
60. Gôda, "'Hijikata butô': Sakuhin nôto 4," 24.
61. Hijikata Tatsumi Archive ed., *Hijikata Tatsumi "Butô" shiryôshû dai ippo*, 56. Gôda points out that the dancers were high school students at a night school where Hijikata was teaching (Gôda, "'Hijikata butô': Sakuhin nôto 3," 44).
62. "Torture paintings" appear to be paintings that depict sadomasochistic themes, so what it means for a dancer to be a "temporal torture painting" is less than clear, but given the tenor of the rest of the essay, a temporal torture painting may be a depiction of sadomasochistic activities over time or a three-dimensional bodily depiction of sadomasochism. A simple web search for the term "torture paintings" (*seme-e*) yields thousands of websites devoted to sadomasochism.
63. Hijikata Tatsumi Archive ed., *Hijikata Tatsumi "Butô" shiryôshû dai ippo*, 56.
64. There was a wider movement in the world of American modern dance away from narrative and psychological depth and towards abstraction, chance processes, and everyday movements. It was spurred by the activities of Merce Cunningham and John Cage, and developed in tandem with the rebellion against abstract impressionism by Robert Rauschenberg and Jasper Johns, who designed sets for Cunningham. Both Mishima and Hijikata were likely aware of that movement to some degree, but larger artistic discourses usually get translated through local sources (and particularly so in the case of people such as Hijikata who were widely read, but not widely traveled and only had competence in a single language). If that is the case, published essays have to serve as a source for how they understood larger movements. For more on Cunningham and the wider revolt against narrative in modern dance see, Roger Copeland, *Merce Cunningham*, Chapter 3 "Beyond the Ethos of Abstract Expressionism."
65. Mishima, "Gendai no muma," 129.
66. Mishima, "Gendai no muma," 130.
67. Mishima, "Gendai no muma," 130–1.
68. Mishima, "Gendai no muma," 129.
69. The photographer Hosoe Eikô had seen one of Hijikata's previous dances and wanted to shoot Hijikata and his dancers. Characteristically, rather than letting Hosoe make an independent work of art, Hijikata convinced Hosoe to publish his photos as the program for Hijikata's next dance concert in a kind of homage to Hijikata.
70. Hijikata Tatsumi, *HTZ*, 1: 187; *WB* 36.
71. Of course something like congenital Minamata disease blurs the distinction I take Hijikata to have been making.
72. *HTZ* 1: 188; *WB* 38.
73. Production here is *seisan*—which could also be "manufacturing," the creation of materials, one's occupation, childbirth. The repudiation of production must be related to Sas writing that elsewhere Hijikata "found th[e] very idea of 'usefulness' suspect." Miryam Sas, "Hands, Lines, Acts," 23.
74. William M. Tsutsui, *Manufacturing Ideology: Scientific Management in Twentieth-Century Japan* (Princeton, NJ: Princeton University Press, 2001), 133–51.
75. *HTZ* 1: 201; *WB* 46. Here in Hijikata's essay and in the essay of Mishima's considered later, the term "actuality" was taken directly from the English, rendered in Japanese as *akuchuariti*. For more on the use of this term and the related term *jitsuzai*, see Sas, *Fault Lines: Cultural Memory and Japanese Surrealism* (Stanford: Stanford University Press, 1999), 112, 169–70; and Sas, "Hands, Lines, Acts," 20–23. Takiguchi and Shibusawa (both cited later) use the *jitsuzai*, which Sas writes "can be defined as real

existence, actual being, essence, actuality, entity, or (in philosophy) absolute being," *Fault Lines*, 112.
76. *HTZ* 1: 190; *WB* 39.
77. *HTZ* 1: 191; *WB* 39–40.
78. Nishi Tetsuo, "Kore ga makoto no 'geijutsu' da: Gaitô ni odori deta ankoku buyô [This is Real 'Art': The Dance of Darkness Takes to the Streets] *Kokusai Shashin Jôhô* 34, no. 10 (Oct. 1960): 62–63.
79. *HTZ* 1: 192; *WB* 40–41.
80. Nishi, "Kore ga makoto no geijutsu," 64.
81. *HTZ* 1: 192; *WB* 41.
82. Even when, in the postwar period, the Kyoto School philosophers suffered a decline in reputation because they were perceived as having been complicit in the war effort, it is a testament to how thoroughly their philosophies penetrated the core of Japanese cultural life that people who had not even read them were still concerned with the concept of experience.
83. Amagasaki Akira, *Geijutsu toshite no shintai* [Body as Art] (Keisou shobô, 1988), 2, 19.
84. Amagasaki Akira, *Media no Genzai* [The Current State of Media] (Perikansha, 1991), 216.
85. Jean Genet, *Our Lady of the Flowers* (New York: Grove Press, 1963), 121. Sartre emphasized the concept of "experience" in discussing Genet's work. See, his assertion that Genet kills his hero "in the name of... experience." Jean Paul Sartre, *Saint Genet: Actor and Martyr,* trans. Bernard Frechtman (New York: George Braziller, 1963), 455.
86. See Robert H. Sharf, "Experience" in Mark Taylor ed., *Critical Terms for Religious Studies* (Chicago: University of Chicago Press, 1998), 94–116.
87. Georges Bataille, *Eroticism: Death and Sensuality,* trans. Mary Dalwood (San Francisco: City Lights Books, 1986), 30.
88. See Nishida Kitarô, *Zen no kenkyû* (Iwanami Shoten, 2001), trans. Masao Abe and Christopher Ives as *An Inquiry into the Good* (New Haven, CT: Yale University Press, 1990), 16.
89. Nishida, *Zen no kenkyû,* 13.
90. Nishida, *Zen no kenkyû,* 16.
91. See Motofuji, *Hijikata Tatsumi to tomo ni,* 89. Taking into account the general lack of distinction between singular and plural nouns in the Japanese language, and despite the fact that the "experience" of the title (650 EXPERIENCE kai) was given in English, Kurihara highlights the number of experiences available by rewording the title as "650 Experiences Recital." The Japanese *kai* can meaning of "meeting," and by extension "society." Kurihara's "recital" plays on the significance of a "meeting," in this case, a dance performance. Kurihara Nanako, "Hijikata Tatsumi: The Words of Butoh," *TDR* 44.1, (Spring 2000): 16.
92. Takiguchi Shûzô. "Tachiai-nin no kotoba" [Words of a Witness], in Morishita, *Hijikata Tatsumi no butô: Nikutai no shururearisumu, shintai no ontorojî* [Tatsumi Hijikata's Butoh: Surrealism of the Flesh, Ontology of the "Body"] (Okamoto Tarô Museum of Art and Keio University Research Center for the Arts and Arts Administration, 2004), 19.
93. Morishita, *Hijikata Tatsumi no butô,* 25. The pamphlet was printed in Japanese and English, and in the English, *senkensha* and *taikensha* were translated as "Senior Experimenter," and "Experimenters," respectively. It is not clear where the translation of *taiken* as "experiment" came from, but there may be a connection between experimental works and having an experience. Perhaps the translator assumed that the standard English word for one who experiences is "experimenter." Those with a background in

Japanese philosophy will recognize that *taiken*, one of two possible words in Japanese (the other being *keiken*) for "experience," contains within it the Chinese ideograph for "body," and usually is used for a more corporeal notion of experience which maps very roughly onto the usage of *erleibnis* and *erhfarung*. Designating Ôno as the *senkensha* could be Hijikata's way of recognizing that Ôno was already doing something like what Hijikata was attempting before Hijikata began to dance, or it could be Hijikata's way of showing Ôno respect. See Kurihara, "The Most Remote Thing," 46.

94. See the poster in Akita Senshû Museum of Art ed., *Hijikata Tatsumi ten: Kaze no metamorufôze* [Hijikata Tatsumi Exhibition: Metamorphosis of the Wind] (Akita: Akita Senshû Museum of Art, 1991), 38.
95. Gôda, "'Hijikata butô': Sakuhin nôto 1," 33.
96. For Abe and the documentary arts movement and avant-garde reportage, see Margaret S. Key, *Truth from a Lie: Documentary, Detection, and Reflexivity in Abe Kôbô's Realist Project* (Lanham, MD: Lexington Books, 2011), 17–19 and Chapter 1. For Sakaguchi and Tamura, see John W. Dower, *Embracing Defeat: Japan in the Wake of World War II* (New York: W. W. Norton /New Press, 1999), 155–58; and Douglas Slaymaker, *The Body in Postwar Japanese Fiction* (New York: Routledge, 2004), 43–60.
97. This and all subsequent quotations in this and the next paragraph taken from Mishima Yukio, "Kiki no buyô" [Crisis Dance] in Morishita, *Hijikata Tatsumi no butô*, 16. Full or partial translations are also available in Mishima Yukio, "Kiki no Buyou: Dance of Crisis," trans. Kobata Kazue, in Ethan Hoffman et al., *Butoh: Dance of the Dark Soul*, 123; and Sas, *Fault Lines*, 169. Again, Mishima's 'actuality' here is the English word rendered as *akuchuariti*.
98. We might expect this from someone who made his living using language, but Mishima was no stranger to being suspicious of the language he used and not at all above romanticizing the body as a way past the difficulties he saw in language.
99. Sas, *Fault Lines*, 169–70.
100. Shibusawa Tatsuhiko, "Hansai no buyôka" in Morishita, *Hijikata Tatsumi no butô*, 17.
101. Shu Kuge, "The Impenetrable Surface of Japanese Writing: Mishima Reads Ôgai" (paper presented at the annual meeting of the Association for Japanese Literary Studies, Dartmouth College, Hanover, NH, Oct. 9, 2005).
102. This will become obvious when we consider Hijikata's concept of the "clouded body" (chapter 7) and the "emaciated body" (Epilogue).
103. Yagawa Sumiko, "Saisei no tame no tainai kaiki: Hijikata Tatsumi to ankoku butô-ha," [Returning to the Womb in Order to be Reborn: Hijikata Tatsumi and the Dance of Darkness School] *Shinfujin* 19, no. 1 (Jan. 1964): 99. Translation taken from Kurihara, "The Most Remote thing in the Universe," 36–37.
104. *The Songs of Maldoror* (translated into Japanese in 1960) was written by the Uruguayan-born French poet Lautréamont (real name, Isadore Lucien Ducasse, 1846–1870). Compte de Lautréamont, *Maldoror and Poems,* trans. Paul Knight (London: Penguin, 1988). Although, Lautréamont died in relative obscurity, his works were discovered by the surrealists and hailed as important precursors to their experiments. Given the incomplete description of this performance, it is not obvious what ties the dance to Lautréamont's work.
105. See Mizutani Isao, "Futatsu no teigon: butai no kosshi" [Two Suggestions: The Framework of the Stage], *Bijutsu techô* 38, no. 561 (May 1986): 58–59; and Mizutani Isao, "Genzai to shorijo toshite no kyanbasu, soshite butai" [The Disposal Place of Original Sin as Canvas and Stage] in Morishita, *Hijikata Tatsumi no butô*, 40–41.
106. Motofuji Akiko and Ôno Yoshito, "Otto toshite no Hijikata, shi toshite no Hijikata," 21.

107. Popping is a technique of repeatedly contracting and relaxing muscles producing jerky noncontinuous movements called "pops."
108. Interviews with the author, July 12, 2007, and Sept. 15, 2009.
109. Nishi, "Kore ga makoto no 'geijutsu' da," 62–63.
110. Gôda reports that in *Forbidden Colors 2*, the heads of the young men were wrapped in black cloth, and they wore black swimming trunks. They extended their right arms, with clenched fists, out in front of themselves and somewhat down, and grabbed their right elbows with their left hands (similar to a pose in Kurt Jooss's *Green Table*, or to how children might make a trunk when playing a make-believe elephant). They then used their extended arms as battering rams. It is not clear whether Gôda was conflating *Dark Body* and *Forbidden Colors 2* or whether Hijikata recycled the motif from one dance to the next. Gôda, "'Hijikata butô': Sakuhin nôto 3," 43–44. (In his 2007 dance *Mu* at the Japan Society, Yoshito demonstrated the arm movement along with many others of his career.)
111. Hijikata Tatsumi Archive ed., *Hijikata Tatsumi "Butô" shiryôshû dai ippo*, 56.
112. See respectively "Waratte nigeru kaze" [Wind that Laughs and Flees Away], "Hijikata Tatsumi shikan" [My Personal View of Hijikata], and "Hijikata Tatsumi wo kataru" [Speaking about Hijikata Tatsumi], collected in Tanemura Suehiro, *Hijikata Tatsumi no hô e: Nikutai no rokujûnendai* [A la Maison de Hijikata Tatsumi: the Body in the 60's] (Kawade Shobô, 2001), 102–3, 143, 14. "Waratte nigeru kaze" was originally in *Yurîka* (Eureka) 18 no. 3 (March 1986): 56–59; and "Hijikata Tatsumi shikan" was originally in Tanemura Suehiro et al. eds., *Hijikata Tatsumi butô taikan: Kasabuta to Kyarameru* [Hijikata Tatsumi: Three Decades of Butoh Experiment] (Yûshisha, 1993), 9–13.
113. Tanemuara, "Waratte nigeru kaze," 57.
114. Takeda Ken'ichi, "Yôzumi to natta nikutai to shintai no rika," 108.

3 A STORY OF DANCES THAT SUSTAIN ENIGMA: SIMULTANEOUS DISPLAY AND SALE OF THE DANCERS

Epigraph: Gilles Deleuze and Félix Guattari, *Anti-Oedipus: Capitalism and Schizophrenia*, trans. Robert Hurley, Mark Seem, and Helen R. Lane (Minneapolis: University of Minnesota Press, 1983), 1.

1. Mishima Yukio, "Junsui to wa" [What is Purity] in Morishita, *Hijikata Tatsumi no butô: Nikutai no shururearisumu, shintai no ontorojî* [Tatsumi Hijikata's Butoh: Surrealism of the Flesh, Ontology of the "Body"]. (Okamoto Tarô Museum of Art and Keio University Research Center for the Arts and Arts Administration, 2004), 18.
2. He used the same word, *sôgô*, as Mishima. Takiguchi Shûzô, "Tachiai-nin no kotoba," in Morishita, *Hijikata Tatsumi no butô*, 18–19.
3. We might say that Takiguchi sees the evening of works as providing an occasion in which each subsequent artwork causes a reevaluation of all prior artworks à la T. S. Eliot. In this case, Takiguchi understands the interpretive process as a real-time near-instantaneous phenomena, which echoes Eliot's longer process (by which each literary work causes a reevaluation of prior literary works). The viewer carries the memory of the prior work(s) and uses that memory to evaluate the current work, and also uses the current work to reevaluate the prior work(s). This takes place over the course of an evening rather than over days, weeks, months, or years. For a concise overview of

Eliot, see Jean-Michel Rabaté, *The Ghosts of Modernity* (Gainesville, FL: University of Florida Press, 1996), xi–xiii.
4. Sas, *Fault Lines: Cultural Memory and Japanese Surrealism* (Stanford: Stanford University Press, 1999), 211.
5. Sas, *Fault Lines*, 211. See also Hosea Hirata's discussion of Nishiwaki Junzaburô's use of these same formulations by Lautrêamont and Breton. Hosea Hirata, *The Poetry and Poetics of Nishiwaki Juzaburô* (Princeton: Princeton University Press, 1993), 151–52.
6. Sas, *Fault Lines*, 119.
7. For the idea of the spark between two realities, see Hirata, *The Poetry and Poetics of Nishiwaki Juzaburô*, 152.
8. Takiguchi, "Tachiai-nin no kotoba," 19.
9. Shibusawa Tatsuhiko, "Zen-ei to sukyandaru" [Avant-garde and Scandal] in Morishita, *Hijikata Tatsumi no butô*, 19.
10. My thinking here again owes much to Sas. She uses a combination of Freudian and Benjaminian terms to articulate a way to think of influence in terms of a collective cultural memory which experiences various shocks, and then must deal with them. Sas is primarily concerned with cross-cultural shocks, but due to the tenor of the time, one must see the intra-artistic activities of this time as also conforming to this model. See Sas, *Fault Lines*, 37–44.
11. Yoshimura Masanobu, "Haireveru na supekutoru" [High Level Specter] *Bijutsu Teichô* 38, no. 561 (May 1986): 56–57.
12. The use of plaster of Paris gradually evolved into the white face and body paint which came to characterize butoh. See the longer discussion in chapter 6.
13. This is a tentative reading of 兎口立男. The context makes it seem as if this is a name, so I have transliterated rather than translated. No one knows the correct reading, although the first two characters will come up in Hijikata's writings again in a context in which it is obvious that he intends them to mean "harelip" (*mitsukuchi*).
14. Haniya Yutaka, "Do to sei no rizumu" [The Rhythm of Motion and Stillness], *Sekai* no. 200 (Aug. 1962): 386.
15. Akasegawa Genpei, "Namaniku de tsutsunda konpyutâ" [Computer Wrapped in Flesh], *Geijutsu Shinchô* 49, no. 579 (March 1998): 46–47. See also Akasegawa Genpei, "Asubesutokan wo meguru" [Encountering Asbestos Hall], *Shingeki* 33, no. 396 (March 1986): 36.
16. See Haniya Yutaka, "Tainai meisô nitsuite," [On Womb Meditation], *Shingeki* 24, no. 292 (Aug. 1977): 18; Motofuji, *Hijikata Tatsumi to tomo ni* [Together with Hijikata Tatsumi] (Chikuma Shobô: 1997), 115–17; and Akasegawa Genpei, "Namaniku de tsutsunda konpyutâ," 46–47.
17. Motofuji, *Hijikata Tatsumi to tomo ni*, 115.
18. The information for this account is taken from two sources. Kazakura Shô, "Haikei Hijikata Tatsumi-sama"[Dear Mr. Hijikata Tatsumi] *Asubesutokan Tsûshin*, 4 (July 1987): 34–37; 6 (Jan. 1988): 24–27. See also, Ichikawa Miyabi, "Nikutai no busshitsu-sei, busshitsu no nikutaisei" [Materiality of the Body; Bodilyness of Material] *Bijutsu techô* 38, no. 561 (May 1986): 28–29.
19. For a possible modification of this theme, see the description later in this chapter of the tube duet that Hijikata choreographed for *Rose-colored Dance*.
20. Emmanuel Levinas, *Time and the Other*, trans. Richard A. Cohen (Pittsburgh: Duquesne University Press, 1987), 69.
21. Ichikawa Miyabi, "Nikutai no busshitsusei," 29.
22. For more on the *objet* and its uses by the neo-Dada artists, see William Marotti, "Political Aesthetics: Activism, Everyday Life, and Art's Object in 1960's Japan," *Inter-*

Asia Cultural Studies 7, no. 4 (2006): 610, where Marotti describes an *objet* as an object that "was put under a kind of radical scrutiny" or "interrogated like a criminal."
23. Ichikawa Miyabi, "Hangidaitokan," in Keio University Center for the Arts and Arts Administration and Hijikata Tatsumi Memorial Archive eds., *Shiki no tame no nijû-nanaban* [Twenty-seven Nights for Four Seasons] (Keio University Center for the Arts and Arts Administration, 1998), 52.
24. Iimura originally issued a shorter roughly 10-minute version. Stephen Barber outlines the various editing techniques that Iimura used when making this and the subsequent super-8 film for *Rose-colored Dance*. This should alert us to the fact that the original film was never intended as a recording of the dance per se, but rather as an artwork in its own right. See Barber, "Tokyo's Urban and Sexual Transformations: Performance Art and Digital Cultures," in Fran Lloyd ed., *Consuming Bodies: Sex and Contemporary Japanese Art* (London: Reaktion Books, 2002), 171. Iimura then issued a 19-minute version with footage restored. This version includes inter-titles which seek to tie the content of the dance to the Japanese practice of massage: "Anma (the massage) is the art of releasing of the mind and body." These titles were not part of the original dance. Much of the reintroduced footage is badly washed out. See Iimura Takahiko, *Cine Dance: The Butoh of Tatsumi Hijikata: Anma (The Masseru*[Sic]*) + Rose Color Dance*, DVD (Takahiko Iimura Media Art Institute, 2005).
25. Fukuda Yoshiyuki and Amasawa Taijirô, "Haikyô ni kitsuritsu suru nikutai: Hijikata Tatsumi no ankoku butô ni furete" [The Body Towering over a Void: On Hijikata Tatsumi's Dance of Darkness], *Gendai no me* 13, no. 12 (Dec. 1972): 245.
26. Motofuji, *Hijikata Tatsumi to tomo ni*, 127. Tanaka Ikkô, "Satôgashi no kaisô" [Memories of Sweets], *Shingeki* 24, no. 292 (Aug. 1977): 36–39.
27. For more detail, see previously in this chapter. See also Kazakura Shô, "Haikei Hijikata Tatsumi-sama," 26. See also the photograph in Morishita, *Hijikata Tatsumi no butô*, 46–47.
28. Motofuji, *Hijikata Tatsumi to tomo ni*, 127. "Hi Red Center" was the name of a group of neo-Dada artists who were intent on taking art beyond the confines of museum walls. The name was taken from the initial characters of their names: taka, aka, and naka, which mean respectively, "tall," "red," and "middle." Hence the name, Hi (as in High) Red Center. Other events included "Movement to Promote the Cleanup of the Metropolitan Area (Be Clean)," which consisted of cleaning the Ginza with cotton swabs as a way to protest the airbrushing of Tokyo for the 1964 Olympics, and "The Imperial Hotel Body: Shelter Plan," which I treat later in this chapter.
29. Motofuji, *Hijikata Tatsumi to tomo ni*, 125.
30. Morishita, *Hijikata Tatsumi no butô*, 71. Earlier, I argued that the increasing fragmentation of the descriptions of the dances indicated that the dances themselves were changing. The filmic record corroborates the disjointedness of the dances.
31. A shamisen is a three-string plucked instrument somewhat similar to a lute. Yoshito says that one of the shamisen songs was "Makkuroke bushi" (Pitch Black Hair Melody—1914) written by the socialist popular song (*enka*) writer Soeda Asenbo (1872–1944), and that it contained a phrase about "catching a glimpse of a young woman's pubic hair as she rode a bicycle." Interview September 15, 2009. Soeda's song referred to the 1914 famine and earthquake in northern Japan, and to the volcanic eruption in southern Japan. His original song did not contain the bawdy phrase Yoshito mentions, but it gave rise to many alternative verses including the following:
 Hey young girl
 You can ride a bike well, but
 Each time you peddle forward forward

I can catch a glimpse of your
Pitch black hair, ahh, pitch black hair.

See Taguchi Takashi, "Makkuroke bushi nitsuite" *Waseda daigaku toshokan kiyô* 31 (Dec. 1989): 42–48; and Kawabata Keiji, "Makkurokenoke," Muroran Kôgyôdaigaku Meitoku-ryô ryôka, http://www.geocities.co.jp/Berkeley/5821/ryouka.html.

32. Yoshito says that while throwing the ball they yelled in mock loud voices to each other as if they were on opposites sides of the universe. They would throw the ball and then wait an inordinately long time before miming catching it. When they threw, they would call out in a mock loud voice as if they had to yell to the person, "Here is comes!" and throw, and then wait and wait and wait (even though they were only a few feet apart) before they mimed catching the ball. Interview September 15, 2009.

33. See Munroe ed., *Japanese Art after 1945: Scream Against the Sky* (New York: H.N. Abrams, 1994), 151–52. See also Thomas R. H. Havens, *Radicals and Realists in the Japanese Nonverbal Arts: the Avant-garde Rejection of Modernism* (Honolulu: University of Hawai'i Press, 2006), 134–43.

34. Many of the dancers and artists involved in the Judson Dance Theater were taking choreography classes from Robert Dunn, who was an accompanist for Cunningham and had taken musical composition classes from John Cage in which he had learned Cage's chance composition procedures. Sally Banes, *Democracy's Body: Judson Dance Theater, 1962–1964* (Ann Arbor, MI: UMI Research Press, 1983), 1–2.

35. Banes, *Democracy's Body*, xvii–xviii.

36. Banes, *Democracy's Body*, see especially Chapter 2 "'A Concert of Dance' at Judson Church" for a description of the varied dances and choreographic techniques described in the flowing paragraph. See also, Sally Banes, "The Choreographic Methods of the Judson Dance Theater" in Ann Dils and Ann Cooper Albright eds., *Moving History / Dancing Cultures: A Dance History Reader* (Middletown, CT: Wesleyan University Press, 2001), 350–61.

37. In the 9-minute-long *Mannequin Dance*, David Gordon slowed turned himself in a space the size of a bathtub and lowered himself to the floor. Banes, *Democracy's Body*, 54–55.

38. Michael Raine, "Ishihara Yûjirô: Youth, Celebrity and the Male Body in the Late-1950s Japan," in Dennis Washburn and Carole Cavanaugh eds., *Word and Image in Japanese Cinema* (New York: Cambridge University Press, 2001), 216–17.

39. See Ian Buruma, "Prologue: The Tokyo Olympics" in *Inventing Japan: 1853–1964* (New York: Modern Library, 2003), 3–9. Considering the place of athletics in the early development of butoh, it seems significant that Cortázar choose 1964, the year that Tokyo hosted the Olympics, as the year for the invention of swimming in grits—that parochial sport that bloomed into an international phenomenon in Cortázar's magical realist imagination.

40. Ann Sherif, "The Aesthetics of Speed and the Illogicality of Politics: Ishihara Shintarô's Literary Debut," *Japan Forum* 17, no. 2 (July 2005): 191, 199, 202.

41. Andrew Gordon, "Conclusion" in Andrew Gordon ed., *Postwar Japan as History* (Berkeley: University of California Press, 1993), 384. Gordon's point is to account for the weakening of unions' bargaining position with management because of the competition.

42. Chiaki Moriguchi and Hiroshi Ono, "Japanese Lifetime Employment: A Century's Perspective" in Magnus Blomstrom and Sumner La Croix, eds., *Institutional Change in Japan*, (New York: Routledge, 2006), 152–76. For the Miike mine in 1953, see Gordon, 381–83. John Price describes the scene of 10,000 police officers facing 20,000 picketers in the Miike Mine in John Price "The 1960 Miike Coal Mine Dispute: Turning Point for Adversarial Unionism in Japan?" in Joe Morre ed., *The Other Japan: Conflict, Compromise, and Resistance since 1945* (Armonk, NY: M.E. Sharpe, 1996), 49. For the

mutual security treaty, see, George R. Packard III, *Protest in Tokyo: The Security Treaty Crisis of 1960* (Princeton, NJ: Princeton University Press, 1966).
43. Vera Mackie, "Understanding through the Body: The Masquerades of Morimura Yasumasa and Mishima Yukio," in Mark McLelland and Romit Dasgupta, eds., *Genders, Transgenders and Sexualities in Japan* (London: Routledge, 2005), 131.
44. Mishima Yukio, *Taiyô to tetsu*, in Saeki Shôichi ed., *Mishima Yukio zenshû*. (Shinchôsha, 1975), 32: 85. Translated by John Bester as *Sun and Steel* (New York: Grove Press, 1970, 1967), 36. I take the idea of connecting Hijikata and Mishima's *Sun and Steel* from Kuniyoshi Kazuko who argues that the attitudes in *Sun and Steel* manifest themselves in Hijikata's early preoccupation with the hardening of the body and the opposition between the body and language. This is not anachronistic, in that Mishima started participating in athletics in 1952 (swimming), boxing (1953–1954), bodybuilding (1955), and kendo (1959) and thus was well into the athletic and competitive phase of his life even if he had not yet written his most famous treatise on athletics yet. See Kuniyoshi Kazuko, "Le Kabuki du Tôhoku et l'empereur," trans. Patrick De Vos, in Claire Rousier ed., *Être ensemble: Figures de la communauté en danse depuis le XXe Siècle*, (Pantin, France: Centre National de la Danse, 2003), 277. See also Kuniyoshi Kazuko, "Sekushuaritii jendaa—butô no baai" [Sexuality and Gender: The Circumstances of Butô] *Buyôgaku* no. 21 (1998), 83. For Mishima, see John Nathan, *Mishima: A Biography* (Rutland, VT and Tokyo: Tuttle, 1974), 119–30.
45. Nathan argues that the often solipsistic Mishima wanted to prove to himself that he existed through these activities, which is a variant of the idea of coming to know actuality (of the self). Nathan, *Mishima*, 128–29,
46. See Munroe, 153, 162, 169–70.
47. Vera Mackie "Understanding through the Body," 131–35.
48. Initially Hijikata was at some distance from this athletic body in that he told Yoshito that one of the issues that he wanted to address in one of the earlier dances (*Crowds of Flowers*) was the psychological inferiority complex that leads Japanese people to mimic the West in such things as bodybuilding. (Interview with Yoshito, July 12, 2007.) Mishima, obviously, must be seen as a representative of this kind of complex.
49. David Harvey, *The Condition of Postmodernity: An Enquiry into Origins of Cultural Change* (Malden, MA: Blackwell Publishing, 1990), 187, see also 151–52, 188–91. Harvey was interested in the way these forms of labor reduced the amount of control the individual laborer had over herself. This is an important issue to which I will return, for Harvey specifically singles out women as being more exploitable under the new systems. Equally important is the brute fact of bodies being reintroduced into the labor when one might have thought that the trend was to move away from bodily participation.
50. See Hugh T Patrick and Thomas P. Rohlen, "Small-scale Family Enterprises" in Kozo Yamamura and Yasukichi Yasuba eds., *The Political Economy of Japan*, vol. 1, *The Domestic Transformation* (Stanford, CA: Stanford University Press, 1987), 331–84); Kent E. Calder, *Crisis and Compensation: Public Policy and Political Stability in Japan, 1949–1986* (Princeton, NJ: Princeton University Press, 1989), 240–41, 314–15; "Japan's Subcontractors: The Buck Stops Here" in Daniel I. Okimoto and Thomas P. Rohlen eds., *Inside the Japanese System: Readings on Contemporary Society and Political Economy* (Stanford, CA: Stanford University Press, 1988), 83–86.
51. A 1978 article reported that a part-time in-home subcontracting woman earned 244 yen per hour, which is roughly $3.74 per hour inflation-adjusted to 2010. "Japan's Subcontractors," 85. Due to government subsidies for rice and to systemic underreporting of income to evade taxes, scholars have argued that the subcontractor lifestyle

was not one of unmitigated poverty. See, for example, Calder, *Crisis and Compensation*, 241. Patrick and Rohlen highlight the wage gap across sectors between men and women, and state that "labor market discrimination...against women and older persons [is] the main source of low-cost productive labor." See "Small-scale Family Enterprises," 122. My point is that such bodily labor constituted a large part of Japanese labor in an era in which in which we might have the impression that corporations were mechanizing away from the body.

52. *HTZ*, 1, 212.
53. See Gavan McCormack, *Chang Tso-lin in Northeast China, 1911–1928: China, Japan, and the Manchurian Idea* (Palo Alto: Stanford University Press, 1977), 223–34.
54. Allen Guttmann and Lee Austin Thompson, *Japanese Sports: A History* (Honolulu: University of Hawaii Press, 2002), 75.
55. Nakanishi Natsuyuki, "Hijikata Tatsumi to no owarinaki taiwa" [My Endless Conversation with Hijikata Tatsumi] *Gendaishi techô* 29, no. 3 (March 1986): 30.
56. This squares with Takiguchi's understanding of the interpretive process as changing moment by moment as the viewer uses prior information and experiences to create initial interpretations (which then become the grist for the next moment), while also using current information to revise prior interpretations. It also rings true to the experiences of Haniya and Akasegawa in *Leda*, in which their respective adventures had started before they entered the dance studio.
57. Ann Plogsterth, "The Institution of the Royal Mistress and the Iconography of Nude Portraiture in Sixteenth-Century France."(Ph.D. diss., Columbia University, 1991), 154–68; especially 164–65 for the significance of touching the breast, and 165–67 for what Plogsterth describes as the "pseudo-lesbianism" of the work.
58. Donald Richie, "New Happening by Hijikata in Store," *Japan Times*, July 10, 1966. Richie's article is actually about Hijikata's subsequent dance *Tomato* (July 16–18, 1966), but he reflects on Hijikata's previous dances.
59. Elsewhere, Hijikata writes that rumors of the emperor's flatulence contributed to his dance. "Asian Sky and Dance Experience," *HTZ* 1: 212.
60. David Goodman, *Angura: Posters of the Japanese Avant-garde* (New York: Princeton Architectural Press, 1999), 72.
61. See Albert J. Koop and Hogitarô Inada, *Japanese Names and How to Read Them: a Manual for Art-collectors and Students, Being a Concise and Comprehensive Guide to the Reading and Interpretation of Japanese Proper Names both Geographical and Personal, as well as of Dates and other Formal Expressions* (Boston: Routledge & Kegan Paul, 1972), 37.
62. "Duchenne" here is (*deshuannu*), and likely refers to Duchenne muscular dystrophy (usually Romanized *Dushannu*), first described by Duchenne de Boulonge (1806–1875), or it may be an error for Duchamp (*dushan*), leading to "Duchamp-style Dancing Girls."
63. In his groundbreaking study of the literature of Heian Japan, Thomas LaMarre argues that a similar rebus treatment of the proto-Chinese language and proto-Japanese language elements in Heian literature spoke to an essentially malleable polyglot miscegenal nature of the Heian courtiers, who were interested in using the prestige of other ethnicities and languages to enhance their own prestige. In his words, paraphrasing Benedict Anderson, the classical community was "indifferent to linguistic differences, ethnically diffuse, territorially porous, and culturally absorptive." Even though a thousand years separated them, and even though Hijikata and his fellow butoh artists were in the middle of a nation-state increasingly concerned with reestablishing ethnic and linguistic purity after the occupation, and even though in the 1960s Hijikata and his fellow artists would likely not have thought Chinese characters to be in any way foreign,

these early butoh artists exhibited a polyglot, culturally absorptive character very similar to that of the Heian courtiers. See Thomas LaMarre, *Uncovering Heian Japan: an Archaeology of Sensation and Inscription* (Durham, NC: Duke University Press, 2000), 3. There was, however, an increasing concern with Japanese identity over the course of the development of butoh.

64. Morishita, *Hijikata Tatsumi no butô*, 76. *Kojien* sb. "Karumera." Motofuji, *Hijikata Tatsumi to tomo ni*, 140.
65. Thomas Haven's writes of Hijikata being "apt to seek meaning in the detritus of ordinary life…to demonstrate the barrenness and insignificance of Japan's bureaucratically administered society." Thomas R. H. Havens, *Radicals and Realists*, 182.
66. H. D. Harootunian, "America's Japan/ Japan's America" in Masao Miyoshi and H. D. Harootunian eds., *Japan in the World* (Durham, NC: Duke University Press, 1993), 204.
67. Currently the only forms still in use are for one, two, three, ten, and twenty.
68. Motofuji, *Hijikata Tatsumi to tomo ni*, 88–89, 115.
69. Motofuji, *Hijikata Tatsumi to tomo ni*, 120–22. Sec Gorgui is the name of one of the characters (a black man) in Genet's *Our Lady of the Flowers*. Translated by Bernard Frechtman. New York: Grove Press, 1963.
70. Motofuji, *Hijikata Tatsumi to tomo ni*, 156. Motofuji writes of being in a duo with Kara. The two of them would perform, and then Kara would steal bottles of beer from the nightclub to take back home with them. Yamada Ippei relates the *Goldfinger* connection. Yamade Ippei, *Dansaa*, [Dancer] (Tokyo: Ôta Shuppan, 1992), 29.
71. Yamada Ippei, *Dansaa*, 29–55.
72. Robert W. Weisberg notes the indispensability of the Hamburg era in the formation of the Beatles who between 1960 and 1962 were performing in strip clubs in Hamburg between five and eight hours per night for 270 nights. Similarly, it is impossible to understand Hijikata's career without taking into account the thousands of hours of he and his dancers spent dancing in strip clubs. See Robert W. Weisberg "Creativity and Knowledge: A Challenge to Theories" in Robert J. Stirnberg ed., *Handbook of Creativity* (Cambridge: Cambridge University Press, 1999), 238–39.
73. I heard this complaint in conversation with one of Hijikata's long-time dancers. I have chosen not to reveal her name.
74. Yanai Yasuhiro, "Sakuhin kaisetsu" [Explanation of the Works] in Sumi Yôichi and others eds., *Barairo dansu no ikonorojî: Hijikata Tatsumi wo saikôchiku suru* [The Iconology of *Rose-colored Dance*: Reconstructing Tatsumi Hijikata], translated by Bruce Baird (Keio University Center for the Arts, 2000), 31.
75. See the photo in Morishita and Yamazaki, 20. See also my discussion in chapter 3 of the Banquet to Commemorate Losing the War, in which the audience would have incorporated a part of Kazakura Shô into their own bodies.
76. See Stephan von Wiese, Jutta Hulsewig and Yoshio Shirakawa, eds., *DADA in Japan: Japanische Avantgarde 1920–1970: Eine Fotodokumentation* (Dusseldorf: Kunstmuseum Dusselddorf, 1983), 120. See also, Shinohara Ushio, *Zen'ei no michi* [Path to the Avant-Garde], especially "Jabu, jabu sutorêto, refuto fukku KO da" [Jab, Jab, Straight, Left Hook, KO] June 25, 2003, and "Refuto fukku ten" [Left Hook Exhibition] July 10, 2003. Respectively at http://www.new-york-art.com/zen-ei-dai-16.htm and http://www.new-york-art.com/zen-ei-dai-17.htm (Nov. 18, 2003)
77. Mishima Yukio, "Kiki no buyô," [Crisis Dance] in Morishita, *Hijikata Tatsumi no butô*, 16. Translated by Kobata Kazue as "Kiki no Buyou: Dance of Crisis." In Jean Viala and Nourit Masson-Sekine, eds., *Butoh: Shades of Darkness* (Tokyo: Shufunotomo, 1988) 16.

78. Shibusawa Tatsuhiko, "Hansai no buyôka" in Morishita, *Hijikata Tatsumi no butô*, 17.
79. From a talk given by Hosoe at the Akita Senshu Museum of Art on September 16, 2001.
80. William Klein later captured this same look (the black cloth or bag covering the face) in his *Tokyo*, shot in 1961 and published in 1964. William Klein, *Tokyo* (New York: Crown Publishers, 1964).
81. Morishita, *Hijikata Tatsumi no butô*, 77.
82. See Nam June Paik's essay "To Catch Up or Not to Catch Up with the West: Hijikata and Hi Red Center" in Alexandra Monroe ed., *Japanese Art After 1945: Scream Against the Sky* (New York: H. N. Abrams, 1994), 80; and the plates on pp. 176–78, and 180 which show figures originally taken from the *General Catalogue of Males*, Nam June Paik's photographs and measurements, Jônouchi's film stills, and a 1965 Fluxus poster for release in New York advertising Hi Red Center activities, which includes a picture of a custom-made bomb shelter (no. 13).
83. Given the continual connections between Hijikata's art and the wider world, it will come as no surprise to find complaints of workers who were not allowed bathroom breaks in the highly energized economy. See Kurata Satoshi's *Jidôsha zetsubô kôjô: aru kisetsukô no nikki* [Automobile Despair Factory: The Diary of a Seasonal Laborer] (Tokyo: Gendaishi Shuppankai, 1974). The truly prototypical crisis image of the late twentieth century was not the back of a man urinating, but rather workers who were not allowed to urinate at all.
84. Hijikata Tatsumi and Shiraishi Kazuko, "Shinra banshô wo kanjitoru kyoku'i" [The Ultimate Feeling that can Perceive All Things], *HTZ*, 2: 85.
85. As with *Masseur*, Iimura released a new version which includes some extra washed-out footage. See Iimura, *Cine Dance*, 2005. The music on both versions is not the original music.
86. Hijikata told Kasai that these tubes were for sucking up things and making them disappear, while he told Yoshito that they were umbilical cords. See Kasai Akira, "Hijikata Tatsumi wo kataru," 56; and Ôno Yoshito interview with author September 15, 2009.
87. Hanayagi Shôtarô was a leading *shimpa* female impersonator (*onnagata*). For information on *shimpa* (a transitional theatrical form between Kabuki and *shingeki*—the Westernized proscenium arch theater of modern Japan), see Benito Ortolani, *The Japanese Theatre: From Shamanistic Ritual to Contemporary Pluralism* (Princeton, NJ: Princeton University Press, 1990), 233–42.
88. Iimura writes, "I myself shot the film as a choreographer with a camera affixed to my own body," and again, "I shot the film with an 8 millimeter camera while moving freely on and off the stage." Iimura Takahiko, "Media and Performance," pamphlet enclosed in Takahiko Iimura, *Cine Dance: The Butoh of Tatsumi Hijikata: Anma (The Masseru* [Sic]*) + Rose Color Dance* DVD, Takahiko Iimura Media Art Institute, 2005. Cited as having originally been in *Dance News* [*Plexus*] no. 5, 2005.
89. Yamda Ippei says that Hijikata told him that he went to get his hair cut the day before he entered naval preparatory school, but as is usual with these claims, there is no record of him having attended a naval preparatory school. Yamada Ippei, *Dansaa*, 35.
90. Inside the program-qua-box along with the sugar candy was a greeting by Katô Ikuya with an etching by Kanô Mitsuo. The greeting read as follows:
> the eve of the festival of the giants that whip up mutually bewitched climbing-dragon mushroom clouds in the impulse that suddenly tries to grasp the ibis of self-love in the hall of immaculate conception, which toasts sesame seeds and the dreams of other worlds, while migrating though evil by means of a chestnut coming ashore during the late summer of a plate from the waters of the revolutions of the zodiac that are made crazy by a winter infant

This greeting poem refers to "the eve of the festival of the giants that whip up mutually bewitched climbing-dragon mushroom clouds" which perhaps sets the dance on the eve of World War II and seems to indicate that the "climbing-dragon mushroom clouds" are the responsibility of "giants" on both sides of the conflict. See "Plates," in Sumi ed., *Barairo dansu no ikonorojî*, no. 15, p. 17.

91. Mishima Yukio, *Taiyô to tetsu*, 86; *Sun and Steel*, 37.
92. Walter Benjamin, "The Work of Art in the Age of Mechanical Reproduction" in *Illuminations*, ed., Hannah Arendt, trans. Harry Zohn (New York: Shocken, 1969) 221–22.
93. Tone Yasunao recognizes *Masseur, Rose-colored Dance*, and the later *Tomato* as forerunners to "multimedia theater" and thus as the highpoint of Hijikata's career. See Tone Yasunao "Kaze wo kutte sarishi fûsen" [The Balloon that Ate the Wind and Went Away], in Maeda, *Nikutai no hanran*, 56.
94. What are referred to here as "letterman's jackets" were called "sukajan" (which was short for "Yokosuka Jumper," or "Sky Dragon Jumper," and was modeled after the word "sutajan"—stadium jumper). After the war, squadrons of US soldiers would have Orientalist designs such as hawks, lions, dragons or Mt. Fuji embossed on the back of their jackets. By the time of *Rose-colored Dance,* they were chintzy mass-produced items sold primarily in Yokosuka and specifically marketed to foreign souvenir seekers. Yoshito reports that he was embarrassed and would have never worn one in everyday life. Interview with author, September 15, 2009.
95. Donald Richie, "New Happening by Hijikata in Store."
96. 軽目 is pronounced "karume" and was a standard attempt to render in Chinese characters a non-Japanese word. It is an abbreviation of the previously discussed "karumera." 乱 would normally be pronounced "ran," but in this case, it seems clear that it should be read as "ra."
97. Morishita Takashi, "Hijikata Tatsumi no butô to *Barairo dansu*" [Hijikata Tatsumi's Butoh and *Rose-colored Dance*]. Translated by Bruce Baird. In Sumi Yôichi, Maeda Fujio, Morishita Takashi, and Yanai Yasuhiro, eds., *Barairo dansu no ikonorojî: Hijikata Tatsumi wo saikôchiku suru* [The Iconology of *Rose-colored Dance*: Reconstructing Tatsumi Hijikata]. Keio University Center for the Arts and Arts Administration, 6–8.
98. For the contradictions in Duchamp, see William A. Camfield, "Marcel Duchamp's *Fountain*: Its History and Aesthetics in the Context of 1917" in Rudolf E. Kuenzli and Francis M. Naumann eds., *Marcel Duchamp: Artist of the Century* (Cambridge, MA: MIT Press, 1989), 64–94; and Larry Shiner, *The Invention of Art: A Cultural History* (Chicago: University of Chicago Press, 2003), 290–92.
99. Munroe, *Scream*, 157.
100. See the English translation of Nishitani Keiji's *Shukyô to wa nanika*, in which he requests that the translator replace "transcendental" with "trans*des*cendental" in order to avoid a Western metaphysical notion of "rising above." Nishitani Keiji, *Religion and Nothingness*, trans. Jan Van Bragt (Berkeley: University of California Press, 1982), 304.
101. The debate still continues. See Arthur Danto's explication of Andy Warhol's *Brillo Box* in which Danto uncovers the artistic training in abstract expressionism of the designer, James Harvey, who originally designed the Brillo boxes which Warhol copied. What Warhol's *Brillo Box* really shows is that even when artists push against the boundaries of art, the audience tends to respond to something familiar. Arthur Coleman Danto, *The Abuse of Beauty: Aesthetics and the Concept of Art* (Chicago: Open Court Publishing, 2003), 3–4.
102. Sas, *Fault Lines*, 3, 12–14 and Hirata, *The Poetry and Poetics of Nishiwaki Juzaburô*, 151–52.

103. Of course, this attitude would be financially beneficial to the artists and dancers, (which dynamic again speaks to the connection between art and the wider world), but it likely goes beyond the immediate financial concern of the local artists, and bespeaks a broader attitude about spectatorship and the demands the artist places on the audience.
104. Interview with Ōno Yoshito, September 15, 2009. Yoshito called this scene a *yokokuen*, that is preview of coming attractions.
105. Morishita, "Hijikata Tatsumi no butô to *Barairo dansu*," 6.
106. Clement Greenberg, "Modernist Painting," *The Collected Essays and Criticisms*, ed., John O'Brian, vol. 4, *Modernism with a Vengence, 1957–1969* (Chicago: University of Chicago Press, 1993), 85.
107. The movement known as "modern dance" is not the same thing as modernist art and architecture. The dance of the 1960s (including Merce Cunningham and Judson Dance Theater) is often called "postmodern dance" in dance circles, as is the multimedia dance of the 1980s. The miminalism characteristic of the 1960s version of postmodern dance is closer to the "modernist" pure or paired down impulse in other disciplines. See Sally Banes, "Is It All Postmodern?" *TDR* 36, no.1 (Spring 1992), 58–61; and Roger Copeland, "Is it Post-Postmodern?" *TDR* 36, no.1 (Spring 1992), 64–67.
108. Ichikawa Miyabi, "Nikutai no busshitsusei," 32.
109. For Shinohara's *Twist Dango*, see Monroe, *Scream*, 154, 157–58.
110. Motofuji, *Hijikata Tatsumi to tomo ni*, 153.
111. Richie, "New Happening by Hijikata in Store."
112. Tezuka Osamu, *Princess Knight = Ribon no kishi* trans. Yuriko Tamaki. (Tokyo: Kodansha International, 2001), vol. 2, Chapter 12, 108. Tezuka appropriated many Disney characters for this manga including Jiminy Cricket, J. Thaddeus Toad, and incorporated Mickey Mouse into Hecate's pet bat. *Ribon no kishi* was initially serialized from 1953 to 1956 in a magazine for young women *Shôjô Kurabu* (Girls Club), and then reworked in *Nakayoshi* between 1963 and 1966.
113. Motofuji, *Hijikata Tatsumi to tomo ni*, 150–51. I have retained punctuation and indentation as in the original.
114. Another set of photos shows him wearing on his head what appears to be a circular laundry rack with feather dusters and a salmon tin hanging from clothespins. This might be from a different scene or from a rehearsal.
115. Ichikawa Miyabi, "Nikutai no busshitsusei," 32.
116. Morishita Takashi and Yamazaki Yôko eds., *Bijutsu to butô no Hijikata Tatsumi ten* [Hijikata Tatsumi Exhibition: Art and Butô] (Ito, Shizuoka: Ikeda Musuem of 20th Century Art, 1997), 23.
117. Kasai, "Hijikata Tatsumi wo kataru," 60, 62. Kasai is adamant that butoh is not a formal genre but only marks an attitude, and he even rejects some of Hijikata's later dances as qualifying for the term "butoh." Interestingly, given the evolution of the word "butoh" from its original use to describe Western dances to its current use, Kasai also thinks that butoh is fundamentally Western in origin, because it depends for its thrust on a Western concept of right and wrong against which it can rebel.

4 PIVOTING PANELS AND SLASHING SPACE: REBELLION AND IDENTITY

Epigraph: Emily Dickinson, *The Complete Poems of Emily Dickinson*, Thomas H. Johnson ed., (Boston: Little Brown and Company, 1960), 443 (poem 945).

1. These photos were turned into the photographic collection *Kamaitachi* (sometimes translated as *Sickle-Weasel*, *Sickle-toothed Weasel*, or *Wind Burn*) the following year. Hosoe Eikô, *Kamaitachi* (Gendaishichôsha, 1969). Reprinted as *Kamaitachi* (New York: Aperture, 2005).
2. Hosoe Eikô, "Notes by Hosoe Eikô" in Jean Viala and Nourit Masson-Sekine, eds., *Butoh: Shades of Darkness* (Tokyo: Shufunotomo, 1988), 191–92.
3. Hosoe Eikô, "'Kamaitachi,' furusato to Akita ni kaeru" [*Sickle-Weasel*: Returning to Akita and to the Hometown] in Akita Senshu Museum of Art ed., *Hijikata Tatsumi Exhibition: The Metamorphosis of the Wind* (Akita: Akita Senshu Museum of Art, 1991).
4. The school teacher was not aware that the kids were cavorting with Hijikata. Much of the background information comes from conversations I had with residents of Tashiro during a September 2001 trip with Hosoe back to revisit the town. The occasion was the grand opening of a retrospective of Hosoe's photographs at the Akita Senshu Museum of Art, and Hosoe invited budding photographers to return to the original town and photograph it. I tagged along for the purpose of seeing the sights and talking to some of the people from the village who had a hand in the photographic shoot.
5. From a lecture at the Akita Senshu Museum of Art, September 16, 2001.
6. Conversation with the author, October, 6, 2001.
7. *HTZ*, 1:193; *WB*, 41, 42. "Lauan" is a generic name for tropical plywood. The lemon soda bottle is "Ramune," a Japanese soda popular among kids that comes in a Codd-neck bottle; it is necessary to push the marble out of the neck in order to drink the soda.
8. Sas addresses the use of the passive voice in Hijikata's writing and concludes that for Hijikata, "the artist is both creative and created by her acts." Miryam Sas, "Hands, Lines, Acts: Butoh and Surrealism," *Qui Parle* 13, no. 2 (Spring/Summer 2003): 33–34.
9. Hijikata Tatsumi, "Itachi no hanashi" [Weasel Talk] *Asubesutokan tûshin* 9: 36. *HTZ*, 2:146.
10. See *Kojien* sb. "Kamaitachi," and *Nihon kokugo daijiten* sb. "Kamaitachi." According to the *Kokugo daijiten*, the first mention of 'kamaitachi' is in a 1695 poem (*haikai* or *senryû*) with the Chinese characters for "sickle weasel" (鎌鼬). A later etymology has "kamaitachi" as a varient of "kamaetachi" (構え太刀—sword held ready) on the supposition that the laceration is like being cut by a sword. Hijikata's definition of "kamaitachi" as a laceration caused by differences in air pressure matches the main one in the *Kokugo daijiten*.
11. Hijikata Tatsumi and Suzuki Tadashi, "Ketsujo to shite no gengo=shintai no kasetsu" [Language as Lack and Temporary Construction of the Body] *Gendaishi techô* 20, no. 4 (April 1977): 111. See also, *WB* 64.
12. Susan Blakely Klein suggested this reading to me, and these are her words.
13. This is nowhere more visible than in the changes to the original *Kamaitachi* photographs seen in the 2005 version. In plates 15 and 18 in the original, the edges of the photographs are overdeveloped and thus washed out and whitened, creating an iris narrowing the focus to Hijikata in the middle. In the new version, plate 18 is recentered, and in both plates the periphery is brought back into normal contrast. The effect in the originals is to isolate Hijikata from his surroundings and make him seem like a crazy outsider. The effect in the 2005 version is to make Hijikata seem less strange, less of an outsider, and more a part of nature and Tôhoku. A similar transformation can be seen in plate 26. See respectively Hosoe Eikô, *Kamaitachi*, (Gendaishichôsha, 1969), and *Kamaitachi* (New York: Aperture, 2005).
14. In this respect, the current response to Hijikata is instructive. When I visited Tôhoku in 2001, I asked everyone I met in Tashiro and Akita whether or not they liked butoh.

Given the social pressure that does not easily accommodate confessing disdain for a strange art to the foreign researcher of that art, many people refrained from expressing a clear distaste for butoh, but told me that they could not understand butoh. However, a significant number of people said they liked butoh, and the local Buddhist priest cheerfully allowed Motofuji and her disciples to desecrate his temple with a butoh performance in which she gave birth to and then lasciviously humped a large gourd culled from a nearby garden. Hijikata's butoh will continue to reverberate in Tôhoku for some time.

15. Kurihara says that Motofuji contradicted Hijikata on this issue and asserted that all his sisters had married and lived normal lives. Kurihara referred to the death(s) of the older sister(s) as symbolic. Kurihara, "The Most Remote Thing in the Universe: A Critical Analysis of Hijikata Tatsumi's Butoh Dance." (Ph.D. diss., New York University, 1996), 74–77. Morishita Takashi concurs and states that about the only thing we can be sure of about Hijikata's early life is that his sisters were not sold into prostitution. Morishita Takashi, "Hijikata Tatsumi no Geijutsu" [Hijikata Tatsumi's Art] *Japanese Bulletin of Arts Therapy* 38, no. 1 (2007), 30.
16. Kuniyoshi Kazuko, electronic mail communication with the author, Feb. 10, 2004.
17. Hijikata Tatsumi, "Watashi ni totte erotishizumu to wa inu no jômyaku ni shitto suru koto kara," [For Me, Eroticism Comes From Being Jealous of a Dog's Vein] *Bijutsu techô* 21, no. 312 (May 1969), 128. *WB*, 58.
18. *HTZ* 1: 171. Originally in Hijikata Tatsumi, *Inu no jômyaku ni shitto suru koto kara* (Yugawa Shobô, 1976). The content in question is identified as 'source unknown' by the publishers of the collected works. See *HTZ*, 1: 390.
19. *HTZ* 1: 199; *WB* 45.
20. *HTZ* 1: 69.
21. *HTZ* 2: 10; *WB* 50.
22. The first half of the title is often translated, using a definite article, as *Hijikata Tatsumi and the Japanese*. This translation inadvertently lumps all Japanese people into one category ("the Japanese"), even though the Japanese language does not require articles. As I shall argue later, the dance itself gives reasons for thinking that Hijikata did not consider Japanese people to belong to a uniform group. I omit the definite article because it has proved a stumbling block for those who have sought to determine whether or not Hijikata intended to identify with Japan or traditional Japanese aesthetics. For example, Holborn wrote that the title "asserted a national identity". Ethan Hoffman et al. eds., *Butoh: Dance of the Dark Soul* (New York: Aperature, 1987), 13. In contrast, William Marotti has argued that the title "suggests the possibility of a negotiation of identity." William Marotti, "Butô no mondaisei to honshitsushugi no wana," [The Problematic of Butô and the Trap of Essentialism] *Shiataa Aatsu* 8 (1997): 93. Marilyn Ivy remarks on a similar (mis)translation ("the Japan") involving the definite article in her *Discourses of the Vanishing: Modernity, Phantasm, Japan* (Chicago: University of Chicago Press, 1995), 61.
23. A reproduction of this filmstrip is available on CD-ROM affixed in an envelop on the inside of the back cover of Morishita, *Hijikata Tatsumi no butô: Nikutai no shururearisumu, shintai no ontorojî* [Tatsumi Hijikata's Butoh: Surrealism of the Flesh, Ontology of the "Body"] (Okamoto Tarô Museum of Art and Keio University Research Center for the Arts and Arts Administration, 2004).
24. Information taken from the video and the anonymously authored essay, "Fukugen: *nikutai no hanran*" [Assemblage: *Rebellion of the Body*] in Maeda, *Nikutai no hanran*, 9–17.
25. Murobushi Kô, lecture at Keio University Hiyoshi Campus, December 7, 2000.
26. *HTZ* 2: 14; *WB*, 55

27. Cited in Morishita, "Nikutai no hanran: Kîwâdo no idiomu o yomu: Hijikata Tatsumi no saineeju kenkyû 1" [Rebellion of the Body: Reading the idioms of the keywords: Research on the Signage of Hijikata Tatsumi]. In Meada Fujio et al. ed., *Nikutai no hanran,: Butô 1968: Sonzai no semiorojî* [Rebellion of the Body: Butoh 1968: Semiology of Being]. (Keio University Research Center for the Arts and Arts Administration, 2009), 21. Original in Tomioka Taeko, "Hijikata Tatsumi: Shikkoku no suodori" [Jetblack Uncostumed Dance: Hijikata Tatsumi] *Bijutsu techô* 20, no. 304 (July 1968): 160–69.
28. Originally, the title was "Hijikata Tatsumi and Japanese People," as can be seen from the poster for the dance, which also indicates that the dance was to take place in June. Something delayed the dance until October. In the meantime, Tanemura Suehiro published an article including the phrase "Rebellion of the Body" and Hijikata adopted the idea as the second part of the title. Tanemura Suehiro, "Ankoku buyôka—Hijikata Tatsumi no kyôki" [The madness of Hijikata Tatsumi—Dancer of the Dance of Darkness] *Bijutsu techô* 20, no. 303 (June 1968): 22–23.
29. Kurihara Nanako, "The Most Remote Thing in the Universe: A Critical Analysis of Hijikata Tatsumi's Butoh Dance." (Ph.D. diss., New York University, 1996), 68–69.
30. See Kasai, "Hijikata Tatsumi wo kataru," in Morishita, *Hijikata Tatsumi no butô*, 55.
31. Kurihara, "The Most Remote Thing in the Universe," 66–67. Shibuswa Tatsuhiko, "Kyôtei Heriogabarusu aruiwa dekadensu no ikkôsatsu" [The Mad Emperor Heliogabalus, or a Consideration of Decadence], in his *Shinsei Jutai* [Divine Conception] (Kawade Shobô, 1987), 42–76.
32. Kurihara, "Hijikata Tatsumi: The Words of Butoh," 20.
33. For general accounts of Artaud's "theater of cruelty," see Susan Sontag, "Artaud" in Susan Sontag ed., *Antonin Artaud: Selected Writings*, trans. Helen Weaver (Berkeley: University of California Press, 1988), xvii–xlix; Martin Esslin, *Antonin Artaud* (New York: Penguin, 1977); Stephen Barber, *Artaud: Blows and Bombs* (Creation Books, 2003).
34. Antonin Artaud, *The Theater and Its Double*, trans. Mary Caroline Richards (New York: Grove Press, 1958), 84.
35. Miryam Sas has insightfully explored the nuances of a later essay by Hijikata about Artaud. See Miryam Sas, "Hands, Lines, Acts," 19–51.
36. Artaud, *Heliogabalus, Or, The Anarchist Crowned* trans. Alexis Lykiard (London: Creation Books, 2003), 106–13.
37. Peter Eckersall, "The Performing Body and Cultural Representation in the Theatre of Gekidan Kataisha," in Stanca Scholz-Ciona and Samuel L. Leiter eds., *Japanese Theatre and the International Stage*, (Boston: Brill, 2001), 327.
38. Artaud, *Heliogabalus* 103–4.
39. The final scene, featuring Hijikata being hoisted into the air, does not have any counterpart in Artuad's account of Heliogabalus. Artuad's Heliogabalus flees from would-be assassins and jumps into a latrine where he is hacked to death. Artaud, *Heliogabalus* 117–18.
40. Murobushi Kô, lecture at Keio University Hiyoshi Campus, December 7, 2000.
41. Yumiko Iida, *Rethinking Identity in Modern Japan: Nationalism as Aesthetics* (New York: Routledge, 2002), 83.
42. David Goodman, *Japanese Drama and Culture in the 1960's: Return of the Gods* (Armonk: M.E. Sharpe, 1988), 3.
43. Cited in Morishita, "Nikutai no hanran: Kîwâdo no idiomu o yomu," 22. Kanai writes: "Hijikata's dance begins from the discovery of the primal body."
44. Richie, *Japanese Portraits*, 111.

45. Motofuji, *Hijikata Tatsumi to tomo ni*, 63–67.
46. *HTZ* 2: 9–10; *WB* 49–50.
47. *HTZ* 2: 12; *WB* 51–52.
48. Sas, "Hands, Lines, Acts," 40–41.
49. Tanikawa Kôichi, "Buta to kirisuto" [Pig and Christ] *Bijutsu techô* 38, no. 561 (May 1986), 52.
50. Kurihara Nanako, "Plucking off the Darkness of the Flesh" *TDR* 44.1, (Spring 2000): 55, note 7.
51. Genet, *Our Lady of the Flowers*. Translated by Bernard Frechtman. (New York: Grove Press, 1963), 57.
52. Genet, *Our Lady*, 304–5.
53. Genet, *Our Lady*, 105.
54. Genet, *Our Lady*, 99, 114.
55. Hijikata Tatsumi, "Watashi ni totte erotishizumu to wa inu no jômyaku ni shitto suru koto kara," 126. *WB*, 56.
56. This transformation in how we understand the connection between butoh and pain is similar to the revision of our understanding of Hijikata's vision of butoh after reading his quotations about his mother and sister.
57. See Thomas Weber, *On the Salt March: The Historiography of Gandhi's March to Dandi* (New Delhi: Harper Collins, 1997), especially his quotation of "old leaders" who want Indians to be "beaten by Englishmen until they [the Englishmen] would be ashamed before the world, ashamed before themselves; until their outraged conscience would drive them to come to terms" with what they had done (408–9). See also the passage by the United Press correspondent Webb Miller (that appeared in 1350 newspapers around the world) detailing British brutality, which played a large part in turning the American public against the British (403–4, 443–47). Weber is careful to note the myths that have grown up around the salt march, but that it is also generally seen as the beginning of the end for British rule in India.
58. Hijikata, "Watashi ni totte erotishizumu to wa inu no jômyaku ni shitto suru koto kara," 126. *WB*, 56.
59. I revisit this passage in the "Epilogue."
60. I revisit the issue of transformation in chapter 6.
61. Antonin Artuad, "The Theater of Cruelty (First Manifesto)," in Mary Caroline Richards, trans., *The Theater and Its Double*, (New York: Grove Press, 1958), 90–95.

5 MY MOTHER TIED ME ON HER BACK:
STORY OF SMALLPOX

Epigraph: Leif Enger, *So Brave Young and Handsome*. (New York: Grove/Atlantic, 2008), 143.

1. As previously explained, Hijikata gave titles to the entire performance and the individual dances in the performance. The rather unwieldy "Great Dance Mirror of Burnt Sacrifice—Performance to Commemorate the Second Unity of the Dance of Utter Darkness Faction—Twenty-seven Nights for Four Seasons" was the full title of the entire 27 night series.
2. Lucia Schwellinger, *Die Entstehung des Butoh: Voraussetzungen und Techniken der Bewegungsgestaltung bei Hijikata Tatsumi und Ôno Kazuo* (Munich: Iudicium, 1998), "Abbildungen," nos. 13, and 15 (unpaginated, but corresponding to pp. 206–7).

3. Motofuji, *Hijikata Tatsumi to tomo ni* [Together with Hijikata Tatsumi] (Chikuma Shobô: 1997), 184.
4. The Shinjuku Art Village was a small theater partially managed by Kanze Hideo, a classically trained *nô* actor who went against his family's wishes and acted in various experimental performances. See Powell, *Japan's Modern Theatre: A Century of Change and Continuity* (London: Japan Library, 2002), 172, 200.
5. Yamada Ippei, *Dansâ* [Dancer] (Ôta Shuppan, 1992), 52–53. Also Kobayashi Saga, interview with the author, May 6, 2002. In a continuation of idea of local experience bonded to capitalism, Nakamuri is projecting onto Kobayashi and Tamano a slide of the commercial design project that Nakanishi did for Asahiuma brand matches (see figure 5.1). See Maeda Fujio, et al. eds., *Nikutai no hanran: Butô 1968: Sonzai no semiorojî* [Rebellion of the Body: Butoh 1968: Semiology of Being] (Keio University Research Center for the Arts and Arts Administration, 2009), 44.
6. For similar photos of the two with large pots on their heads, or wearing cowboy hats, see also respectively Morishita, *Hijikata Tatsumi no butô: Nikutai no shururearisumu, shintai no ontorojî* [Tatsumi Hijikata's Butoh: Surrealism of the Flesh, Ontology of the "Body"] (Okamoto Tarô Museum of Art and Keio University Research Center for the Arts and Arts Administration, 2004), 130; and Motofuji, *Hijikata Tatsumi to tomo ni*, 202.
7. Motofuji, *Hijikata Tatsumi to tomo ni*, 200.
8. The film strip, by Ôuchida Keiya, cannot be considered an entirely reliable recording of the performance, but has rather been reworked. For example, the sound continues seamlessly across cuts and there are mismatches between the sound and stamps. Thus the sound was most likely added professionally afterwards. I use the past tense in describing the dance, but the sound track may not reflect the actual sounds of the performance. For more on this dance see, Kurihara Nanako, "The Most Remote Thing in the Universe: A Critical Analysis of Hijikata Tatsumi's Butoh Dance." (Ph.D. diss., New York University, 1996), 226–40. Portions of the dance are available on a CD-ROM included in Morishita, *Hijikata Tatsumi no butô*, 200.
9. Hijikata was prone to doing things like this. Tanaka Min related the story of Hijikata employing Caucasian models as receptionists at a book publication party, and some people grumbling about being forced to use English when they registered for the party. Interview with the author, July 5, 2007.
10. *Goze* were blind beggar women who earned money by playing songs on the *shamisen*.
11. Tsugaru-jamisen is a type of *shamisen* (three-stringed lute) music associated with northern Japan.
12. Wooden sandals with strips of wood on the underside to elevate the wearer out of the mud.
13. See similar photos from *Gibasan* and *Fin Whale*, which were presented a month prior to "Twenty Seven Nights for Four Seasons" and were the predecessors to *Story of Smallpox*. Akita Senshû Museum of Art ed., *Hijikata Tatsumi ten*, 28; Tanemura Suehiro, et al. eds., *Hijikata Tatsumi butô taikan: Kasabuta to Kyarameru* [Hijikata Tatsumi: Three Decades of Butoh Experiment] (Yûshisha, 1993), 60–63, and 80–1; Keio Arts Center for the Arts and Arts Administration and Hijikata Tatsumi Memorial Archive eds., *Shiki no tame no nijûnanaban* [Twenty-seven Nights for Four Seasons] (Keio University Research Center for the Arts and Arts Administration, 1998), 22; Morishita, *Hijikata Tatsumi no butô*, 147.
14. The term "Hijikata Method" is contentious because many claim that butoh has no method. The first recorded use of the term was in "'Nihon no zen'eiteki na dansu—butô'—Shinpô intabyû, ripôto" *Bankûbaa shinpô* 22, No. 50 (Dec. 7, 2000). An alternate term is "notational butoh" (*butôfu*), see Hijikata Tatsumi Archive, *Hijikata Tatsumi*

Notational Butoh, translation and voice narration, Bruce Baird (DVD. Research Center for the Arts and Arts Administration and Research Institute for Digital Media and Content, Keio University, 2007).

15. Kobayashi Saga, interview with the author, July 4, 2007. The heavily tattooed characters were supposed to be mafia (yakuza) and cows. Compare this with the "Animal Exercise" in Method acting. Moni Yakim and Muriel Broadman, *Creating a Character: A Physical Approach to Acting* (Milwaukee: Hal Leonard Corporation, 1993), Chapter 10 "Animals."
16. For a detailed look at the images and ways that Hijikata used them (including direct borrowings from paintings for "Twenty-seven Nights for Four Seasons") see Kurt Wurmli, "The Power of Image: Hijikata Tatsumi's Scrapbooks and the Art of Butoh," (Ph.D. diss., University of Hawai'i at Manoa, 2008), (176, 186–89, 191, 254, and 272).
17. Kobayashi Saga, interview with the author, May 25, 2002.
18. This comes at roughly one hour and three minutes in the dance. A photograph of the end of this sequence is in Tanemura et al eds., *Hijikata Tatsumi butô taikan*, 78–79.
19. Wurmli writes of Hijikata "borrowing and replicating an image" and "borrowing and adapting parts of an image." Wurmli, "The Power of Image," 175, 178.
20. Hijikata Tatsumi, unpublished notebook, "Beggars; Material for Hanako," 8. The Hijikata Tatsumi Archive at Keio University has paginated the notebooks in the archive. Many of the notebooks have titles, but the archive has named the untitled notebooks to reflect their content. I have followed the archive's pagination and titles.
21. Hijikata, "Beggar," 8–11. On successive pages, Hijikata (or his scribe) has circled three figures, and also assigned letters or numbers to fifteen figures. Kobayashi Saga identified the beggar marked with an "E" as one of the ones used in *Story of Smallpox*.
22. Kobayashi Saga, interview with the author, May 25, 2002. No reproduction of the Mayan paintings Hijikata looked at exists in the extant notebooks.
23. This pose was first introduced in the 1970 dance "Hijikata Tatsumi Burnt Sacrifice Great Mirror of Dance (Supplement) Simultaneous Display of the Collection." See Motofuji, *Hijikata Tatsumi to tomo ni*, 197. See also Alix de Morant, "*Hôsôtan* dairokuba: *Bokushin no gogo* e no henka" ["Hôsôtan," Sixième Tableau: En Écho à "L'Apres Midi d'un Faune"], Japanese trans. by Patrick deVos and Yokoyama Yoshiyuki, in Morishita, *Hijikata Tatsumi no butô*, 154–55; and the "Black Mayan" in *Shiki no tame no nijû-nanaban* (Keio University Research Center for the Arts and Arts Administration, 1998), 22–23.
24. See Hijikata Tatsumi Archive, *Hijikata Tatsumi Notational Butoh*. Translation and voice narration by Bruce Baird. DVD. Research Center for the Arts and Arts Administration and Research Institute for Digital Media and Content, Keio University, 2007. See also the drawings in Hans Bellmer, *Note au sujet de la jointure a boule* (Paris: Cnacarchive, 1971), 42.
25. See Wurmli's "adopting and image" and "adopting parts of an image." Wurmli, "The Power of Image," 184, 191.
26. Kobayashi Saga, interview with the author, July 4, 2007. The word "prostitute" translates several words of varying levels of euphemism: *hashitame*, *geisha*, and *jorô*. *Hashitame* (literally "margin woman") clearly indicates a sex worker. *Geisha* originally indicated an entertainer (either male or female), but soon came to designate female entertainers who were skilled in various performing arts. There are indications that geisha were not *legally* sex workers, but many geisha provided sexual services and many

non-geisha advertised themselves as geisha, leading to confusion. The word *jorô* can be used as a general term for "woman," but in practice is used for sex workers—as in the phrase *jorô-craziness* (becoming infatuated with a prostitute and visiting the red-light district often). For more information see Ayako Kano, *Acting Like a Woman in Modern Japan: Theater, Gender, and Nationalism* (New York: Palgrave, 2001), 42–45; 242 (fn. 13); and Cecilia Segawa Seigle, *Yoshiwara: The Glittering World of the Japanese Courtesan* (Honolulu: University of Hawaii Press, 1993). Kurihara notes that *goze* would have traveled in groups of three. "The Most Remote Thing," 210. Incidentally, there are indications that *goze* would also engage in prostitution.

27. See Richard Lane, *Images of the Floating World: The Japanese Print* (New York: Putnam, 1978), 187. "O-Kane was a legendary amazon and courtesan of Lake Biwa, renowned for her feat of subduing a wild horse with one stamp of her sandal; she appears several times in ukiyo-e."
28. I shall revisit the depth of performance in the next chapter.
29. *HTZ* 1: 169. These may be fictional incidents. It is hard to imagine that Hijikata's mother actually strapped four children on her back and carried them five miles.
30. The synesthesia of the passage matches the multisensory experience of the dance. —The mother runs onomatopoeically ("don don don don") while breathing heavily ("haa haa"); then scampers away ("dadada") followed by the father's rapping feet ("kon kon kon"). These may be echoed in the dance in the percussive clomping *geta*.
31. Robert Bethune, "Describing Performance in the Theatre: Kabuki and the Western Acting Student," *TDR* 33, no. 4 (Winter 1989): 150–1.
32. Kurihara, on the other hand, reads the moment in *Masseur* when the men kneel in front of the aged *shamisen* players as a return of the prodigal son to his aged mother. See "The Most Remote Thing," 227.
33. In fact the sound, *shi*, can conservatively mean about 200 different things.
34. Motoori Norinaga was an eighteenth century nativist scholar who sought to isolate an authentic Japanese sensibility as opposed to imported Confucianism. Given the fragmentary nature of the documentation of the dance, it is not possible to say what connection there is between "Norinaga" and the other elements of the dance that are ethnically coded as Japanese or Asian, such as the rickshaw, the physiognomy chart and the photo of Hanayagi.
35. However, this layering may have been on Hijikata's mind long before *Rose-colored Dance*. In his 1960 resume for the Jazz Cinema Experimental Laboratory, he wrote: "established experience dance, studied naked movement, and then went on to rose-colored dance, dance of darkness, layering methods, mold walk, back, erased face, and others." In light of the first "Hijikata Tatsumi DANCE EXPERIENCE Gathering," it is relatively easy to assign correlations to most of this list ("experience dance," "naked movement," "mold walk, back, erased face"), but "layering methods" (*kasanaru mesôdo*) is opaque. This could possibly refer to one man lying atop another and sodomizing him, or to the repetition of actions, but perhaps it also indicates that Hijikata was thinking about layering movement or meaning from early in his career. Hijikata Tatsumi Archive ed., *Hijikata Tatsumi "Butô" shiryôshû dai ippo* [Hijikata Tatsumi "BUTOH" Materials] (Keio University Research Center for the Arts and Arts Administration, 2004), 56.
36. Kurihara, "The Most Remote Thing in the Universe," 77.
37. Nishi Tetsuo, "Kore ga mokoto no geijutsu da: Gaitô ni odori deta ankoku buyô" [This is Real "Art": The Dance of Darkness Takes to the Streets] *Kokusai Shashin Jôhô* 34, no. 10 (Oct. 1960): 65.

6 THE POSSIBILITY BODY: EMBODYING THE OTHER, NEGOTIATING THE WORLD

Epigraph: John Keats, Letter "To Percy Bysshe Shelley: 16 August 1820," in Grant F. Scott ed., *Selected Letters of John Keats* (Cambridge, MA: Harvard University Press, 2002), 464.

1. See among others Marie-Gabrielle Rotie, "The Reorientation of Butoh" *Dance Theater Journal* 13, no. 1 (1996): 35, in which she speaks of the "extraordinary ability [of Eiko and Koma] to transform their bodies into elemental and animistic forces," and then says, "What distinguishes these performers is the striving to be the image rather than to act or interpret it."
2. Ethan Hoffman, et al. *Butoh: Dance of the Dark Soul* (New York: Aperture Foundation, 1987), 18.
3. Mikami Kayo. *Utsuwa toshite no Shintai: Ankoku butô gihô e no apurôchi* [Body as Receptacle: An Approach to the Techniques of Ankoku Butoh] (ANZ-Do, 1993), 81–82.
4. Hijikata Tatsumi, "Watashi ni totte erotishizumu to wa inu no jômyaku ni shitto suru koto kara," [For Me, Eroticism Comes From Being Jealous of a Dog`s Vein]. *Bijutsu Techô* 21, no. 312 (May 1969): 126.
5. See Lee Chee Keng, "Hijikata Tatsumi and Ankoku Butoh: A Body Perspective." Master's thesis. (National University of Singapore, 1998) 25–28; Mikami, *Utsuwa*, 81–83; and Kurihara, "The Most Remote Thing in the Universe: A Critical Analysis of Hijikata Tatsumi's Butoh Dance." (Ph.D. diss., New York University, 1996), 103, in which she quotes Ashikawa as telling the dancers, "Erase your self-consciousness" and "Abandon self-consciousness."
6. It is beyond the scope of this book, but a consideration of the racial politics of the early dances would be very informative.
7. Motofuji Akiko, *Hijikata Tatsumi to tomo ni* [Together with Hijikata Tatsumi] (Chikuma Shobô: 1997), 31.
8. Yoshimura Masanobu, "Haireveru na supekutoru" [High Level Specter]. *Bijutsu Techô* 38, no. 561 (May 1986): 56–57.
9. Motofuji Akiko and Ôno Yoshito, "Otto toshite no Hijikata, shi toshite no Hijikata" [Hijikata as Husband; Hijikata as Teacher]. *Geijutsu Shinchô* 49, no. 579 (March 1998): 21. For a picture of the cracked and flecked thick body paint, see Morishita Takashi and Yamazaki Yôko eds., *Bijutsu to butô no Hijikata Tatsumi ten* [Hijikata Tatsumi Exhibition: Art and Butô] (Ito, Shizuoka: Ikeda Musuem of 20th Century Art, 1997), 21. See also fig. 3.12.
10. Yoshioka Minoru, *Hijikata Tatsumi shô* [Admiring Hijikata Tatsumi: Through Journals and Quotations] (Chikuma Shobô, 1987), 109; and Yamada Ippei, *Dansaa*, [Dancer] (Ôta Shuppan, 1992), 120.
11. Yoshioka Minoru, *Hijikata Tatsumi shô*, 109.
12. It would be characteristic of Hijikata to have had more than one meaning for the make-up. Morishita Takashi says that Hijikata usually meant something by everything he did or said, but it is not clear whether he meant the same thing each time. Conversation, December 6, 2000.
13. Hijikata Tatsumi, "Notes by Tatsumi Hijikata," in Jean Viala and Nourit Masson-Sekine eds., *Butoh: Shades of Darkness* (Tokyo: Shufunotomo, 1988), 185.
14. Proust's novel, written from 1913–1927, had been translated as early as 1934, while Huysmans's much earlier novel (1884), was not translated until 1962. It is not possible

to determine which book Hijikata read first, although Kurihara notes Hijikata's interest in and allusion to Proust—as in the subtitle of *Rose-colored Dance*: *A la Maison de M. Civecawa*. Kurihara, "The Most Remote Thing," 74.

15. Kasai says that he discussed Huysmans's *Against Nature* with Hijikata for three hours the first time they met in 1963. Kasai Akira, "Hijikata Tatsumi wo kataru: Ishiki no henkaku wo mezashita butôka" [Talking about Hijikata Tatsumi: A Dancer who Wanted to Change Consciousness]" in Morishita, *Hijikata Tatsumi no butô: Nikutai no shururearisumu, shintai no ontorojî* [Tatsumi Hijikata's Butoh: Surrealism of the Flesh, Ontology of the "Body"] (Okamoto Tarô Museum of Art and Keio University Research Center for the Arts and Arts Administration, 2004), 55.

16. Joris-Karl Huysmans, *Against Nature*, trans. Robert Baldick and Patrick McGuinness (London: Penguin Classics, 2003), 47.

17. Marcel Proust, *Remembrance of Things Past* (New York: Vintage, 1982), 48–51.

18. Mikami, *Utsuwa*, 131. Mikami does not give a citation for the quotation. Hijikata may have said it in a training session.

19. Hijikata, "Notes by Tatsumi Hijikata," in Jean Viala and Nourit Masson-Sekine eds., *Butoh: Shades of Darkness* (Tokyo: Shufunotomo, 1988), 185.

20. The information in the following pages (except where otherwise explicitly noted) comes from two interviews with Kobayashi Saga conducted on May 6 and May 25, 2002. The second of the two interviews was videotaped at a dance studio where she demonstrated movements while answering questions. I also taped interviews with Waguri Yukio. The main sources for the structure of Hijikata's late butoh are as follows: Yamada, *Dansaa*, 58–60; Mikami, *Utsuwa*. Kurihara, "The Most Remote Thing in the Universe." Waguri Yukio, *Butô Kaden*, CD-ROM and Booklet (Tokushima: Justsystem, 1998). Lee Chee Keng, "Hijikata Tatsumi and Ankoku Butoh"). Yamada was the first person to refer to the Hijikata's new experiments, but his analysis is quite short. Mikami lays out the structure of the dances the most clearly. She studied with Hijikata from 1978 to 1981 when he was not staging dances. This limits the value of her book with respect to Hijikata's individual dances. However, other dancers from different eras describe the dances much the same way she does. Kurihara's dissertation relied on her experiences studying butoh with Ashikawa Yôko, but she does not analyze the dance structure to the same degree as Mikami. The design of Waguri's CD-ROM renders it difficult to understand how the components fit together, but he shows short snippets of dance. Nakajima Natsu (one of the earliest and longest working dancers with Hijikata) has not written her own explication of butoh, but she collaborated with Lee Chee Keng on his Master's thesis, so his account can be taken to represent her understanding of the dance form.

21. Mikami, *Utsuwa*, 110. Here and elsewhere, in translating these instructions, I have tried as much as possible to render the flavor of these personal notations. Thus I have retained the bullets, dashes, slashes, and indentation that the dancers use to indicate the instructions for how to execute individual forms and arrows to indicate the sequence or connections between forms.

22. Mikami, *Utsuwa*, 118–19.

23. Mikami, *Utsuwa*, 182–183.

24. Mikami, *Utsuwa*, 114–117.

25. Mikami, *Utsuwa*, 150.

26. In a workshop, Waguri Yukio told a dancer that she was too focused toward the front of the stage and the audience and that she should strive to project in all directions. Waguri Yukio workshop with Camille Mutel, Oct. 1, 2009.

27. Mikami, *Utsuwa*, 175.

28. Kurihara, "The Most Remote Thing," 125–29.

29. Kurihara, "The Most Remote Thing," 109.
30. Mikami, *Utsuwa*, 119, 148.
31. Eugenio Barba, *The Paper Canoe: A Guide to Theatre Anthropology*, trans. Richard Fowler (New York: Routledge, 1995), 71–72.
32. Mikami, *Utsuwa*, 146.
33. Interview with Waguri Yukio, Sept. 2009.
34. See Hijikata Tatsumi, "Beggars," Unpublished and undated notebook, Hijikata Tatsumi Memorial Archive, Keio University Research Center for the Arts and Arts Administration, 8.
35. Mikami, *Utsuwa*, 122.
36. Mikami, *Utsuwa*, 177.
37. Sakurai Keisuke, *Nishiazubu dansu seminaa* [Nishiazabu Dance Seminar] (Parco, 1995), 211.
38. The comparison with Forsythe can be taken one more step to demonstrate that people are responding to similar situations in different parts of the world. One of Forsythe's techniques for creating new movements was to use parts of the body to spell out letters. Recall that Yoshito indicated that in *Forbidden Colors*, he was supposed to write something on the ground with his thumb in a jerky zig-zag motion. Moreover, Kobayashi Saga tells of a movement called 'Mountain" in which one uses one's shoulder to trace the silhouette of three mountains on the horizon. In practice this looks like the dancer is using her shoulder to make three little bumps. Kobayashi Saga, interview with the author, May 25, 2002.
39. Mikami, Utsuwa, 173–74. Keng has more information on the "Yardstick Walk." Keng, "Hijikata Tatsumi and Ankoku Butoh," 25–28.
40. Morishita Takashi, Lecture at Keio University Hiyoshi Campus, Dec. 7, 2000.
41. Barba, *The Paper Canoe*, 72.
42. Lee Strasberg, *A Dream of Passion: The Development of the Method* (New York: Plume, 1987), 85.
43. Strasberg, *A Dream*, 68.
44. Strasberg, *A Dream*, 115, 149–50.
45. Different actors had different conceptions of Method acting and the importance of emotional memory. See Sanford Meisner and Dennis Londwell, *Sanford Meisner On Acting* (New York: Vintage, 1987), for an account of a Method that does not include emotional memory, although it still includes personal adjustments that may not have anything to do with the action of the play itself, especially pp. 9 and 79.
46. Constantin Stanislavski, *An Actor Prepares*, trans. Elizabeth Reynolds Hapgood (New York: Routledge, 1964), 11–14.
47. See, for example, Foster Hirsh's discussion of the economic forces on the Actors Studio in *A Method to Their Madness: A History of the Actors Studio* (Cambridge, MA: Da Capo Press, 2002), 120.
48. Kurihara, "The Most Remote Thing," 141–44.
49. See Nancy Allison, *The Illustrated Encyclopedia of Body-mind Disciplines* (New York: Rosen Publishing Group, 1999), especially Chapters IX ("Movement Therapy Methods") and X ("Somatic Practices").
50. Lulu Sweigard, *Human Movement Potential: Its Ideokinetic Facilitation* (New York: Harper and Row, 1974), 239; and Vernon Howard, *Artistry* (Indianapolis: Hackett, 1982), 46–47.
51. I have put this account together from various sources including conversations with students of Noguchi such as Arai Hideo, but see Noguchi Michizô, *Noguchi taisô: omosa ni kiku* [Noguchi Exercises: Learning from Weight] (Shunjusha, 2002), 3–27;

Noguchi Michizô, *Genshô seimeitai to shite no ningen: Noguchi taisô no riron* [Humans as Primal Life-bodies: The Theory of Noguchi Exercises] (Iwanami Shoten, 2003 [1972]), Hattori Misao ed., *Noguchi taisô: kotoba ni kiku, Noguchi Michizô goroku* (Shunjusha, 2004), and Fukumoto Maaya, "Ideokineshisu to Noguchi taisô no hikaku kenkyû: tsûru toshite no imêji no yakuwari ni chakumoku shite" [A Comparative Study on Ideokinesis and Noguchi-Taiso: with Attention to the Different Roles of Images as Tools] *Geibun* (Toyama daigaku geijutsu bunka gakubu kiyô) 5 (Feb. 2011): 114–25.
52. Noguchi Michizô, *Genshô seimeitai to shite no ningen*, 194, 198, 210.
53. See Lucia Schwellinger, *Die Entstehung des Butoh: Voraussetzungen und Techniken der Bewegungsgestaltung bei Hijikata Tatsumi und Ôno Kazuo* (Munchen: Iudicium, 1998), 114. See also, among others, the various photographs in the appendix of Joan Laage's dissertation, "Embodying the Spirit: The Significance of the Body in the Japanese Contemporary Dance Movement of Butoh." (Ph.D. diss., Texas Woman's University, 1993).
54. Conversation with Maro Akaji, April 12, 2002. See also Schwellinger, *Die Entstehung des Butoh*, 113. "The discontinuity in the flow of movement can be observed particularly in Hijikata's early seventies dances, in which frequently the motion of the entire body ceases for a moment."
55. The companies Sankai Juku, Dairakudakan, and Goosayten have all used this exercise.
56. Kurihara, "The Most Remote Thing," 120–21.
57. It apparently does this by activating more regions of the brain than simply telling someone (or oneself) to do something. See Eric N. Franklin, *Dynamic Alignment Through Imagery* (Champaign, IL: Human Kinetics, 1996), 34.
58. Mikami, *Utsuwa*, 134.
59. See for example, Takeo Doi, *The Anatomy of Self: The Individual Versus Society*, trans. Mark A. Harbison (New York: Kodansha America, 2001), Chapter 2, "Tatemae and Honne."
60. For the idea that languages impel what we are required to take in account at every moment, see Guy Deutscher, *Through the Language Glass: Why the World Looks Different in other Languages* (New York: Henry Holt, 2010), especially "The Language Lens."
61. David Harvey, *The Condition of Postmodernity: An Enquiry into Origins of Cultural Change* (Malden, MA: Blackwell Publishing, 1990), 300–1.
62. For an example of fantasy fulfillment, see the discussion of the experience of Euro-American gay men in Japan in John Whittier Treat's *Great Mirrors Shattered: Homosexuality, Orientalism and Japan* (Oxford: Oxford University Press, 1999). For the continuing presence of American soldiers see Chalmers A. Johnson, *Blowback: the Costs and Consequences of American Empire* 2nd ed., (New York: Metropolitan Books/ Henry Holt, 2010), 34–64.
63. Marilyn Ivy, *Discourses of the Vanishing: Modernity, Phantasm, Japan* (Chicago: University of Chicago Press, 1995), 34.
64. Mikami, *Utsuwa*, 107–8.
65. I am indebted here to Jameson's notion of the "colonization of the unconscious." Fredrick Jameson, *Signatures of the Visible* (New York: Routledge, 1992), 202; and Fredrick Jameson, *Jameson on Jameson: Conversations on Cultural Marxism* (Durham, NC: Duke University Press, 2007), 80.
66. Mikami, *Utsuwa*, 187.
67. Mikami, *Utsuwa*, 188–89. The original is completely punctuation free, and has segments of text separated by single spaces. Once again, in order to retain this quality,

I have omitted all punctuation (except where the English demands commas) and inserted a double space between what appear to be units. A hard return without indentation indicates that in the original the next phrase started at the top of a new column. I have added the line numbers for ease of reference in the subsequent paragraph.

68. Mikami, *Utsuwa*, 84–91.
69. Mikami, *Utsuwa*, 114.
70. Wurmli, Kurt, "The power of image," 105–9.
71. Wurmli, 186–91. See also Michael Peppiatt, *Francis Bacon: Anatomy of an Enigma* (New York: Skyhorse Publishing, 2009), 305, for an account of the way that Bacon was an outcast from his family because he was a homosexual.
72. Kitano Ryuichi, "The End of Isolation: Hansen's Disease in Japan" *Harvard Asia Quarterly* 6, no. 3 (Summer 2002): 40, 43.
73. Kuniyoshi Kazuko, "Butoh in the Late 1980s," trans. Richard Hart, Kobo Butô, http://www.xs4all.nl/~iddinja/butoh , p. 6 (accessed Nov. 16, 2002). Also in *Notes* (Netherlands Institute for Dance) Nov. 1991: 11–17.
74. See Jill Dolan, *The Feminist Spectator as Critic* (Ann Arbor, MI: UMI Research Press, 1998), 1 and 48.
75. The connection between cubism and butoh has usually been construed differently: the strange facial contortions of Ashikawa have been taken as an attempt to embody the cubism of paintings like De Kooning's *Marilyn Monroe* (1954) and *Woman I* (1952) found pasted in Hijikata's "Avalanche Candy Scrap Book" (*HTZ*, 2: 225, 230). See Uno Kuniichi, "Hijikata Tatsumi no sokuryô" [Surveying Hijikata Tatsumi], *Buyôgaku* 24 (2001): 59. Strictly speaking, De Kooning's style was abstract expressionism, but he was modifying cubist forms, and Hijikata was looking at De Kooning and other more orthodox cubist painters. I approach cubism from the other side, the side of trying to look from multiple perspectives simultaneously.
76. Walter Benjamin, "On Some Motifs in Baudelaire," in *Illuminations*. Edited by Hannah Arendt. Translated by Harry Zohn (New York: Shocken, 1969), fn. 8, p. 197.
77. Mikami, *Utsuwa*, 151.
78. Mishima Yukio, "Kiki no buyô," [Crisis Dance] in Morishita, *Hijikata Tatsumi no butô*, 16. Translated by Kobata Kazue as "Kiki no Buyou: Dance of Crisis." In Jean Viala and Nourit Masson-Sekine eds., *Butoh: Shades of Darkness* (Tokyo: Shufunotomo, 1988), 16.

7 METAPHORICAL MISCEGENATION IN MEMOIRS: HIJIKATA TATSUMI IN THE INFORMATION AGE

Epigraph: Kenneth Koch, *Days and Nights* (New York: Random House, 1982), 46.

1. *HTZ* 1: 11. I have translated literally in order to retain the flavor of the surrealistic prose.
2. The *sôra* of the opening sentence could be a variant of *sora* meaning "this," "sky," or "hey," yielding the following possibilities: "Hey, look!" "Look at that!" or "Look at the sky."
3. Hijikata probably intended a resonance between reincarnation and transformation.
4. Hijikata Tatsumi, "Yameru Maihime: Initial Serialization," *Shingeki* 24, no. 288 (April 1977): 97.

5. Lest one think that this was an anomaly, Hijikata had presented competing versions of quotations seventeen years earlier in his career. In April, 1960, in the program for the Second Female Avant-gardists Dance Recital, Hijikata wrote: "Hook your stomach up in order to turn your solar plexus into a terrorist!—Letter to the psychic Eileen Garett (from the dancer Hijikata Tatsumi)" (Hijikata Tatsumi Archive ed., *Hijikata Tatsumi "Butô"shiryôshu: Dai Ippo*, 56). He recycled the quotation in the opening of the essay "Material," which reads: "You have to pull your stomach up high in order to turn your solar plexus into a terrorist. That is a line from a letter I sent to Ms. Elian Margaret" (*HTZ*, 1: 187; translation modified from *WB* 36). Hijikata commonly used pseudonyms to refer to various people, so "Elian Margaret" or "Aileen Garett" need not be the actual names of a person. Motofuji says that Hijikata used the name "Elian Margaret" to indicate a woman, Onrai Sahina, with whom he collaborated.
6. Kurihara Nanako, "Hijikata Tatsumi: The Words of Butoh," *TDR* 44.1, (Spring 2000): 24. Miryam Sas, *Fault Lines: Cultural Memory and Japanese Surrealism* (Stanford: Stanford University Press, 1999), 169–72.
7. The *ni* here could either be short for *ni yotte* in which case the parceling would be carried out through the observations, or show the end point of the parceling in which case the body would be parceled into some observations. The first seems more likely.
8. *HTZ*, 1: 54.
9. Controlling for the number of words per page, I counted the number of *garu*s and *tagaru*s in a random thirty-page sample from Hijikata and compared his usage with samples from Japanese writers Oe Kenzaburô, Enchi Fumiko, and Natsume Soseki. Hijikata used *garu* for the I or the self ten times in thirty pages, while the others never used it in this way.
10. The example is modified from Samuel Martin, *A Reference Grammar of Japanese*, (Rutland, VT: Tuttle, 1987), 358.
11. Hijikata had already used a similar technique in an earlier essay: "This I breathing nearby will make the faraway I who, paralyzed with cold, no longer knows whose ancestor he is, aware of himself as one virginal body." It is almost as if the narrator stands at a remove from a nearby self, and a spatially or temporally distant self, and surveys both. Hijikata Tatsumi, "Watashi ni totte erochishizumu wa inu no jômyaku ni shitto suru koto kara," [For Me, Eroticism Comes From Being Jealous of a Dog's Vein]. *Bijutsu Techô* 21, no. 312 (May 1969): 129.
12. The I-novel was a turn-of-the-century development in Japanese fiction stemming in part from European naturalism. It was supposed to be autobiographical and "represent with utter conviction the author's personal experience." Edward Fowler, *The Rhetoric of Confession: Shishôsetsu in Early Twentieth Japanese Fiction* (Berkeley: University of California Press, 1988), xvi.
13. Fowler *The Rhetoric of Confession*, 39.
14. *HTZ* 1: 110–11.
15. In comparison with other authors (Oe, Enchi, and Soseki) in random thirty-page excerpts, Hijikata used *rashisa*-type constructs (*yô/rashii/mitai/gotoku*) three-to-four times more than any other author and twenty times the number of *tari*s.
16. *HTZ* 1: 31, my emphasis.
17. HTZ 1: 35, my emphasis.
18. Mishima Yukio, "Kiki no buyô," [Crisis Dance] in Morishita, *Hijikata Tatsumi no butô*, 16. Translated by Kobata Kazue as "Kiki no Buyou: Dance of Crisis," in Jean Viala

and Nourit Masson-Sekine eds., *Butoh: Shades of Darkness* (Tokyo: Shufunotomo, 1988), 16.
19. Nakanishi Natsuyuki, "Teate to fukushû: butô no ashi no ura" [Treatment and Review: The Undersoles of Butô], *Bijutsu teichô* 38, no. 561 (May 1986): 71. See also "Notes by Natsuyuki Nakanishi," in Jean Viala and Nourit Masson-Sekine eds., *Butoh: Shades of Darkness* (Tokyo: Shufunotomo, 1988), 190.
20. Kuniyoshi Kazuko, "Butôfu shiron: Hijikata tatsumi no shiryô kara" (An Essay on the Butoh-fu: From the Scrap Books of Tatsumi Hijikata), *InterCommunication* 29 (Summer 1999): 86–87.
21. *Kanjigen.* s.v. "蛙 (a, wa, e, kaeru, kawazu)."
22. Kuniyoshi Kazuko, "Butôfu shiron," 86–87.
23. Sas, *Fault Lines*, 110–11.
24. Andre Breton, *What is Surrealism: Selected Writings*, ed., Franklin Rosemont, (New York: Pathfinder, 1978), 162, 165–66.
25. In conjunction with a dance form that provides its audience with physical experiences by shocking them or making them uncomfortable, Hijikata's writings can be seen as striving in the same direction. Just as Hijikata required the reader to modify "hunting dog" with "translator of the wind," Hijikata require his dancers to subject movements to various mental constraints in order to modify the movements. As noted previously, the dancers were required to spread their concentration out to as many as seventeen mental instructions for executing a movement, or to combine disparate mental conditions into one movement, such as imagining eyes on their fingertips while playing the role of a mendicant. Subjecting a movement to two different constraints such as imagining the sensation of light extending under the nose while imagining being observed from a bird's-eye view is similar to the reader's task of trying to reconcile "hunting dog" and "translator of the wind."
26. *HTZ*, 1: 141–42.
27. See the discussion of "Grave Watchman" in chapter 7.
28. *HTZ*, 1: 11.
29. *HTZ*, 1: 25, my emphasis.
30. Slavoj Zizek, "Introduction: Alfred Hitchcock, or, The Form and its Historical Mediation," in Slavoj Zizek ed., *Everything You Always Wanted to Know about Lacan (But Were Afraid to Ask Hitchcock)*, (New York: Verso, 1992), 6.
31. *HTZ*, 1: 25
32. This category of enwrapping words (haze, fog, mist) is also related to Hijikata's conception of the body in which the body is minutely sensed, fragmented, and compartmentalized. Hijikata often used such words in training, and in the instructions for movements, in order to enable the dancers to spread their concentration through, over, and outside their bodies.
33. *HTZ* 1: 23.
34. *HTZ* 1: 36
35. *HTZ* 1: 113.
36. *HTZ* 1: 114. This is a popular children's song "Black Kite" written by Kuzuhara Shigeru (lyrics) and Yanada Tadashi (music).
37. *HTZ* 1: 70
38. See James C. Spall, *Introduction to Stochastic Search and Optimization: Estimation, Simulation and Control* (Hoboken, NJ: John Wiley and Son, 2003), sects. 1.1, 1.2 and 10.6. A simple search for "stochastic method" in Google or on any of the scientific databases (such as Pubmed) yields tens of thousands of hits bespeaking the centrality of it for the scientific process.

39. Kurihara, "The Words of Butoh," 17. Kurihara cites the influential dance critic for the *New York Times* Anna Kisselgoff and Vickie Sanders. Anna Kisselgoff, "Japan's New Dance Is Darkly Erotic." *The New York Times*, July 15, 1984, sec. 2, and Vickie Sanders, "Dancing and the Dark Soul of Japan: an Aesthetic Analysis of Butoh," *Asian Theatre Journal* 5, no. 2 (Fall 1988): 148. A LexisNexis Academic search for "butoh" and "atomic bomb" picks up many other articles that echo Kisselgoff's interpretation.
40. See for example A. O. Scott's reference to the "familiar Hollywood archetype" of the "lone white racist who exists to soothe the consciences of the white audience with the fiction that racism is caused by maladjusted individuals, rather than by systemic injustice." A. O. Scott, "A 'Mind' Is a Hazardous Thing to Distort: When Films Juggle the Facts" *The New York Times*, 21 March 2002, sec. E.
41. *Saturday Night Live: The Best of Eddie Murphy*, (Vidmark/Trimark, 1998), videocassette.
42. For example, see Dower, *Embracing Defeat, : Japan in the Wake of World War II* (New York: W.W Norton/The New Press, 1999), 197; 493.
43. All that having been said, to the extent that butoh deals with pain, there is nothing in principle that would stop a person from creating a dance about the atomic bomb, as the bomb produced a tremendous amount of suffering. The parents of Osuka Isamu, the founder of the company Byakkosha, lived in Hiroshima at the time of the bomb, and he has consistently maintained that his dances addressed the bomb.
44. Hijikata Tatsumi, "Kyokutan na gosha: Hijikata Tatsumi shi intabyu" [The Extreme Luxury: Interview of Hijikata Tatsumi). W-NOtation, 2 (July 1985): 17. *WB* 20.
45. Michel Foucault , "Technologies of the Self," in Luther Martin ed., *Technologies of the Self: A Seminar with Michel Foucault* (Amherst: University of Massachusetts Press, 1988), 40.
46. For "all and each" see Michel Foucault, *Security, Territory, Population: Lectures at the College de France 1977—1978* (New York: Macmillan, 2009), 95, 129–30, 166–68.
47. Michel Foucault, *Security, Territory, Population,* 18.
48. Karatani Kojin, "One Spirit, Two Nineteenth Centuries," in Masao Miyoshi and H. D. Harootunian eds., *Postmodernism and Japan* (Durham, NC: Duke University Press, 1989), 265–271.
49. Leslie Pincus, "In a Labyrinth of Western Desire: Kuki Shuzo and the Discovery of Japanese Being," in Masao Miyoshi and H. D. Harootunian eds., *Japan in the World* (Durham, NC: Duke University Press, 1993), 234. See also Leslie Pincus, *Authenticating Culture in Imperial Japan: Kuki Shūzō and the Rise of National Aesthetics* (Berkeley and Los Angeles, CA: University of California Press, 1996), 21.
50. See Lucia Schwellinger, *Die Entstehung des Butoh: Voraussetzungen und Techniken der Bewegungsgestaltung bei Hijikata Tatsumi und Ôno Kazuo* (Munchen: Iudicium, 1998), 110–11.
51. See Kurt Wurmli, "The Power of Image: Hijikata Tatsumi's Scrapbooks and the Art of Butoh." (Ph.D. diss., University of Hawai'i at Manoa, 2008), 179, 254, and 258.
52. Wurmli, "The Power of Image," 200–2.
53. John A. Tucker, "Anime and Historical Inversion in Miyazaki Hayao's *Princess Mononoke*" *Japan Studies Review* 7 (2003): 68.
54. Tucker, "Anime and Historical Inversion," 70. See also Susan J. Napier, *Anime from Akira to Princess Mononoke* (New York: Palgrave, 2001), 175–77.
55. See David Goodman, "*Concerned Theatre Japan* Thirty Years Later: A Personal Account," in Stance Scholz-Ciona and Samuel Leiter eds., *Japanese Theatre and the International Stage* (Boston: Brill, 2001), 348–49; and Jacob Raz, "Foreword: The

Turbulent Years," in Jean Viala and Nourit Masson-Sekine eds., *Butoh: Shades of Darkness* (Tokyo: Shufunotomo, 1988), 14–15.

8 EPILOGUE: THE EMACIATED BODY IN THE WORLD

Epigraph: Patrick Donnelly, from "Prayer over Dust," *The Charge* (Keene, NY: Ausable Press, 2003), 69–70.

1. Four dances from the later period survive on film: *Human Shape* (1976), *Costume en Face: a Primer of Blackness for Young Boys and Girls* (1976), *Lady on a Whale String* (1976), and *Tôhoku Kabuki Plan Four* (1985). I have been unable to procure photographs for *Human Shape*, so I have included photographs from *Lady on a Whale String*. If the "Lady" of the title is an indication that the dance concerns the life of a woman, *Lady on a Whale String* may have parallels with *Human Shape* beyond structural ones.
2. Due to copyright concerns, it was very difficult to see these dances until 2009, so I have been unable to sit down with Hijikata's dancers and view the dances with them, and talk about them. On October 1, 2009, I had a brief chance to watch selected clips of *Human Shape* with Hijikata's dancer Waguri Yukio. This was only enough time to ascertain that there was indeed an entire mental universe behind the movements. In scene ten, Waguri said that he and the other four dancers on the dais behind Ashikawa were executing a pose called the "Turner." This was modeled after paintings by J. M. W. Turner. Hijikata was drawn to the diffuse paintings of Turner's later years (1830's and 1840's), and often asked his dancers to try to replicate the diffuseness of the paintings within themselves.
3. Kurihara Nanako, "The Most Remote Thing in the Universe: A Critical Analysis of Hijikata Tatsumi's Butoh Dance." (Ph.D. diss., New York University, 1996), 90–91, 220–23.
4. Gôda Nario, "Shizukesa to yutakasa to: Hakutôbô kôen" [Quietness and richness: Hakutôbô Performance], *Shûkan on sutêji shinbun* 16 July 1976; and Gôda Nario, "Butô no dôshi 12," *Gendaishi techô* 28, no. 6 (May 1985): 100. It is not possible to tell if Gôda arrived at this interpretation based on conversations with Hijikata.
5. Kurihara, "The Most Remote Thing in the Universe," 221.
6. Kurihara, "The Most Remote Thing in the Universe," 223. Ashikawa writes that one of her favorite roles was "Queen of the execution place." Ashikawa Yôko, "Watashi no odotta suki na yakugara" *Gendaishi techô* 20, no. 4 (April 1977): 74.
7. Jean Viala and Nourit Masson-Sekine, *Butoh: Shades of Darkness* (Tokyo: Shufunotomo, 1988), 92.
8. Personal conversation with one of his dancers.
9. Hijikata Tatsumi, "Wind Dharma," *Gendaishi techô* 28, no. 6 (May 1985): 70. *WB* 72.
10. Hijikata, "Wind Dharma," 72. *WB* 74.
11. Takeda Kenichi, "Yôzumi to natta nikutai to shintai no rika,"108.
12. Tamah Nakamura, "Beyond Performance in Japanese Butoh Dance: Embodying Re-Creating of Self and Social Identities." (Ph.D. Dissertation, Felding Graduate University, 2007).
13. Nakamura, "Beyond Performance," 85–86.
14. Nakamura translates this as "a space or time to reflect on herself and witness others."
15. Nakamura, "Beyond Performance," 87.

16. Nakamura points out that there were still unspoken conventions and customs at work in the group. The participants were not allowed by the unwritten rules of the group to claim technical superiority, and when it came time for a performance, they sorted themselves into a hierarchy. See Nakamura, "Beyond Performance," 75–77.
17. Mishima committed suicide in front of Japan's Self Defense Forces to try to urge them into an uprising to seize power.

Bibliography

Note on the bibliography: In an attempt to reach a wider audience, the publishers of several of the museum catalogues and books on butô have included an English title which is not a direct translation of the Japanese title. I have given the original Japanese title, but then used the English title provided rather than translate the Japanese title. Japanese books without a specific place of publication were published in Tokyo.

Akasegawa Genpei. "Asubesutokan wo meguru" [Encountering Asbestos Hall]. *Shingeki* 33, no. 396 (March 1986): 36–38.

———. "Namaniku de tsutsunda konpyutâ" [Computer Wrapped in Flesh]. *Geijutsu Shinchô* 49, no. 579 (March 1998): 46–47.

Akita Senshû Museum of Art, ed. *Hijikata Tatsumi ten: Kaze no metamorufôze* [Hijikata Tatsumi Exhibition: Metamorphosis of the Wind:]. Akita: Akita Senshû Museum of Art, 1991.

Allison, Anne. *Millennial Monsters: Japanese Toys and the Global Imagination.* Berkeley: University of California Press, 2006.

Allison, Nancy. *The Illustrated Encyclopedia of Body-mind Disciplines.* New York: Rosen Publishing Group, 1999.

Amagasaki Akira. *Geijutsu toshite no shintai* [Body as Art]. Keisô shobô, 1988.

———. *Media no Genzai* [The Current State of Media]. Perikansha, 1991.

Anderson, Benedict. *Imagined Communities: Reflections on the Origin and Spread of Nationalism.* New York: Verso, 1991.

Appadurai, Arjun. *Modernity at Large: Cultural Dimensions of Globalization.* Minneapolis: University of Minnesota Press, 1996.

Artaud, Antonin. *Heliogabalus, Or, The Anarchist Crowned.* Translated by Alexis Lykiard. London: Creation Books, 2003.

———. *Le Théâtre et Son Double, Suivi de: le Théâtre de Séraphin.* Paris: Gallimard, 1972. Translated by Mary Caroline Richards as *The Theater and its Double.* New York: Grove Press, 1958.

Ashikawa Yôko. "Watashi no odotta suki na yakugara" [My Favorite Roles]. *Gendaishi techô* 20, no. 4 (April 1977): 74–75.

Auslander, Philip. *From Acting to Performance: Essays in Modernism and Postmodernism.* New York: Routledge, 1997.

Banes, Sally. "The Choreographic Methods of the Judson Dance Theater." In *Moving History / Dancing Cultures: A Dance History Reader.* Edited by Ann Dils and Ann Cooper Albright, 350–61. Middletown, CT: Wesleyan University Press, 2001.

———. *Democracy's Body: Judson Dance Theater, 1962–1964.* Ann Arbor, MI: UMI Research Press, 1983.

———. "Is It All Postmodern?" *TDR* 36, no.1 (Spring 1992): 58–61.

Barba, Eugenio. *The Paper Canoe: A Guide to Theatre Anthropology.* Translated by Richard Fowler. New York: Routledge, 1995.

Barber, Stephen. *Artaud: Blows and Bombs.* London: Creation Books, 2003.

Barber, Stephen. *Hijikata: Revolt of the Body.* London: Creation Books, 2005.
———. "Tokyo's Urban and Sexual Transformations: Performance Art and Digital Cultures." In *Consuming Bodies: Sex and Contemporary Japanese Art.* Edited by Fran Lloyd, 166–85. London: Reaktion Books, 2002.
Bataille, Georges. *Eroticism: Death and Sensuality.* Translated by Mary Dalwood. San Francisco: City Lights Books, 1986.
Bellmer, Hans. *Note au sujet de la jointure a boule.* Paris: Cnacarchive, 1971, 42.
Benjamin, Walter. *Illuminations.* Edited by Hannah Arendt. Translated by Harry Zohn. New York: Shocken, 1969.
Bethune, Robert. "Describing Performance in the Theatre: Kabuki and the Western Acting Student." *TDR* 33, no. 4 (Winter 1989): 146–66.
Bourdieu, Pierre. *The Logic of Practice.* Translated by Richard Nice. Stanford, CA: Stanford University Press, 1990.
Breton, Andre. *What is Surrealism: Selected Writings.* Edited by Franklin Rosemont. New York: Pathfinder, 1978.
Buruma, Ian. *Inventing Japan: 1853–1964.* New York: Modern Library, 2003.
Calder, Kent E. *Crisis and Compensation: Public Policy and Political Stability in Japan, 1949–1986.* Princeton, NJ: Princeton University Press, 1989.
Camfield, William A. "Marcel Duchamp's *Fountain*: Its History and Aesthetics in the Context of 1917." In *Marcel Duchamp: Artist of the Century.* Edited by Rudolf E. Kuenzli and Francis M. Naumann, 64–95. Cambridge, MA: MIT Press, 1989.
Copeland, Roger. "Is it Post-Postmodern?" *TDR* 36, no.1 (Spring 1992), 64–67.
———. *Merce Cunningham: the Modernizing of Modern Dance.* New York: Routledge, 2004.
Cortázar, Julio. "Nadando en la piscina de gofio." In *Un Tal Lucas*, 105–8. Madrid: Ediciones Alfaguara, 1979. Translated by Gregory Raba as "Swimming in a Pool of Gray Grits." In *A Certain Lucas*, 80–83. New York: Knopf, 1984.
Danto, Arthur Coleman. *The Abuse of Beauty: Aesthetics and the Concept of Art.* Chicago: Open Court Publishing, 2003.
Deleuze, Gilles, and Félix Guattari. *Anti-Oedipus: Capitalism and Schizophrenia.* Translated by Robert Hurley, Mark Seem, and Helen R. Lane. Minneapolis: University of Minnesota Press, 1983.
Deutscher, Guy. *Through the Language Glass: Why the World Looks Different in other Languages.* New York: Henry Holt, 2010.
Dickinson, Emily. *The Complete Poems of Emily Dickinson.* Edited by Thomas H. Johnson. Boston: Little Brown and Company, 1960.
Doi, Takeo. *The Anatomy of Self: The Individual Versus Society.* Translated by Mark A. Harbison. New York: Kodansha America, 2001.
Dolan, Jill. *The Feminist Spectator as Critic.* Ann Arbor, MI: UMI Research Press, 1988.
Donnelly, Patrick. From "Prayer over Dust." In *The Charge.* Keene, NY: Ausable Press, 2003.
Dower, John. *Embracing Defeat: Japan in the Wake of World War II.* New York: W.W Norton/The New Press, 1999.
Durozoi, Gérard. *History of the Surrealist Movement.* Translated by Alison Anderson. Chicago: University of Chicago Press, 2002.
Eckersall, Peter. "The Performing Body and Cultural Representation in the Theatre of Gekidan Kataisha." In *Japanese Theatre and the International Stage.* Edited by Stance Scholz-Ciona and Samuel Leiter, 313–28. Boston: Brill, 2001.
Eguchi Baku, Kageyasu Masao, and Yamada Gorô. "Sekusu buyô nitsuite." *Gendai Buyô* 7, no. 7 (July 1959): 7.

Enger, Leif. *So Brave Young and Handsome*. New York: Grove/Atlantic, 2008.
Esslin, Martin. *Antonin Artaud*. New York: Penguin, 1977.
Foucault, Michel. *The History of Sexuality: An Introduction*. New York: Vintage, 1990.
———. *Security, Territory, Population: Lectures at the College de France 1977–1978*. New York: Macmillan, 2009.
———. "Technologies of the Self." In *Technologies of the Self: A Seminar with Michel Foucault*. Edited by Luther Martin, 16–49. Amherst: University of Massachusetts Press, 1988.
Fowler, Edward. *The Rhetoric of Confession: Shishôsetsu in Early Twentieth-Century Japanese Fiction*. Berkeley: University of California Press, 1988,
Franklin, Eric N. *Dynamic Alignment through Imagery*. Champaign, IL: Human Kinetics, 1996.
Fukuda Yoshiyuki and Amasawa Taijirô. "Haikyô ni kitsuritsu suru nikutai: Hijikata Tatsumi no ankoku butô ni furete" [The Body Towering over a Void: On Hijikata Tatsumi's Dance of Darkness]. *Gendai no me* 13, no. 12 (Dec. 1972): 244–54.
Fukumoto Maaya, "Ideokineshisu to Noguchi taisô no hikaku kenkyû: tsûru toshite no imêji no yakuwari ni chakumoku shite" [A Comparative Study on Ideokinesis and Noguchi-Taiso: with Attention to the Different Roles of Images as Tools]. *Geibun* (Toyama daigaku geijutsu bunka gakubu kiyô) 5 (Feb. 2011): 114–25.
Galtung, Johan. *Peace by Peaceful Means: Peace and Conflict, Development and Civilization*. London: Sage Publications, 1996.
Genet, Jean. *Our Lady of the Flowers*. Translated by Bernard Frechtman. New York: Grove Press, 1963.
Gôda Nario, "Ankoku Butô nitsuite" [On the Dance of Darkness]. In *Butô: Nikutai no shûrurearisutotachi* [Butô: Surrealists of the Body]. Edited by Hanaga Mitsutoshi. Gendai Shokan, 1983.
———. "Butô no dôshi 12" [Twelve butoh verbs]. *Gendaishi techô* 28, no. 6 (May 1985): 95–103.
———. "'Hijikata butô': Sakuhin nôto" [Hijikata's Butô: Notes on the Dances]. Pts. 1–6. *Asubesutokan tsûshin* 2 (Jan. 1987): 28–35; 5 (Oct. 1987): 38–43; 6 (Jan. 1988): 40–46; 7 (April 1988): 22–28; 8 (Aug. 1988): 26–32; and 10 (July 1989): 46–52.
———. "Kinen subeki 'wakaki seishin' no bakuhatsu=hyô" [A Memorable Explosion of 'Young Spirit']. *Daily Sports* undated 1959. Photocopy available at the Keio University Center for the Arts and Arts Administration.
———. "Sen kyûhyaku gojû kyû nen go gatsu nijûyon nichi—Hijikata Tatsumi ga shissô wo kaishi shita hi" [May 24, 1959—the Day that Hijikata Tatsumi Began to Run]. *W-NOtation* [Daburu nôtêshon] 2 (July 1985): 86–99.
———. "Shizukesa to yutakasa to: Hakutôbô kôen" [Quietness and Richness: Hakutôbô's Performance]. *Shûkan on sutêji shinbun* July 16, 1976.
Goodman, David. *Angura: Posters of the Japanese Avant-garde*. New York: Princeton Architectural Press, 1999.
———. "*Concerned Theatre Japan* Thirty Years Later: A Personal Account." In, *Japanese Theatre and the International Stage*. Edited by Stance Scholz-Ciona and Samuel Leiter, 343–53. Boston: Brill, 2001.
———. *Japanese Drama and Culture in the 1960s: The Return of the Gods*. Armonk: M.E. Sharpe, 1988.
Gordon, Andrew. "Conclusion." In *Postwar Japan as History*. Edited by Andrew Gordon, 449–64. Berkeley and Los Angeles: University of California Press, 1993.
Gramsci, Antonio. *Selections from the Prison Notebooks*. New York: International, 1971.
Greenberg, Clement. "Modernist Painting." *The Collected Essays and Criticisms*. Edited by John O'Brian. Vol. 4. Chicago: University of Chicago Press, 1993.

Guttmann, Allen and Lee Austin Thompson. *Japanese Sports: a History.* Honolulu: University of Hawaii Press, 2002.

Hamera, Judith. "Silence That Reflects: Butoh, *Ma*, and a Crosscultural Gaze." *Text and Performance Quarterly* 10 (1990): 53–60.

Haniya Yutaka. "Dô to sei no rizumu" [The Rhythm of Motion and Stillness] *Sekai* 200 (Aug. 1962): 382–86. Listed in table of contents as "Kuro to shiro no rizumu" [The Rhythm of Black and White].

———. "Tainai meisô nitsuite" [On Womb Meditation]. *Shingeki* 24, no. 292 (Aug. 1977): 18.

Harootunian, H. D. "America's Japan/ Japan's America." In *Japan in the World.* Edited by Masao Miyoshi and H. D. Harootunian, 196–221. Durham, NC: Duke University Press, 1993.

Harvey, David. *The Condition of Postmodernity: An Enquiry into Origins of Cultural Change.* Malden, MA: Blackwell Publishing, 1990.

Hattori Misao, ed. *Noguchi taisô: kotoba ni kiku, Noguchi Michizô goroku* [Noguchi Exercises: Leaning from words, A collection of aphorisms of Noguchi Michizô]. Shunjusha, 2004.

Havens, Thomas R. H. *Radicals and Realists in the Japanese Nonverbal Arts: the Avant-garde Rejection of Modernism.* Honolulu: University of Hawai'i Press, 2006.

Hijikata Tatsumi. "Gyokutan na Gosha (Ekusutora-vagansu): Hijikata Tatsumi-shi intavyû" [Extravagance: An Interview with Hijikata Tatsumi]. *W-NOtation* [Daburu-nôtêshon] 2 (July 1985): 2–27.

———. *Hijikata Tatsumi Zenshû* [The Collected Works of Hijikata Tatsumi], 2 vols. Edited by Tanemura Suehiro et al. Tokyo: Kawade Shobô, 1998.

———. "Inu no jomyaku ni shitto suru koto kara" [From Being Jealous of a Dog's Vein] (extended version). *W-NOtation* [Daburu nôtêshon] 2 (July 1985): 100–21.

———. "Itachi no hanashi" [Weasel Talk]. *Asubesutokan tûshin* 9: 36. *HTZ*, 2:146.

———. "Kaze Daruma" [Wind Dharma]. *Gendaishi techô* 28, no. 6 (May 1985): 70–76.

———. "Kyokutan na gosha: Hijikata Tatsumi shi intabyu" [The Extreme Luxury: Interview of Hijikata Tatsumi). W-NOtation, 2 (July 1985): 17. *WB* 20.

———. "Watashi ni totte erotishizumu towa: Inu no jomyaku ni shitto suru koto kara" [For Me, Eroticism Comes From Being Jealous of a Dog's Vein]. *Bijutsu Techô* 21, no. 312 (May 1969), 126–29.

———. "Yameru Maihime." *Shingeki* "Initial Serialization," 24, no. 288 (April 1977): 97–105; "Seventh Serialization," 24, no. 294 (Oct. 1977): 90–103.

Hijikata Tatsumi and Shiraishi Kazuko. "Shinra banshô wo kanjitoru kyoku'i" [The Ultimate Feeling that can Perceive All Things]. *Hijikata Tatsumi Zenshu* 2: 83–91.

Hijikata Tatsumi and Suzuki Tadashi. "Ketsujo toshite no gengo=shintai no kasetsu" [Language as Lack and Temporary Construction of the Body]. *Gendaishi Techô* 20. no. 4 (April 1977): 108—26.

Hijikata Tatsumi Archive. *Hijikata Tatsumi Notational Butoh.* Translation and voice narration by Bruce Baird. DVD. Research Center for the Arts and Arts Administration and Research Institute for Digital Media and Content, Keio University, 2007.

Hijikata Tatsumi Archive, ed. *Hijikata Tatsumi "Butô" shiryôshû dai ippo* [Hijikata Tatsumi "BUTOH" Materials]. Keio University Research Center for the Arts and Arts Administration, 2004.

Hirata, Hosea. *The Poetry and Poetics of Nishiwaki Juzaburô.* Princeton, NJ: Princeton University Press, 1993.

Hirsh, Foster. *A Method to Their Madness: A History of the Actors Studio.* Cambridge, MA: Da Capo Press, 2002.

Hoffman, Ethan, et al. *Butoh: Dance of the Dark Soul.* New York: Aperture Foundation, 1987.

Hosoe Eikô, *Kamaitachi*. Gendaishichôsha, 1969. Reprinted as *Kamaitachi*. New York: Aperture, 2005.

———. "'Kamaitachi,' furusato to Akita ni kaeru" [*Weasel Sickle*: Returning to Akita and to the Hometown]. In *Hijikata Tatsumi Exhibition: The Metamorphosis of the Wind*. Edited by the Akita Senshû Museum of Art, 16. Akita: Akita Senshu Museum of Art, 1991.

———. "Notes by Hosoe Eikô." In *Butoh: Shades of Darkness*. Edited by Jean Viala and Nourit Masson-Sekine, 191—92. Tokyo: Shufunotomo, 1988.

Howard, Vernon. *Artistry*. Indianapolis: Hackett, 1982.

Huysmans, Joris-Karl. *Against Nature*. Translated by Robert Baldick and Patrick McGuinness. London: Penguin Classics, 2003.

"Hyôgenryoku no busoku ga medatsu: Zennihon geijutsu buyô kyôkai dairokukai shinjin buyô kôen" [An Insufficiency of Expressive Ability Stands Out: Sixth Newcomers Dance Recital of the All Japan Art Dance Association]. *Tokyo Shimbun* May 25, 1959.

Ichikawa Miyabi. "Hangidaitokan" In *Shiki no tame no nijûnanaban*. Edited by Keio University Center for the Arts and Arts Administration and Hijikata Tatsumi Memorial Archive, 52–56. Keio University Center for the Arts and Arts Administration, 1998.

———. "Nikutai no busshitsusei, busshitsu no nikutaisei" [Materiality of the Body; Bodilyness of Material]. *Bijutsu Techô* 38: 561 (May 1986): 26–51.

Iida, Yumiko. *Rethinking Identity in Modern Japan: Nationalism as Aesthetics*. New York: Routledge, 2002.

Iimura Takahiko. *Cine Dance: The Butoh of Tatsumi Hijikata: Anma (The Masseru*[Sic]*) + Rose Color Dance*. DVD. Takahiko Iimura Media Art Institute, 2005.

Isozaki Arata. "Bamen—Hijikata Tatsumi" [Scene—Hijikata Tatsumi]. *W-NOtation* 2 (July 1985): 87–89.

Ivy, Marilyn. *Discourses of the Vanishing: Modernity, Phantasm, Japan*. Chicago: University of Chicago Press, 1995.

Jameson, Fredrick. *Jameson on Jameson: Conversations on Cultural Marxism*. Durham, NC: Duke University Press, 2007.

———. *Signatures of the Visible*. New York: Routledge, 1992.

"Japan's Subcontractors: The Buck Stops Here." In *Inside the Japanese System: Readings on Contemporary Society and Political Economy*. Edited by Daniel I. Okimoto and Thomas P. Rohlen, 83–86. Stanford, CA: Stanford University Press, 1988.

Johnson, Chalmers A. *Blowback: the Costs and Consequences of American Empire*. 2nd ed. New York: Metropolitan Books/Henry Holt, 2010.

Kamizawa Kazuo. *Nijûisseiki buyôron* [A Dance Theory for the 21st Century]. Oshukan Shoten, 1995.

Kano, Ayako. *Acting Like a Woman in Modern Japan: Theater, Gender, and Nationalism*. New York: Palgrave, 2001.

Karatani Kojin, "One Spirit, Two Nineteenth Centuries." In *Postmodernism and Japan*. Edited by Masao Miyoshi and H. D. Harootunian, 259–72. Durham, NC: Duke University Press, 1989.

Kasai Akira, "Hijikata Tatsumi wo kataru: Ishiki no henkaku wo mezashita butôka" [Talking about Hijikata Tatsumi: A Dancer who Wanted to Change Consciousness]. In *Hijikata Tatsumi no butô: Nikutai no shururearisumu, shintai no ontorojî* [Tatsumi Hijikata's Butoh: Surrealism of the Flesh, Ontology of the "Body"]. Edited by Morishita, 55–63. Okamoto Tarô Museum of Art and Keio University Research Center for the Arts and Arts Administration, 2004.

Kazakura Shô. "Haikei Hijikata tatsumi-sama" [Dear Mr. Hijikata Tatsumi]. Pts 1 and 2. *Asubesutokan Tsûshin* 4 (July 1987): 34–37; and 6 (January 1988): 24–27.

Keats, John. Letter "To Percy Bysshe Shelley: 16 August 1820." In *Selected Letters of John Keats*. Edited by Grant F. Scott, 463—64. Cambridge, MA: Harvard University Press, 2002.

Keio University Center for the Arts and Arts Administration and Hijikata Tatsumi Memorial Archive, eds. *Shiki no tame no nijûnanaban* [Twenty-seven Nights for Four Seasons]. Keio University Center for the Arts and Arts Administration, 1998.

Keng, Lee Chee. "Hijikata Tatsumi and Ankoku Butoh: A Body Perspective." Master's thesis, National University of Singapore, 1998.

Key, Margaret S. *Truth from a Lie: Documentary, Detection, and Reflexivity in Abe Kôbô's Realist Project*. Lanham, MD: Lexington Books, 2011.

Kisselgoff, Anna. "Japan's New Dance Is Darkly Erotic." *The New York Times*, July 15, 1984, sec. 2.

Kitano Ryuichi. "The End of Isolation: Hansen's Disease in Japan." *Harvard Asia Quarterly* 6, no. 3 (Summer 2002): 39–45.

Klein, Susan Blakeley. *Ankoku Butô: the Premodern and Postmodern Influences on the Dance of Utter Darkness*. Ithaca, NY: East Asia Program, Cornell University, 1988.

Klein, William. *Tokyo*. New York: Crown Publishers, 1964.

Kobayashi Saga. "Daibutai ni tatsu" [Standing on the Big Stage]. In *Shiki no tame no nijûnanaban*. Edited by Keio University Center for the Arts and Arts Administration and Hijikata Tatsumi Memorial Archive, 30–35. Keio University Center for the Arts and Arts Administration, 1998.

Koch, Kenneth. *Days and Nights*. New York: Random House, 1982.

Kondô Tomomi. "'Nihon no zen'eiteki na dansu—butô'—Shinpô intabyû, ripôto." *Bankûbaa shinpô* 22, No. 50 (Dec. 7, 2000).

Koop, Albert J. and Hogitarô Inada. *Japanese Names and How to Read Them: A Manual for Art-collectors and Students, Being a Concise and Comprehensive Guide to the Reading and Interpretation of Japanese Proper Names both Geographical and Personal, as well as of Dates and other Formal Expressions*. Boston: Routledge & Kegan Paul, 1972.

Kuge, Shu. "The Impenetrable Surface of Japanese Writing: Mishima Reads Ôgai." Paper presented at the annual meeting of the Association for Japanese Literary Studies, Dartmouth College, Hanover, NH, Oct. 9, 2005.

Kuniyoshi Kazuko. "Butôfu shiron: Hijikata tatsumi no shiryô kara" [An Essay on the Butoh-fu: From the Scrap Books of Tatsumi Hijikata]. *InterCommunication* 29 (Summer 1999): 80–87.

———. "Le Kabuki du Tôhoku et l'empereur." In *Être ensemble: Figures de la communauté en danse depuis le XXe Siècle*. Translated by Patrick De Vos. Edited by Claire Rousier, 274–84. Pantin, France: Centre National de la Danse, 2003.

———. *Performing Arts in Japan Now: Butoh in the Late 1980s*. Translated by Richard Hart. Tokyo: Japan Foundation, 1991.

———. "Sekushuariti, jendâ: butô no baai" [Sexuality and Gender: The Circumstances of Butô]. *Buyôgaku* no. 21 (1998): 83.

———. "Shômetsu suru kôzô: butôka no rôgo no tame ni" [Perishing Structure: In order that a Dancer can Grow Old] *Kikan shichô* 4 (April 1989): 81.

———. *Yume no ishô: Kioku no tsubo* [Costume of Dreams: Receptacle of Memory]. Shinshôkan: 2002, 173–78.

Kurata Satoshi. *Jidôsha zetsubô kôjô: aru kisetsukô no nikki* [Automobile Despair Factory: The Diary of a Seasonal Laborer]. Gendaishi Shuppankai, 1974.

Kurihara Nanako. "Hijikata Tatsumi: The Words of Butoh." *TDR* 44.1, (Spring 2000): 10–28.

———. "The Most Remote Thing in the Universe: A Critical Analysis of Hijikata Tatsumi's Butoh Dance." Ph.D. diss., New York University, 1996.
———. "Plucking off the Darkness of the Flesh." *TDR* 44.1, (Spring 2000): 55, note 7.
Kawabata Keiji, "Makkurokenoke," Muroran Kôgyôdaigaku Meitoku-ryô ryôka, http://www.geocities.co.jp/Berkeley/5821/ryouka.html.
Laage, Joan. "Embodying the Spirit: The Significance of the Body in the Japanese Contemporary Dance Movement of Butoh." Ph.D. diss., Texas Woman's University, 1993.
LaMarre, Thomas. *Uncovering Heian Japan: An Archaeology of Sensation and Inscription*. Durham, NC: Duke University Press, 2000.
Lane, Richard. *Images of the Floating World: The Japanese Print*. New York: Putnam, 1978.
Lautréamont, Compte de. *Maldoror and Poems*. Translated by Paul Knight. London: Penguin, 1988.
Levinas, Emmanuel. *Time and the Other*. Translated by Richard A. Cohen. Pittsburgh, PA: Duquesne University Press, 1987.
Lloyd, Fran, ed. *Consuming Bodies: Sex and Contemporary Japanese Art*. London: Reaktion Books, 2002.
Mackie, Vera. "Understanding through the Body: The Masquerades of Morimura Yasumasa and Mishima Yukio." In *Genders, Transgenders and Sexualities in Japan*. Edited by Mark McLelland and Romit Dasgupta, 126–44. London: Routledge, 2005.
Maeda Fujio, Watanabe Yôko, Morishita Takashi, and Homma Yu, eds. *Nikutai no hanran: Butô 1968: Sonzai no semiorojî* [Rebellion of the Body: Butoh 1968: Semiology of Being]. Keio University Research Center for the Arts and Arts Administration, 2009.
Manning, Susan. *Ecstasy and the Demon*: *Feminism and Nationalism in the Dance of Mary Wigman*. Berkeley: University of California Press, 1993.
Marotti, William. "Butô no Mondaisei to Honshitsu Shugi Wana" [The Problematic of Butô and the Trap of Essentialism]. *Shiataa Aatsu* 8 (1997):88–96.
———. "Political Aesthetics: Activism, Everyday Life, and Art's Object in 1960's Japan." *Inter-Asia Cultural Studies* 7, no. 4 (2006): 606–18.
Martin, Samuel. *A Reference Grammar of Japanese*. Rutland, VT: Tuttle, 1987.
Mauk, Norbert. "Body Sculptures in Space: Butoh Retains Its Aesthetic Relevancy." *Ballet international/Tanz aktuell* 8 (Aug./Sept. 1994): 55–59.
McCormack, Gavan. *Chang Tso-lin in Northeast China, 1911–1928: China, Japan, and the Manchurian Idea*. Palo Alto: Stanford University Press, 1977.
Meisner, Sanford and Dennis Londwell. *Sanford Meisner on Acting*. New York: Vintage, 1987.
Mies, Maria. *Patriarchy and Accumulation on a World Scale: Woman in the International Division of Labour*. New York: Zed Books, 1998.
Mikami Kayo. *Utsuwa toshite no Shintai: Ankoku butô gihô e no apurôchi* [Body as Receptacle: An Approach to the Techniques of Ankoku Butoh]. ANZ-Do, 1993.
Millett, Kate. *Sexual Politics*. Champaign Urbana: University of Illinois Press, 2000.
Mishima Yukio. *Forbidden Colors*. Translated by Alfred H. Marks. New York: Berkeley Medallion Books, 1974.
———. "Gendai no muma: *Kinjiki* o odoru zen'ei buyôdan" [Contemporary Nightmare: An Avant-garde Dance Group Dances *Forbidden Colors*]. *Geijutsu Shinchô* 10, no. 9 (Sept. 1959):128–31.
———. "Junsui to wa" [What is Purity]. In *Hijikata Tatsumi no butô: Nikutai no shururearisumu, shintai no ontorojî* [Tatsumi Hijikata's Butoh: Surrealism of the Flesh, Ontology of the "Body"]. Edited by Morishita, 18. Okamoto Tarô Museum of Art and Keio University Research Center for the Arts and Arts Administration, 2004.

Mishima Yukio. "Kiki no buyô" [Crisis Dance]. In *Hijikata Tatsumi no butô: Nikutai no shururearisumu, shintai no ontorojî* [Tatsumi Hijikata's Butoh: Surrealism of the Flesh, Ontology of the "Body"]. Edited by Morishita, 16. Okamoto Tarô Museum of Art and Keio University Research Center for the Arts and Arts Administration, 2004. Translated by Kobata Kazue as "Kiki no Buyou: Dance of Crisis." In *Butoh: Shades of Darkness*. Edited by Jean Viala and Nourit Masson-Sekine, 123. Tokyo: Shufunotomo, 1988.

———. "Suisen no kotoba" [Words of Recommendation]. In *Hijikata Tatsumi no butô: Nikutai no shururearisumu, shintai no ontorojî* [Tatsumi Hijikata's Butoh: Surrealism of the Flesh, Ontology of the "Body"]. Edited by Morishita, 18. Okamoto Tarô Museum of Art and Keio University Research Center for the Arts and Arts Administration, 2004.

———. *Taiyô to tetsu* (1967). In *Mishima Yukio zenshû*. Edited by Saeki Shôichi 32: 62–140. Shinchôsha, 1975. Translated by John Bester as *Sun and Steel*. New York: Grove Press, 1970.

———. "Zen-ei buyô to mono tono kankei" [The Relationship between Avant-garde Dance and Things]. In *Hijikata Tatsumi no butô: Nikutai no shururearisumu, shintai no ontorojî* [Tatsumi Hijikata's Butoh: Surrealism of the Flesh, Ontology of the "Body"]. Edited by Morishita, 16–17. Okamoto Tarô Museum of Art and Keio University Research Center for the Arts and Arts Administration, 2004.

Miyoshi, Masao and H. D. Harootunian, eds. *Japan in the World*. Durham, NC: Duke University Press, 1993.

Mizohata Toshio, ed. *Ôno Kazuo to Hijikata Tatsumi no 60 nendai* [Kazuo Ohno and Tatsumi Hijikata in the 1960s]. Yokohama: BankART 1929, 2005.

Mizutani Isao. "Futatsu no teigen: butai no kosshi" [Two Suggestions: The Framework of the Stage]. *Bijutsu Techô* 38, no. 561 (May 1986): 58–59

———. "Genzai to shorijo toshite no kyanbasu, soshite butai" [The Disposal Place of Original Sin as Canvas and Stage]. In *Hijikata Tatsumi no butô: Nikutai no shururearisumu, shintai no ontorojî* [Tatsumi Hijikata's Butoh: Surrealism of the Flesh, Ontology of the "Body"]. Edited by Morishita, 40–41. Okamoto Tarô Museum of Art and Keio University Research Center for the Arts and Arts Administration, 2004.

de Morant, Alix. "*Hôsôtan* dairokuba: *Bokushin no gogo* e no henka" ["Hôsôtan," Sixième Tableau: En Écho à "L'Apres Midi d'un Faune"]. Japanese translation by Patrick de Vos and Yokoyama Yoshiyuki. In *Hijikata Tatsumi no butô: Nikutai no shururearisumu, shintai no ontorojî* [Tatsumi Hijikata's Butoh: Surrealism of the Flesh, Ontology of the "Body"]. Edited by Morishita, 150–56. Okamoto Tarô Museum of Art and Keio University Research Center for the Arts and Arts Administration, 2004.

Moriguchi, Chiaki and Hiroshi Ono. "Japanese Lifetime Employment: A Century's Perspective." In *Institutional Change in Japan*. Edited by Magnus Blomstrom and Sumner La Croix, 152–76, New York: Routledge, 2006.

Morishita Takashi. "Hijikata Tatsumi no butô sôzô no hôhô wo megutte—butô no honshitsu to sakubu ni okeru shururearisumu no shisô to hôhô" [In Search of Hijikata Tatsumi's Creative Method: The Essence of Butoh and Surrealistic Methods and Thought in the Choreographic Process]. In *Jenetikku âkavu enjin—dejitaru no mori de odoru Hijikata Tatsumi* [Genetic Archive Engine: Hijikata Tatsumi Dancing in a Digital Forest]. Edited by Sumi Yôichi and Maeda Fujio, 47–77. Keio University Research Center for the Arts and Art Administration, 2000.

———. "Hijikata Tatsumi no butô to *Barairo dansu*" [Hijikata Tatsumi's Butoh and *Rose-colored Dance*]. Translated by Bruce Baird. In *Barairo dansu no ikonorojî: Hijikata Tatsumi wo saikôchiku suru* [The Iconology of *Rose-colored Dance*: Reconstructing Tatsumi Hijikata]. Edited by Sumi Yôichi, Maeda Fujio, Morishita Takashi, and Yanai Yasuhiro, 6–8. Keio University Center for the Arts and Arts Administration, 2000.

———. "Hijikata Tatsumi no Geijutsu" [Hijikata Tatsumi's Art]. *Japanese Bulletin of Arts Therapy* 38, no. 1 (2007), 30–32.

———. "Nikutai no hanran: Kîwâdo no idiomu o yomu: Hijikata Tatsumi no sainêji kenkyû 1" [Rebellion of the Body: Reading the idioms of the keywords: Research on the Signage of Hijikata Tatsumi]. In *Nikutai no hanran,: Butô 1968: Sonzai no semiorojî* [Rebellion of the Body: Butoh 1968: Semiology of Being]. Edited by Maeda Fujio et al., 18–23. Keio University Research Center for the Arts and Arts Administration, 2009.

———. "Yokô Tadanori *Barairo dansu* postâ wo bunkai suru" [Dissecting Tadanori Yokô's Poster for *Rose-colored Dance*]. Translated by Bruce Baird. In *Barairo dansu no ikonorojî: Hijikata Tatsumi wo saikôchiku suru* [The Iconology of *Rose-colored Dance*: Reconstructing Tatsumi Hijikata]. Edited by Sumi Yôichi, Maeda Fujio, Morishita Takashi, and Yanai Yasuhiro, 32–33. Keio University Center for the Arts and Arts Administration, 2000.

Morishita Takashi and Yamazaki Yôko, eds. *Bijutsu to butô no Hijikata Tatsumi ten* [Hijikata Tatsumi Exhibition: Art and Butô]. Ito, Shizuoka: Ikeda Musuem of 20th Century Art, 1997.

Morishita Takashi, ed. *Hijikata Tatsumi no butô: Nikutai no shururearisumu, shintai no ontorojî* [Tatsumi Hijikata's Butoh: Surrealism of the Flesh, Ontology of the "Body"]. Okamoto Tarô Museum of Art and Keio University Research Center for the Arts and Arts Administration, 2004.

Motofuji Akiko. *Hijikata Tatsumi to tomo ni* [Together with Hijikata Tatsumi]. Chikuma Shobô: 1997.

Motofuji Akiko and Ôno Yoshito. "Otto toshite no Hijikata, shi toshite no Hijikata" [Hijikata as Husband; Hijikata as Teacher]. *Geijutsu Shinchô* 49, no. 579 (March 1998): 16–24.

Munroe, Alexandra. *Japanese Art after 1945: Scream Against the Sky*. New York: H.N. Abrams, 1994.

Nakamura, Tamah. "Beyond Performance in Japanese Butoh Dance: Embodying Re-Creating of Self and Social Identities." Ph.D. Diss. Felding Graduate University, 2007.

Nakanishi Natsuyuki. "Hijikata Tatsumi to no owarinaki taiwa" [My Endless Conversation with Hijikata Tatsumi]. *Gendaishi Techô* 29, no. 3 (March 1986): 29–32.

———. "Teate to fukushû: butô no ashi no ura" [Treatment and Review: The Undersoles of Butô]. *Bijutsu Techô* 38, no. 561 (May 1986): 63–72.

Napier, Susan J. *Anime from Akira to Princess Mononoke*. New York: Palgrave, 2001.

Nathan, John. *Mishima: A Biography*. Rutland, VT and Tokyo: Tuttle, 1974.

"'Nihon no zen'eiteki na dansu—butô'—Shinpô intabyû, ripôto" *Bankûbaa shinpô* 22, No. 50 (Dec. 7, 2000).

Nishi Tetsuo. "Kore ga makoto no 'geijutsu' da: Gaitô ni odori deta ankoku buyô" [This is Real 'Art': The Dance of Darkness Takes to the Streets]. *Kokusai Shashin Jôhô* 34, no. 10 (Oct. 1960): 61–65.

Nishida Kitarô. *Zen no* kenkyû. Iwanami Shoten, 2001. Translated by Masao Abe and Christopher Ives as *An Inquiry into the Good*. New Haven, CT: Yale University Press, 1990.

Nishitani Keiji. *Religion and Nothingness*. Translated by Jan Van Bragt. Berkeley: University of California Press, 1982.

Noguchi Michizô. *Genshô seimeitai toshite no ningen: Noguchi taisô no riron* [Humans as Primal Life-bodies: The Theory of Noguchi Exercises]. Iwanami Shoten, 2003 [1972].

———. *Noguchi taisô: omosa ni kiku* [Noguchi Exercises: Learning from Weight]. Shunjusha, 2002.

Ohno Kazuo, and Ohno Yoshito,. *Kazuo Ohno's World: from Without and Within*. Introduced by Mizohata Toshio and translated by John Barrett. Middletown, CT: Wesleyan University Press, 2004.

Oikawa Hironobu, "Naimen no kattô" [内面の葛藤] and "1956–60 nen no Hijikata Tatsumi 3—Zushi Akiko and Ohara Atsushi [1956—60年の土方巽(3)―図師明子と小原庄], Hironobu Oikawa [Blog], July 29, 2007 (http://scorpio-oik.blogspot.com/2007/07/blog-post_28.html) and "Hironobu Oikawa [Blog], August 18, 2007 (http://scorpio-oik.blogspot.com/2007/08/blog-post_5650.html) (accessed May 31, 2011).

Ôno Kazuo. *Ôno Kazuo butôfu: goten, sora wo tobu* [The Palace Soars through the Sky: Kazuo Ôno on Butoh]. Shinchôsha, 1998.

———. *Ôno Kazuo: Tamashii no kate* [Ôno Kazuo: Food for the Soul]. Firumu Aato Sha: 1999.

Ortolani, Benito. *The Japanese Theatre: from Shamanistic Ritual to Contemporary Pluralism.* Princeton, NJ: Princeton University Press, 1990.

Ozasa, Yoshio. *Nihon Gendai Engekishi* [The History of Modern Japanese Theater]. Hakusuisha, 1985.

Packard, George R. III. *Protest in Tokyo: The Security Treaty Crisis of 1960.* Princeton, NJ: Princeton University Press, 1966.

Paik, Nam June. "To Catch Up or Not to Catch Up with the West: Hijikata and Hi Red Center." In *Japanese Art After 1945: Scream Against the Sky*. Edited by Alexandra Munroe, 76–81. New York: H.N. Abrams, 1994.

Patrick, Hugh T. and Thomas P. Rohlen, "Small-scale Family Enterprises." In *The Political Economy of Japan,* vol. 1, *The Domestic Transformation*. Edited by Kozo Yamamura and Yasukichi Yasuba, 331–84. Stanford, CA: Stanford University Press, 1987.

Peppiatt, Michael. *Francis Bacon: Anatomy of an Enigma.* New York: Skyhorse Publishing, 2009.

Pilisuk, Marc and Jennifer Tennant. "The Hidden Structure of Violence." *ReVision* 20 (Fall 1997): 25–31.

Pincus, Leslie. *Authenticating Culture in Imperial Japan: Kuki Shûzô and the Rise of National Aesthetics*. Berkeley and Los Angeles: University of California Press, 1996.

———. "In a Labyrinth of Western Desire: Kuki Shuzo and the Discovery of Japanese Being." In , *Japan in the World*. Edited by Masao Miyoshi and H. D. Harootunian, 222–36. Durham, NC: Duke University Press, 1993.

Plogsterth, Ann. "The Institution of the Royal Mistress and the Iconography of Nude Portraiture in Sixteenth-Century France." Ph.D. diss., Columbia University, 1991.

Powell, Brian. *Japan's Modern Theatre: A Century of Change and Continuity*. London: Japan Library, 2002.

Price, John. "The 1960 Miike Coal Mine Dispute: Turning Point for Adversarial Unionism in Japan?" In *The Other Japan: Conflict, Compromise, and Resistance since 1945*. Edited by Joe Morre, 49–74. Armonk, NY: M.E. Sharpe, 1996.

Proust, Marcel. *Remembrance of Things Past*. New York: Vintage, 1982.

Rabaté, Jean-Michel. *The Ghosts of Modernity*. Gainesville, FL: University of Florida Press, 1996.

Raine, Michael. "Ishihara Yûjirô: Youth, Celebrity and the Male Body in the Late-1950s Japan." In *Word and Image in Japanese Cinema*. Edited by Dennis Washburn and Carole Cavanaugh, 202–25. New York: Cambridge University Press, 2001.

Raz, Jacob. "Foreword: The Turbulent Years." In *Butoh: Shades of Darkness*. Edited by Jean Viala and Nourit Masson-Sekine, 10–15. Tokyo: Shufunotomo, 1988.

Richie, Donald. *Japanese Portraits: Pictures of Different People*. North Clarendon, VT: Tuttle Publishing, 2006.

———. "New Happening by Hijikata in Store." *Japan Times*, July 10, 1966.

Roediger, David R. *The Wages of Whiteness: Race and the Making of the American Working Class*. Revised edition. New York: Verso, 1999.

Rotie, Marie-Gabrielle. "The Reorientation of Butoh." *Dance Theater Journal* 13, no. 1 (1996): 34–35.
Sakai, Naoki. "Two Negations: The Fear of Being Excluded and the Logic of Self-Esteem." In *Contemporary Japanese Thought*. Edited by Richard F. Calichman, 159–92. New York: Columbia University Press, 2005.
Sakurai Keisuke. *Nishiazubu dansu seminâ* [Nishiazabu Dance Seminar]. Parco, 1995.
Sanders, Vicki. "Dancing and the Dark Soul of Japan: an Aesthetic Analysis of Butô." *Asian Theatre Journal* 5, no.2 (Fall 1988): 148–63.
Sartre, Jean Paul. *Saint Genet: Actor and Martyr*. Translated by Bernard Frechtman. New York: George Braziller, 1963.
Sas, Miryam. *Fault Lines: Cultural Memory and Japanese Surrealism*. Stanford: Stanford University Press, 1999.
———. "Hands, Lines, Acts: Butoh and Surrealism." *Qui Parle* 13, no. 2 (Spring/Summer 2003): 19–51.
Saturday Night Live: The Best of Eddie Murphy. VHS. Vidmark/Trimark, 1998.
Schwellinger, Lucia. *Die Entstehung des Butoh: Voraussetzungen und Techniken der Bewegungsgestaltung bei Hijikata Tatsumi und Ôno Kazuo*. Munchen: Iudicium, 1998.
Scott, A. O. "A 'Mind' Is a Hazardous Thing to Distort: When Films Juggle the Facts." *The New York Times,* March 21, 2002, sec. E.
Scott Stokes, Henry. *The Life and Death of Yukio Mishima*. Revised edition. New York: Farrar, Straus and Giroux, 1995.
Seigle, Cecilia Segawa. *Yoshiwara: The Glittering World of the Japanese Courtesan*. Honolulu: University of Hawaii Press, 1993.
Sharf, Robert, H. "Experience." In *Critical Terms for Religious Studies*. Edited by Mark Taylor, 94–116. Chicago: University of Chicago Press, 1998.
Sherif, Ann. "The Aesthetics of Speed and the Illogicality of Politics: Ishihara Shintarô's Literary Debut." *Japan Forum* 17, no. 2 (July 2005): 185–211.
Shibusawa Tatsuhiko. "Hansai no buyôka" [Burnt Offering Dancer]. In *Hijikata Tatsumi no butô: Nikutai no shururearisumu, shintai no ontorojî* [Tatsumi Hijikata's Butoh: Surrealism of the Flesh, Ontology of the "Body"]. Edited by Morishita, 17. Okamoto Tarô Museum of Art and Keio University Research Center for the Arts and Arts Administration, 2004.
———. "Kyôtei Heriogabarusu aruiwa dekadensu no ikkôsatsu" [The Mad Emperor Heliogabalus, or a Consideration of Decadence]. In *Shinsei Jutai* [Divine Conception]. Kawade Shobô, 1987, 42–76.
———. "Zen-ei to sukyandaru" [Avant-garde and Scandal]. In *Hijikata Tatsumi no butô: Nikutai no shururearisumu, shintai no ontorojî* [Tatsumi Hijikata's Butoh: Surrealism of the Flesh, Ontology of the "Body"]. Edited by Morishita, 19. Okamoto Tarô Museum of Art and Keio University Research Center for the Arts and Arts Administration, 2004.
Shiner, Larry. *The Invention of Art: A Cultural History*. Chicago, University of Chicago Press, 2003.
Shinohara Ushio. *Zen'ei no michi* [Path to the Avant-Garde], especially "Jabu, jabu sutorêto, refuto fukku KO da" [Jab, Jab, Straight, Left Hook, KO] June 25, 2003, and "Refuto fukku ten" [Left Hook Exhibition] July 10, 2003. Respectively at http://www.new-york-art.com/zen-ei-dai-16.htm and http://www.new-york-art.com/zen-ei-dai-17.htm (Nov. 18, 2003).
Scholz-Cionca, Stanca, and Samuel L. Leiter, eds. *Japanese Theatre and the International Stage*. Boston: Brill, 2001.
Slaymaker, Douglas. *The Body in Postwar Japanese Fiction*. New York: Routledge, 2004.
Sontag, Susan. "Artaud." In *Antonin Artaud: Selected Writings*. Edited by Susan Sontag, xvii–lix. Berkeley: University of California Press, 1988.

Spall, James C. *Introduction to Stochastic Search and Optimization: Estimation, Simulation and Control.* Hoboken, NJ: John Wiley and Son, 2003.

Stanislavski, Constantin. *An Actor Prepares.* Translated by Elizabeth Reynolds Hapgood. New York: Routledge, 1964.

Stevenson, Anne. *Elizabeth Bishop.* New York: Twain Publishers, 1966.

Strasberg, Lee. *A Dream of Passion: the Development of the Method.* New York: Plume, 1987.

Sumi Yôichi, Maeda Fujio, Morishita Takashi, and Yanai Yasuhiro, eds. *Barairo dansu no ikonorojî: Hijikata Tatsumi wo saikôchiku suru* [The Iconology of *Rose-colored Dance*: Reconstructing Tatsumi Hijikata]. Keio University Center for the Arts and Arts Administration, 2000.

Suzuki, Tomi. *Narrating the Self: Fictions of Japanese Modernity.* Stanford: Stanford University Press, 1996.

Sweigard, Lulu. *Human Movement Potential: Its Ideokinetic Facilitation.* New York: Harper and Row, 1974.

Tachiki Takashi, ed. *Tennin keraku: Ôno Kazuo no sekai* [The Pleasure of an Angel: The World of Ôno Kazuo]. Seikyûsha, 1993.

Taguchi Takashi, "Makkuroke bushi nitsuite." *Waseda daigaku toshokan kiyô* 31 (December 1989): 42–63.

Takeda Ken'ichi. "Yôzumi to natta nikutai to shintai no rika" [The flesh that has lost its usefulness and the parting song of the body]. *Gendaishi Techô* 28, no. 6 (May 1985):106–8.

Takiguchi Shûzô. "Tachiai-nin no kotoba" [Words of a Witness]. In *Hijikata Tatsumi no butô: Nikutai no shururearisumu, shintai no ontorojî* [Tatsumi Hijikata's Butoh: Surrealism of the Flesh, Ontology of the "Body"]. Edited by Morishita, 18–19. Okamoto Tarô Museum of Art and Keio University Research Center for the Arts and Arts Administration, 2004.

Tanaka Ikkô. "Satôgashi no kaisô" [Memories of Sweets]. *Shingeki* 24, no. 292 (Aug. 1977): 36–39.

Tanemura Suehiro. "Ankoku buyôka—Hijikata Tatsumi no kyôki" [The madness of Hijikata Tatsumi—Dancer of the Dance of Darkness]. *Bijutsu techô* 20, no. 303 (June 1968): 22–23.

———. *Hijikata Tatsumi no hô e: Nikutai no rokujûnendai* [A la Maison de Hijikata Tatsumi: The Body in the 60's]. Kawade Shobô, 2001.

———."Shizuka na daisôdô: Hijikata Tatsumi to bijutsukatachi" [A Quiet Commotion: Hijikata Tatsumi and the Artists]. *Geijutsu Shinchô* 49, no. 3 (March 1998): 64.

Tanemura Suehiro, Tsuruoka Yoshihisa, and Motofuji Akiko, eds. *Hijikata Tatsumi Butô Taikan: Kasabuta to Kyarameru* [Hijikata Tatsumi: Three Decades of Butoh Experiment]. Yûshisha, 1993.

Tanigawa Kôichi. "Buta to kirisuto" [Pig and Christ]. *Bijutsu Techô* 38, no. 561 (May 1986): 52–53.

Tezuka Osamu. *Princess Knight = Ribon no kishi.* Translated by Yuriko Tamaki. Kodansha International, 2001.

Tomioka Taeko. "Hijikata Tatsumi: Shikkoku no suodori" [Jet Black Un-costumed Dance: Hijikata Tatsumi]. *Bijutsu techô* 20, no. 304 (July 1968): 160–69.

Tone Yasunao. "Kaze wo kutte sarishi fûsen" [The Balloon that Ate the Wind and Went Away]. In *Nikutai no hanran: Butô 1968: Sonzai no semiorojî* [Rebellion of the Body: Butoh 1968: Semiology of Being]. Edited by Maeda Fujio et al., 18–23. Keio University Research Center for the Arts and Arts Administration, 2009, 56.

Treat, John Whittier. *Great Mirrors Shattered: Homosexuality, Orientalism and Japan.* Oxford: Oxford University Press, 1999.

Tsutsui, William M. *Manufacturing Ideology: Scientific Management in Twentieth-Century Japan.* Princeton, NJ: Princeton University Press, 2001.

Tucker, John A. "Anime and Historical Inversion in Miyazaki Hayao's *Princess Mononoke*." *Japan Studies Review* 7 (2003): 65–103.
Uno Kuniichi, "Hijikata Tatsumi no sokuryô" [Surveying Hijikata Tatsumi]. *Buyôgaku* 24 (2001): 57–59.
Viala, Jean and Nourit Masson-Sekine. *Butoh: Shades of Darkness*. Tokyo: Shufunotomo, 1988.
von Wiese, Stephan, Jutta Hülsewig and Yoshio Shirakawa, eds. *DADA in Japan: Japanische Avantgarde 1920–1970: Eine Fotodokumentation*. Düsseldorf: Kunstmuseum Düsselddorf, 1983.
Waguri Yukio. *Butoh kaden*. CD-ROM and book. Tokushima: Justsystem: 1998.
Weber, Thomas *On the Salt March: The Historiography of Gandhi's March to Dandi*. New Delhi: Harper Collins, 1997.
Weisberg, Robert W. "Creativity and Knowledge: A Challenge to Theories." In *Handbook of Creativity*. Edited by Robert J. Stirnberg, 226–50. Cambridge: Cambridge University Press, 1999.
Weisenfeld, Gennifer. *Mavo: Japanese Artists and the Avant-Garde 1905–1931*. Berkeley: University of California Press, 2002.
Wurmli, Kurt. "The Power of Image: Hijikata Tatsumi's Scrapbooks and the Art of Butoh." Ph.D. Diss., University of Hawai'i at Manoa, 2008.
Yagawa Sumiko. "Saisei no tame no tainai kaiki: Hijikata Tatsumi to ankoku butô-ha" [Returning to the Womb in Order to be Reborn: Hijikata Tatsumi and the Dance of Darkness Faction]. *Shinfujin* 19, no. 1 (Jan. 1964): 99.
Yakim, Moni and Muriel Broadman. *Creating a Character: A Physical Approach to Acting*. Milwaukee: Hal Leonard Corporation, 1993.
Yamada Ippei. *Dansâ* [Dancer]. Ôta Shuppan, 1992.
Yanai Yasuhiro. "Sakuhin kaisetsu" [Explanation of the Works]. Translated by Bruce Baird. In *Barairo dansu no ikonorojî: Hijikata Tatsumi wo saikôchiku suru* [The Iconology of Rose-colored Dance: Reconstructing Tatsumi Hijikata]. Edited by Sumi et al. Translated by Bruce Baird, 25–31. Keio University Center for the Arts, 2000.
Yeung, Bernice. "Dancing with the Butoh Masters." *SF Weekly*, July 17–23, 2002, p. 14–22.
Yokô Tadanori, "Totsuzen hen-i no postâ" [Suddenly Transformed Poster]. *Bijutsu Techô* 38, no. 561 (May 1986), 55–56.
Yoshida Yoshie. "Sengo zen'ei shoen aragoto jûhachiban: nikutai no hanran no yochô" [The Best of the Postwar Avant-garde Connections: Portents of the Rebellion of the Body]. *Bijutsu Techô* 23, no. 346 (Sept. 1971): 224–32.
Yoshimura Masanobu. "Haireveru na supekutoru" [High Level Specter]. *Bijutsu Techô* 38, no. 561 (May 1986): 56–57.
Yoshioka Minoru. *Hijikata Tatsumi Shô: Nikki to Inyô ni yoru* [Admiring Hijikata Tatsumi: Through Journals and Quotations]. Chikuma Shobô: 1987.
Zhuangzi, *Wandering on the Way: Early Taoist Tales and Parables of Chuang Tzu*. Translated by Victor Mair. Honolulu: University of Hawai'i Press, 1994.
Zizek, Slavoj. "Introduction: Alfred Hitchcock, or, The Form and its Historical Mediation." In *Everything You Always Wanted to Know about Lacan But Were Afraid to Ask Hitchcock*. Edited by Slavoj Zizek. New York: Verso, 1992.

Index

"6 Avant-gardists: September 5th 6:00 Gathering," 33, 60, 221
650 EXPERIENCE Society, 33–34, 44, 47, 75, 221, 239, 241

A La Maison de M.Civeçawa, 76, 79–80, 227
actuality, 8, 12, 42, 48–51, 56, 59, 67, 73, 93, 104, 116–17, 131, 196, 200–1, 204, 218–20
adjustments, 170, 178, 260
Admiring La Argentina (Ôno), 34, 219, 237
affective memory, 170
Aileen Garett, 263
Ailing Terpsichore (Hijikata), 113, 185–86, 190–91, 193–94, 197–98, 201, 212
Ainu, 12
Akasegawa Genpei, 64, 66–67, 69, 88, 90, 95–96, 219
Akita, 11, 106–7, 114, 161, 203–4
All Japan Art Dance Association, 32, 219
"All Japan Art Dance Association: Sixth Newcomers Dance Recital," 17
Allison, Anne, 6
Amagasaki Akira, 44–47, 61, 66
"Amazing Grace," 210
Andô Mitsuko/Sanko, 219
"Andô Mitsuko, Horiuchi Kan Unique Ballet Group Performance," 12
"Andô Mitsuko Special Performance of The Dancing Heels," 12
androgyny, 86, 91, 155
anger, 46
anguish, 143
angura, 219
ankoku butô, 219
Antai
 see *Dark Body*
anti-art, 95–96
anti-dance, 95–97
anti-social, 24, 29–30, 71
Appadurai, Arjun, 7–8

Arrowroot Leaves
 see *Kuzu no ha*
Art Village
 see Shinjuku Art Village
Artaud, Antonin, 124–25, 128–29, 134–35, 204
Asbestos Hall, 18, 63–65, 81, 94, 97, 159, 171, 208–9, 219
Ash Pillar Walk, 178
Ashikawa Yôko, 138, 140–43, 145, 147–48, 150, 159–60, 169, 207–11, 219
ash-leveler
 see *hainarashi*
athletic/athleticism, 2–3, 7, 12–13, 44, 49, 55, 59, 67–69, 72–74, 92, 101, 104, 119, 121, 133, 137, 145, 174, 217
atomic bomb, 200–3
Atsugi Bonjin, 16–19, 32, 219
Avalanche Candy, 137, 179
avant-garde, 16, 23, 39, 44, 47–51, 60–62, 65, 70, 85–86, 159, 229

baby, 90, 94, 106, 112
back, 38–39, 41, 51, 71, 86–87, 93, 146–48, 163
back-flip, 141
background medium, 7, 167–68, 210
Bacon, Francis, 148–49, 179–81, 200
"Bailero," 143–44
ballad, 113–14
ballet, 11–12, 16, 23, 32, 42, 49, 90, 95–97, 99, 138, 149
"Banquet to Commemorate Losing the War," 66–67
Barba, Eugenio, 167, 169
barber, 1, 90–91, 115
barbershop pole, 1, 115
Bataille, Georges, 45, 48
Beardsley, Aubrey, 164
Beatles, The, 38, 247
beggars, 149–50, 180

"Beginning of the Summer that will Freeze and Wane in the Non-melodic Metropolis," 16–17, 220
Benjamin, Walter, 22, 94, 182, 233, 242
bestiality, 16, 24, 26–30
Bethune, Robert, 153
biaxial orientation, 153
birds, 7, 77, 101, 126–27, 144, 163, 165, 176–77, 194
bird's eye view, 160, 165–66, 264
Birth of a Jazz Maiden, 12, 220
Black Point, 40, 220
Blue Echoes, 82–83, 220
blues, 18, 20, 31
body
 as covered in conventions, 5, 8–10, 50–52, 56–57
 as musical instrument, 13, 128–29, 133, 154, 215
 sympathetic response and, 129–31
body therapy, 171
Boleslavsky, 170
bomb
 see atomic bomb
Bonjin, Atsugi, 16, 18, 219
boredom, 212
Bosch, Hieronymous, 149–50, 176–77, 180, 194, 200
boys, 25–26, 35–39
Breton, Andre, 60, 192
Buddhism, 152, 156, 252
bugs, 169, 185–86, 192–94
bullet train, 76
buyô, 103, 220

camera, 93–94, 106, 108–10
Campbell's Soup Cans (Warhol), 75
can-can, 2, 117–19, 121
Canteloube, Joseph, 143
caramel, 81
 see also Garmela
caramel disease, 94, 97
caramelo, 81
 see also Garmela
"Catalogue of Experiences" (Hijikata), 52–57, 62
causality, 14, 180, 194–95, 198, 200, 217
ceremony, 29, 49, 183
chaos theory, 195
character type, 7, 167, 210

cherry blossoms, 207, 210
chicken, 12, 15–16, 18–31, 35–37, 50, 65, 101, 116, 160, 198, 210
childhood, 11, 76, 99, 107, 113–14, 133–34, 162, 189, 194
Chinese characters, 78, 81, 155–56, 180, 192, 217, 247, 249
Christ
 see Jesus
Christianity, 71, 202
Civeçawa 77, 79, 225
 see also Shibusawa
clothespins, 68, 70, 73, 99, 250
Clothespins Assert Churning Action, 220
coercion, 24–31, 38
Cold War, 88–89, 102, 156
collocation, 14, 123, 191, 197–99, 203–4
compartmentalization, 172–73, 214
competition, 3–4, 7–8, 10–13, 59, 67, 71, 73–75, 82, 85, 88–90, 92, 104, 111, 133, 171, 204
 synthesis and, 60–62
conflict, 2–4, 59, 72, 108, 111, 133, 174, 215
Contemporary Theatre Arts Association, 12, 220, 226
contrast, 2, 114, 143
conventions, 2–3, 5, 7–10, 46, 48, 50–52, 56–57, 81, 97–98, 111, 122, 124–26, 129, 161, 179, 187, 191, 198, 200–1, 204, 212, 217–18
Cortázar, Julio, 7–8, 230
Costume en Face: a Primer of Blackness for Young Boys and Girls, 220
Courageous Woman Okane of Ômi Province, The, 142, 150–52, 167, 220
crisis, 43–44, 73–74, 87–89, 156
"Crisis Dance," 41, 49–52
Crowds of Flowers, 52, 53–54, 109, 220
crucifixion, 130–32
cruelty, 124, 128, 135
customs, 2, 9, 49–51, 55, 156, 162, 179, 191, 196, 198, 200–1, 217–18

Dairakudakan, 221
Dali, Salvadore, 68, 236
Dance of the Burial Mound Figurine, 12, 23, 25–26, 28, 220
dance titles, 236, 254
Dancing Gorgui, 83, 220

danshoku
 see homosexuality
Dark Body, 52, 54–56, 220, 241
de Morant, Alix, 256
"Death of Divine," 33–34, 130, 220
"Death of the Young Man," 34–36, 55, 220
definite article, 252–53
d'Estree sisters, 78, 97, 99
Dharsana, 132
Diaghilev, 32, 99
disease, 2, 41, 76, 94–95, 97, 133, 180, 189, 210
Disposal Place—Extract from the Song of Maldoror, 52–53, 62, 67, 93, 220
Dissolute Jewel, 137, 140, 176, 203
Divinariana, 34, 130, 220
Divine, 33–34, 130, 220
dog, 85–89, 94, 99, 131–34, 155, 177, 189, 191–93, 195, 199–200, 203–4, 211, 213, 264
dokata, 220, 231
dotera, 139, 141, 153, 220
Dower, John W., 240, 265
Duchamp, Marcel, 95, 138, 221, 246, 249
Duchenne, 80, 221, 246
Duchenne muscular dystrophy, 221, 246

Eckersall, Peter, 124
Eguchi Baku, 31, 235
Eguchi Takaya, 11, 171, 221
Egypt, 135, 149
Eisenstein, Sergei, 180
Elian Margaret, 263
emaciation (emaciated body), 14, 143, 207–18
embarrassment, 53–54, 57, 109, 249
emerge/emergence, 2, 13, 44, 55, 161–63, 174–75
emotional memory, 170, 260–61
endure, 88
erection, 1, 38, 117, 125, 136
ero-guro nansensu, 76
eternal revolution, 125, 136
ethics, 29, 133, 178, 180, 194, 198, 200
ethnicity
 celebration of, 106
 costumes marked as, 2, 117–20, 125, 154
 identity, 134–35
 rebellion against, 9, 11, 122–23
evil, 16–17, 38, 43, 49, 51, 201, 249

expectations, 33, 38–41, 43, 56, 65, 72, 97, 155
experience
 as authentic, 49–51, 55, 203–4
 as mind unifying, 46–51
 as primal, 44–45, 48, 54
"Extravagantly Tragic Comedy: Photo Theater Starring a Japan Dancer and Genius (Hijikata Tatsumi)," 105–11, 154, 225

father, 113–14, 151–54, 156
feminism, 85, 114
Fin Whale, 138, 141, 221
flamenco, 2, 16, 23, 117, 123, 125, 161
flower, 34, 36, 53–54, 71, 99, 102, 107–9, 120, 176, 192, 207
 see also *Crowds of Flowers*
Fontainebleau School, 75–76, 99
Forbidden Colors, 12, 15–33, 37, 42, 47, 50, 52, 62, 65, 89–90, 96–97, 112, 161, 207, 210, 221, 233, 237
 associations with bestiality, 16, 24, 26–30
 audience for, 31–34
 as commentary about social forces and coercion, 24–31
 experience and, 44–48
 "Hijikata Tatsumi DANCE EXPERIENCE Gathering," 41
 "Inner Material" and, 41–44
 making the audience work, 21–22
 narrative and, 22–24
 overview, 14–22
 reading, 20–31
 shock and, 21
Forbidden Colors 2, 33–42, 52, 55, 130, 221, 232, 241
 intimations of change, 35–41
force, evading, 38–39, 51, 56
formalism, 12–13
Forsythe, William, 168, 260
Foucault, Michel, 6–7, 9–10, 30, 191, 202–3
Fowler, Edward, 189
"From Being Jealous of a Dog's Vein," 131, 133, 213

Gabrielle d'Estrée, 75–76, 78, 97, 99
Gandhi, Mohandas, 132–33
Garett
 see Aileen Garett

Garmela, 81
Garmela Disease
 see caramel disease
"Garmela Mercantile," 76, 79, 81–83, 94, 97
garu, 188–89, 263
garumera shôkai, 81, 221
gauze, 62, 144, 161
gender fluidity, 234
General Catalogue of Males '63, 88, 102, 221
Genet, Jean, 17, 29, 34, 45, 111, 130–32, 134, 210
genocides, 200
German expressionist dance, 7, 11–12, 23, 34, 135, 230, 234
geta, 141, 143, 146–47, 150–51, 153–54, 167, 221
Gibasa, 221
Gibasan
 see *Seaweed Granny*
gidayu
 see ballad
globalization, 7–8
goal-orientation, 2, 49
Gôda, Nario, 17–21, 25–31, 36–39, 41, 47, 50, 52, 161, 210–11, 237, 241
"Gold Dust Show," 83–84, 221
Goodman, David, 78, 231
Gorgui, 247
"Goya—Pope of Pus," 178–84
goze, 140, 151, 153, 221, 256, 257
Graham, Martha, 23
"Grave Watchman," 176–77, 221
gravity, 119, 171–73
grease, 161
 see also olive oil
"Great Dance Mirror of Burnt Sacrifice," 137–38, 221
Green Table (Jooss), 23, 233, 241

hainarashi, 140, 221
half-point, 140–41, 146–47, 153
Hamera, Judith, 5
Hanako, 149, 221
Hanatachi
 see *Crowds of Flowers*
Hanayagi Shôtarô, 90–91, 94, 222, 248, 257
Hanchikik, 12, 23, 222
handicap, 119, 133, 160, 217

Hangidaitôkan
 see "Great Dance Mirror of Burnt Sacrifice"
Haniwa no mai
 see *Dance of the Burial Mound Figurine*
Haniya Yutaka, 63–65, 78
Hansen's Disease, 133, 180
Happenings, 12, 59, 70–71, 74, 94, 97, 113, 129
hase, 137
health, 16, 72, 131, 160
Heliogabalus, 123–33, 134, 155, 204, 254
Hendrix, Jimi, 138
Hexentanz, 23
Hi Red Center, 67, 69, 88, 156, 191, 221, 243
high school, 44, 48, 109, 126–27, 170
Hijikata Genet, 12, 222
Hijikata Kunio, 12, 222
Hijikata Nero, 12, 222
Hijikata Nue, 12, 222
Hijikata Tatsumi and Japanese People: Rebellion of the Body, 1–2, 4–5, 9–11, 13, 105–7, 115–38, 145, 154–55, 174, 191, 211, 222
 about title, 2, 4, 5, 9–11, 121–23, 126, 128, 229, 252–53
 as about either rebellion or ethnic identity, 2, 4, 5, 9, 11, 123
 as about personal identity, 122
 as fellow (Japanese) rebels, 123, 126
 as Roman/Emesani procession, 123–25
 as series of latent selves, 122
Hijikata Tatsumi DANCE EXPERIENCE Gathering, 41, 44, 47, 62, 67, 74, 87–88, 109, 222, 258
Hiroshima, 200, 265
Hitogata
 see *Human Shape*
hogusu, 172, 222
Holborn, Mark, 15, 253
Holocaust, 200
homelessness, 149, 194
homosexuality, 24–25, 29–30, 35, 38, 50, 56, 73, 86, 131–32, 179, 183, 235
Horiuchi Kan, 97, 222
Hosoe Eiko, 54, 88, 105–11, 156, 222, 231, 238, 251
Hosoe Eikô's Photographic Collection Dedicated to Hijikata Tatsumi, 41, 88, 222

Hôsôtan
 see *Story of Smallpox*
Human Shape, 207, 210–11, 222, 266

"I Can See Clearly Now," 207, 210
I Ching, 90, 95, 99
Ichikawa Miyabi, 66–67, 102
ideokinesis, 171, 173
igata no hokô, 54, 222
Iimura Takahiko, 67, 90, 222, 243, 248
Ikeda Tatsuo, 11, 222
illness, 67, 213
Imai Shigeyuki, 12, 222
imitation, 13, 43, 49, 56, 112
"Imperial Hotel Body: Shelter Plan," 88–89, 102, 222
improvisation, 34, 39–40, 70, 83–84, 103, 127, 211, 217, 236
Improvisation Technologies, 168
Indians, 132, 210, 230, 254
inertia, 171, 200
information
 lack of, 3, 10–11, 183
 negotiating, 8–9, 189–90
 overabundance of, 3, 14
injury, 112, 132
"Inner Material," 41–44, 48, 222
I-novel, 189, 263
insect/s, 7, 101, 166, 186–87, 191–92, 200, 212
Instructional Illustrations for the Study of Divine Favor in Sexual Love: Tomato, 99–100, 222
instructions, 14, 36, 64, 71, 163–69, 173, 176–77, 179–81, 183, 210, 260, 264
 see also adjustments
interaction, 2–5, 9, 31, 38–39, 46, 53, 59, 61–62, 115, 174, 210, 215–16
interrupting movement, 172–73, 178
invitation, 75–81, 180–84
Ishii Baku, 11, 222
Ishii Mitsutaka, 84, 91, 96, 122, 130, 222
Itô Mika's Bizarre Ballet Group, 138, 222

jazz, 11–12, 16, 23, 54, 83
Jazz Cinema Experimental Laboratory, 54, 222, 231, 258
jazz dance, 19, 208–9
Jesus, 130, 132

joints, 10, 38–41, 51, 56–57, 62, 129, 165–66, 217
Jôkyô
 see *Situation*
Jôno'uchi Motoharu, 88, 222, 248
Jooss, Kurt, 23, 233, 241
Joplin, Janis, 138
judgment, 46
jumping, 117, 119, 211
juxtaposition, 2–5, 39, 61, 65, 96, 135, 137–38, 169, 192, 200, 205, 217

kabuki, 12, 16, 94, 153, 161, 248
Kamaitachi, 109
 see also Sickle-Weasel
Kanemori Kaoru, 11, 223
Kano, Ayako, 257
Kanô Mitsuo, 79, 85–86, 249
kanôtai
 see possibility body
Kara Jûrô, 83, 138, 171, 223
karamaru, 196, 223
karamu, 196, 223
karayuki, 210, 223
karumera, 81, 223, 249
karumerashôsô, 94, 223
Kasai Akira, 91, 215, 223
Katô Ikuya, 91, 102, 223, 249
Katushika-ku, 107
Kawara On, 11, 223
Kazakura, Shô, 66–69, 73, 91, 93–94, 99, 132, 223, 247
Keng, Lee Chee, 260
kimono, 1–2, 64, 68, 102, 113–21, 123, 139–41, 147, 153, 208
King of Fools, 130
Kinjiki
 see *Forbidden Colors*
Kisselgoff, Anna, 265
Klein, Susan Blakeley, 234, 252
Klein, William, 248
Kobayashi Saga, 138–40, 142, 145, 147, 148–51, 156, 176, 223, 255, 257, 259
Kunio (Hijikata's given name), 11–12, 222
Kuniyoshi Kazuko, 151–52, 180, 192, 229, 232, 233, 245
Kurihara, Nanako, 18, 124, 155, 165–66, 171, 173, 200, 210–11
Kuroki Fugoto, 223
Kusama Yayoi, 53, 223

Kuzu no ha, 140, 223
Kyoto School, 45, 239

L'Après Midi d'un Faune, 149
Laban, Rudolf, 171, 230
Lady on a Whale-String, 208–9, 223, 266
language, 5, 7–9, 12, 14, 17, 20, 39–40, 49, 51, 56, 61, 81, 92–93, 102, 104, 134–35, 155, 169, 174, 188–91, 194, 198, 217, 230, 231, 238, 239, 240, 245, 247
 transforming, 191–93
Leda
 see *Three Phases of Leda*
Left Hook Exhibition, 86, 223
Les Mendicants (Bosch), 180, 200
Levinas, Emmanuel, 66
lighting, 21, 32, 37, 54, 63, 99, 105, 127–28, 134–35, 139–40, 156
likeness, 14, 181, 190
love, 25–31, 86
Love for Sale, 223

Maldoror, 52–53, 220, 240
man, as character in Forbidden Colors, 16–20, 26–31, 35–36, 112, 210, 233, 235
Manteau, 165, 193–94
Margaret
 see Elian Margaret
Maro Akaji, 83, 171, 172, 223
Marotti, William, 243, 253
martial arts, 153, 175
Masseur, 12, 67–74, 76, 81, 82, 91–93, 96–97, 99, 102, 145, 154–55, 161, 174, 223, 248, 249, 257
Masson-Sekine, Nourit, 16, 28, 211
Masumura Katsuko, 11, 224
"Material," 41, 43, 48, 108, 223
"Material from the Storehouse," 79–80
Mauk, Nourbert, 233
Mavo, 16–17, 223
Maya, 149, 151, 169, 256
Mayazumi Toshirô, 34
McGuffin, 195, 201
Meisner, Sanford, 260
memoirs, 14, 113, 185–205
memory, 23, 41, 52–54, 137, 170–71, 188–89, 194, 196, 198
Metemotionalphysics, 102–4, 224

Method acting, 7, 170–71, 173
Michaux, Henri, 165–67, 181
Michelangelo, 99
micro-movements, 212, 214
 see also movement
Mid-afternoon Secret Ceremony of a Hermaphrodite, 62, 161, 224
Mies, Maria, 235
Mikami Kayo, 160–62, 168, 173–76, 178–80
mimeticism, 12–13, 15, 19, 22–24, 29, 31, 56, 70–71, 207
misery, 41–43
Mishima Yukio, 12, 17, 29, 32, 38–41, 49–51, 53–54, 56, 59–60, 65, 67, 72–73, 86, 92–93, 99, 102, 109, 133, 155, 174, 183, 190, 198, 214, 216–17, 224
 as committing suicide, 236
 as concerned with athletics, 72–73, 92–93, 133, 174, 214, 217
 as supporting avant-garde dance, 39, 49–51, 60, 65
mitai, 190–91, 200
 see also *yô na*
Mitsukuchi Tateo, 63, 224
Miya Sôko, 11, 224
Mizutani Isao, 52–54, 62, 67, 93–94, 224
modern dance, 11, 16, 23–24, 29, 31–32, 39, 42, 48, 70, 96–99, 113, 149, 152, 211, 250
moji, 39, 224
mold walk, 54–55, 258
molding, 105, 198
 see also mold walk
Morishita Takeshi, 95, 98–99, 102, 126, 136
mother, 105–6, 108, 111, 113–14, 151–54, 156, 160, 176, 178, 180, 200
motion, 25, 127, 141, 146, 150, 162, 165, 172, 208–9, 214
 see also movement
Motofuji Akiko, 12, 18–19, 32, 47, 54, 63–65, 67, 76, 81–84, 101, 126, 138, 224, 231, 237
movement, 138–41
 beauty and, 215
 butoh and, 178–81
 characterization and, 150–51
 creation of new, 168–69, 203
 emergence of, 161

Human Shape and, 207–11
Japanese culture and, 153–54
modification of, 159, 161, 163–68, 200
multivalent, 154–57
narrative and, 152, 154–57
sources, 148–50
teaching of, 171–73
vocabulary, 145–48
see also micro-movements
Mt. Fuji, 76, 249
Munroe, Alexandra, 96
Murobushi Kô, 125, 136, 224
Murphy, Eddie, 201
music, 7, 13, 15–18, 32, 46, 64–65, 81–84, 126–29, 133–36, 153–54, 209–10
Music Concrete's Maiden of Dôjô Temple, 12, 224
musical instrument, body as, 13, 128–29, 133, 135–36, 154, 217
Mutual Security Treaty, 72, 125
"my young persona," 185, 188, 190
"my youth"
 see "my young persona"

Nadare-ame
 see Avalanche Candy
Nagasaki, 200
Nagata Kiko, 16–17, 224
Nakajima Natsu, 167–69, 224, 260
Nakamura Hiroshi, 115, 138, 224
Nakamura Matagoro, 153
Nakanishi Natsuyuki, 67, 69, 73, 75–76, 79, 85–86, 88–89, 102, 130, 138, 155–56, 191, 224, 255
nanshoku
 see homosexuality
narrative(s), 12–14, 15, 22–24, 31, 37, 41, 50, 52, 59, 62, 65, 71, 84, 97, 104, 107, 137–39, 151–57, 159, 163, 176–78, 182–83, 186–87, 189, 194–96, 210
 early dances and, 12, 15, 22–24, 31, 62
 forsaking, 12, 37, 41, 50–52, 59, 65, 71, 84, 104, 233–34, 238
 in Hijikata's writing, 186–89, 194, 196
 multiple in one dance, 14, 137–38, 151–52, 154–57
 necessity for spectator to practice constructing, 14, 182–83

as structural element in Hijikata's late dances, 176–78, 210
nation
 communication and, 61
 identity and, 9, 10, 123–24, 204
neo-Dadaism, 12, 59, 62, 66–67, 69–74, 86, 88, 92, 94, 97, 101, 191
new theater
 see Shingeki
night school, 44, 53, 238
Nijinsky, Vaslav, 32, 99, 149
Nimura Momoko, 142, 145, 147, 150
Nipper (RCA Victor Dog), 95–96, 99
Nishi Tetsuo, 239, 248
Nishida Kitarô, 44–46, 48, 224
Nishitani Keiji, 96, 224, 249
Noguchi Michizô, 171–73, 175, 224, 261
Nonaka Yuri, 63, 85, 224
Norinaga, Motoori, 90, 94, 99, 155, 224, 257
nostalgia, 106, 115, 154, 188

objects, 59, 64, 66–67, 69, 89, 92, 95, 99, 135, 154–55
objet, 66–67, 73, 86, 129
Oikawa Hironobu, 12, 23, 224, 232, 234
Okamoto Taro, 11, 224
olive oil, 17, 54, 161
Ôno Kazuo, 11, 23, 33, 34, 47, 79, 90, 94, 100, 214, 224
Ôno Yoshito
 see Yoshito
Onrai Sahina, 224, 263
opposition, 2, 4–5, 43, 48, 114, 143, 147–48, 151, 170–71, 181, 195, 212, 215
Ortolani, Benito, 248
Otsuji Seiji, 18–19, 21–26
Our Lady of the Flowers, 34, 130, 210, 235
Ozasa Yoshio, 5, 230

Pachelbel, 210
Packard, George, 245
Paik, Nam Jun, 248
Pain, 10, 21, 37–38, 41–44, 47–48, 56, 62, 66–67, 73, 115, 130–34, 136, 201, 211
panels, 1, 115–17, 125–27, 207, 209, 211
pariah, 180
"Pariah Girl," 167–68, 221
passive voice, 108, 187
peeing, 1, 20, 87, 93
 see also urinating

percussion, 64, 134–35, 154, 217
"Person that Derives Pleasure from Destroying Art," 94–95, 97
phallus, 1–2, 85, 116–18, 120, 125, 137
photography
 audience and, 94
 the body and, 39, 88–92
 Dark Body and, 54–55
 of *Forbidden Colors*, 17–18
 neo-Dadaism and, 71
 as part of performance, 28–29
 Rose-colored Dance and, 75–76, 78
 slashing space and, 105–11
phrases, 88, 93, 103, 154, 163, 176–77, 180
pig, 1, 115–16, 130
plaster of Paris, 62, 102, 242
Plogsterth, Anne, 246
plot, 22–24, 112, 176
Poinciana, 16, 225
politics, 125, 153, 183
pop culture, 73, 207, 210
possibility, 174–75, 187–88
possibility body, 14, 159, 174–75
posters
 Hijikata Tatsumi and Japanese People: Rebellion of the Body, 105–6
 inspiration for, 204
 Rose-colored Dance, 75–90, 94–99, 155
 Three Phases of Leda, 63
postures, 28, 151, 153, 165, 171, 190, 208
postwar Japan, 2, 4, 6–7, 10, 12, 14, 32, 42, 47–50, 72–73, 82, 85, 88, 124, 174, 180, 192
power, 6–7, 9, 28–30, 38, 91, 112, 124, 129, 134–35, 178, 202–3, 215, 235
Presumed Portrait of Gabrielle d'Estrée and her Sister the Duchess of Villars, 77, 97, 99
Productive/Productivity/Production, 5–9, 15, 42–43, 49, 51, 110, 112, 215, 238
profile, 54, 141, 146, 149
prostitution, 34, 42, 44, 56, 111–14, 124, 130, 132, 151, 180, 210
Proust, Marcel, 155, 161–62, 170, 175, 259
psyche, 12, 61–62, 64–67, 73–74, 85, 98–99, 216
pure experience, 45–47

quotations, sourceless, 186, 191, 194, 263

Ra Aruhenchîna shô, 219
 see *Admiring La Argentina*
random search method, 199
randomness, 13, 68–69, 71, 89, 162, 175, 199, 217
rashisa, 14, 190, 198, 264
"Rebellion of the Body," 1–2, 4–5, 9–11, 13, 105–7, 115–28, 132, 134–36, 137–38, 145, 154–55, 174, 191, 211, 222
receiver, 159
Reverdy, Pierre, 96
Revolt of the Flesh
 see "Rebellion of the Body"
revolution, 44, 51, 125, 136
Ribon no kishi, 101, 225, 250
Richie, Donald, 34, 76, 99, 126, 128, 234
riddles, 78, 89, 96, 155, 217
ritual, 55
romanization, 219
rond de jambe, 147
Rose-colored Dance, 12, 43, 74–99
 poster, 75–90, 94–99, 155
 understanding, 90–99
Rotie, Marie, 258
rumba, 210

sacrifice, 43, 49, 56
Sade, Marquis de, 60, 63, 108, 236
Sakurai Keisuke, 168
salmon can, 75, 250
salsa, 210
Sartre, Jean Paul, 239
Sas, Miryam, 50, 61, 74, 96, 129, 192
satyagraha, 132
scandal, 61–62, 64, 66, 73, 98
Schwellinger, Lucia, 138, 203
science, 199–200, 204
Scott, A. O., 265
"script of welts," 37, 225
Seals and Crofts, 207–8
Seaweed Granny, 137
"Second 6 Avant-gardists," 60, 225
Seed, 52, 55–56, 63, 148, 225
Segal, George, 161
sei, 14, 194–98, 201, 203, 225
Seigle, Cecilia Segawa, 257
Seiryukai, 215–16, 225
seisan, 44, 225, 238
seisansei, 225

sexuality, 21, 28–30, 50, 57, 86
shamisen, 68–69, 141, 154, 243
Sharf, Robert, 239
"Shelf Full of Duchamp Style Dancing Girls, A," 95
Shibamata, 107
Shibusawa Tatsuhiko, 50, 60–62, 64, 76, 79, 87, 98–99, 113, 121, 124, 128–29, 162, 183, 216, 225
shimpa, 90, 94, 248
Shingeki, 129, 186, 225
Shinjuku Art Village, 138, 159, 225, 255
Shinjuku Culture Art Theater, 137, 225
Shinohara Ushio, 11, 86, 96, 99, 174, 225
Shiraishi Kazuko, 89
shishôsetsu, 189, 225
 see also I-novel
Shizuka na ie, 204, 225
shock, 7, 15, 17, 21–24, 28–29, 31
shônen, 17, 225
Showa, 76, 79–80
Shushi
 see *Seed*
Sickle-Weasel, 109, 111, 251
sickness, 210, 213, 216
sign (system), 6–7, 191
"Simultaneous Display and Sale of the Dancers," 13
sister, 105, 111–15, 252
Situation, 16
Situation Theater, 225
"Sixth Newcomers Dance Recital," 17, 219
sketches, 54–55, 101, 149, 201
slashing space, 109–11, 114–15, 217
slowness, 211, 234
smell, 7, 66, 124, 165, 170
Snipe, 12, 225
snow-cones, 181–82
socialization, 12–13, 32, 46–51, 104, 112, 115, 122, 156, 162, 187, 196, 201–4, 212, 215–17
sodomy, 19, 21, 23, 26–27, 30, 35, 48, 90–91, 137, 147, 155, 258
somatics, 171–73, 175
Soupault, Phillipe, 192
Space Capsule, 138, 159, 225
space music, 210
speed, 71–72, 211–12
spinning, 1, 68, 70, 73, 116, 126, 164, 211, 214, 217–18

"spontaneous inevitability," 60–61, 226
Stanislavski, Constantin, 169–71
Stanislavski System, 7, 170–71, 173
starvation, 193
Story of Smallpox, 137, 139, 222
Strasberg, Lee, 170
stratification methods, 54
striptease, 43, 84–85, 99
Study of the Good, A
 see *Zen no kenkyû*
suffering, 66, 115, 130, 132, 200–1
suffocation, 11, 21–22, 28–29, 83, 130, 234
sukajan, 225, 249
Sumi Yoichi, 247
"Summer Breeze," 207–8, 210
sumo, 72, 140, 153
Sunohara Masahisa, 12, 225
surreal/surrealism, 1–3, 7, 9–10, 13–14, 20, 47, 53, 59–62, 65, 96, 123, 137, 162, 169, 177, 191–94, 198–200, 204–5, 215, 217
Susamedama
 see *Dissolute Jewel*
sutajan, 226, 249
Suzuki Tadashi, 109
Sweigard, Lula, 171
sympathetic response, 129–31
synthesis, 60–65

tagaru, 188, 263
Takai Tomiko, 85, 102, 104
Takamatsu Jiro, 88, 226
Takechi Tetsuji, 12
Takiguchi Shûzô, 47, 53, 60–62, 96, 99, 192, 226, 241
Tamah Nakamura, 215–16
Tamano Koichi, 138–39, 142, 146, 226
Tanaka Min, 212, 255
Tanemura Suehiro, 55–56, 148, 226
tari, 14, 190–91, 193, 198–99, 203
Tashiro, 106–7, 110, 226, 251, 252
Tashuma/Teshuma, 7–8
tatami, 67–68, 71, 91, 137, 154, 188
technique, 38–39, 42–43, 50–52, 59, 70–71, 159–63
technology
 of body, 7
 of self, 9–10, 202
 types, 6
 using on stage, 7, 94

Temple School, 141
temporal continuity, 40, 53–54
Terakoya
　see Temple School
Terayama Shûji, 174, 276
"that kind of pulling I," 188
"Theatre Human/Contemporary Theatre Arts Association Joint Concert," 12, 226
Three Phases of Leda, 63–65, 66, 71, 78, 96, 103, 139, 226, 246
toe shoes, 32, 49
Tohoku, 106, 108–11, 160, 181, 201
Tokyo
　as location of photo shoot with Hosoe Eiko, 105–11
　as location of soft bodies, 44
Tomato, 99–102, 222, 249
torso, 13, 17, 102, 141, 145–46, 149, 151, 153, 208
tragedy, 42–43, 49, 51, 56, 101
transformation, 13, 37–39, 79–80, 125, 159–62, 168, 170, 173–75, 202, 209, 211, 217
Treat, John Whittier, 262
Tsubouchi Itchû, 86, 226
Tsuda Nobutoshi, 12, 16–18, 26, 32, 226
Tsugaru-jamisen, 140, 153–54, 226, 256
Tsukuba Mountain, 107
tsutsumu, 196, 226
tungsten, 63
TUTIKATA, 226, 231
Twenty-seven Nights for Four Seasons, 137, 139, 148, 155–56, 159, 221
Twist Dango, 99

Ueno Kurumazaka, 42
Ugo-machi, 106, 226
unconsciousness, 13, 30, 162, 172, 175, 191–93, 201, 204, 217
Unique Ballet Group, 12, 219
urinating, 50, 85–87, 89, 93, 156, 248
Urirabu
　see *Love for Sale*
usefulness, 6, 11, 44, 215, 229, 238
Utagawa Kuniyoshi, 151, 226
utility, 5, 7, 12–13

Vakhtangov, Yevgeny, 170
Velazquez, Diego, 180
Viala, Jean, 16, 28, 211

Victor dog
　see Nipper
Vietnam War, 84, 102
viewpoint/s
　adopting viewpoint of bodily part, 166
　adopting viewpoint of dancer, 160
　adopting viewpoint of other, 10, 13, 168, 170–71, 183–84, 188, 202, 216–17
　communication of, 10
　seeing oneself from somewhere else, 133–36
　see also back; peeing; urinating
violence, 2, 16, 21, 24, 31, 35–38, 41, 57, 72, 88, 91, 112, 114, 151, 156, 178

Wages of Whiteness, The, 31
Waguri Yukio, 142–44, 146, 226, 259, 266
Wakamatsu Miki, 16, 34, 226
war, 72–74, 84, 91, 107, 124, 201, 204, 210, 233
　see also postwar Japan; Vietnam War; World War II
Warhol, Andy, 75, 250
watakushi-shôsetsu
　see I-novel
waves, 76, 109, 207
West/Western, 27, 30, 44–45, 47, 63, 90, 97, 103, 124, 128, 136, 153, 178, 200, 203, 210, 245, 248–50
　forms of dance studied by Hijikata, 16, 97, 103, 123
　interpretations of butoh, 27, 30, 200
　thought, 44–45, 47, 153, 203, 249
　use of in Hijikata's dances, 90, 103, 123, 178, 210
white, 17–19, 31, 53, 64, 66–67
white paint, 15, 161
Wigman, Mary, 11, 23
wind-sprints, 68, 71, 73, 133, 211, 214
Womb, 63, 172, 240
World War II, 72, 210, 249

Yagawa Sumiko, 52–54, 63
Yamada Ippei, 138, 161
Yamagata, 106–7
Yameru maihime
　see *Ailing Terpsichore*
Yanai Yasuhiro, 247, 248
Yasuda Shûgo, 17, 226
yô na, 189–91, 193, 203

Yokô Tadanori, 75, 77, 79, 227
Yokohama, 83–84
yokoku-en, 227, 250
Yomiuri Independent Exhibition, 73
Yoneyama Kunio, 11–12, 106, 227
Yonezawa, 107
Yoshida Yoshie, 20, 238
Yoshimura Masunobu, 62, 66, 99, 161, 227

Yoshino Tatsu'umi, 66, 145, 147, 150, 227
Yoshito, 17–18, 27, 53–54, 224, 233
Young Man, 17–31, 34–37, 50, 55, 227, 235
yûfu, 151–52, 227

Zen no kenkyû, 44
Zizek, Slavoj, 264